Secret Knowledge
Rediscovering the lost techniques of the Old Masters
David Hockney

Thames & Hudson

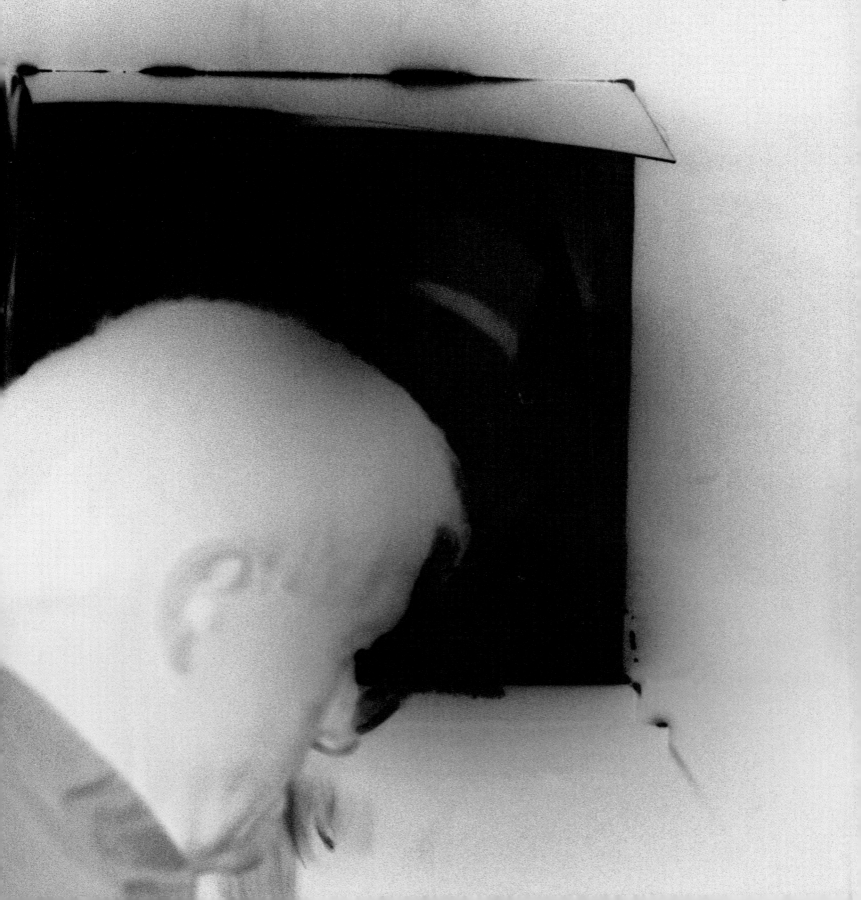

Secret Knowledge

Rediscovering the lost techniques of the Old Masters

David Hockney

First published in the United Kingdom in 2001 by
Thames & Hudson Ltd, 181A High Holborn, London WC1V 7QX

British Library Cataloguing-in-Publication Data
A catalogue record for this book is available from the
British Library

ISBN 0-500-23785-9

Printed and bound in Singapore by CS Graphics

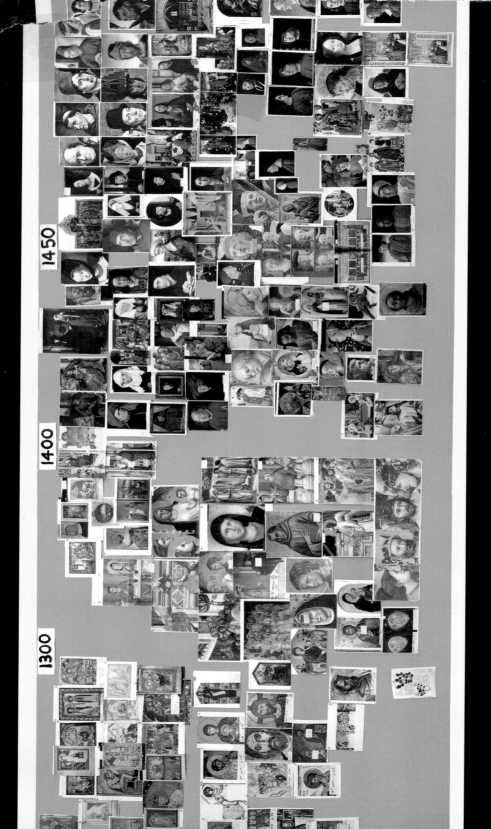

1450

1400

1300

The Great Wall, 31 March 2000

Overleaf: The beginning of the wall – c. 1150
Byzantine mosaic, Cefalù Cathedral, Sicily (pre-optics)

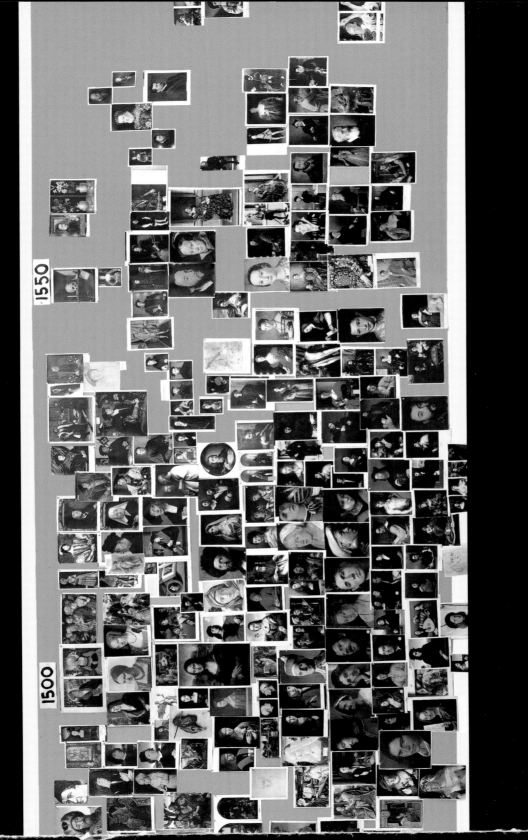

contents

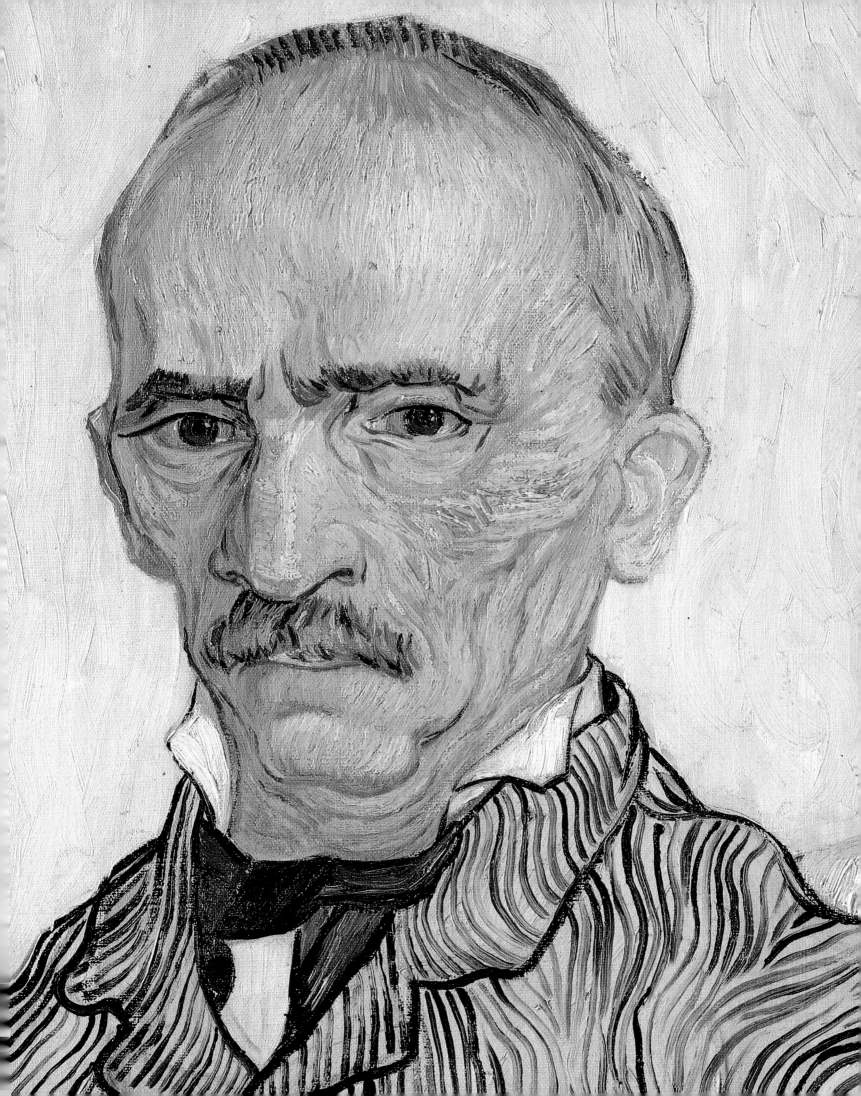

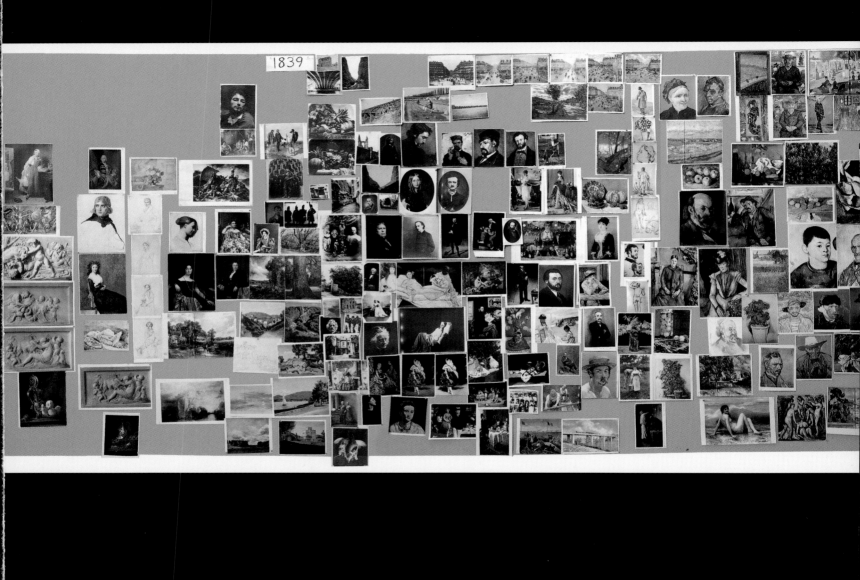

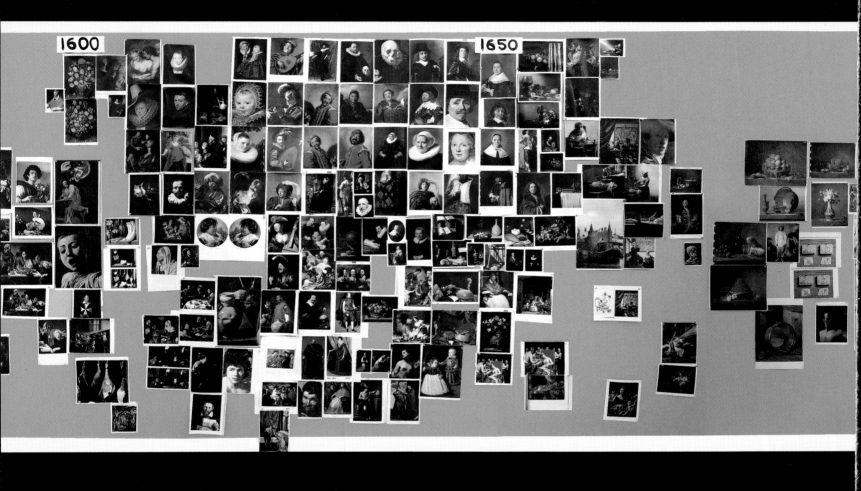

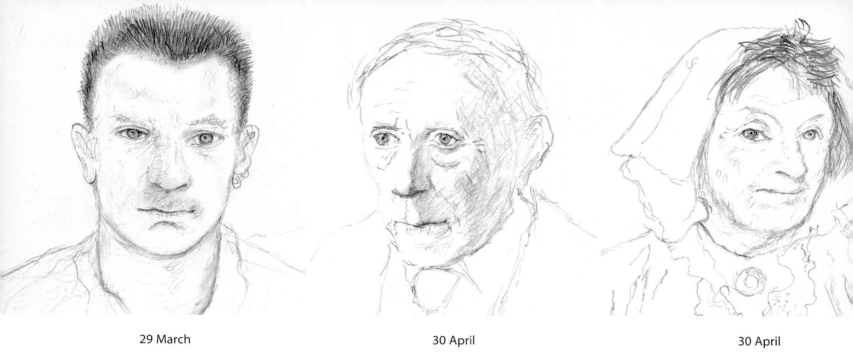

29 March 30 April 30 April

This book is in three parts. The first is the visual presentation of a thesis I have been developing over the past two years. The second is a collection of extracts from some of the documents I came across during my research. And the third is a selection of notes, essays and letters written to clarify my ideas as they developed and as part of a dialogue with Martin Kemp, Charles Falco, John Walsh and other experts. This correspondence tells the story of my investigations.

 The thesis I am putting forward here is that from the early fifteenth century many Western artists used optics – by which I mean mirrors and lenses (or a combination of the two) – to create living projections. Some artists used these projected images directly to produce drawings and paintings, and before long this new way of depicting the world – this new way of seeing – had become widespread. Many art historians have argued that certain painters used the camera obscura in their work – Canaletto and Vermeer, in particular, are often cited – but, to my knowledge, no one has suggested that optics were used as widely or as early as I am arguing here.

 In early 1999 I made a drawing using a camera lucida. It was an experiment, based on a hunch that Ingres, in the first decades of the nineteenth century, may have occasionally used this little optical device, then newly invented. My curiosity had been aroused when I went to an exhibition of his portraits at London's National Gallery and was struck by how small the drawings were, yet so uncannily 'accurate'. I know how difficult it is to achieve such precision, and wondered how he had done it. What followed led to this book.

 At first, I found the camera lucida very difficult to use. It doesn't project a real image of the subject, but an illusion of one in the eye. When you move your head everything moves with it, and the artist must learn to make very quick notations to fix the position of

1 May 1 May 3 May

the eyes, nose and mouth to capture 'a likeness'. It is concentrated work. I persevered and continued to use the method for the rest of the year – learning all the time. I began to take more care with lighting the subject, noticing how a good light makes a big difference when using optics, just like with photography. I also saw how much care other artists – Caravaggio and Velázquez, for example – had taken in lighting their subjects, and how deep their shadows were. Optics need strong lighting, and strong lighting creates deep shadows. I was intrigued and began to scrutinize paintings very carefully.

Like most painters, I imagine, when I look at paintings I am as interested in 'how' it was painted as 'what' it is saying or 'why' it was painted (these questions are, of course, related). Having struggled to use optics myself, I found I was now looking at pictures in a new way. I could identify optical characteristics and, to my surprise, I could see them in the work of other artists – and as far back as the 1430s, it seemed! I think it is only in the late twentieth century that this has become visible. New technology, mainly the computer, was needed to see it. Computers have allowed cheaper and higher-quality colour printing, leading to a great improvement in the last fifteen years in the standard of art books (even twenty years ago, most were still in black and white). And now with colour photocopiers and desktop printers anyone can produce cheap but good reproductions at home, and so place works that were previously separated by hundreds or thousands of miles side by side. This is what I did in my studio, and it allowed me to see the whole sweep of it all. It was only by putting pictures together in this way that I began to notice things; and I'm sure these things could have only been seen by an artist, a mark-maker, who is not as far from practice, or from science, as an art historian. After all, I'm only saying that artists once knew how to use a tool, and that this knowledge was lost.

12 May 12 May 15 May

I discussed my observations with friends, and was introduced to Martin Kemp, professor of art history at Oxford University and an authority on Leonardo and the links between art and science. From the start, he encouraged my curiosity and supported my hypotheses, albeit with reservations. Others, though, were horrified at my suggestions. Their main complaint was that for an artist to use optical aids would be 'cheating'; that somehow I was attacking the idea of innate artistic genius. Let me say here that optics do not make marks, only the artist's hand can do that, and it requires great skill. And optics don't make drawing any easier either, far from it – I know, I've used them. But to an artist six hundred years ago optical projections would have demonstrated a new vivid way of looking at and representing the material world. Optics would have given artists a new tool with which to make images that were more immediate, and more powerful. To suggest that artists used optical devices, as I am doing here, is not to diminish their achievements. For me, it makes them all the more astounding.

Other questions I faced were, 'Where are the contemporary writings?' 'Where are the lenses?' 'Where is the documentary evidence?' I could not answer these questions at first, but I was not put off. I know artists are secretive about their methods – they are today, and there's no reason to suppose they were ever any different. They were probably even more secretive in the past: in medieval and Renaissance Europe, for instance, those who revealed the 'secrets' of God's kingdom might have been accused of sorcery and burned at the stake! I was to find out later that there *are*, in fact, many contemporary documents which support my thesis (you can see extracts from some of these in the second part of the book).

The popular conception of an artist is of a heroic individual, like, say, Cézanne or van Gogh, struggling, alone, to represent the world in a new and vivid way. The medieval or

15 May

16 May

19 May

Renaissance artist was not like that. A better analogy would be CNN or a Hollywood film studio. Artists had large workshops, with a hierarchy of jobs. They would attract the talented, and the best would be quickly promoted. They were producing *the only* images around. The Master was part of the powerful social élite. Images spoke and images had power. They still do.

I had begun to juxtapose images – Ingres and Warhol, Dürer's and Caravaggio's lutes, Velázquez and Cranach – before Gary Tinterow invited me to speak at an Ingres symposium at the Metropolitan Museum in New York, and with the addition of some of my own camera lucida drawings I put together a slide show upon which I could base my talk. The evidence I was presenting was the pictures themselves – but I had learned a great deal by making those drawings, and I felt my experience as a practitioner must count for something. After the talk, Ren Wechsler wrote an account of my developing theories in the *New Yorker*, and I soon began to get letters from all over the world. Some people were shocked at my suggestions; others were excited by the implications, or said that they had noticed similar things themselves.

I was already aware that this was a big subject. And the response to Ren's article showed me that it was of interest to a great many others. At the lecture, the audience had responded immediately to the images, and I realized that if people were to be convinced by my arguments they had to be presented with the visual evidence I had observed in the paintings. A book seemed the best way to do this. You bring your own time to a book, it is not imposed, as with film or television. With a book you can stop to think something through, or go back and look at something again if you need to. The central argument had to be visual, I decided, because what I had found came from looking at the pictures

15 June

17 June

22 June

(which, as art historian Roberto Longhi pointed out, are primary documents). I realized I would have to write and design the book at the same time. As it turned out, many key discoveries were still to come – measurable optical distortions in paintings, for example, and that a concave mirror can project an image – so the scope of the book expanded as it progressed.

In February 2000, with the help of my assistants David Graves and Richard Schmidt, I started to pin up colour photocopies of paintings on the wall of my studio in California. I saw this as a way I could get an overview of the history of Western art, and as an aid to the selection of pictures for the book. By the time we had finished, the wall was seventy feet long and covered five hundred years more or less chronologically, with northern Europe at the top and southern Europe at the bottom.

As we began to put the pages of the book together, we were also experimenting with different combinations of mirrors and lenses to see if we could re-create the ways in which Renaissance artists might have used them. The projections we made delighted everyone who came to the studio, even those with a camera in their hands. The effects seemed amazing, because they were unelectronic. The images we projected were clear, in colour and they moved. It became obvious that few people know much about optics, even photographers. In medieval Europe, projected 'apparitions' would be regarded as magical; as I found out, people still think this today.

In March we were visited by Charles Falco, an optical scientist who had read Ren's piece in the *New Yorker*. Charles instantly became an enthusiastic and insightful correspondent, and what is more, his detailed calculations, based on 'optical artefacts' in the paintings, provided scientific data to back up my arguments. All the time, the

28 July

28 July

14 December

evidence – visual, documentary and scientific – was mounting and becoming more and more compelling.

It is perfectly clear that some artists used optics directly and others did not, although after 1500 almost all seem to have been influenced by the tonalities, shading and colours found in the optical projection. Brueghel, Bosch, Grünewald immediately come to mind as artists who were not involved in the direct use of optics. But they would have seen paintings and drawings made with them, and maybe even some projections themselves (to see optical projections is to use them); and as apprentices they probably copied works with optical effects. I must repeat that optics do not make marks, they cannot make paintings. Paintings and drawings are made by the hand. All I am saying here is that, long before the seventeenth century, when there is evidence Vermeer was using a camera obscura, artists had a tool and that they used it in ways previously unknown to art history.

It seems to me that my insights open up a vast range of issues and questions. Some must remain unanswered here; some, I am sure, are as yet unasked. This book is not just about the past and the secret techniques of artists; it is also about now and the future, the way we see images, and perhaps 'reality' itself, today. Exciting times are ahead.

This book would not have been possible without the collaboration, enthusiasm and support of others – too numerous to catalogue at this point, where the reader will want to get on with the book. By deferring my tribute to them until the end, I hope to be able to acknowledge their invaluable contributions more fully.

the **visual evidence**

This part of the book is in the form of a visual argument. Early on, I was asked, 'What are you seeing?' – I am trying to show you here. I will make comparisons between paintings from different times and places, between works of close contemporaries, and between different paintings by the same hand. The chronology will emerge, and is summarized at the end.

When I went to see the Ingres exhibition at the National Gallery in London in January 1999, I was captivated by his very beautiful portrait drawings – uncannily 'accurate' about the features, yet drawn at what seemed to me to be an unnaturally small scale. What made Ingres's achievement in these drawings all the more astounding was that the sitters were all strangers (it is much easier to catch the likeness of someone you know well), and that the drawings were drawn with great speed, most having been completed in a single day. Over the years I have drawn many portraits and I know how much time it takes to draw the way Ingres did. I was awestruck. 'How had he done them?' I asked myself.

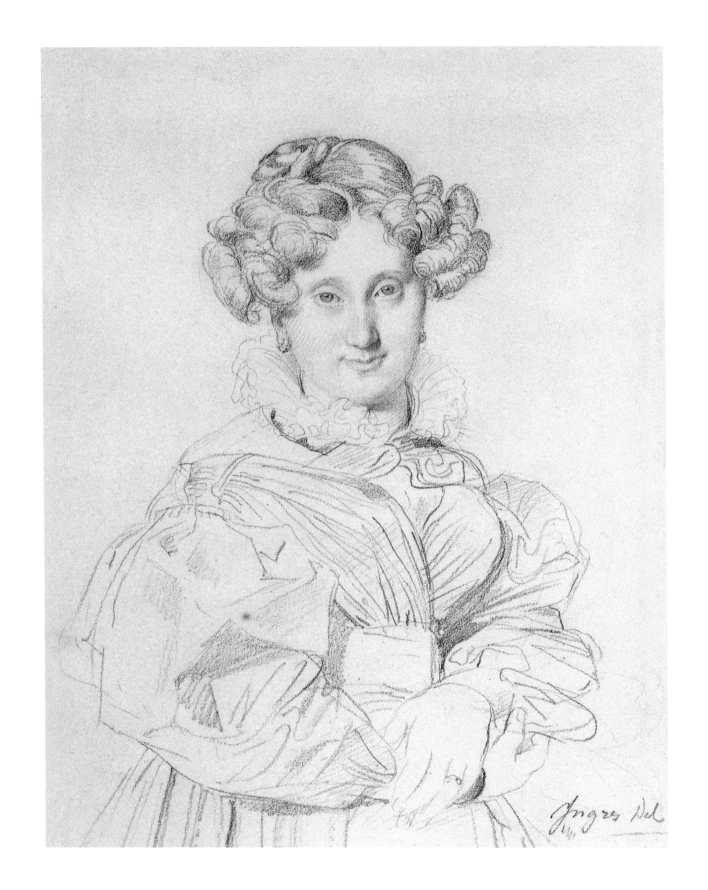

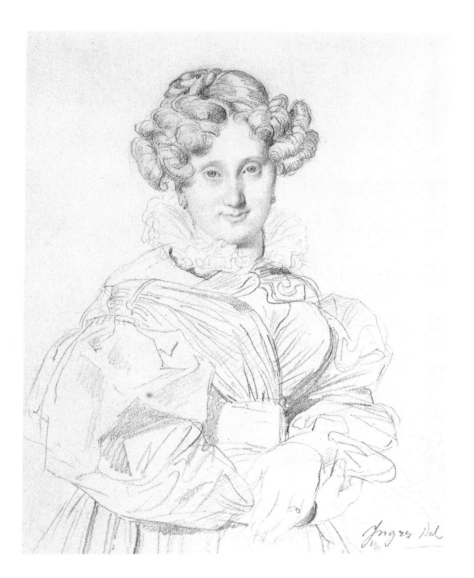

On the opposite page is a reproduction of Ingres's portrait drawing of Madame Louis-François Godinot from 1829. It is reproduced at exactly the same size as the real image. Although it is not regarded as one of Ingres's finest drawings of the period, it is very useful for our purposes for it contains a number of visual clues that suggest he used a camera lucida – an instrument made in 1806 for artists, mainly as a measuring device for drawing – to create it.

You will come across my term 'eyeballing' throughout this book. By this, I mean the way an artist sits down in front of a sitter and draws or paints a portrait by using his hand and eye alone and nothing else, looking at the figure and then trying to re-create the likeness on the paper or canvas. By doing this, he 'gropes' for the form he sees before him.

But the swiftness of Ingres's lines in this drawing does not look groped for. The form is so precise and accurate. I think he did the head first by looking at the lady through a camera lucida and making a few notations on the paper, fixing the position of her hair, her eyes, her nostrils and the edges of her mouth (notice the deep shadows). This may have taken him a few minutes to do. Then, he finished drawing her face from observation, eyeballing – the delicacy of the portrait suggests he spent an hour or two doing this. Later, perhaps after lunch, he did the clothes, but for this he would probably have had to move his camera lucida slightly. It is now we notice that the lady's head seems very large in relation to her body, especially compared with her shoulders and hands. If Ingres had moved his camera lucida to get in the clothes, a slight change in the magnification would have occurred, explaining the difference in scale we have noticed. I think this is what happened, because when we reduced the head by about 8% (*left*) it seemed to 'fit' her body much better.

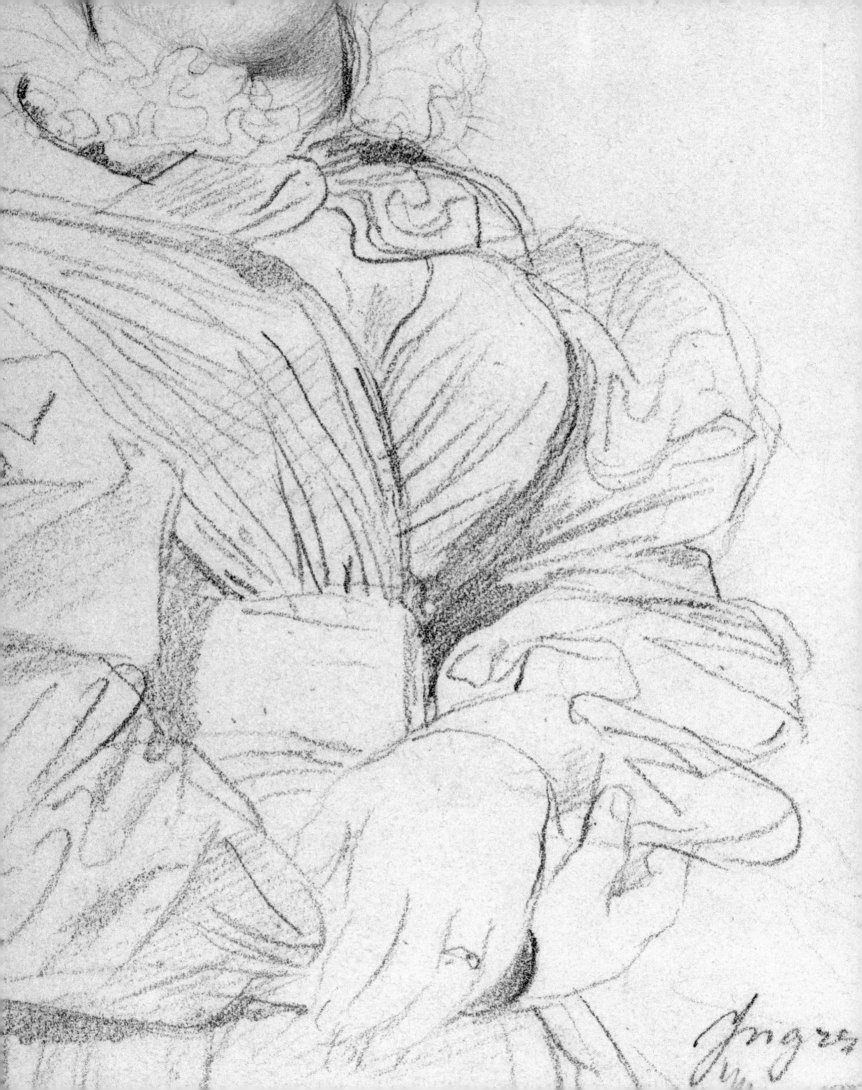

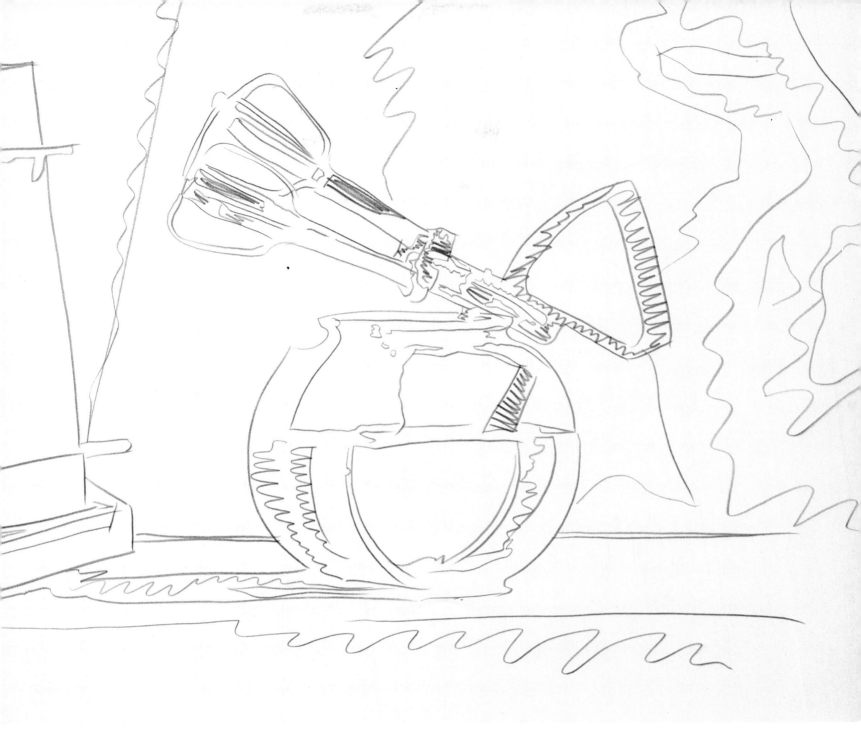

Ingres opposite; Warhol above. I know that Warhol used a projector to make drawings like this. His line has an obviously 'traced' look. It was seeing this drawing that made me recognize a similarity to the clothes in Ingres's portraits. In the Warhol, the left-hand edge of the bowl moves cleanly down, but instead of continuing round the bottom of the bowl to describe its shape, the line veers confidently off to the left to form a shadow. Similarly, in the Ingres, the cuff of the left sleeve is not followed 'round the form' as you would expect, but carries on into the folds.

The three small drawings by Ingres on this page, on the other hand, are all obviously eyeballed. The lines are groped for, there are signs of hesitation. My word 'groping' suggests uncertainty – 'Exactly where is the correct position?' he seems to ask. Notice the difference between the sleeve to the right (done in a conventional, eyeballed way) with that on the opposite page, which is drawn with confidence and continuous lines. There is no groping here – indeed, once again the drawing has the look of Warhol's traced line. It seems to have been done with a certain speed. All drawn lines have a speed that can usually be deduced: they have a beginning and an end, and therefore represent time, as well as space. Even a tracing of a photograph contains more 'time' than the original photograph (which represents just a fraction of a second), because the hand takes time to do it.

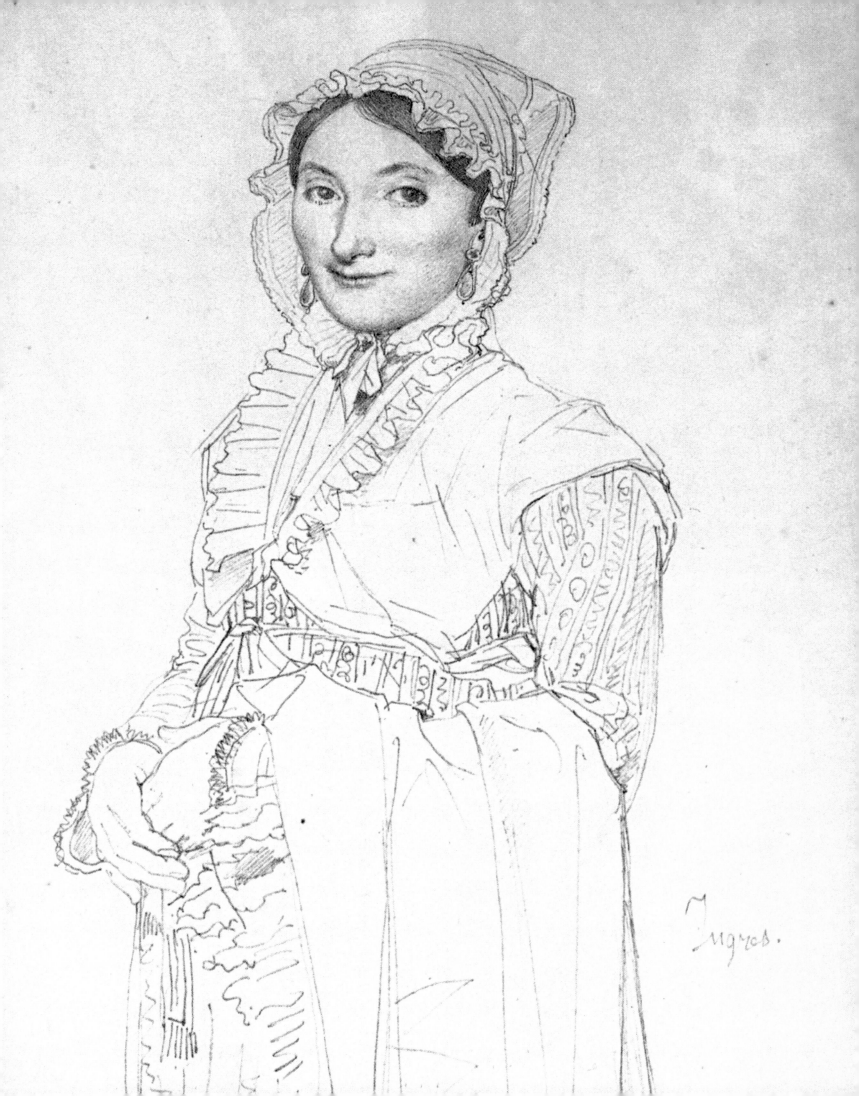

The camera lucida is not easy to use. Basically, it is a prism on a stick that creates the illusion of an image of whatever is in front of it on a piece of paper below. This image is not real – it is not actually on the paper, it only seems to be there. When you look through the prism from a single point you can see the person or objects in front and the paper below at the same time. If you're using the camera lucida to draw, you can also see your hand and pencil making marks on the paper. But only you, sitting in the right position, can see these things, no one else can. Because it is portable and can be carried anywhere, the camera lucida is perfect for drawing landscapes. But portraiture is more difficult. You must use it quickly, for once the eye has moved the image is really lost. A skilled artist could make quick notations, marking the key points of the subject's features. In effect, this is a fast forward of the normal measuring process that takes place in the head of a good draughtsman but which usually takes much longer. After these notations have been made, the hard work begins of observing from life and translating the marks into a more complete form. I tried to use the camera lucida myself for a year, drawing hundreds of portraits with it, including those of the National Gallery guards on the next page.

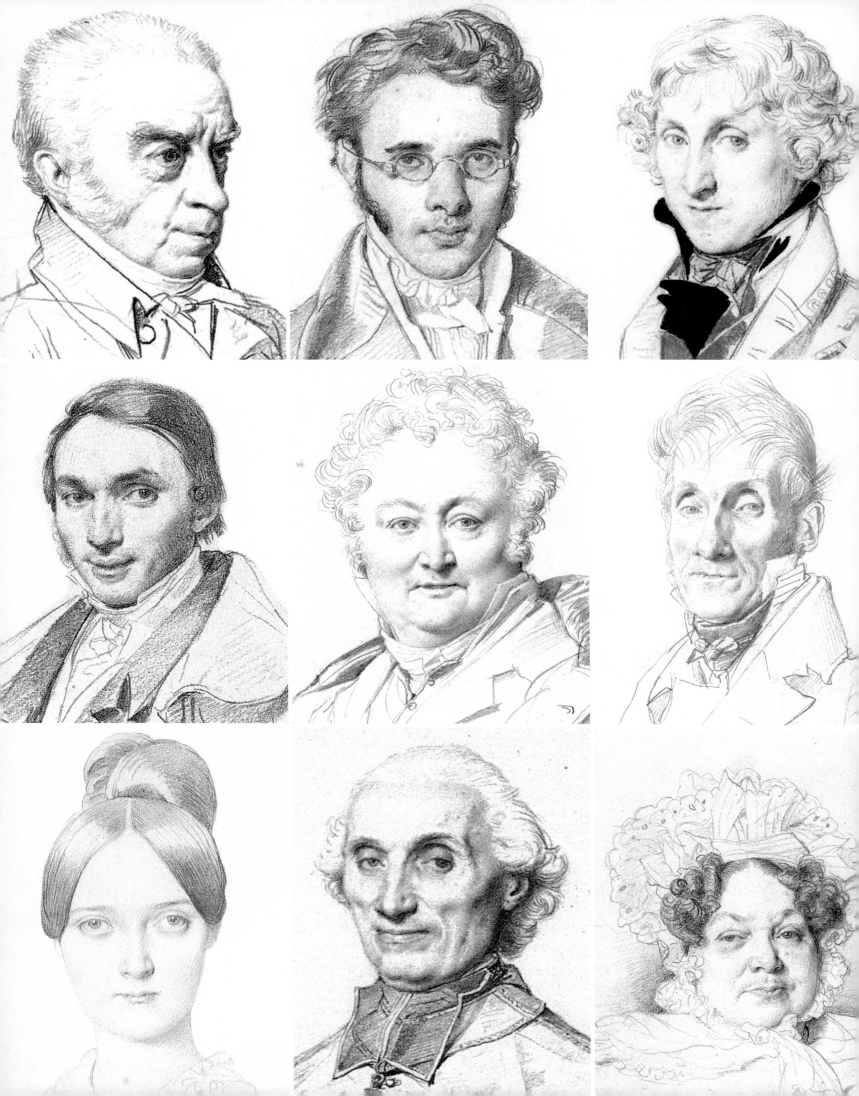

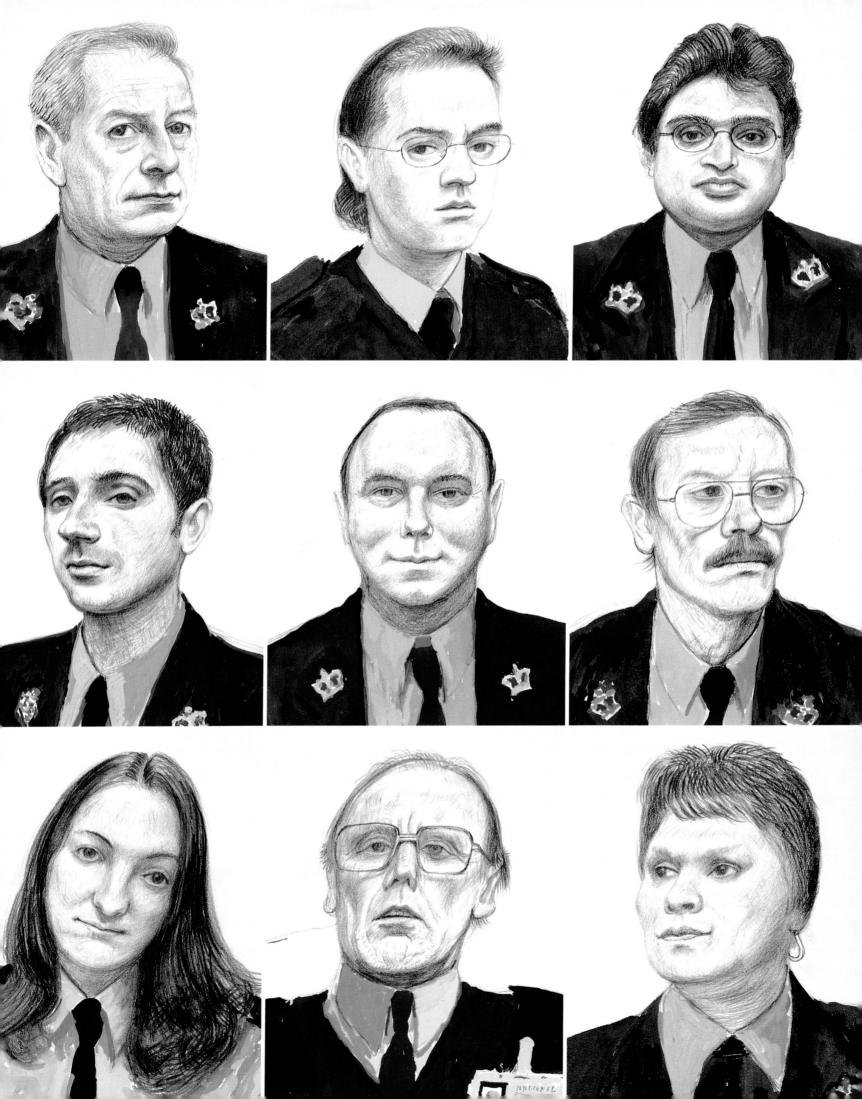

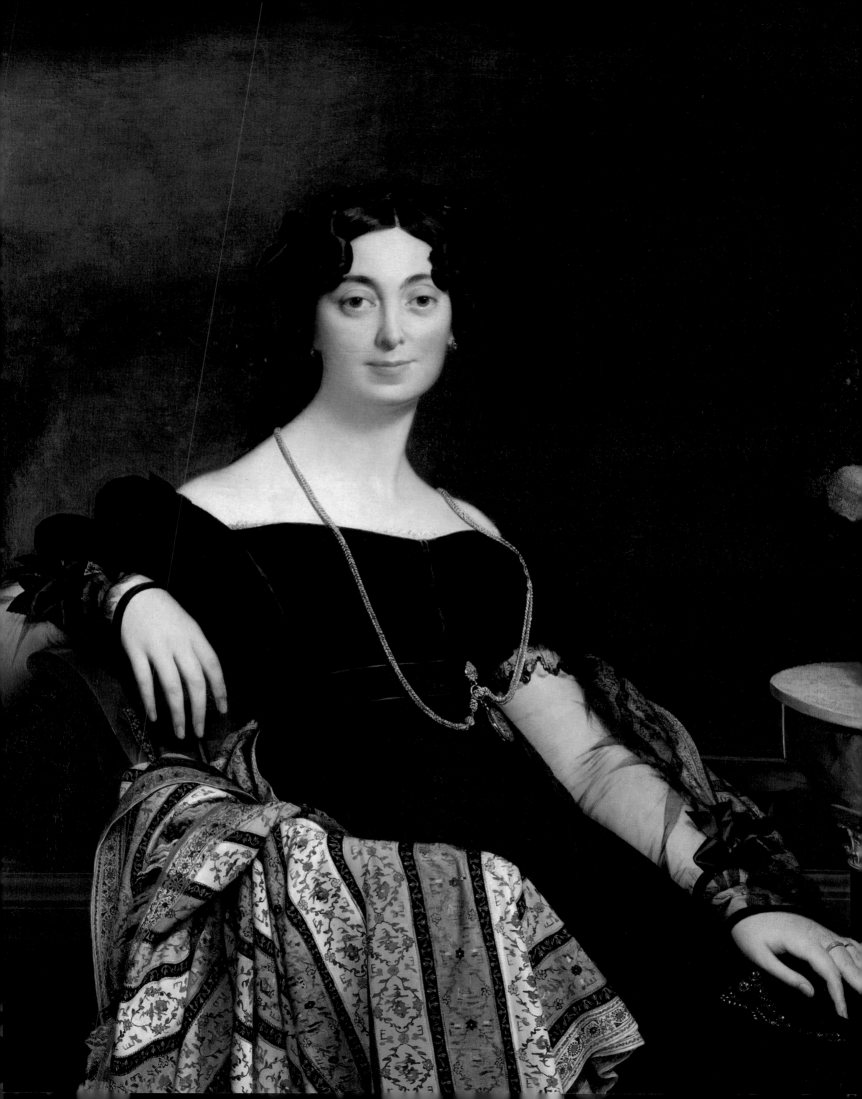

If Ingres used a camera lucida to draw portraits then perhaps he used optical devices for his painting, too? Take, for instance, the very beautiful portrait of Madame Leblanc opposite, painted in 1823, more than fifteen years before the invention of chemical photography. Look how precisely realistic the patterned fabric appears. How different it seems from Cézanne's study of a curtain on the left, a picture that was certainly eyeballed. The hand and eye (and heart) are at work there; you can plainly see how the image was constructed. Was the fabric on Ingres's portrait done in the same way? If you reject the use of some kind of optics, then you have to say yes, that it, too, was eyeballed. But I find this hard to believe. There is no 'awkwardness' in the depiction of the folds, the shadows or the delicate pattern, which follows every turn of the material so convincingly. It would take observational and painting skills of the highest order to do this 'freehand'. It would also have taken a vast amount of time, precious time for an artist who was in as much demand as Ingres. Surely, if he had known of a way of speeding up the process he would have used it. He was, after all, in the *business* of making images. Ingres lived to see the advent of photography and, according to one account, made use of photographs in his later years. He would certainly have known about the camera obscura and there is no reason to suppose he would not have made use of that, too. The fabric draped over Madame Leblanc's chair could not, I believe, have been done without some optical help. The pattern follows the folds flawlessly, which means it must have been plotted point by point. Optics provide the only practical means to be able to do that.

CLAESZ 1638 SL

KALF 1660 SL

VERMEER c1660 L.

Sebastian Stoskopf
Still Life with Glasses and Bottles, c. 1641-44
Oil on canvas, 122 x 99 cm
Stiftung preußischer Kulturbesitz, Staatliche
Museen, Berlin

c1665

Jan Davidsz. de Heem

I am confident that Ingres used some form of optical device in his art, probably a camera lucida for the drawings, but perhaps some form of camera obscura for the meticulous detail in the paintings. This seems to me the only explanation. But Ingres was not the first to use optics. Vermeer was thought to have used a camera obscura – this can be deduced from optical effects in the paintings. Was he the first, or were artists using optics before him? I started to look through books and catalogues for whatever evidence I could find. I began to see things I had never noticed before. My curiosity grew.

1438 Pisanello

I began to notice clothes. Giotto's full-length lady of 1303–6, for instance, is done in a simple, graphic way. Pisanello follows form in a more 'accurate' way. But by 1553 Moroni is painting the most elaborate of dresses, with a bold design that is always believable on its surface, following the folds, and with subtle highlights and shadows all depicted. On the next two pages, another comparison shows a similar development, and perhaps reveals the use of a new tool.

< **1303–6** Giotto　　　　　　　　**1553** Giovanni Battista Moroni

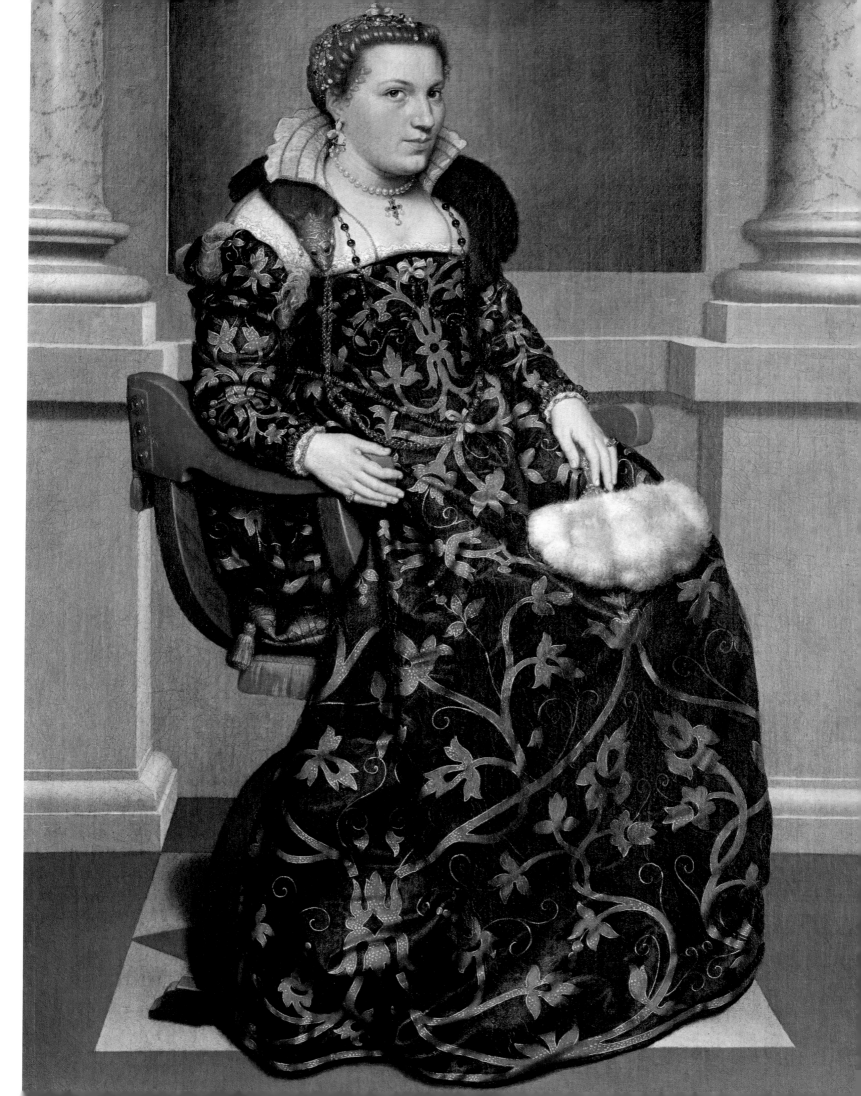

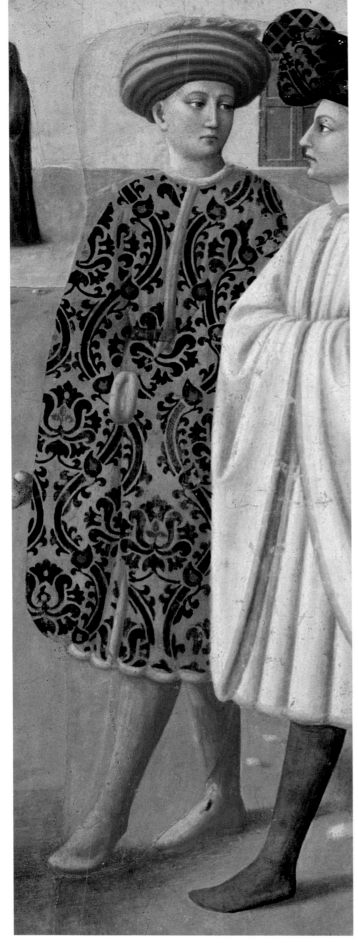

c. 1425 Masolino da Panicale

1467–8 Antonio and Piero del Pollaiuolo

1545 Agnolo Bronzino >

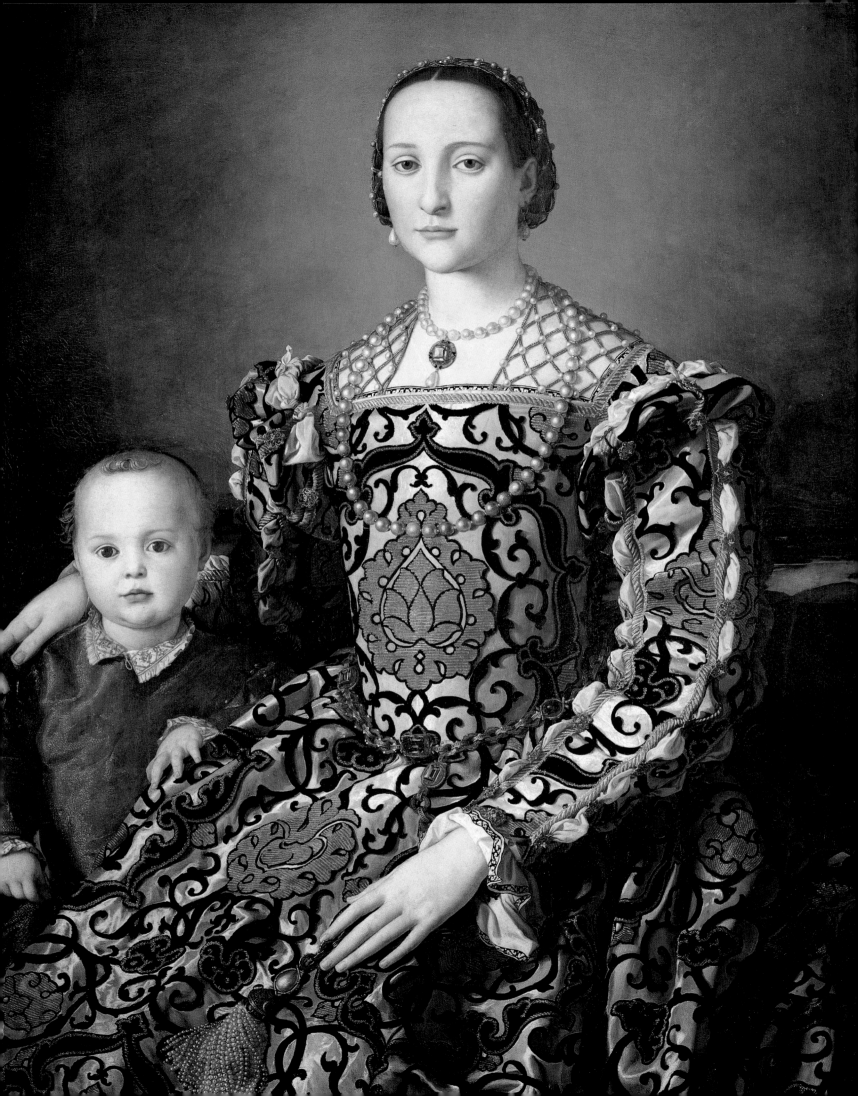

1514 Lucas Cranach the Elder

Again elaborate fabrics. Neither Giotto nor Cranach shows patterns closely following the folds, but in Moroni's portrait the delicate design follows the complex curved surfaces precisely. Have we got a new tool at work here?

1302–5 Giotto

1560 Giovanni Battista Moroni >

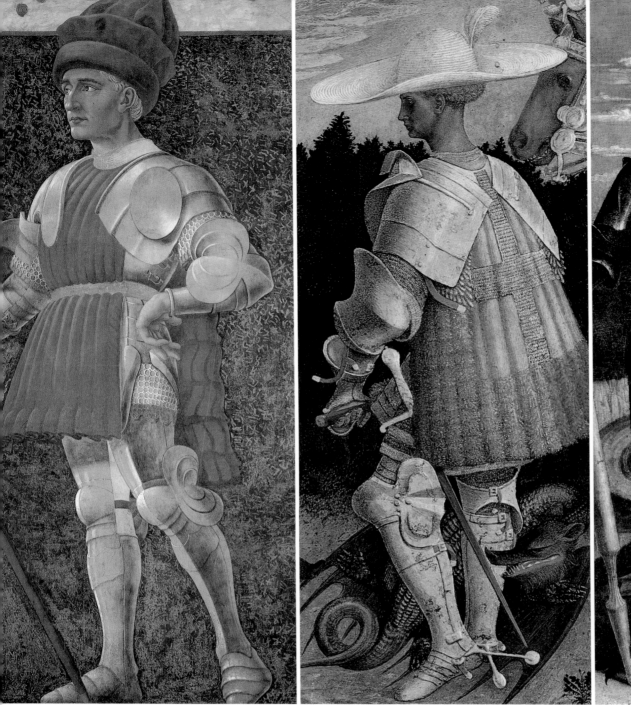

1448 Andrea del Castagno

c. 1450 Pisanello

c. 1460 Andrea Mantegna

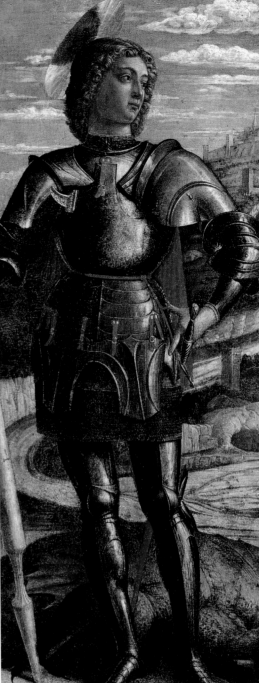

A look at the depiction of armour through two centuries shows a similar change. These are all wonderful paintings, though the armour on the first three seems awkward compared with the later ones – notice the stylized depiction of reflections in the shiny metal. Suddenly, in 1501, Giorgione's helmet and face look much more 'modern', much more realistic. By 1557, in the picture by Mor, the armour is painted with very 'accurate' detail: the shine seems genuine, and the patterns and the chain-mail follow the rounded forms perfectly. By the time of van Dyck, the armour looks almost like a photograph. The engraving on his breastplate seems accurate, or unawkward, and the difficult drawing of the sword-handle, as it projects out towards the viewer, seems 'perfect'. Was this really just eyeballed? What happened to make this painting so different from the first?

c. 1501 Giorgione **1557** Antonis Mor **1625–7** Anthony van Dyck

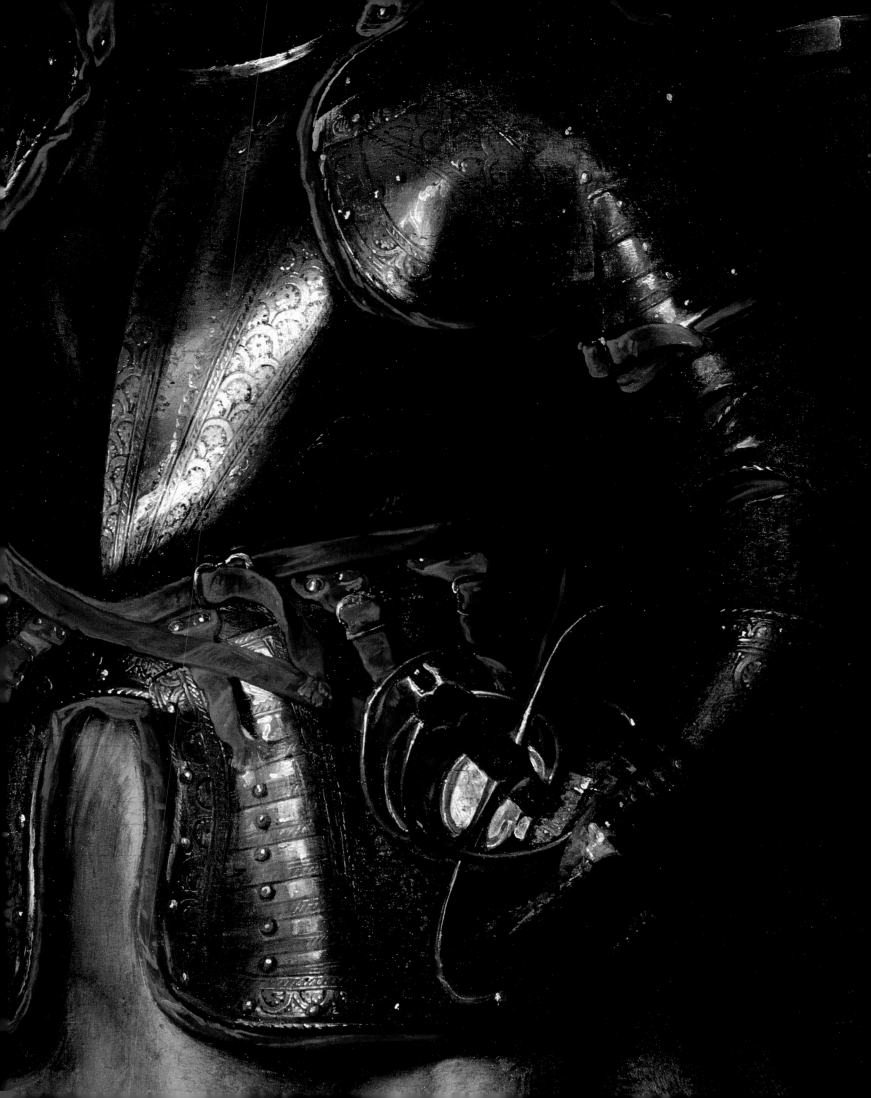

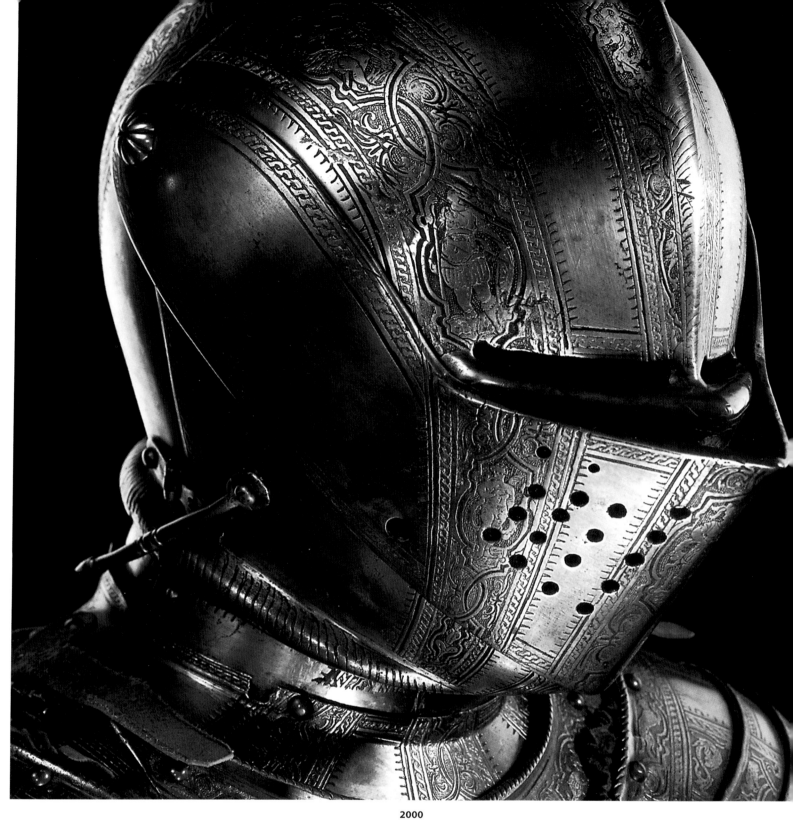

2000

Opposite is a detail of the armour from the van Dyck, which is stunningly painted and would have been very difficult to do, even with optics. Above is a photograph of some armour – using optics, of course.

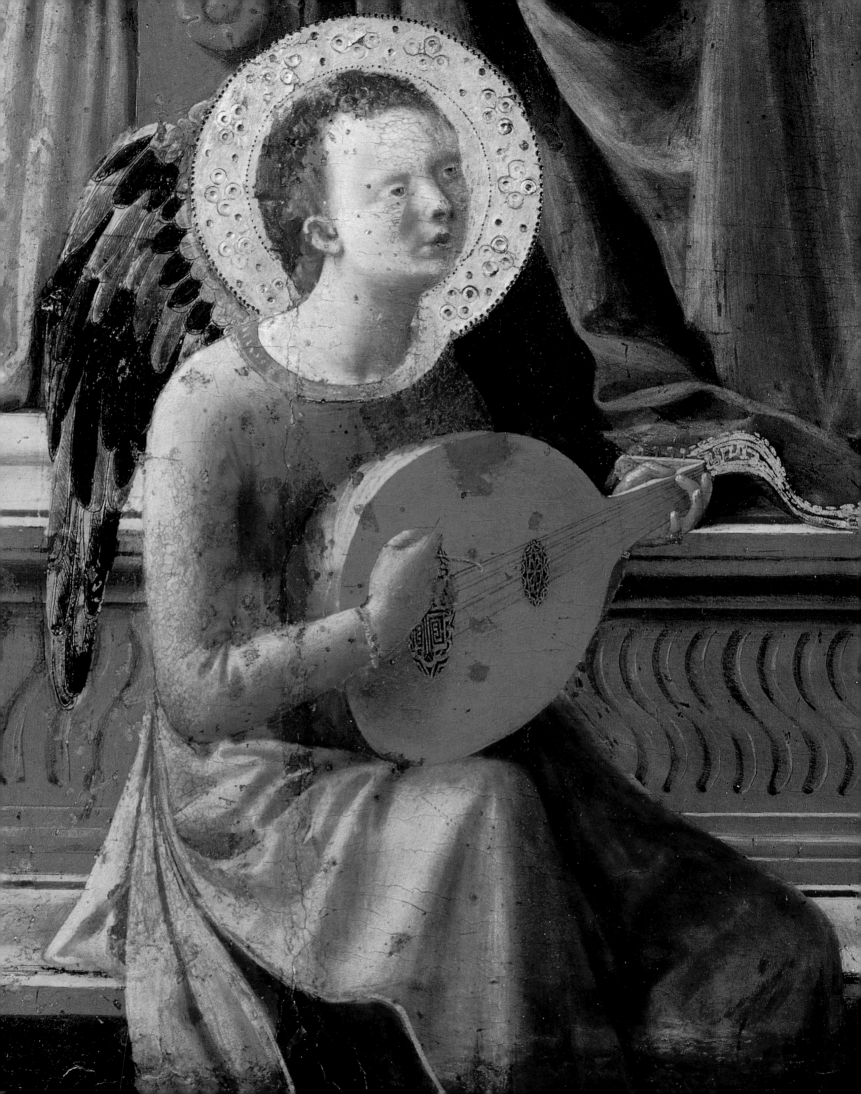

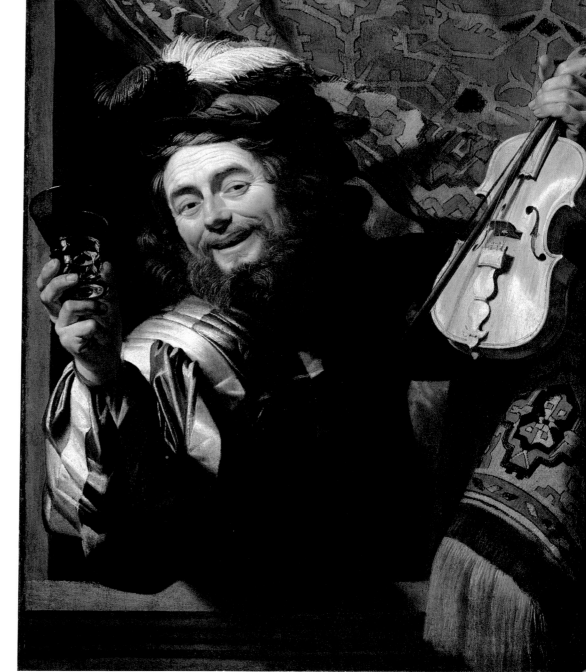

1623 Gerrit van Honthorst

c. **1623** Gerrit van Honthorst

These two paintings may show the beginning of the use of optics in art (the Masaccio) and its height (the van Honthorst). Masaccio's angel has a superbly foreshortened lute, which may have come from a knowledge of optics. But now compare his musician with the merry one painted by van Honthorst two hundred years later. In black and white, the Dutch painting looks like a photograph, with the lighting we associate with photography. How could this change, this 'advance' in naturalism, have happened? Better drawing skills cannot be the answer – van Honthorst's drawings (*above left*) seem rather crude when compared with his paintings.

< **1426** Masaccio

Here's another comparison between two pictures at either end of the Renaissance to show you the dramatic transformation that took place in painting: the detail opposite is from Giotto's *The Death of the Virgin* and dates from 1310–11; the one on this page is by Caravaggio and is from 1599. Compare the wings, in particular. Giotto's are an imaginative invention (he probably hadn't seen an angel in real life!). They look very beautiful but are stylized compared with Caravaggio's, which look much more 'photographic'. Because of his method of working, Caravaggio probably had some real wings right there in front of him – perhaps a pair of eagle's wings. We know that he only painted directly from the model ('He can't paint without models' was a contemporary criticism of his work). The same, of course, could be said of any photographer (until very recently, that is – computers have changed what used to be a fundamental requirement of photography).

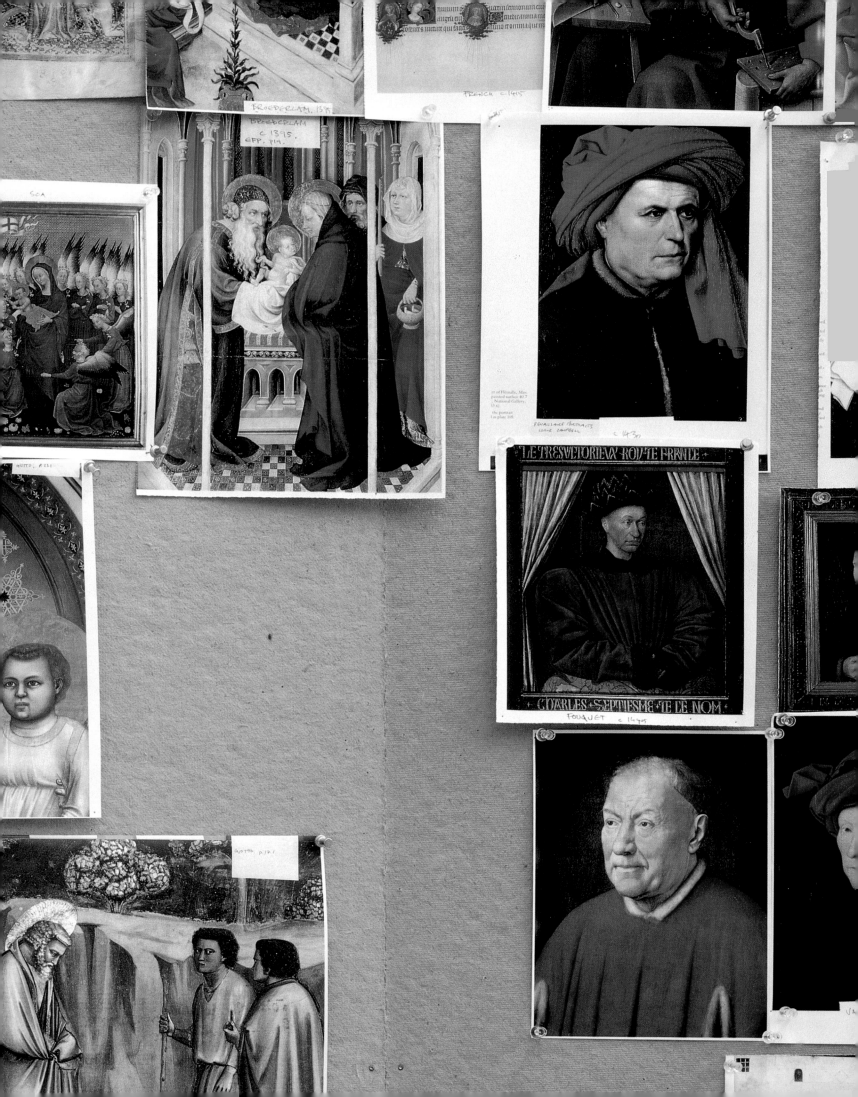

BROEDERLAM 13??
BROEDERLAM
c 1395.
EFP, P14.

FRENCH c.1415

er of Flémalle, Mas.
painted surface 40.7
National Gallery,
15 x).

the portrait
1 as plate 108.

RENAISSANCE PORTRAITS
LORNE CAMPBELL c 143??

GIOTTO, P.221

LE TRESVICTORIEUX ROY DE FRANCE

C. CHARLES SEPTIESME DE CE NOM.

FOUQUET c 1445

GIOTTO. p.171

My *Great Wall* allowed me to see, with one sweep of the eye, what art historians have long recognized as a shift towards ever greater naturalism from the fifteenth century to the nineteenth. But what was immediately apparent, surrounded by so many images, was that this was not a gradual process – the optical look arrived suddenly, and was immediately coherent and complete.

I know from experience that the methods artists use (materials, tools, techniques, insights) have a profound, direct and instant influence on the nature of the work they produce. The sudden change I could see suggested to me a technical innovation rather than a new way of looking that then led to a progressive development of drawing skills. We know of one such innovation in the early fifteenth century – the invention of analytical linear perspective. This provided artists with a technique for depicting recession in space, with objects and figures scaled just as they would appear to the eye from a single point. But linear perspective does not allow you to paint patterns following folds, nor shine on armour. Optical aids would, but it is commonly assumed that the technology and knowledge did not exist until much later.

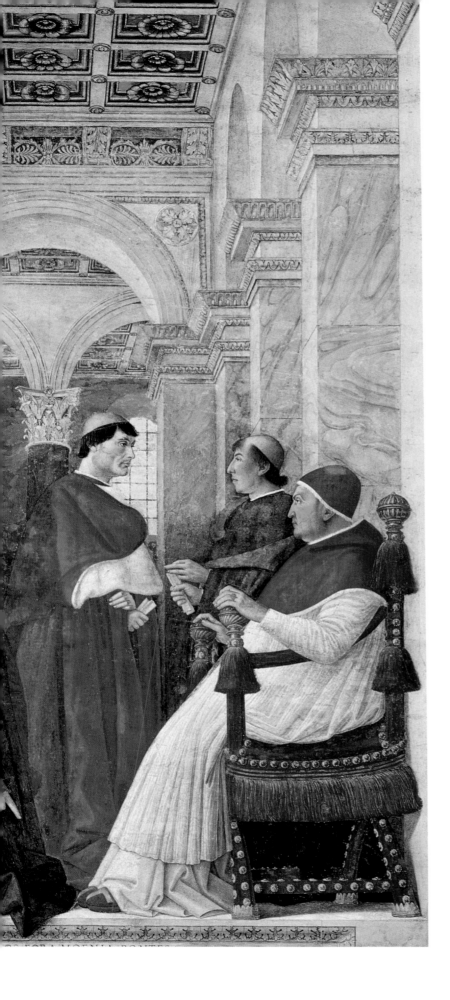

These two pictures are of the same subject – the Pope with attendants. The one on the left was painted around 1475 by Melozzo da Forlì. It is clearly of the mathematical school, with its space and architecture rendered according to the laws of linear perspective. It shows no obvious evidence of optics; I show it only as a contrast with the work opposite. Raphael's 1518–19 portrait of Leo X seems of a completely different order. It was said that people gasped when they saw it – 'a realistic marvel', 'amazing verisimilitude', etc. Andrea del Sarto said that making a copy of it was the hardest thing he'd ever done. Look at the Pope's clothes, for instance: they are depicted 'naturalistically' and with convincing volume. The space, on the other hand, seems unreal and enclosed, and it has a dark background, features I was beginning to notice in other suspected 'optical' works, too. That the standing

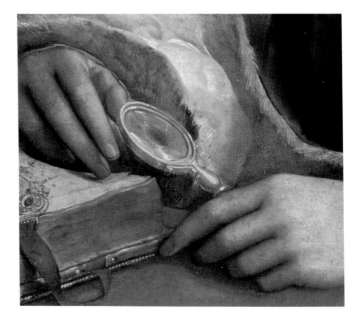

attendants are the same height as the sitting Pope is odd – they should be taller than him – but could be accounted for by the use of optics: 'Just bob down a bit', photographers say (the Pope may, of course, be sitting on a raised throne). Yet the real interest is what he is holding: a magnifying glass. It shows that Raphael was at least aware of lenses (though not that he knew how to use them). He would have wanted to make as vivid a portrait as he could. As a professional painter, he had a job to do and would have used all the tools at his disposal, including, if he thought they would help, lenses. He would not think 'I'm a great artist at the height of the Renaissance who should disdain such methods.'

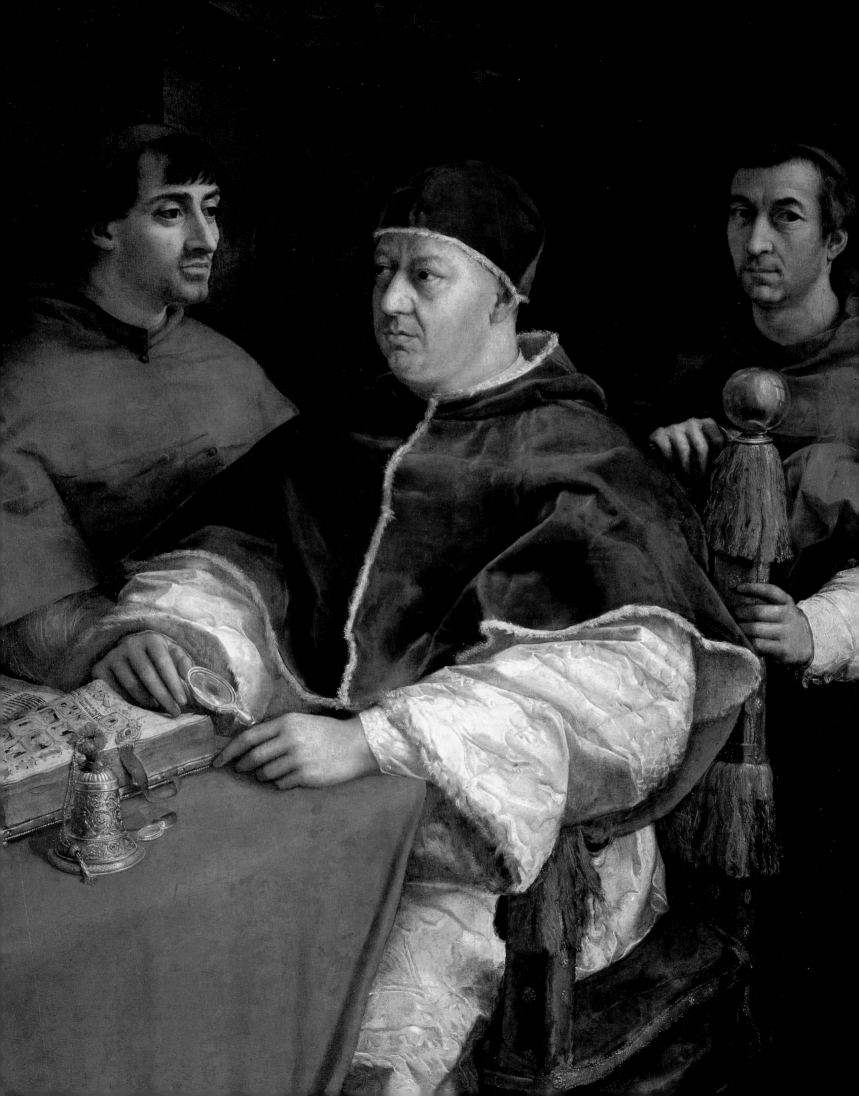

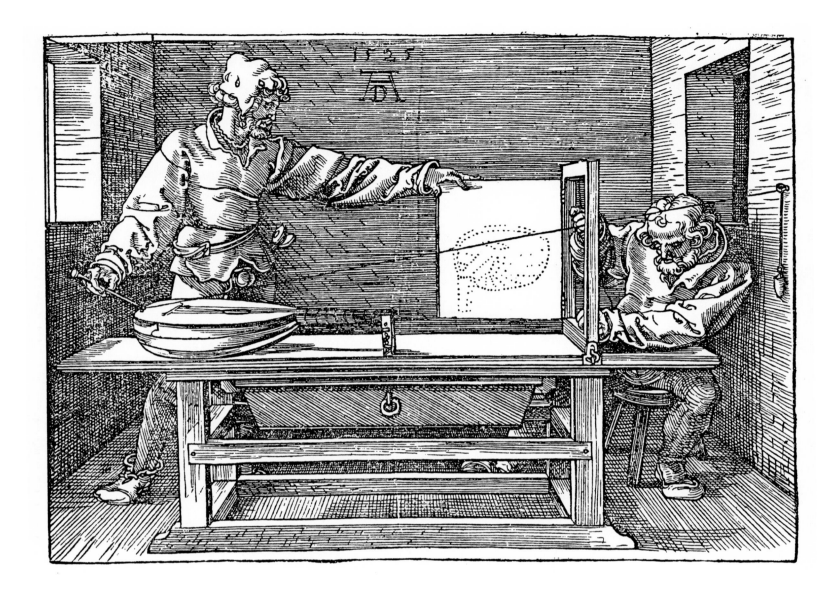

Some of the most difficult things to paint with linear perspective are curved objects such as lutes. Dürer's famous woodcut of 1525 suggests that some artists used technical aids to help them. Dürer was a prodigy, a great draughtsman, yet he also had a keen interest in technology. Here he shows how a piece of string is attached to a point on the wall, representing the observer's viewpoint. The string is then connected to a point on the lute and its position is recorded by moving two other strings stretched across a wooden frame and then marking where these meet on a hinged screen. This is repeated until there are enough points on the screen to construct the shape of the lute. It is a difficult process, one that requires two men.

Now look at Caravaggio's painting of around 1595. These two pictures were among the first I brought together to ask a question. Could Caravaggio really have used Dürer's method to paint that incredibly foreshortened lute (he left no drawings), and how about the violin on the table, and the music that follows the curve of the page so perfectly? It would be very difficult to do these things with a drawing machine, and would take a very long time. Was it just divine skill, or could he have used optics?

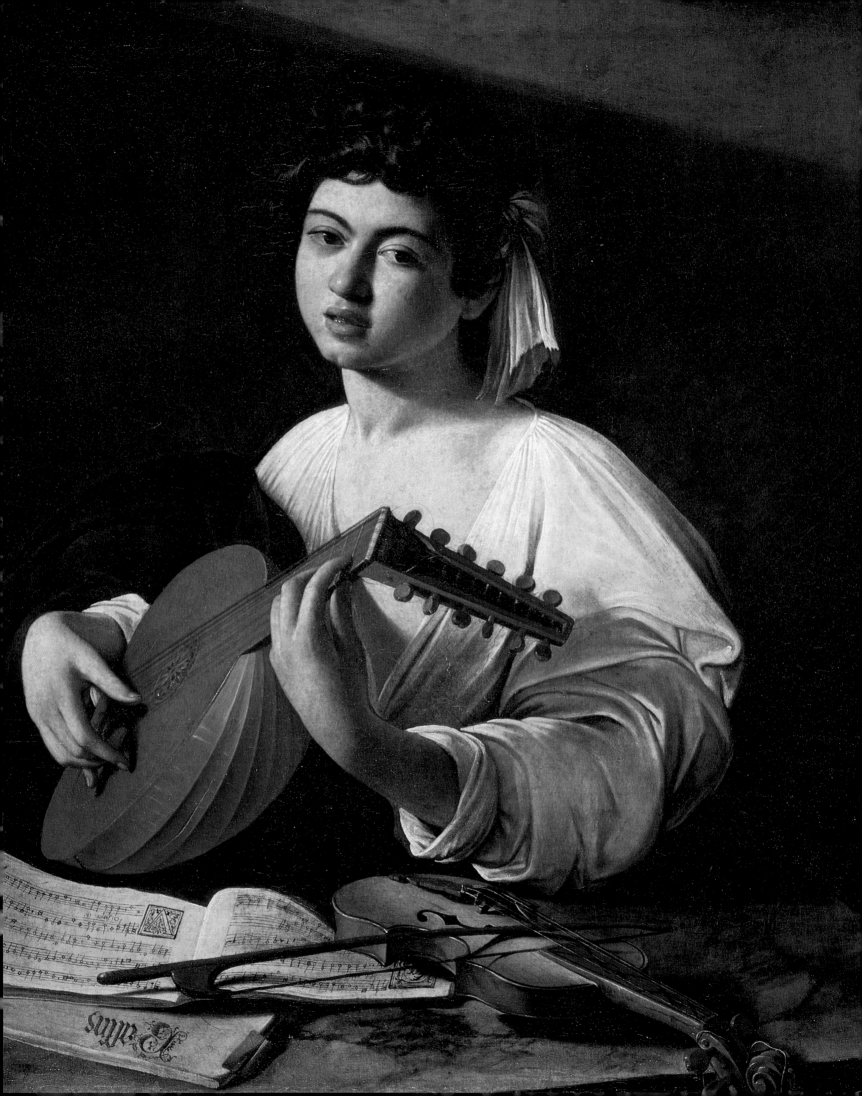

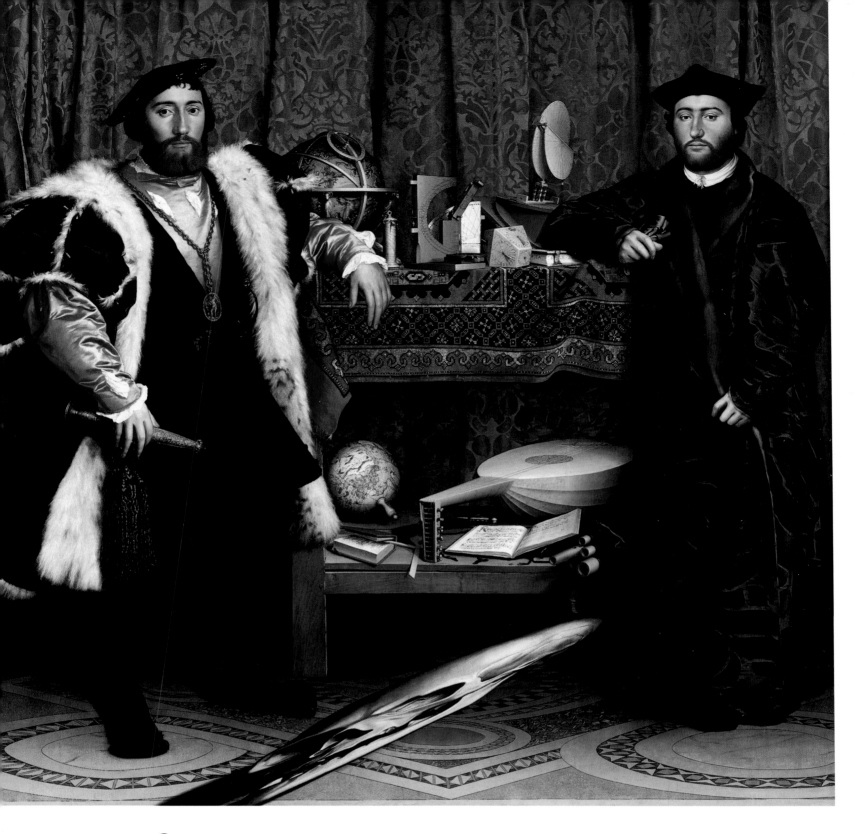

Caravaggio painted his lute-player seventy years after Dürer's woodcut, and, of course, the technology of drawing machines may have moved on in that time. But were such machines already out of date in 1525? Was Dürer depicting an earlier and now obsolete method of drawing ellipses and curves in perspective? Hans Holbein's *The Ambassadors* (*above*) was painted in 1533, just eight years after Dürer's print. It is filled with curved and spherical objects, all of which would have been difficult to eyeball, and yet all of them are marvellously 'accurate' in their foreshortening. Holbein *could* have used Dürer's machine to paint the lute on the bottom shelf, which is shown in much simpler foreshortening

than Caravaggio's, and from a similar angle to that in Dürer's print, but look at the other curved objects. The celestial globe on the top shelf, for example, is perfect in its rendering. The patterns on the curtain behind and on the tablecloth are utterly believable as they follow the folds. The lines of longitude and latitude on the terrestrial globe on the bottom shelf trace the curvature of the sphere precisely, as does the word 'AFFRICA'. And the musical score is accurately depicted on the curved pages of the open book. That alone would have been near impossible to paint using Dürer's machine. It would have been possible, however, to use a lens to project an image of the book and the other three-dimensional objects onto a flat surface and trace the now two-dimensional, projected shapes.

The strange form in the foreground is a distorted skull – Holbein has stretched it. Such distortion can be achieved by tilting the surface onto which you project an image. I produced the detail of the skull below by squeezing it back into shape on a computer. It looks very 'real'. Is this not a clue that Holbein used optical tools?

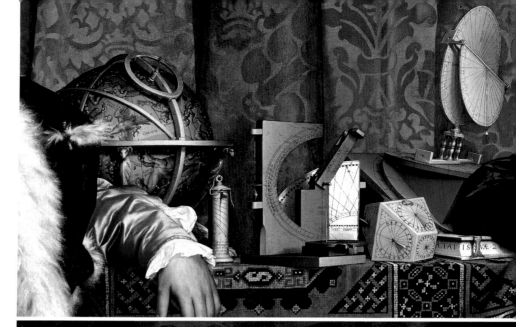

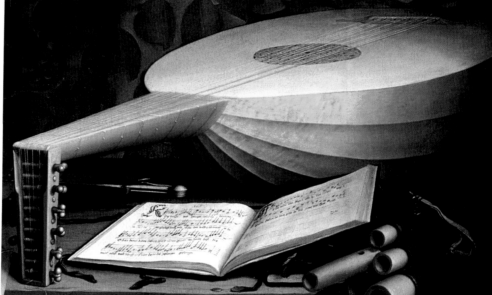

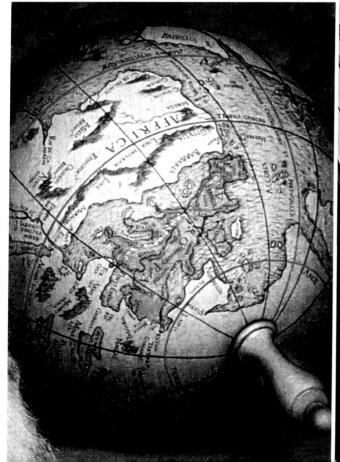

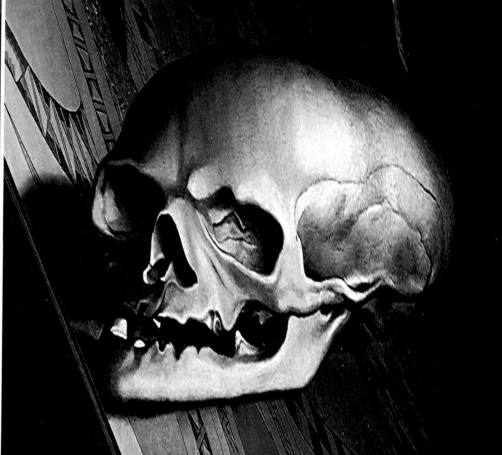

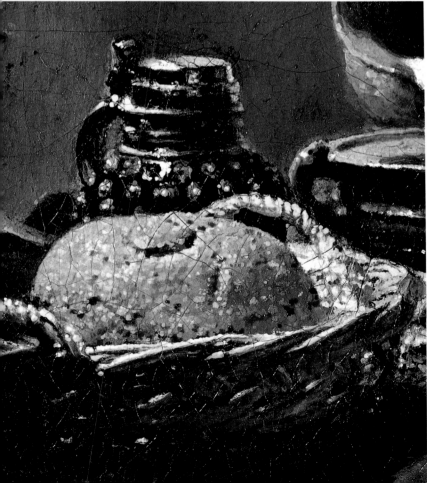

It is now generally accepted that Vermeer, working about fifty years after Caravaggio, not only had knowledge of optical instruments but also used them in some way in his painting. (Van Leeuwenhoek, the great microscopist and lensmaker, was a neighbour of his and executor of his will.) Much of the evidence is within the paintings themselves. Vermeer seems to have been delighted by the optical effects of the lens and tried to re-create them on the canvas. Foreground objects and figures are sometimes very large; some things are painted in soft focus, or out of focus altogether. In this painting of a milkmaid, for example, the basket in the foreground is out of focus compared with the basket hanging up behind, a distortion Vermeer would not have seen with the naked eye. Nor could he have rendered the 'halo' effect of out-of-focus highlights, seen here on the basket, the bread, the tankard and the jug, unless he had seen it! So, this was a starting-point: Vermeer was an artist who had used optics – his paintings demonstrate as much.

I would like to point out here that this is Vermeer's most solid figure. She has a greater presence than his ladies. Could this be because she is a servant (one of the so-called 'low-life' subjects of many early optical painters) and so wouldn't have been able to complain, 'Oh I have a headache. I need to lie down now', which 'ladies' would have been able to get away with?

c. 1658–60 Johannes Vermeer >

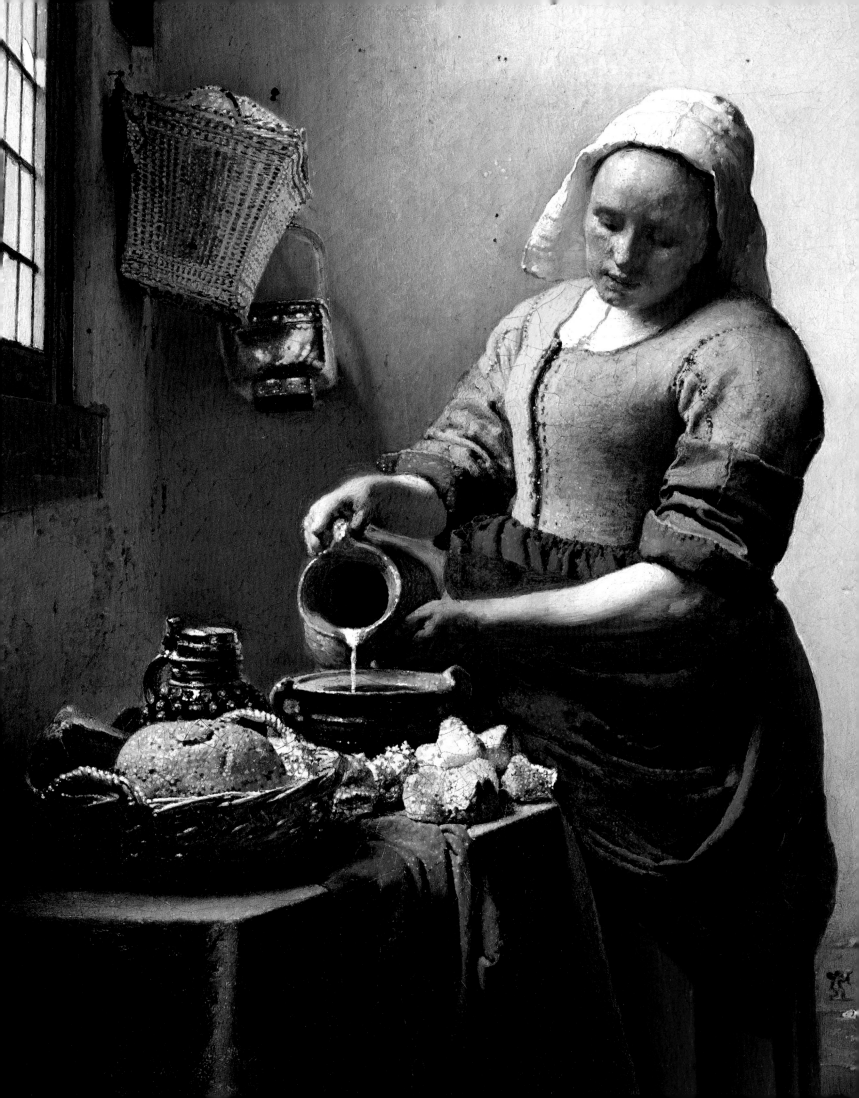

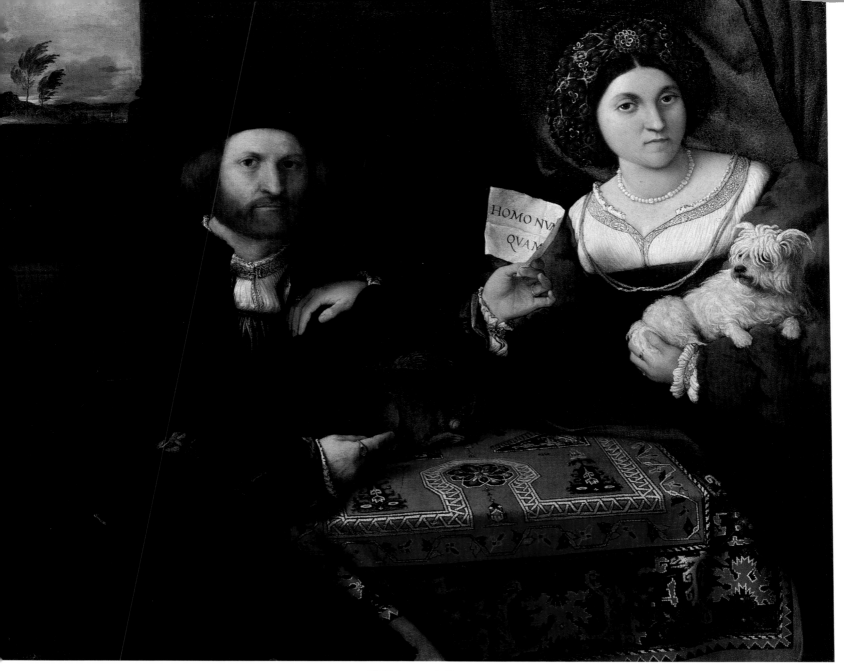

1543 Lorenzo Lotto

One of the paintings on my wall was *Husband and Wife* by Lotto. I noticed that the top of the 'keyhole' pattern on the oriental carpet clearly goes out of focus (words which would have had little meaning before optics). The human eye would not see it like this, but a lens would. I showed this to Charles Falco, an optical scientist, and he pointed out that there are at least two vanishing points in the picture. This can be seen most clearly on the detail of the border opposite. Had linear perspective been used, the pattern would have receded in a straight line, the single vanishing point corresponding to a single viewpoint. But halfway back there is a kink in the pattern and it carries on in a slightly different direction. Charles reasoned that Lotto had set up a lens to project the pattern but discovered that it could not all be in focus at the same time. He had to refocus to do the back part of the carpet. But refocusing has a side effect – it changes the magnification. The difference would be only slight on the narrow border, but the pattern in the centre, being five times broader, would have changed five times as much, too much to ignore. The solution was to paint it out of focus. For Charles, these effects are 'optical artefacts', and are solid scientific evidence of the use of optics.

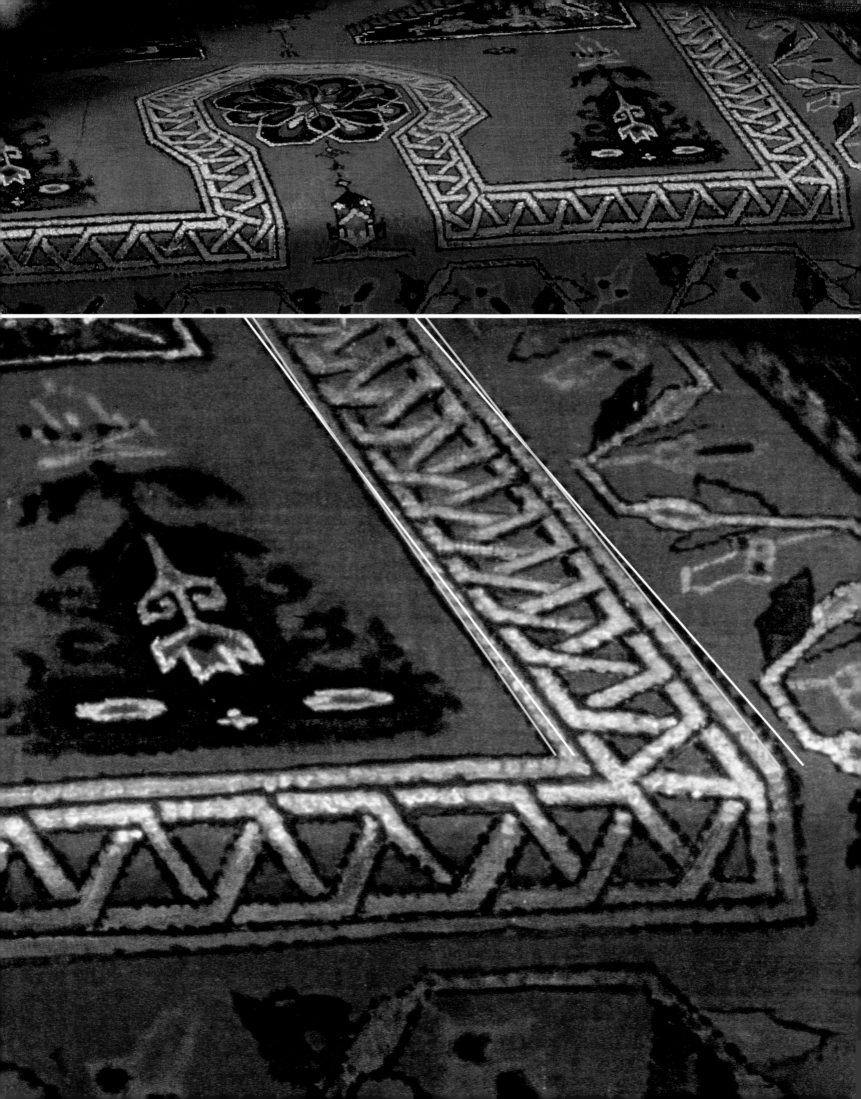

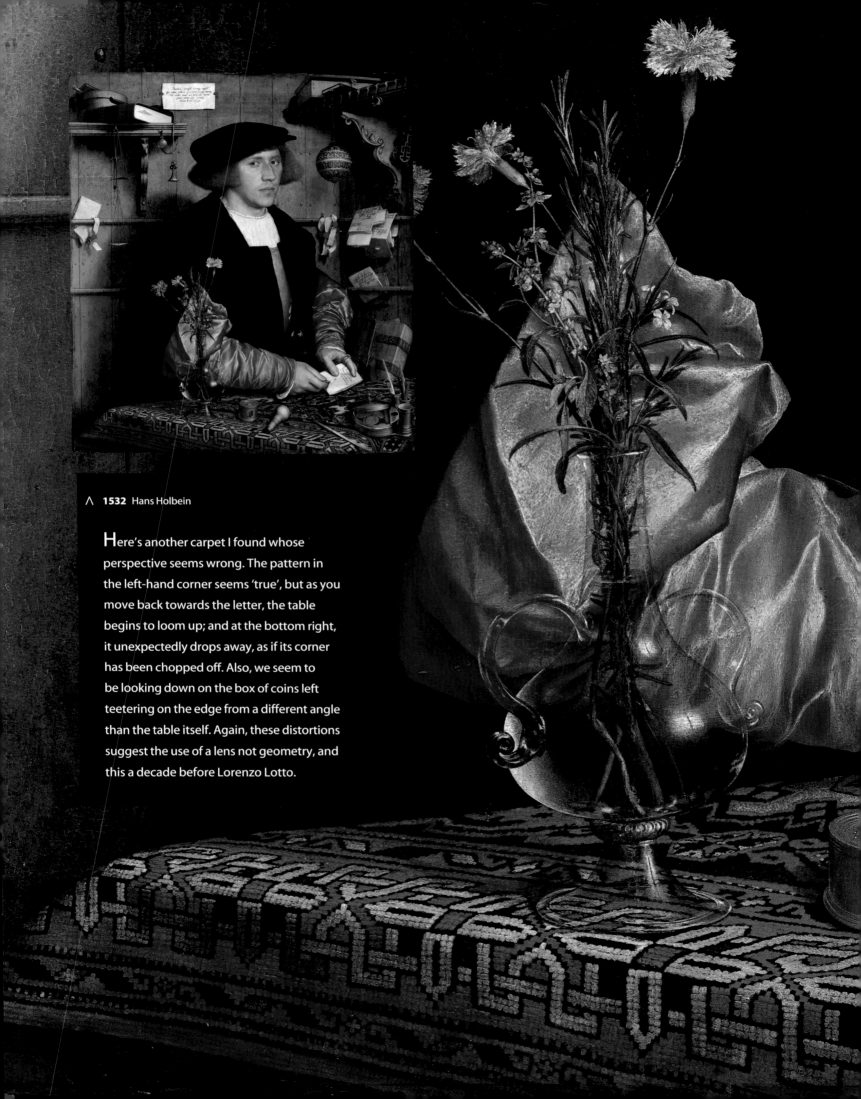

∧ **1532** Hans Holbein

Here's another carpet I found whose perspective seems wrong. The pattern in the left-hand corner seems 'true', but as you move back towards the letter, the table begins to loom up; and at the bottom right, it unexpectedly drops away, as if its corner has been chopped off. Also, we seem to be looking down on the box of coins left teetering on the edge from a different angle than the table itself. Again, these distortions suggest the use of a lens not geometry, and this a decade before Lorenzo Lotto.

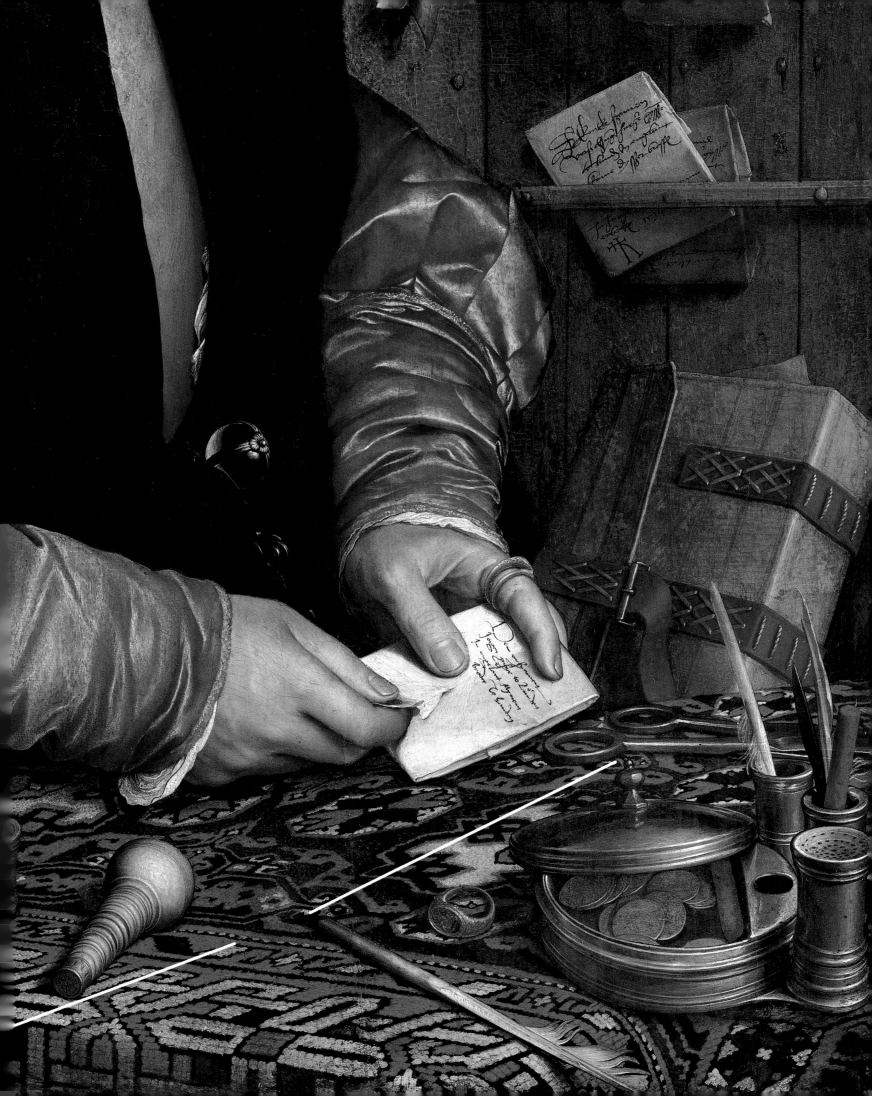

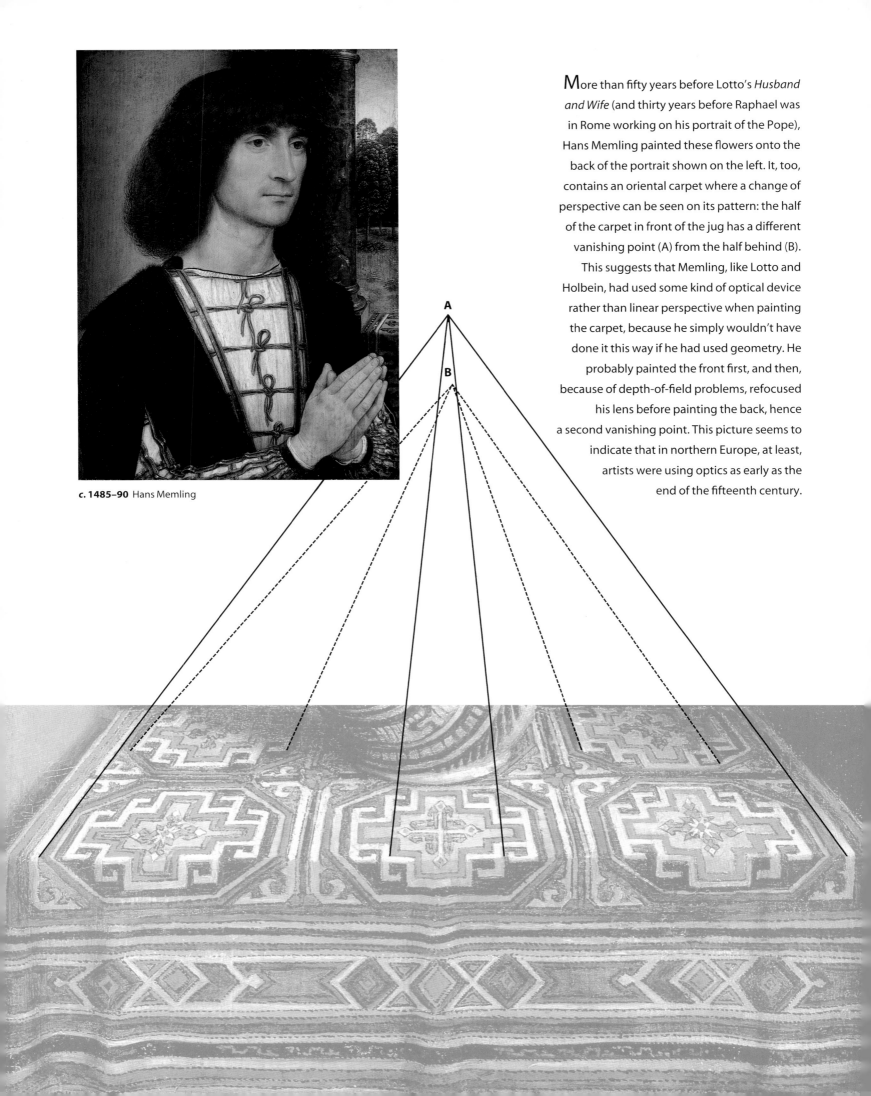

c. 1485–90 Hans Memling

More than fifty years before Lotto's *Husband and Wife* (and thirty years before Raphael was in Rome working on his portrait of the Pope), Hans Memling painted these flowers onto the back of the portrait shown on the left. It, too, contains an oriental carpet where a change of perspective can be seen on its pattern: the half of the carpet in front of the jug has a different vanishing point (A) from the half behind (B). This suggests that Memling, like Lotto and Holbein, had used some kind of optical device rather than linear perspective when painting the carpet, because he simply wouldn't have done it this way if he had used geometry. He probably painted the front first, and then, because of depth-of-field problems, refocused his lens before painting the back, hence a second vanishing point. This picture seems to indicate that in northern Europe, at least, artists were using optics as early as the end of the fifteenth century.

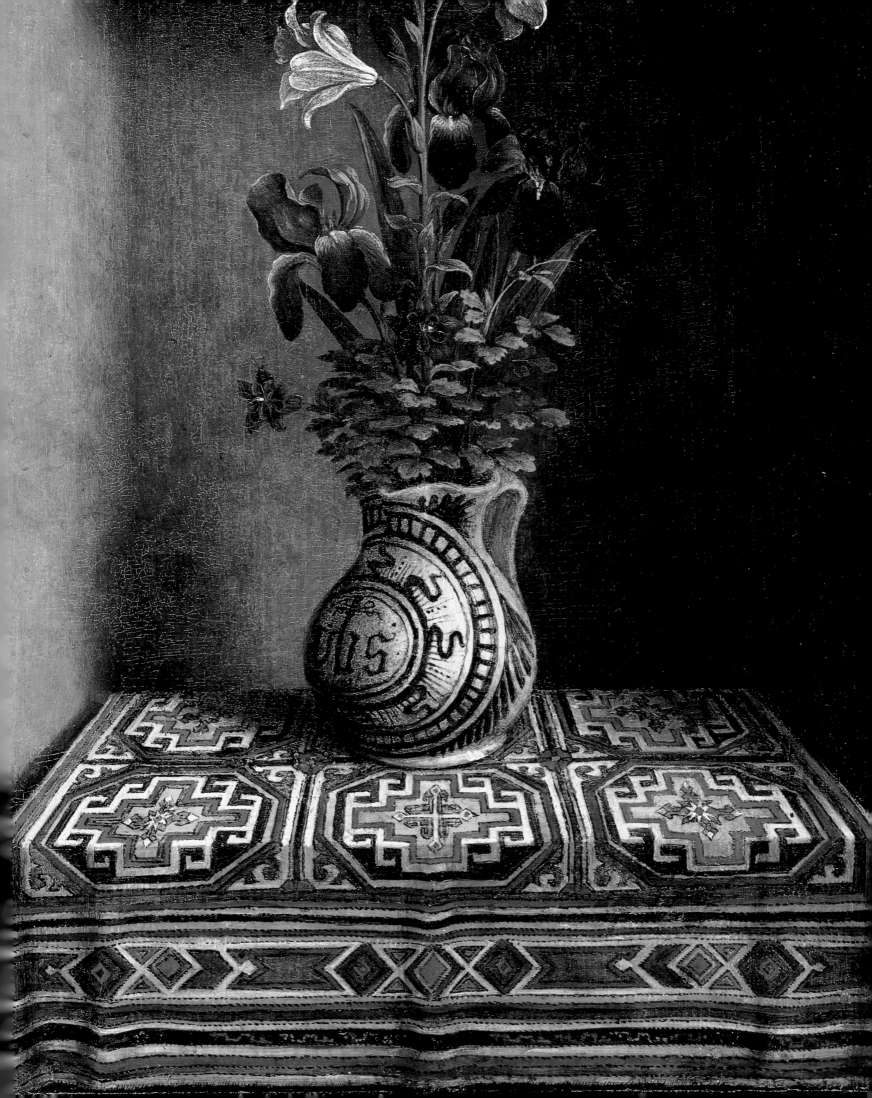

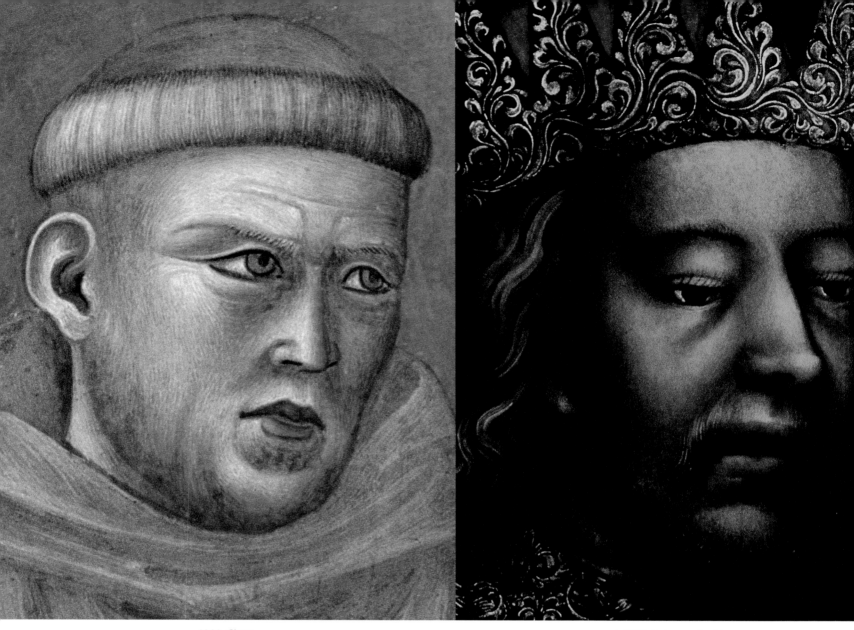

1300 Giotto

c. **1365** Unknown Austrian

Finding evidence of the use of optics in northern Europe in the late fifteenth
century made me look more closely at early Flemish painting. On my wall
a sudden, dramatic change stood out.

Here are four portraits painted 130 years apart. Giotto's of 1300 certainly has
an interesting expression in the face. Sixty-five years later an unknown artist
makes a portrait of Rudolf IV of Austria – like Giotto's, it is awkward. By 1425,
in Italy, Masolino has more order in the face; the turban seems to follow the
form of the head and looks as though it fits properly. But just five years later, in
Flanders, something happens. Robert Campin's face looks startlingly 'modern';
it could be someone from today. There is clear lighting – notice the shadow
under the nose – suggesting a strong source of light; the folds in the turban
aren't awkward; the man's small double chin is seen clearly; and the mouth and

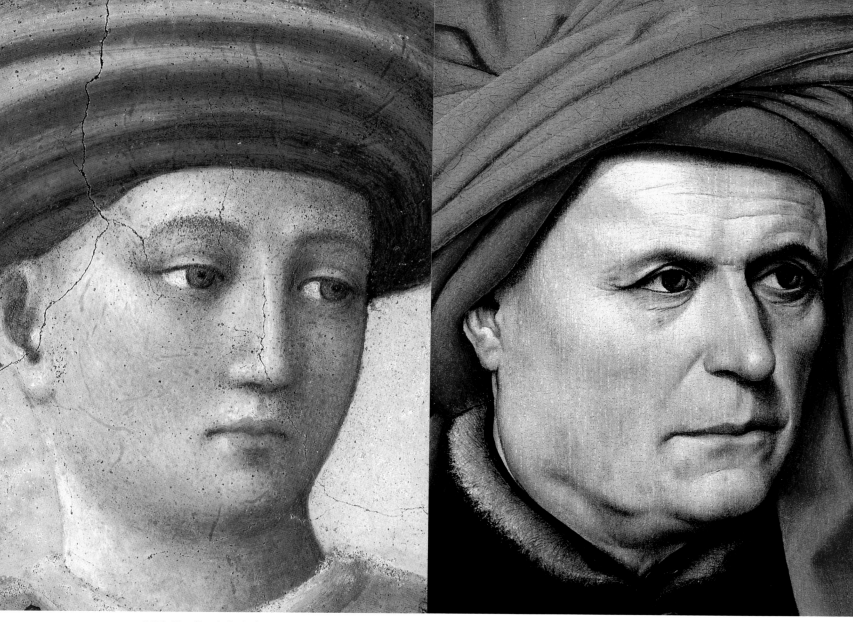

eyes are far more related, giving an intensity to his appearance. This painting
has a totally different 'look'.

Of course, the medium is different. Campin's portrait is one of the earliest
uses of oil tempera, which makes the blending of colour much easier. Yet it is the
new 'look' that interests us here, a look that is radically different from Giotto's
(compare his faces on the next page against those of Dieric Bouts). By itself, oil
paint is not enough to explain this change. Something else is in play.

The only other faces that compare with the Campin are the ones by Masaccio
in the Brancacci Chapel in Florence, which date from 1422. They certainly have
individuality and could have been done by the same method, though the fresco
technique hides this. Nevertheless, the dates are almost the same – the big
change occurred some time around 1420–30.

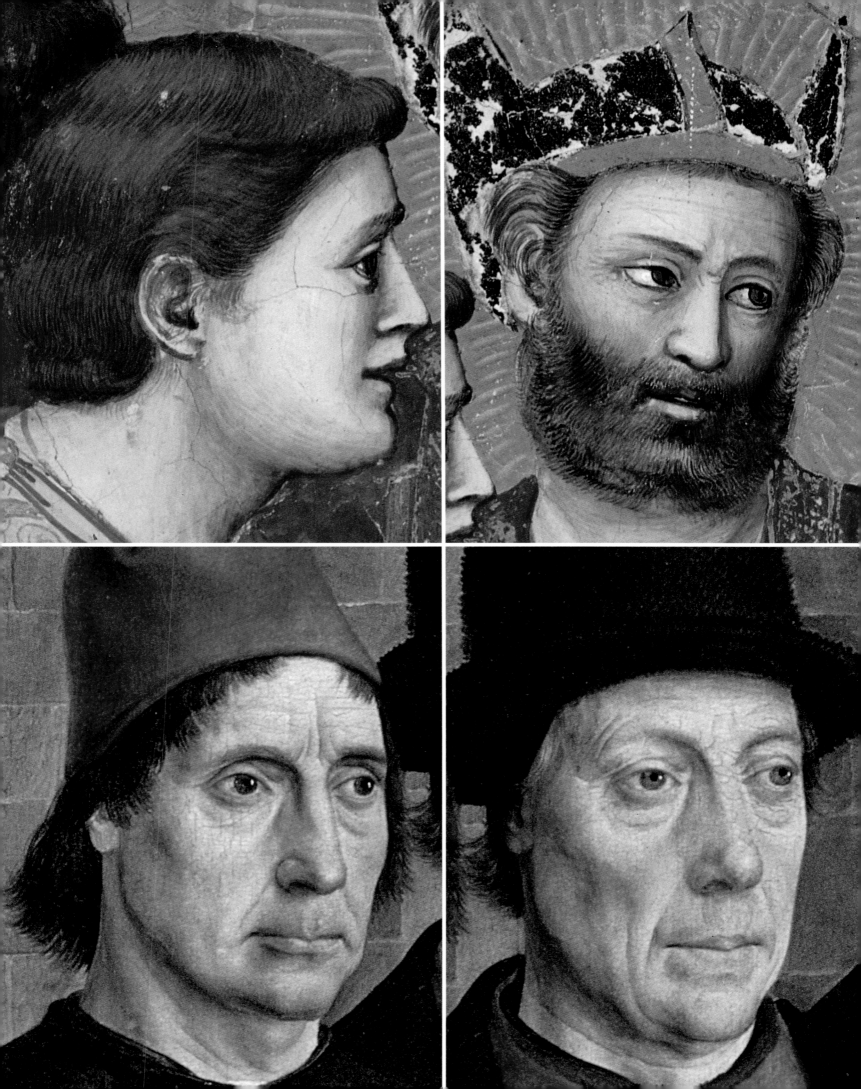

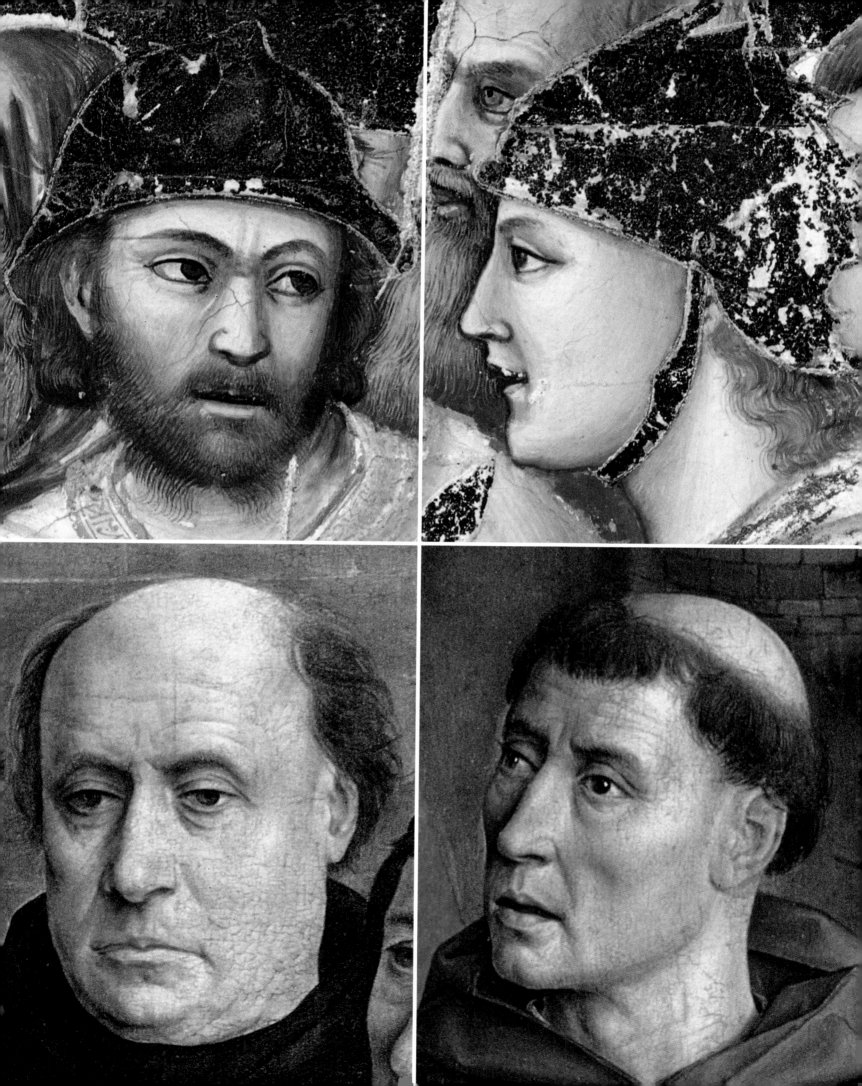

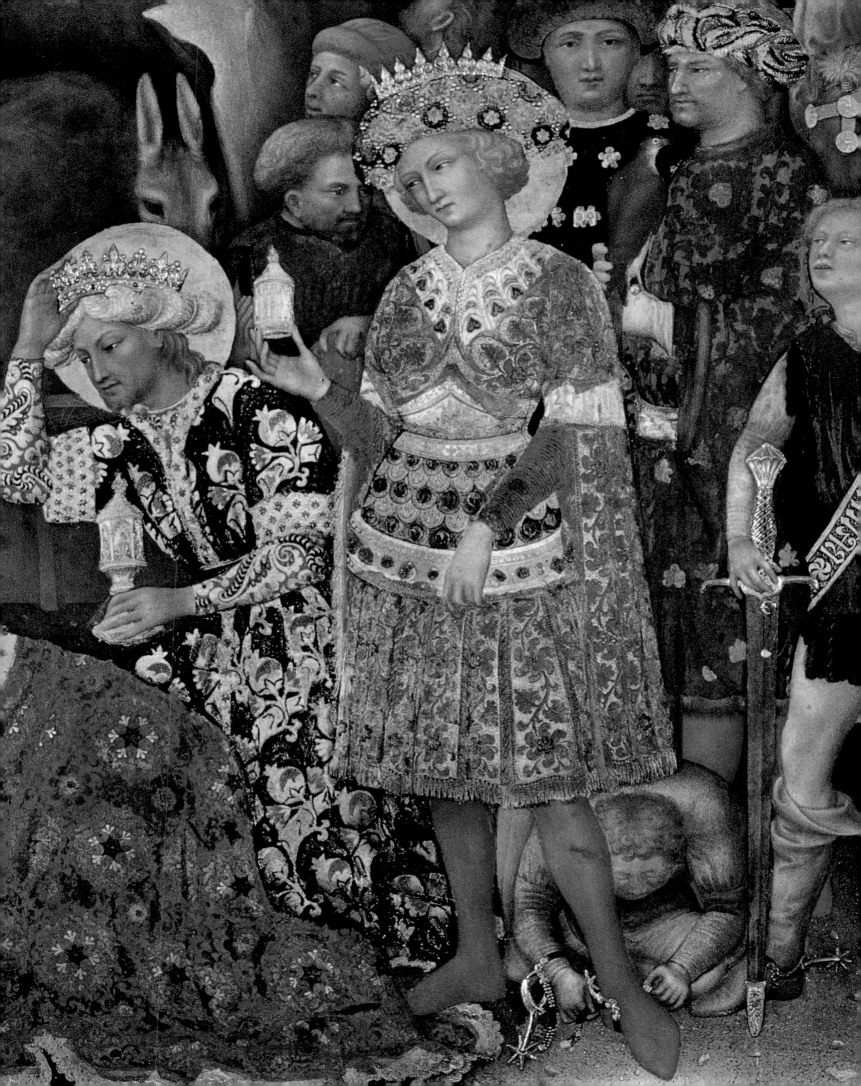

To emphasize again what happened within the space of just a few years, compare these two pictures, one painted in Florence in 1423, the other in Bruges around 1436. Gentile da Fabriano's fabrics are elaborate but do not follow the form convincingly – they are essentially flat. Van Eyck's Chancellor Rolin wears similarly heavy clothes, and they are equally elaborate – look at the highlights in the gold thread. But unlike da Fabriano's fabrics, they have convincing folds and give the impression that a real person is wearing them. Like Robert Campin's man in a red turban, the portrait of the Chancellor is also much more individualistic and 'modern' than any of the faces in the Gentile da Fabriano. Notice, too, the 'accurate' architectural reliefs behind him.

Having at first observed only that painting at the end of the Renaissance was much more naturalistic than it had been at the beginning, now we can be much more specific: the change to greater naturalism occurred suddenly in the late 1420s or early 1430s in Flanders. Could this have been down to optics? What other explanation could there be? Why would artists like Campin and van Eyck suddenly start producing far more modern, 'photographic-looking' pictures? We are familiar today with images projected through a lens. A camera works because an image of the 'real world' is projected onto film. Had Campin and van Eyck seen the world projected in this way?

< **1423** Gentile da Fabriano **c. 1436** Jan van Eyck >

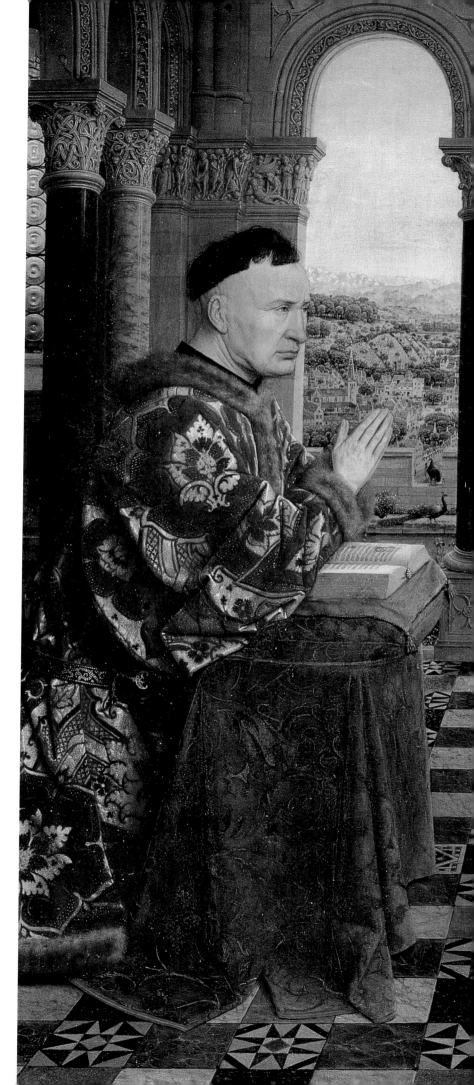

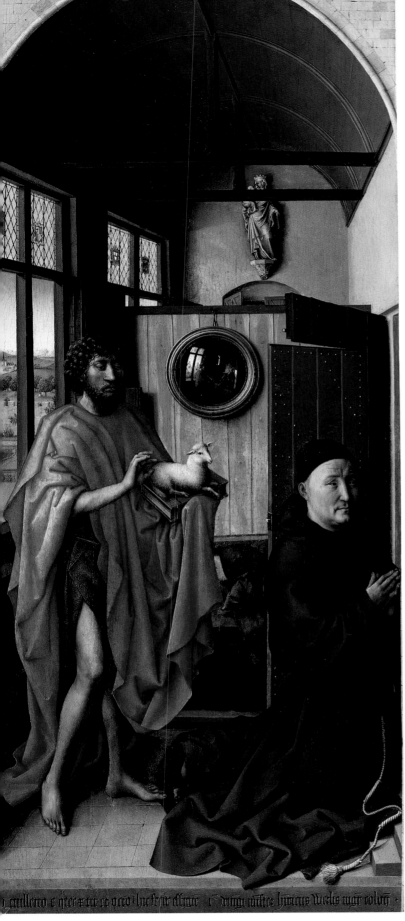

1438 Robert Campin

I can be certain that Robert Campin and Jan van Eyck knew about mirrors and lenses – the two basic elements of the modern camera – for they painted some in several of their pictures of the 1430s (and, at that time, painters and mirror-makers were both members of the same guild). In the Campin, the mirror is convex (easier to make than a flat mirror); and in the van Eyck, Canon van der Paele holds a pair of spectacles. Lenses and mirrors were still rare then, and artists would have been fascinated by the strange effects they produced. As people who made images, they must have been amazed that whole figures, even whole rooms, could be seen in just a small convex mirror. Surely it is no coincidence that such mirrors arrived in painting at the same time as greater individuality appeared in portraiture.

1436 Jan van Eyck >

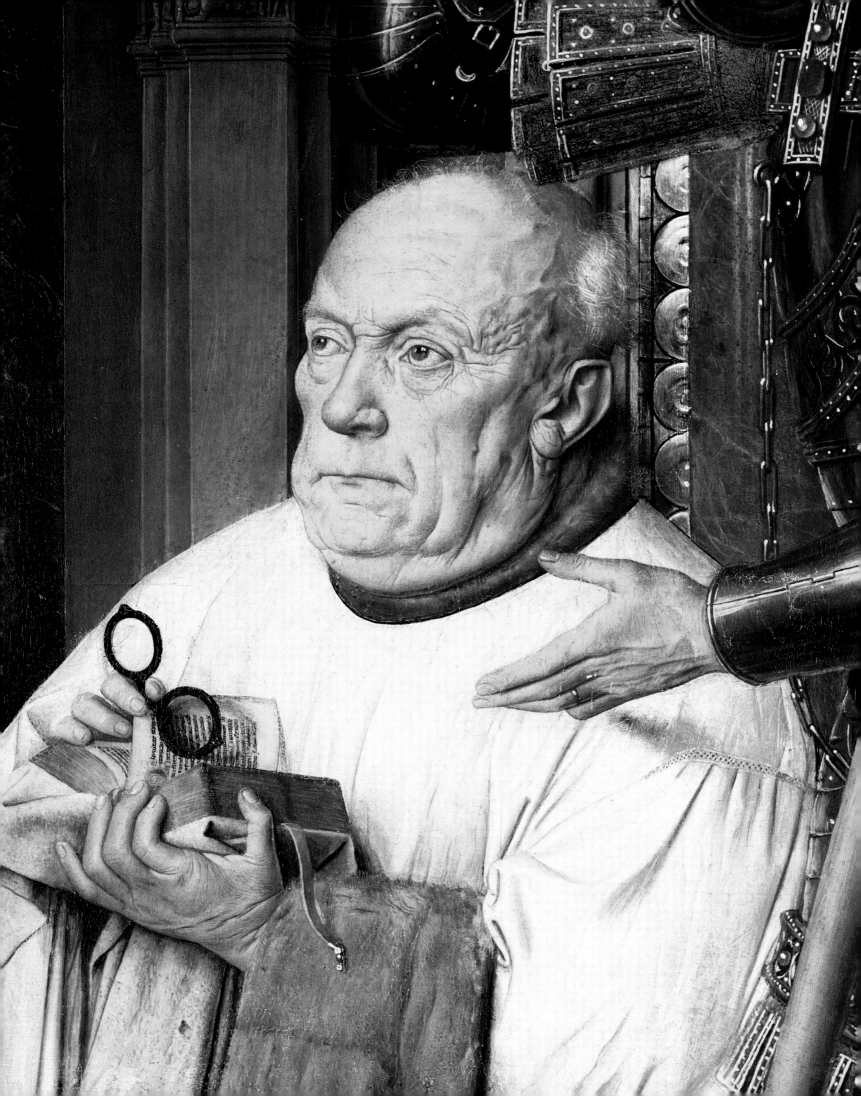

In March 2000, at the end of his second visit to my studio, Charles Falco just happened to say – in a sub-clause of a sub-clause – that a concave mirror has all the optical qualities of a lens and can project images onto a flat surface. Suddenly, it clicked. He thought this was common knowledge (maybe it is in the rarefied world of optics), but I knew it wasn't.

The next day, we used a simple shaving mirror – the only known domestic use for a concave mirror – to project images onto a wall. We could see them so clearly – it was a Eureka moment. The equipment we used was simple and small – about the size of a top of a can and not very thick. Nothing much really, small enough to slip in a pocket.

Then I started to experiment. To make the projected images even clearer I cut a hole in a piece of board to make a little window like those I had seen in Netherlandish portraits. I then placed this board in a doorway and blacked out the room. I pinned a piece of paper next to the hole, inside the darkened room, and set up the mirror opposite the window and turned it slightly towards the paper. Then a friend sat outside the hole in the bright sunlight. Inside the room, I could see his face on the paper, upside down but right way round and very clear. Because the image was not reversed I was able to make a few key 'measurements' and mark out the corners of the eyes, nose, mouth, just like I had done with the camera lucida. Then I took the paper down, turned it the right way up and worked from life, which is what I'm doing here. The image from the 'mirror-lens', as I call it, remained there on the black wall.

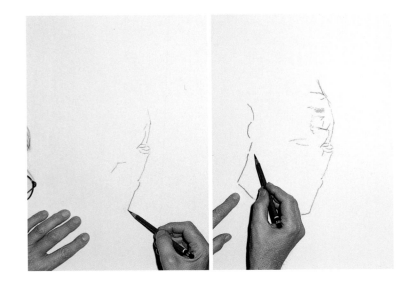

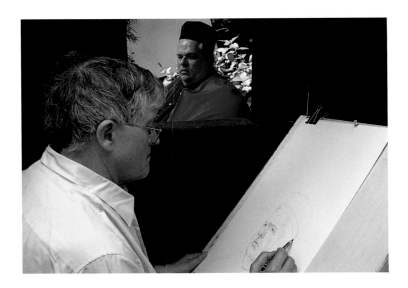

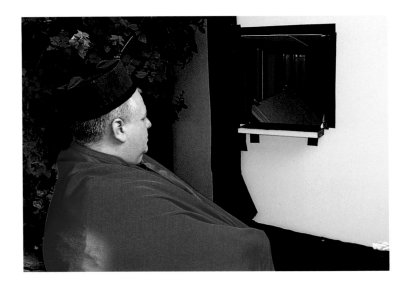

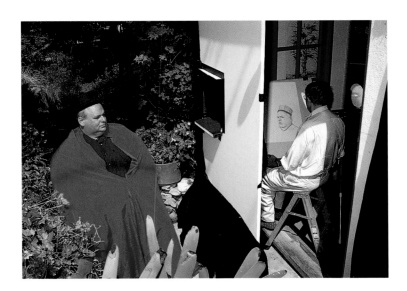

These photographs show the process in more detail. At the top left you can see the projection on the paper as I make my initial marks, two stages of which you can see top right. After making the measurements, I take down the paper and complete the drawing from life (the finished portrait is opposite). The subject, who sits outside throughout, can see very little of what is going on in the room. He is not even aware that the mirror is there (*above and left*).

I have been told by some art historians that there are written accounts of similar set-ups in the fifteenth and sixteenth centuries, but as yet I have not located them.

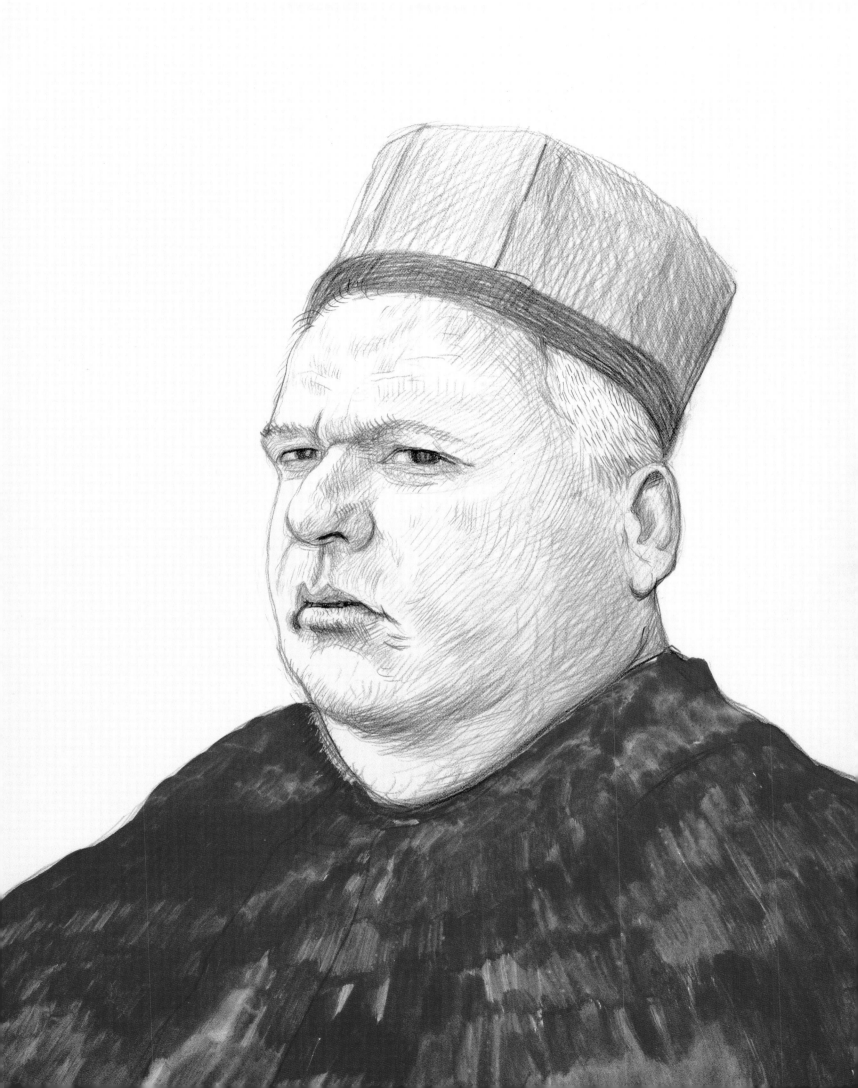

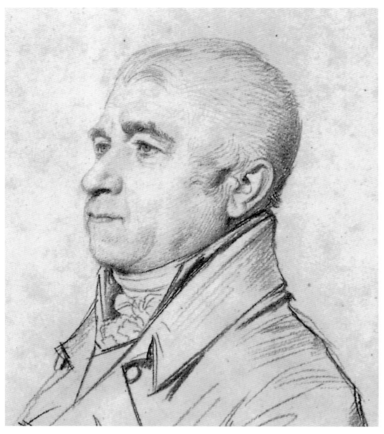

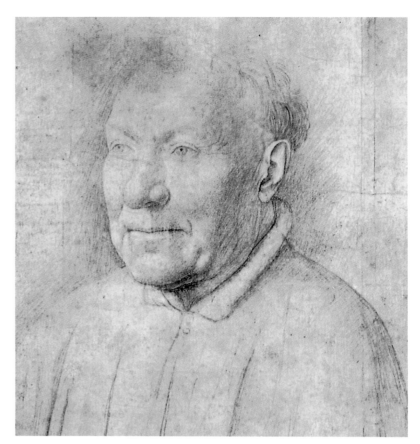

1816 Jean-Auguste-Dominique Ingres **1431** Jan van Eyck

The portrait above right is one of the few surviving drawings by Jan van Eyck. It is said to be of Cardinal Niccolò Albergati, and was drawn while he was in Bruges on a three-day trip in December 1431. To me it has the look of an Ingres drawing, like the one above, for the physiognomy is perfectly accurate while the clothes are less precise, possibly eyeballed. The Cardinal's pupils are sharply contracted, as if he were in a strong light. As I discovered with my mirror-lens set-up, you need a strong light for any 'natural' projection.

Van Eyck's drawing of the Cardinal is about 48% life size, but the painting (*opposite*) is 41% larger than the drawing. What is amazing is that when you enlarge the drawing by that amount and lay it over the painting, many of the features line up *exactly*: the forehead and the right cheek, the nose and the nostrils, the mouth and the lips, the eyes and the laughter lines – all align perfectly. Now shift the drawing

to the right by just 2mm and the neck and collar match; shift it up by 4mm and the ear and left shoulder are spot on. Charles Falco pointed this out to me. As he said, to have scaled the drawing up so precisely, van Eyck must have used an aid of some kind. It cannot have been squared up – the correspondences between the sketch and finished painting are too exact – but optics could account for this precision. If van Eyck had used a mirror-lens like mine to produce the drawing quickly (Albergati was in Bruges on business and van Eyck had a limited time to take his likeness), he could have then, with the same mirror, built an epidiascope, which projects an image from a flat surface onto another, enlarged or reduced, to transfer the magnified drawing to the panel. In the process, he may have knocked the mirror, the drawing or the panel by a few millimetres, thus accounting for the shifts in the alignment of features we noticed.

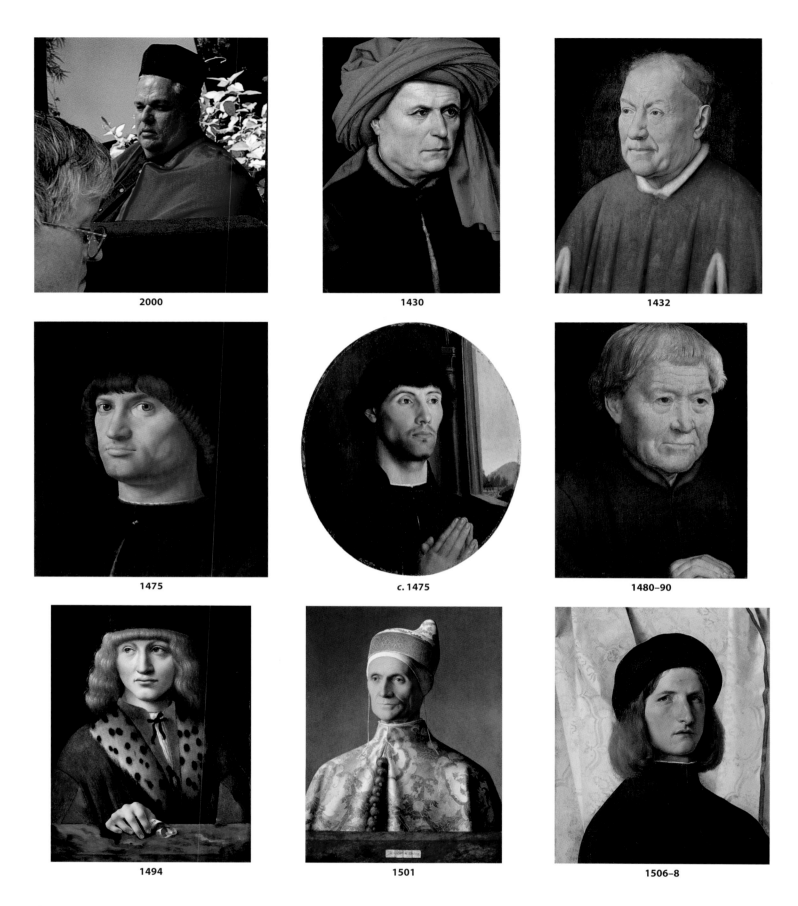

2000

1430

1432

1475

c. 1475

1480–90

1494

1501

1506–8

As soon as one artist had achieved a likeness as naturalistic as van Eyck's Cardinal Albergati, word of the new style would spread and others would try to imitate it. Their customers would want to be portrayed just as accurately and vividly – it's human vanity. Look at these portraits from the fifteenth and sixteenth centuries, and notice how different they are from the Giottos we saw earlier. They are remarkably similar in scale,

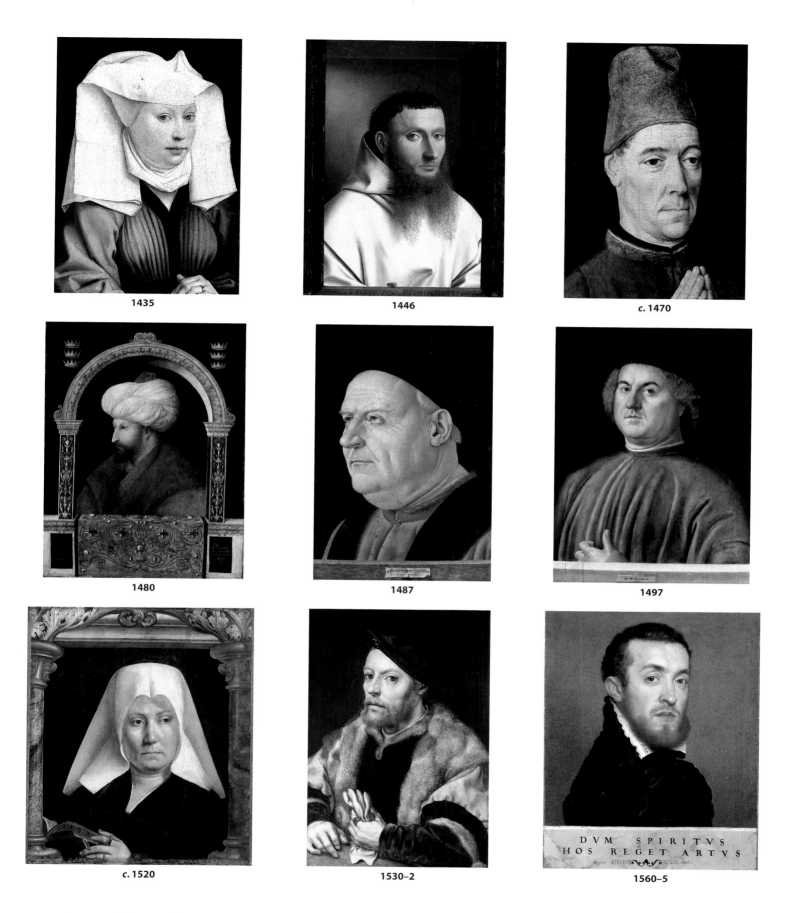

1435

1446

c. 1470

1480

1487

1497

c. 1520

1530–2

1560–5

composition and lighting. They all look as if they're seen through a window, and many have a shelf or ledge at the bottom. Why? The mirror-lens is one explanation, and to me the most convincing: our hole-in-the-wall experiment produced identical effects.

I am not suggesting that all these artists used the mirror-lens themselves, or even that they knew about it, but once one had used it others would try to re-create the look.

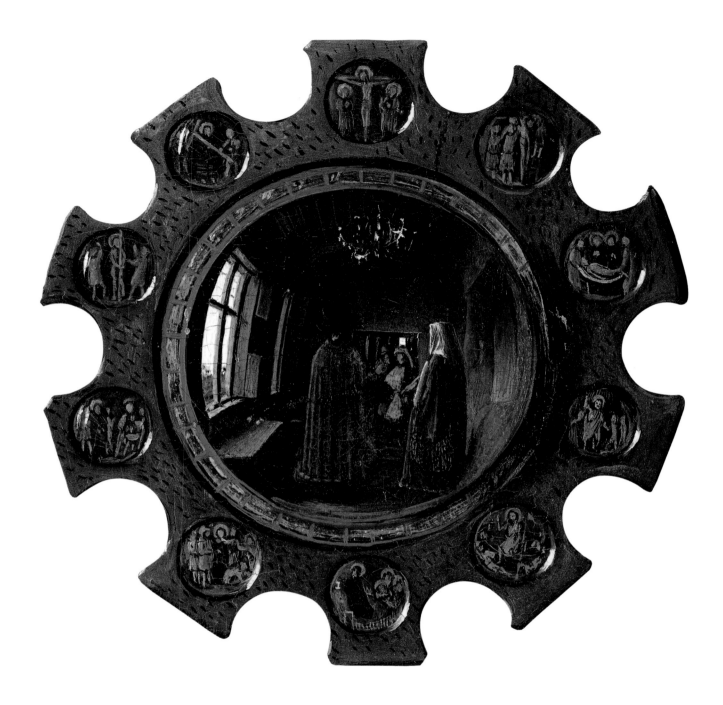

This is van Eyck's *Arnolfini Wedding* of 1434. I have admired the picture longer than any other in this book, and have gone back to look at the real one again and again. There is the convex mirror again. If you were to reverse the silvering, and then turn it round, this would be all the optical equipment you would need for the meticulous and natural-looking detail in the picture. The chandelier has always fascinated me. It was done without any detailed underdrawing or corrections (it's the only object in the picture to have been painted like that), amazing for such a complicated foreshortened form. Van Eyck could have hung the panel upside down next to the viewing hole and painted it directly, following the forms he could see on the surface. Notice how the chandelier is seen head on (not from below, as you would expect). This is the effect you would expect with a mirror-lens, which must be level with the objects you want to draw or paint. It would have been a superb subject to show off his skills. Artists think of these things.

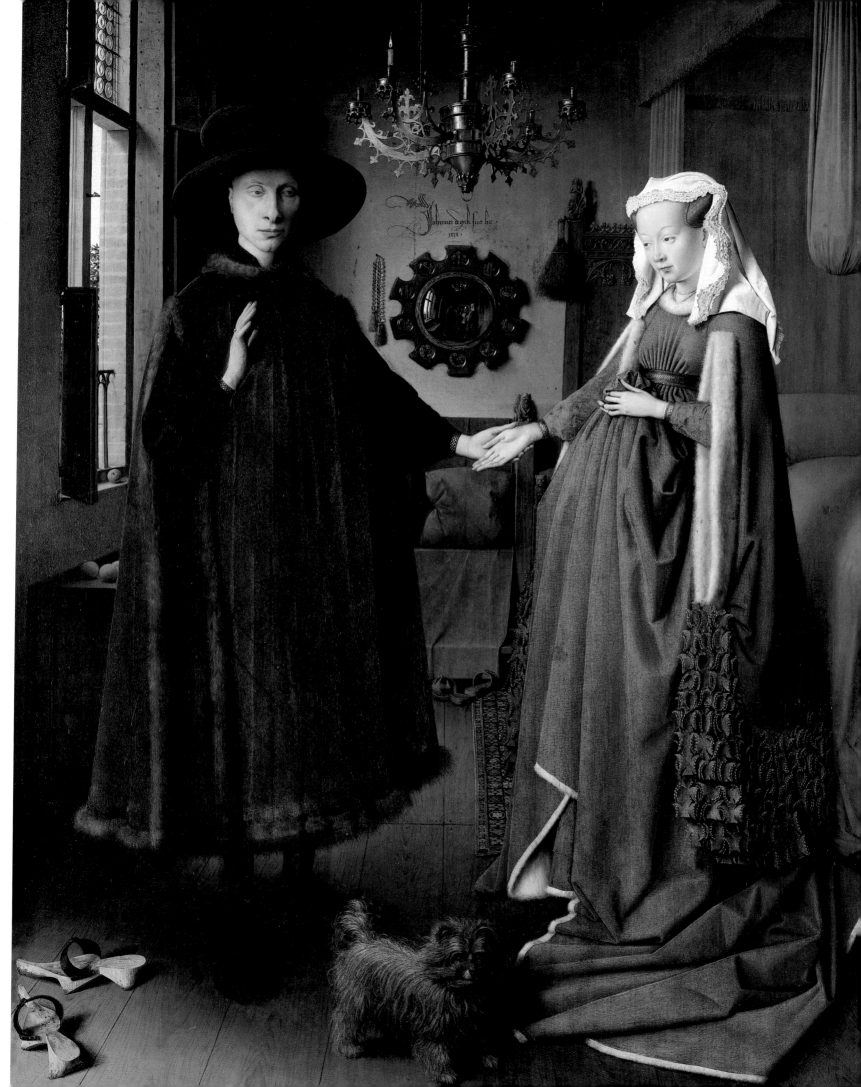

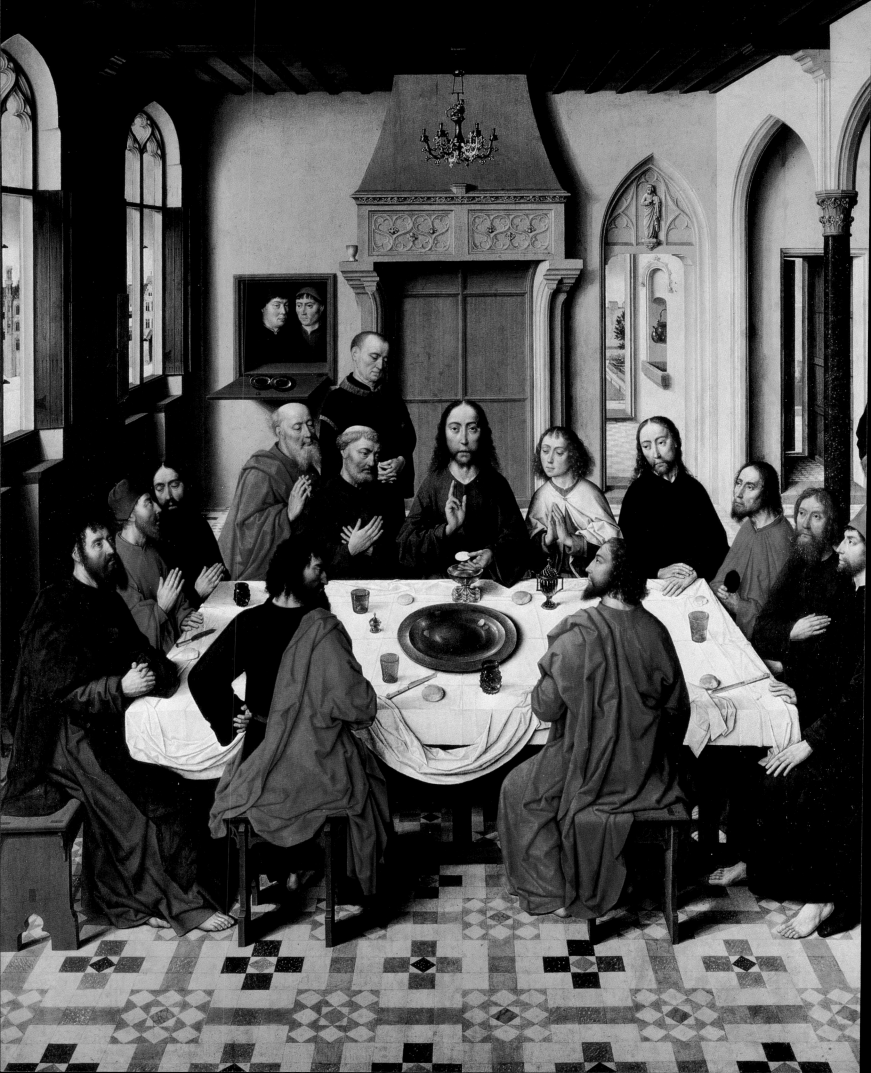

This Last Supper scene is the central panel of an altarpiece painted by Dieric Bouts between 1464 and 1468. Just like in the *Arnolfini Wedding*, the chandelier is seen head on, not from below as you'd expect. And look at the faces. Not only do they have their own individuality, but they, too, are all seen head on like the chandelier. Some of the figures seem unrelated to each other, and some models appear to have been used more than once. I am sure that each element in the painting – each face, each object – was drawn separately with a mirror-lens and the hole-in-the-wall method, using a window just like the one on the back wall, and then pieced together on the panel. In effect, it's a collage. Bouts has managed to construct the painting so beautifully that we accept its marvellous space as a believable unit. The effect, though, is to bring everything (even distance) close to the picture plane.

My own polaroid collages have the same effect. Every single photograph was taken close to the subject, and then put together to make an attempt at space. Many windows. Many windows.

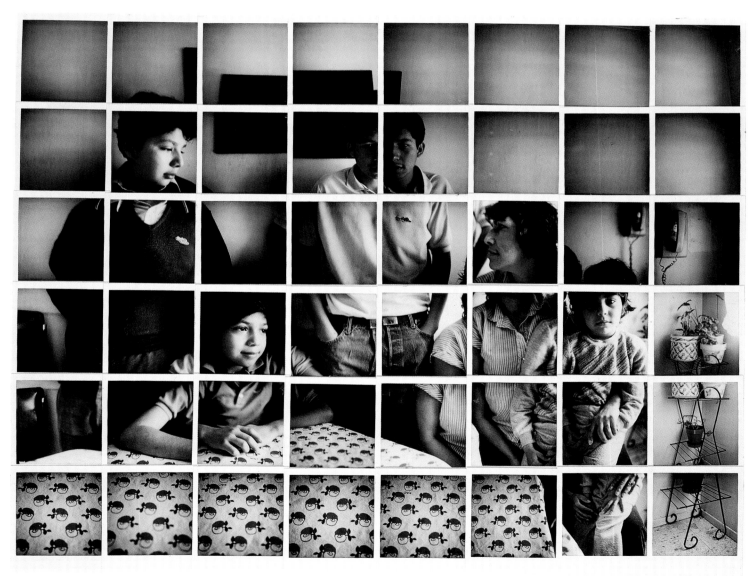

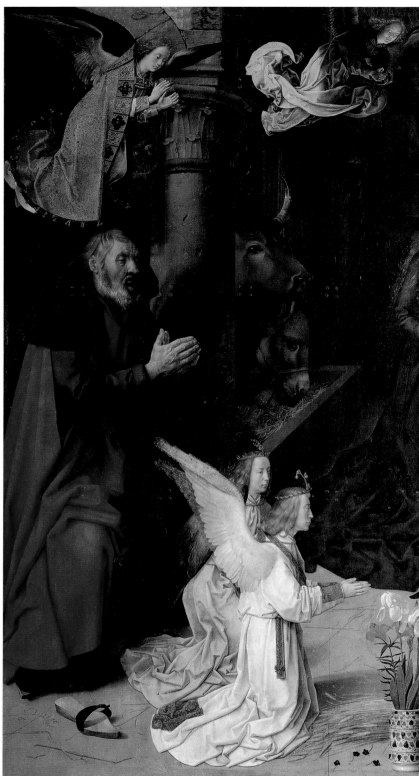

This Nativity scene by the Netherlandish painter Hugo van der Goes was commissioned around 1473 by Tommaso Portinari, agent for the Medici bank in Bruges. When it was sent to Florence in the 1480s, it was widely admired and had an immediate influence. The intense realism of individual features confirms close observation of small details (notice the shepherds' hands, for instance), and yet the space seems 'unreal'. It is noticeable, much more than in Bouts's enclosed interior, that the composition has not been constructed according to the laws of single-point linear perspective but has instead many different viewpoints, many different

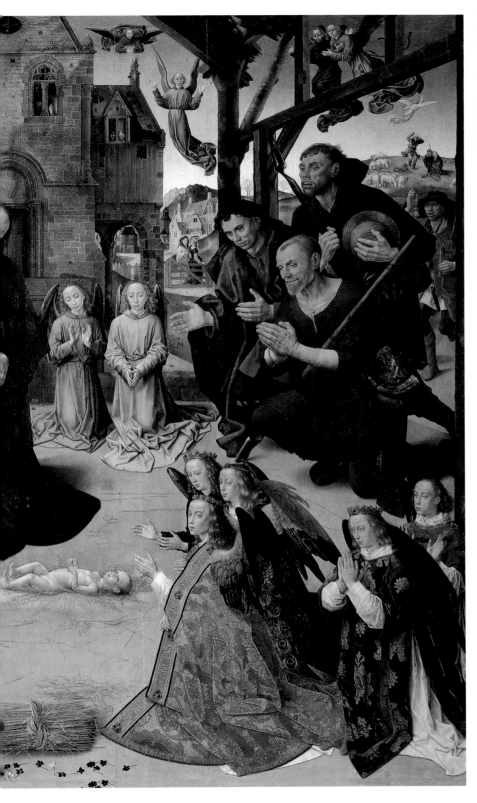

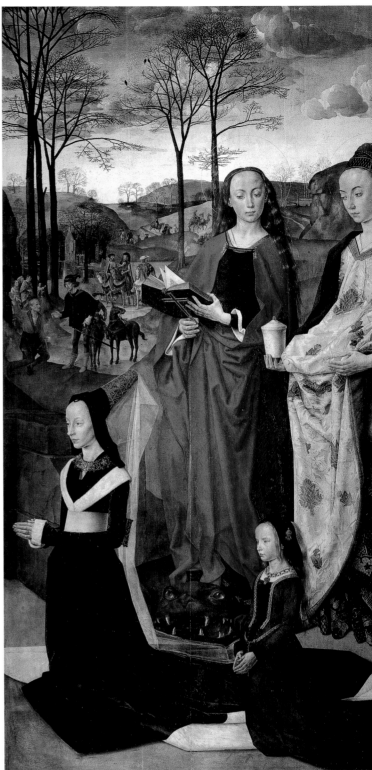

windows onto the world – it has a 'multiwindow' perspective. We see each figure straight on, regardless of where they are in the scene, even those on the distant mountains. There are also dramatic differences in scale (or magnification) – just compare the shepherds to the right of the Virgin with the angels beside them. The kneeling man on the left is Portinari himself. His head was actually painted on a separate support and stuck onto the panel later. We can be sure that that particular window, at least, was done separately from the rest of the picture and so has a different viewpoint.

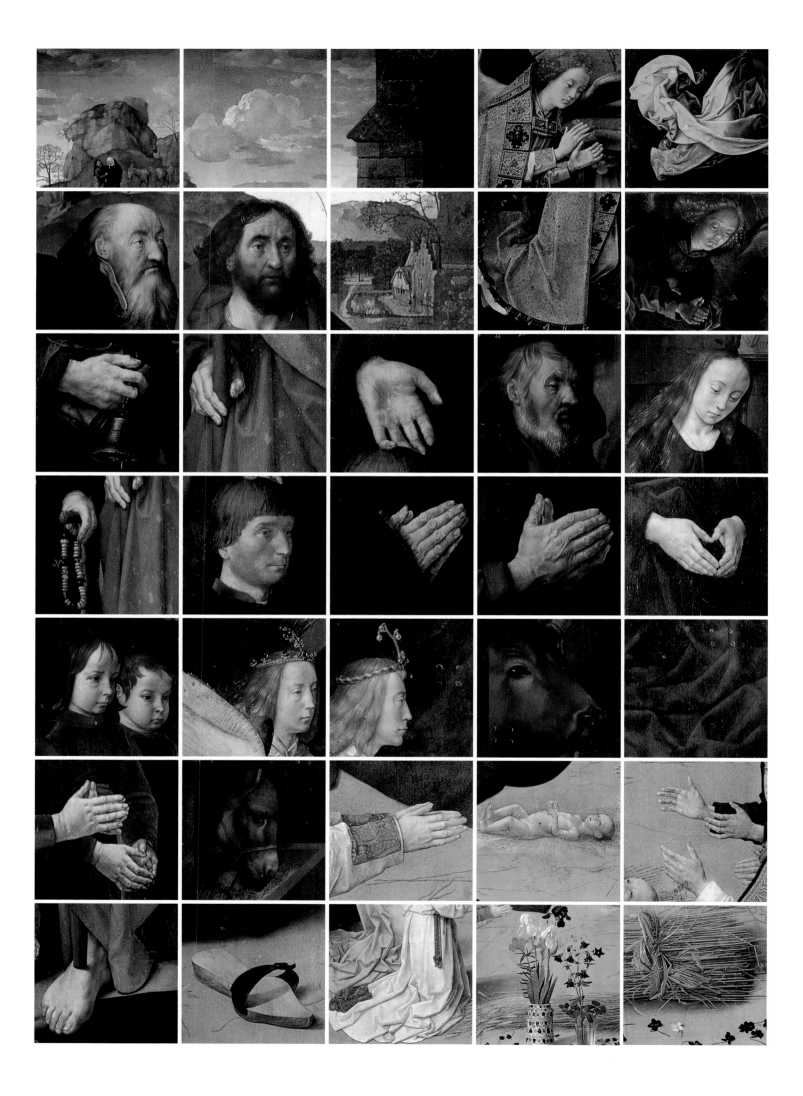

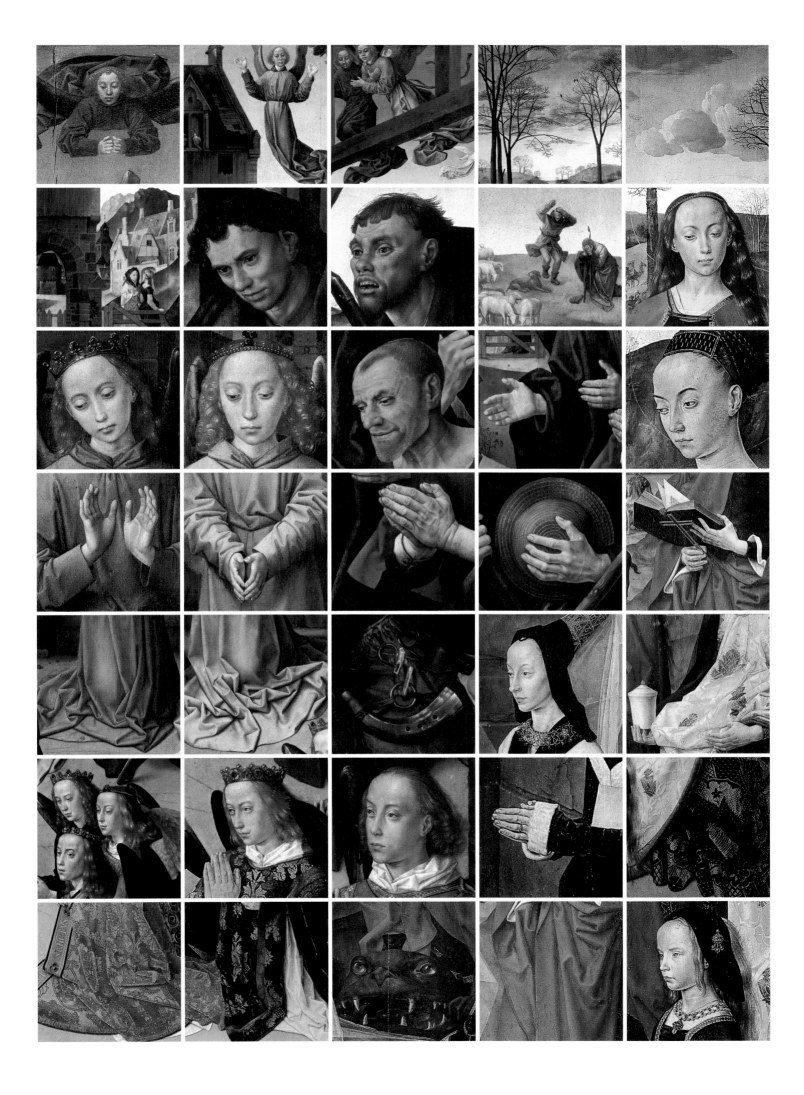

I know it might seem outrageous to compare these two pictures, but it is only in their spatial structures that I am drawing parallels. Van Eyck's *Ghent Altarpiece* (1432) has the powerful feeling of great depth when seen in the original, the glowing colours (not reproducible here) playing an important part in this, but when you look at the painting in the flesh you also notice that everything is seen close up, brought up against the picture plane. It is not like the depiction of space in, say, a Piero della Francesca – think of the *Flagellation* (*see page 125*).

In the eighteenth century, some commentators thought that the altarpiece was an example of 'wrong perspective' – it didn't follow the rules – and yet the sense of depth is always there. We look straight on at the lamb of God, and we move above when looking at the fountain. The left and right groups in the foreground are seen from the front, with a slight rise of viewpoint towards the centre. The crowds in the middle distance are seen head on, with very beautiful details of bushes and plants seen from the front, again head on. The angels are on the ground but their lovely shapes also suggest flying. The rays of the sun radiate out as though the sun were the painting's vanishing point (infinity), yet a 'V' shape rises from the bottom of the picture to contradict this. It is a miraculous composition, around which we move from viewpoint to viewpoint. It is not 'primitive' at all, as it is sometimes described, but a highly sophisticated construction that is deeply satisfying spatially.

My own construction of *Pearblossom Highway* suggested to me how this sense of both closeness to everything yet at the same time depth could be achieved. Multiple viewpoints create a far bigger space than can be achieved by one. Our bodies may accept one central viewpoint, but our mind's eye moves around close to everything, except the far horizon, which has to be near the top of the picture.

Although *Pearblossom Highway* looks like it has a central fixed viewpoint, none of the photographs that make it up were taken from what could be called 'outside' the picture. I moved about the landscape, slowly constructing it from different viewpoints. The stop sign was taken head on, indeed from a ladder, the words 'STOP AHEAD' on the ground were seen from above (using a tall ladder), and everything was brought together by 'drawing' to create a feeling of wideness and depth, but at the same time everything was also brought up to the picture plane.

Is this the effect of the montage technique? What is known of van Eyck's methods is that he made lots of drawings of various elements and then 'drew' the whole painting out in detail from them. In making the drawings, everything would be close to him, alterations of scale being made from an intuitive but amazingly knowledgeable geometry. The farther away a crowd is the smaller it seems, yet there is no loss of detail (I scrutinized this painting with binoculars the last time I was in Ghent). We marvel at the 'realistic details', partly caused by use of shadows, yet the source of light seems an even one, certainly not coming from the sun. My point is that multiple viewpoints (many, many windows) have a similar distancing effect on a two-dimensional surface as a bird's-eye view, but that this is contradicted in the details. *The Ghent Altarpiece* is a magnificent construction of wide and deep space that pulls us in. We are outside it only for a few moments.

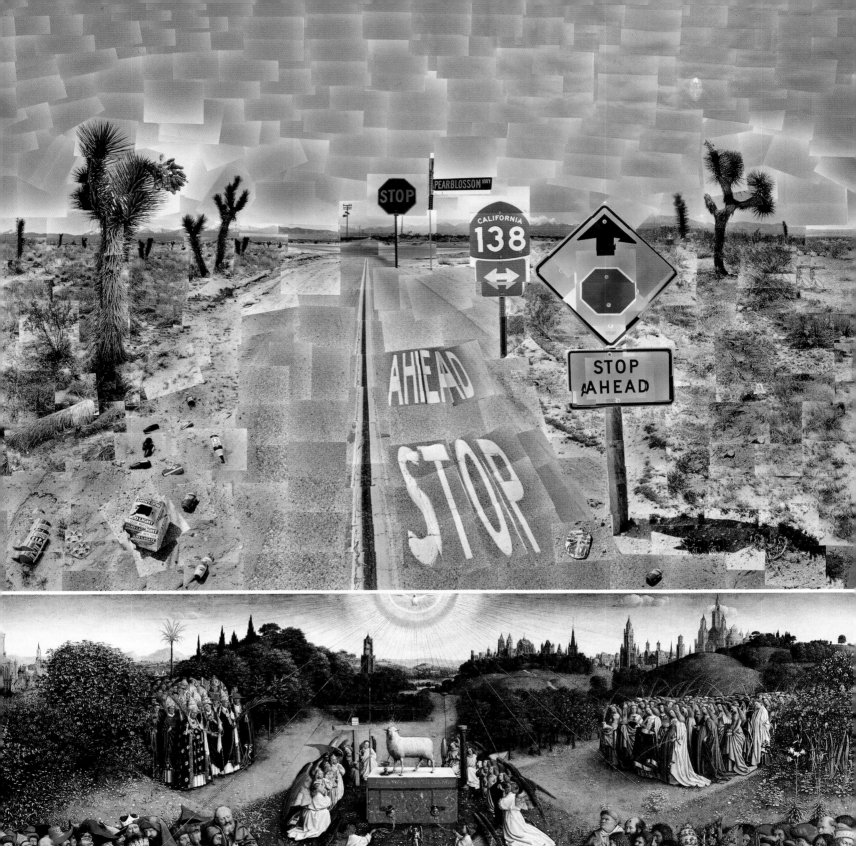

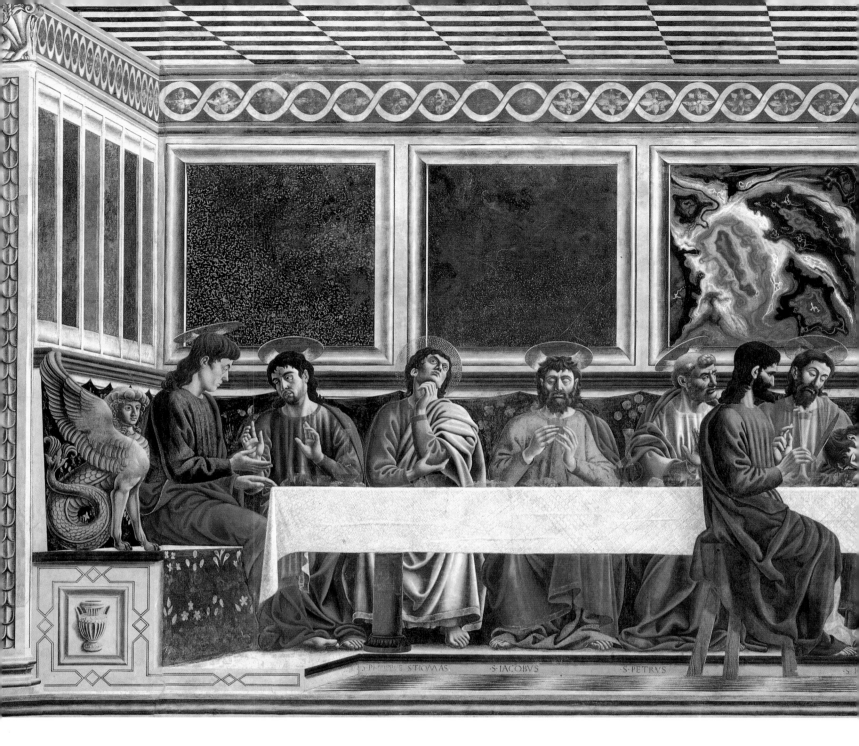

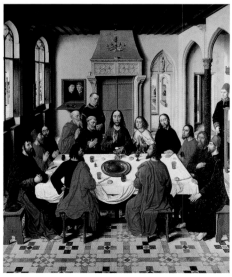

To see the completely different kinds of space you get with single-point linear perspective and 'multiwindow' perspective look at these two depictions of the Last Supper. You feel with Andrea del Castagno's 1447–9 version (*above*) that the action is taking place in a coherent space. This is because our viewing position is fixed; we see everything from the same point: the floor is seen from above, the table and disciples from straight on, and the ceiling from below. However, the painting also points to one of the limitations of linear perspective: because it is concerned with creating the illusion of depth, not of depicting everything equally,

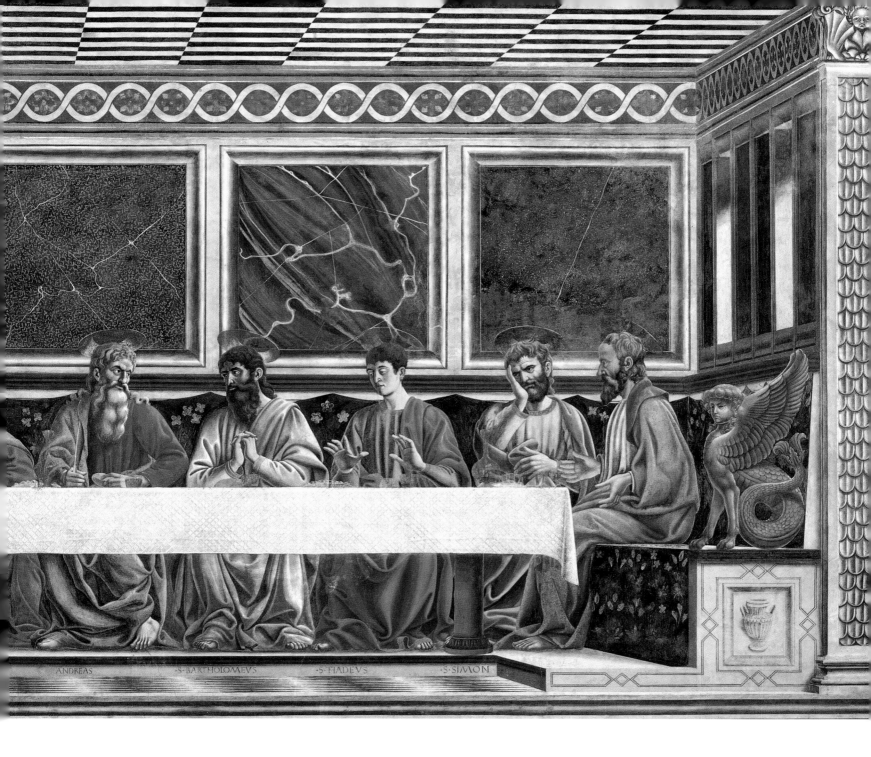

the artist has had to use a friezelike composition to show each of the figures, otherwise they wouldn't all be visible. Suppose you take a photograph of friends at a dinner party – unless you ask some of them to lean forward or back (an indecorous pose for a saint), you won't see them all. Bouts's multiwindow perspective, on the other hand, allows us to see everything in equal measure, because we are constantly moving – or floating – from one part of the painting to the next, never still. Though quite different, both pictures are beautiful depictions of very sophisticated spaces.

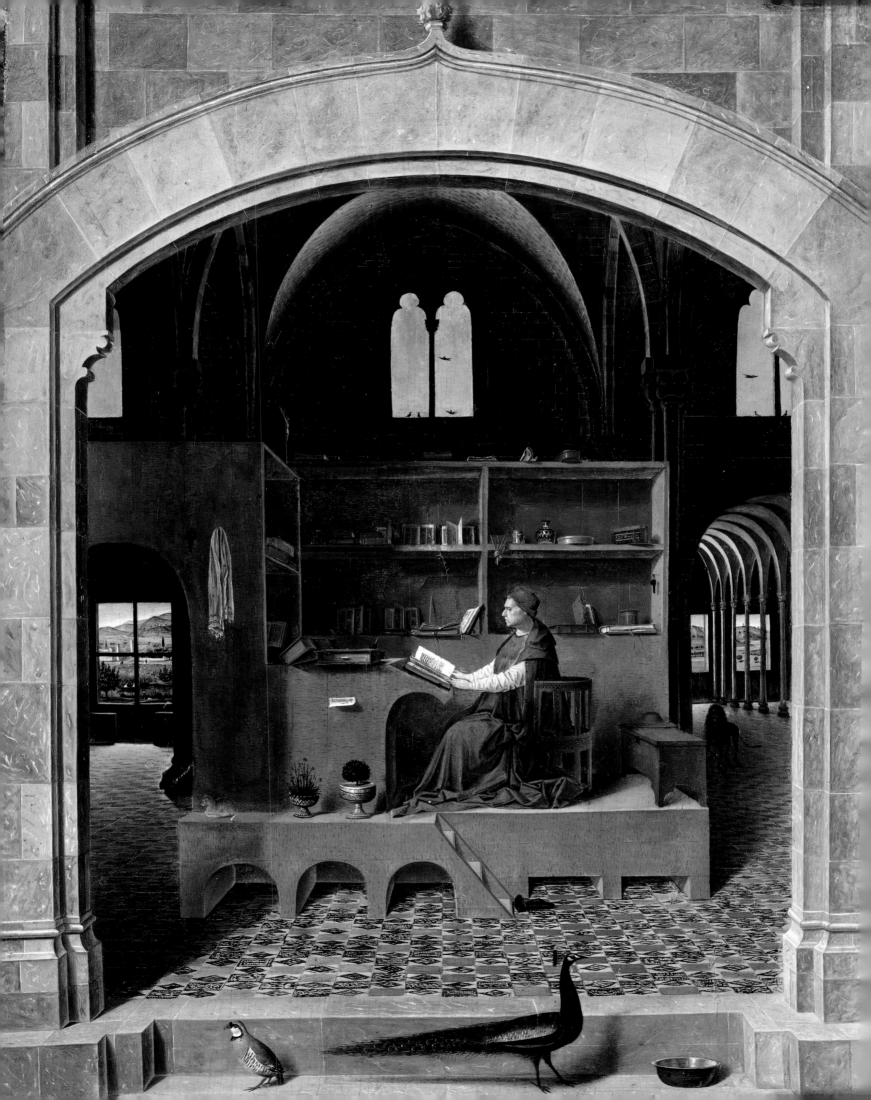

Antonello da Messina is traditionally credited with the introduction of oil painting to Italy from the north. He may have seen a van Eyck painting in Naples, or he may have actually gone to Flanders. He certainly discovered some of van Eyck's methods – could the mirror-lens have been among them? This painting of St Jerome in his study of c. 1460–5 was regarded as being 'very Netherlandish' at the time. It certainly seems to combine the new northern techniques with Italian concerns. The strong shadows, for instance, are unusual in Italian painting of this time, but could be explained by the lighting needed for the mirror-lens. The room itself is drawn according to Alberti's linear perspective but the objects within it aren't – they are all seen head on. Many windows within one window?

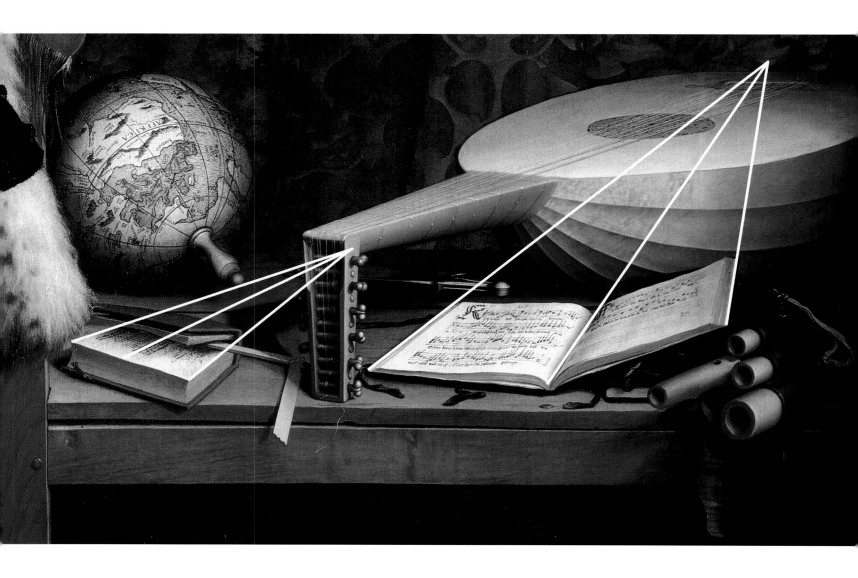

That Holbein understood and used Alberti's perspective is clear in this copy of one of his drawings from *c.* 1520 (*opposite*). Yet in the above detail from his *Ambassadors* we have what seems to be a collage construction. It is clear that the two books have vanishing points at different levels, which in analytical perspective means different eye levels. This indicates that they were seen at different times and from different viewpoints. Was the painting constructed using a mirror-lens? The globe seems to suggest this: it is incredibly 'accurate' in its spherical surface, which is very difficult to do convincingly.

It's true we do not notice these two vanishing points easily, but there must be a reason when as knowledgeable an artist as Holbein defies the conventions. They can be explained rationally by the mirror-lens collage technique.

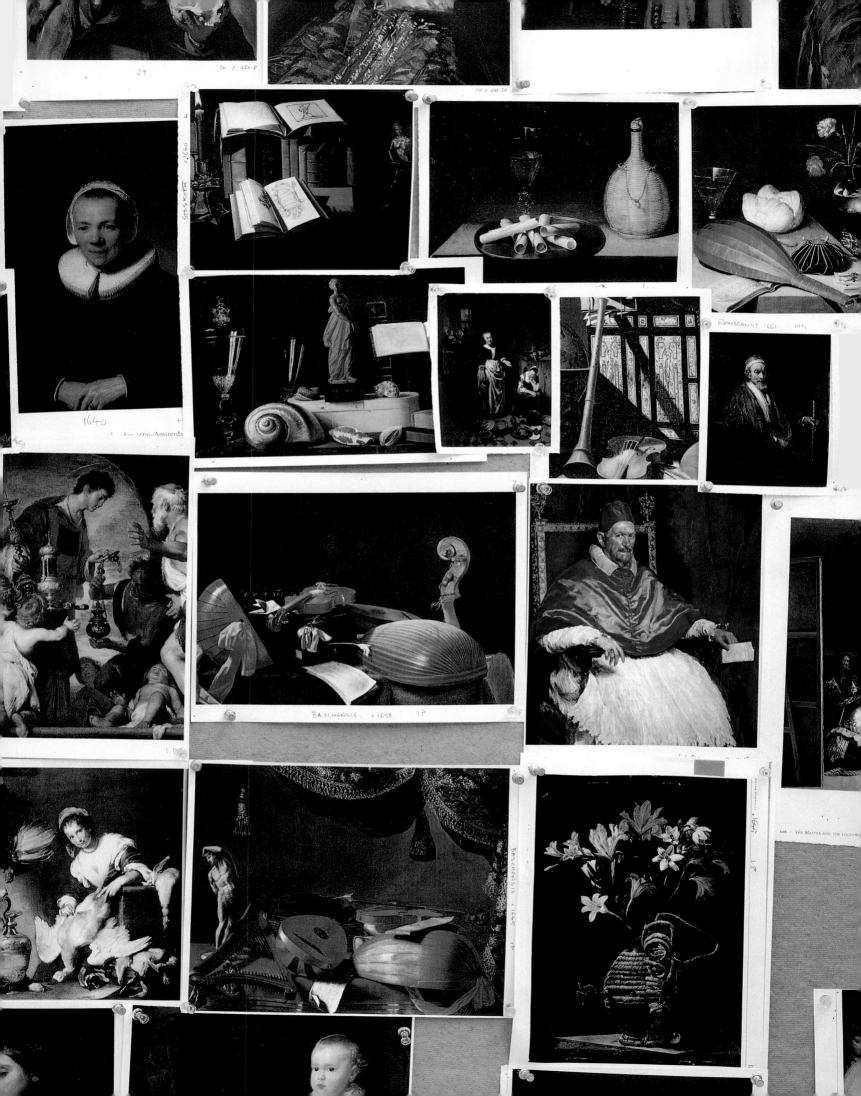

With a mirror-lens projection, the usable image is never much more than a foot (thirty centimetres) across – this is an optical characteristic of all concave mirrors, no matter how big they are. Outside this 'sweet spot' it is impossible to get the image into sharp focus. Paintings made with the help of a mirror-lens must therefore be very small, or must be a collage of small glimpses: portraits; details of hands, clothes, feet; fragments of landscape – and still lifes. From the late fifteenth century (Memling's little vase of flowers must be one of the first), and increasingly through the sixteenth century, the still life gradually became established as a genre in its own right. Inanimate objects do not move (though they may decay), and can be carefully scrutinized for a long time. They are perfect subjects for optical projection, and for artists who used projections.

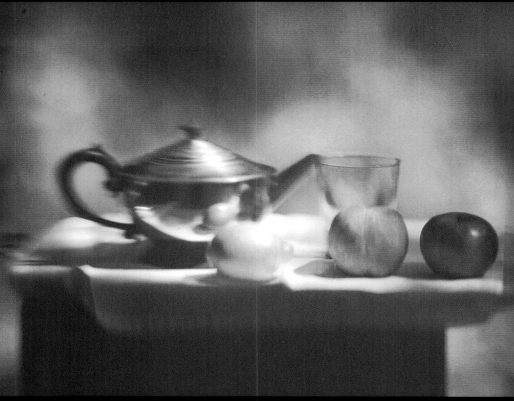

On these two pages are a few photographs of the still-life projections we made with a concave mirror (seen on the right). On the left is a photograph of an arrangement we set up outside in strong sunlight. Below it is its mirror-lens projection inside our darkened room. Notice how 'painterly' the projection looks. In this case, the image has been projected onto a white surface. On the opposite page is a photograph of another of our projections, this time on a black surface. Below it is a still-life painting by Chardin.

The two smaller pictures at the bottom of this page show how, if you arrange some objects farther back than others, it is impossible to have everything in focus at once. This is because the mirror-lens has a limited depth of field. But by moving the mirror or the paper you can change the point of focus. In the top projection, the mirror is focused on the glass and the coffee tin; in the bottom one, it is focused on the fruit. This is a problem a photographer has to overcome, as does a painter using optics.

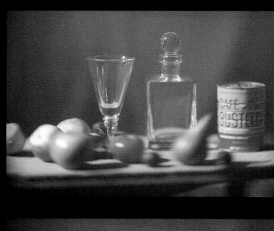

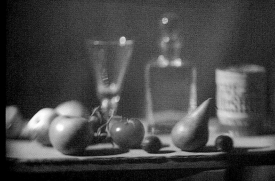

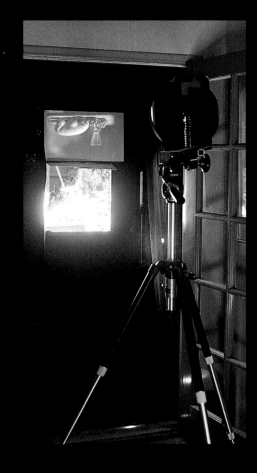

Juan Sánchez Cotán painted this still life in 1602. The setting itself – a small window with a ledge – suggests our hole-in-the-wall technique, as does the lighting. How long would the cabbage look like that with such a strong light on it? How long would the cut melon (the lute of the fruit world) stay like that without decaying? Not very long, that's for sure, certainly not long enough for Cotán to have eyeballed it so precisely. Cotán's is a beautiful painting with a lovely, satisfying, yet simple composition. The curve formed by the objects has been commented on before, and sometimes given a religious interpretation. But

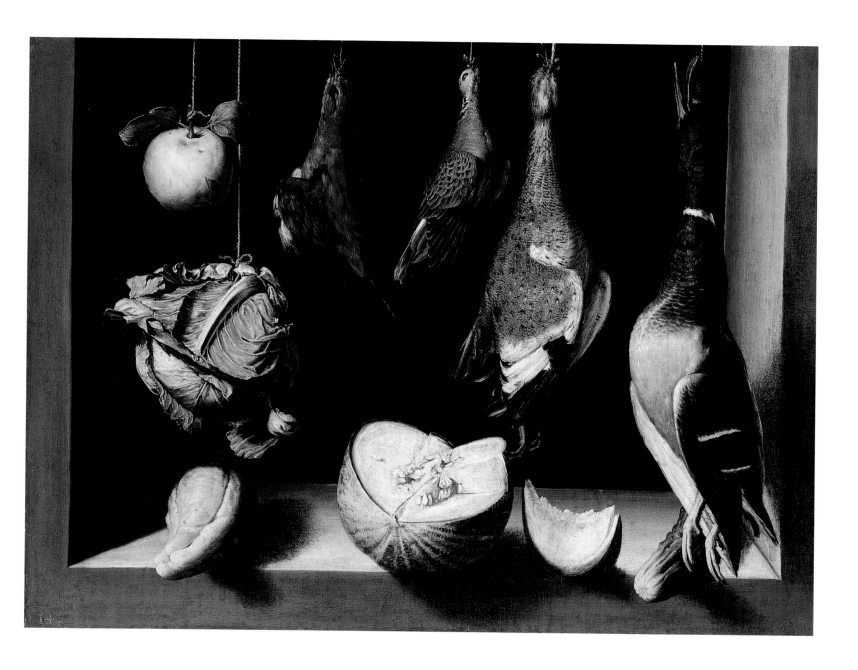

I would suggest that the objects are all on the same plane because of the depth-of-field problems I discussed and illustrated on the previous page. Now look at the second version of Cotán's still life, also painted in 1602. The composition is identical except for the addition of game and the vegetable in the bottom-left corner. The quince, cabbage, melon and cucumber are all in exactly the same place as in the first version. Could Cotán have used his mirror-lens as an epidiascope to make this copy, as I think van Eyck had done with the portrait of Cardinal Albergati almost two centuries earlier (*see pages 78–9*)?

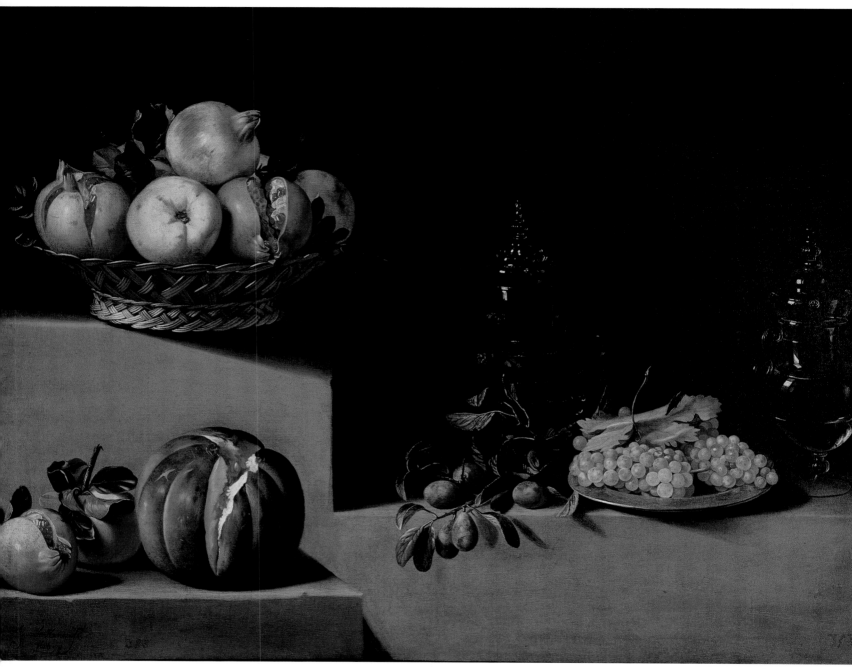

1626 Juan van der Hamen y León

It seems to me that three windows are at work here. If the whole arrangement had been set up together, the grapes would have rotted by the time the basket of pomegranates had been painted; and the melon wouldn't have stayed as fresh as that for very long, especially in the intense summer heat of Spain. Even if the painter did have a step organized like this in front of him, he would have had to paint each section separately and montage them together to create the bigger picture.

Sure enough, when you divide the objects up as I have done here, each group looks like a complete picture in itself. Notice there are no overlaps. Later on, artists would develop the collage technique further, learning how to unite the separate 'windows' by placing objects between the various sections. Van der Hamen was also a portraitist, and he left no drawings. Like van Eyck with the chandelier, he could have used the mirror-lens to project each 'window' directly onto the canvas.

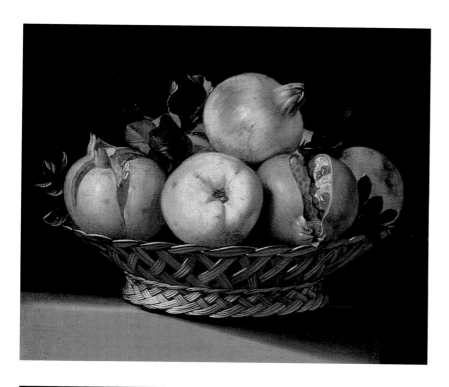

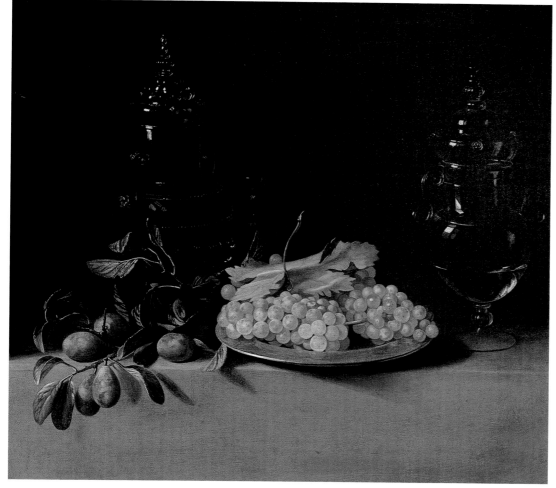

Caravaggio painted this basket of fruit thirty years before van der Hamen's fruit and just six years before Cotán's two still lifes. It is seen absolutely level and straight on. All the fruit is depicted with great naturalism, and the highlights and shading on the basket – the result of intense light from the front left – are simplified tonally. The background was probably added later: it does not seem to correspond with the source of light. Below is a photograph of an arrangement of fruit we set up in my studio; below that is a photograph of its mirror-lens projection. Look how the highlights and tones of the basket are simplified in the projection. Surely Caravaggio knew about this simple scientific fact.

Le 1570's. I.C.

1602 I.C.

FIGURA 7. *Suonatore di liuto.* Leningrado, Ermitage.

1594. I.C.

Emmaus. Londra, National Gallery.

FIGURA 27. *Cena in Emmaus.* Londra, National Gallery.

1598. I.C.

My projections of still lifes with a mirror-lens had a distinctive look: objects seen head on, a unifying totality with strong highlights and shadows, a dark background and restricted depth – all characteristics imposed by the limitations of the equipment. As we have seen, artists found ways of overcoming these limitations by 'collaging' various elements together to make a larger painting – but those elements are still seen head on and close up. It is the artist's compositional skills that convince us everything is placed within a coherent space.

When conventional lenses became large enough and of good enough quality to use instead of a concave mirror (some time in the sixteenth century), an artist already schooled in the use of the mirror-lens projection would see one distinct advantage: a wider field of view. Several artists made this transition, but it is seen most clearly in the work of Caravaggio. He used the lens so imaginatively that his example soon had an influence across Europe, with young artists making pilgrimages to Italy to see his paintings and to learn from his followers, the Caravaggisti.

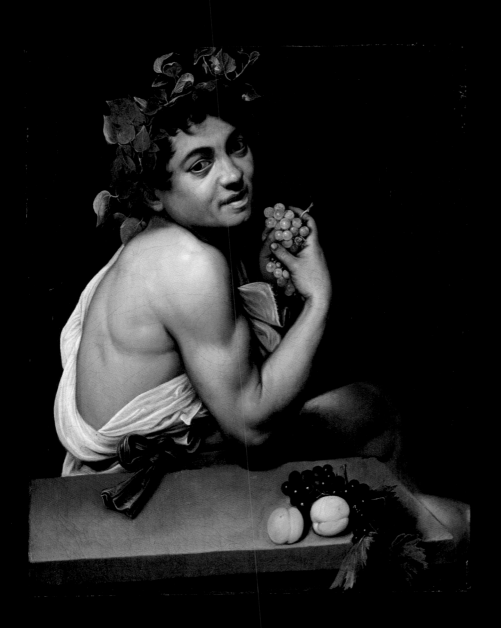

This is Caravaggio's *Sick Bacchus* of 1594. Caravaggio certainly owned mirrors – they are mentioned in lists of his effects – and many scholars accept that he used them. But historians have generally interpreted contemporary accounts of how he used mirrors 'to paint portraits' to mean that he was painting *himself*. But if he had been using a mirror-lens he would have been painting someone else. To have painted this figure, Caravaggio may have used the montage technique, capturing the model in bits and then piecing him together. On the right, I have made four windows to show how this might have been done. Notice how we look down on the table but see the still life of fruit head on; the fruit also seems remote from the figure, as if it were a separate composition.

Now turn the page and compare this painting with another Bacchus that Caravaggio painted just a year or so later. In the 1594 painting, the head and shoulders seem very close to us (as we have seen, the effect of using a mirror-lens and montage is to bring the subject nearer the picture plane). But in the later Bacchus, from 1595–6, he seems much farther back. This is an effect you would expect from a conventional lens, which can project a wider field of view and therefore more of the figure in one go. Also, see how the figure is holding the glass in his left hand. Again, this could be attributed to the use of a lens, which, unlike the mirror-lens, reverses everything.

I see these two paintings as marking a radical shift. I believe that at some point in the mid-1590s Caravaggio came into the possession of a lens, perhaps given to him by his powerful patron Cardinal del Monte, who had given advice to Galileo about how he could improve his telescope. The Cardinal was therefore clearly knowledgeable about optics, and no doubt owned several lenses.

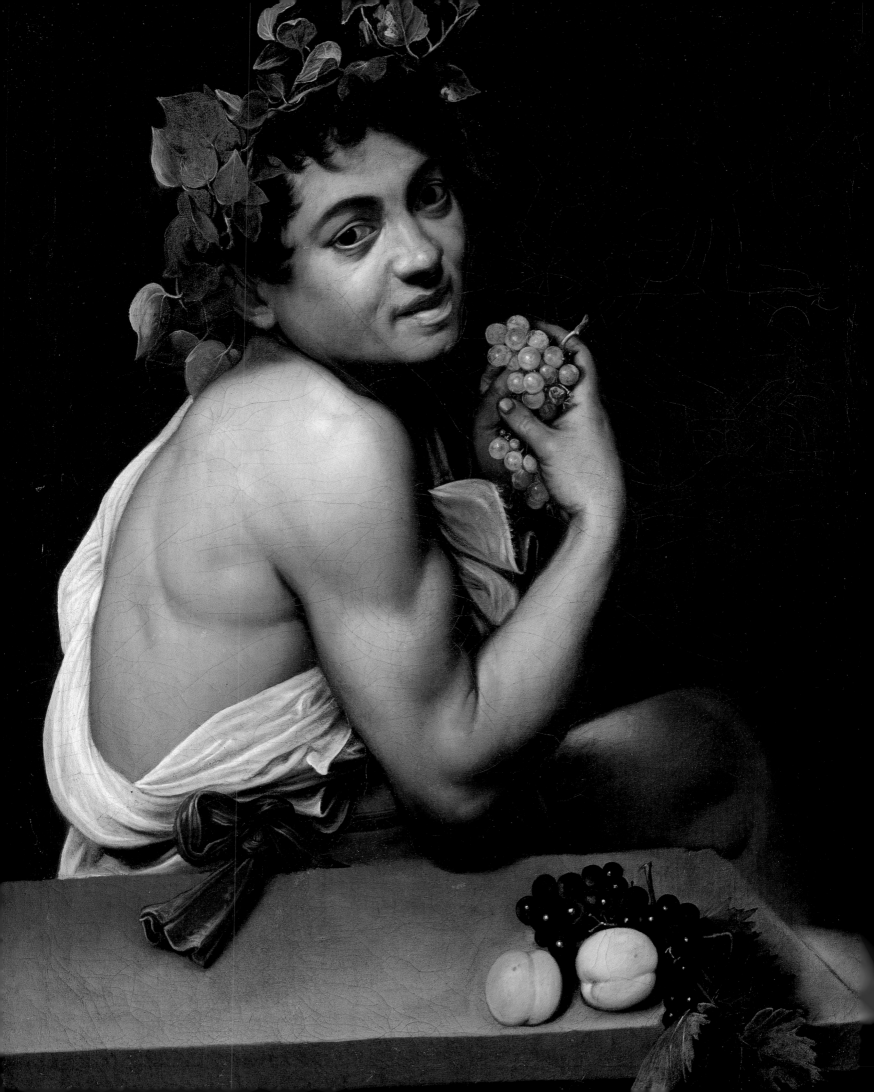

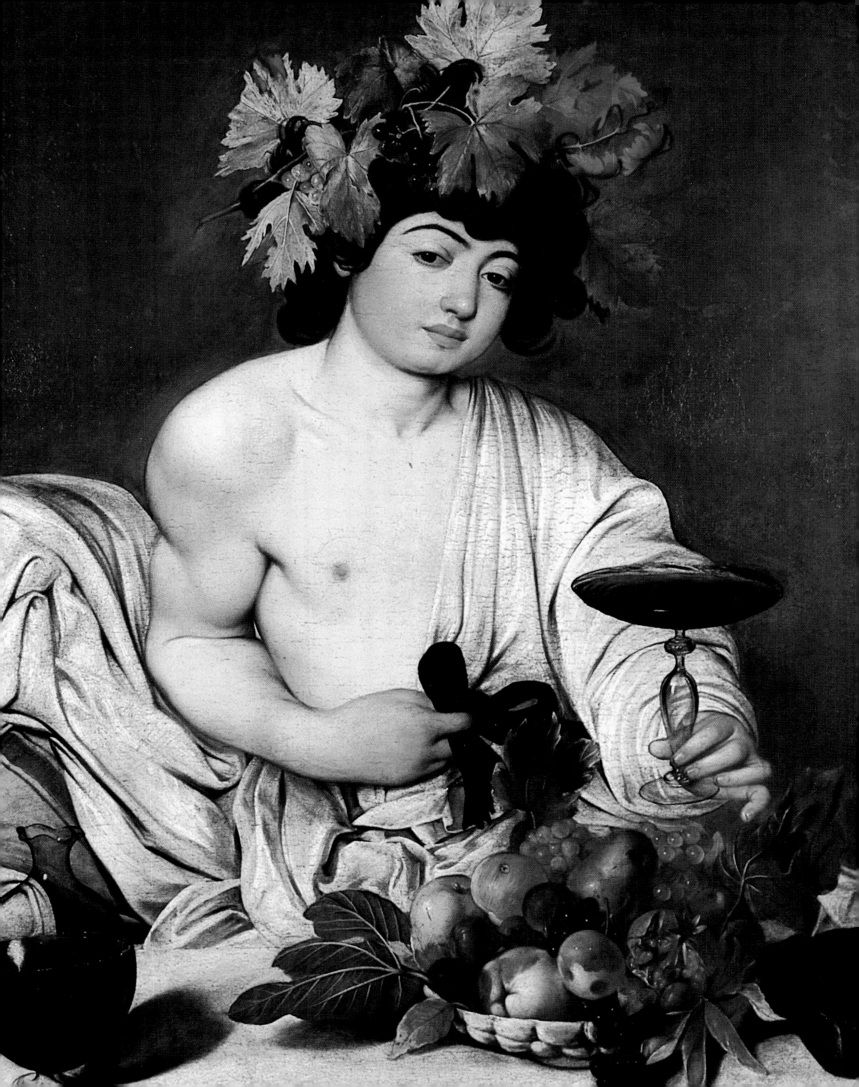

1595–6 Caravaggio

Three paintings of drinkers. In each case, the version on the left is the correct picture, with the sitter holding the glass in their left hand; the one on the right is a 'mirror image'. What is interesting for me is how the paintings on the right look more natural and harmonious, the models seem more comfortable. I would suggest that this is because they were really right-handed to begin with – they only *appear* left-handed because they've been reversed by a lens.

Most people lift a glass in their right hand; glasses and cups are usually laid out on the right at dinner; revolutionaries raise their right fist; soldiers salute with their right hand. Giotto and other earlier artists painted people as they saw them, drinking with their right hand. Is it a coincidence that at the end of the sixteenth century, when I believe lenses were first used by painters, there are suddenly a lot of left-handed drinkers? This phenomenon appears with Caravaggio and lasts for about forty years, when good-quality flat mirrors reversed the image back.

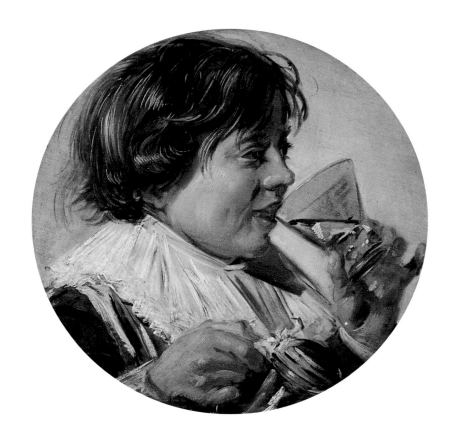

1582–3 Annibale Carracci

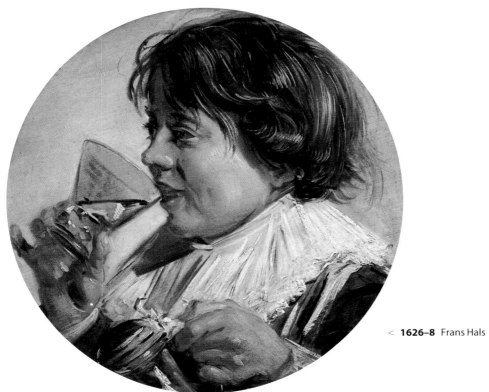

< **1626–8** Frans Hals

Caravaggio's new lens enabled him to attempt ever more complex and naturalistic images. Below is his *Supper at Emmaus* from between 1596–8 and 1601. Look at the remarkable foreshortened arms of St Peter on the right and Christ in the centre. Compare that realistic rendering with the awkward depiction of a fallen knight in Paolo Uccello's *Battle of San Romano* from the 1450s (*above*), one of the best-known examples of Italian Renaissance linear foreshortening. Though we accept Caravaggio's representation as natural, if we look closer we see some strange discrepancies. Christ's right hand is the same size as Peter's, although it is supposed to be nearer to us; and Peter's right hand seems larger than his left, which is also nearer. These may be deliberate artistic decisions, or may be a consequence of movements of lens and canvas when refocusing because of depth-of-field problems. It is also interesting to note that Caravaggio covers the patterned tablecloth with a white one, eliminating the problem of matching the pattern when refocusing (*see pages 60–1*).

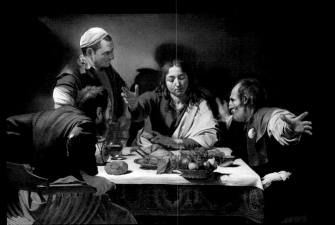

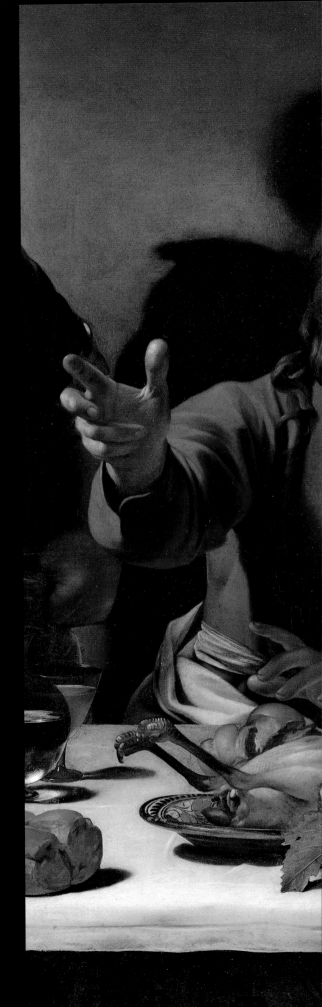

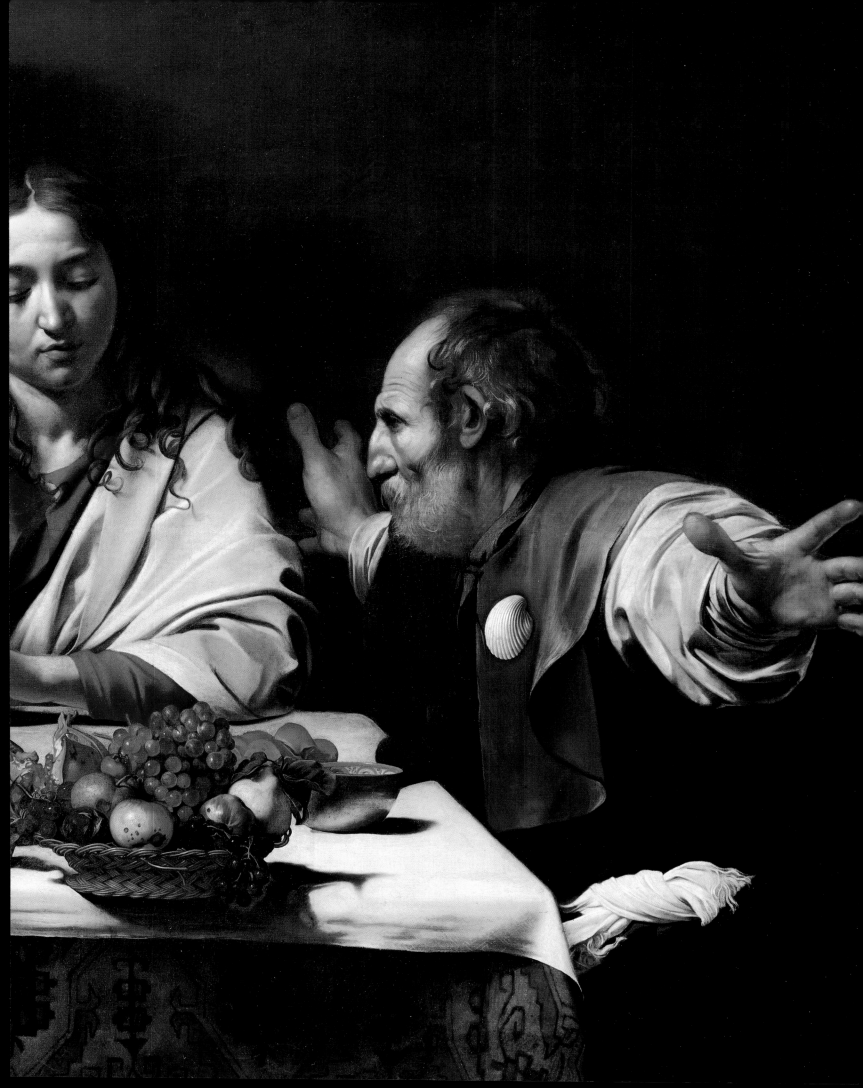

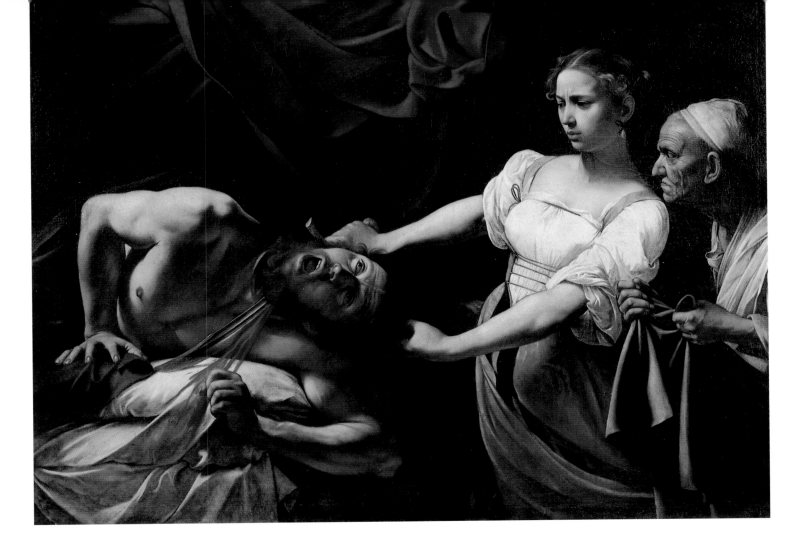

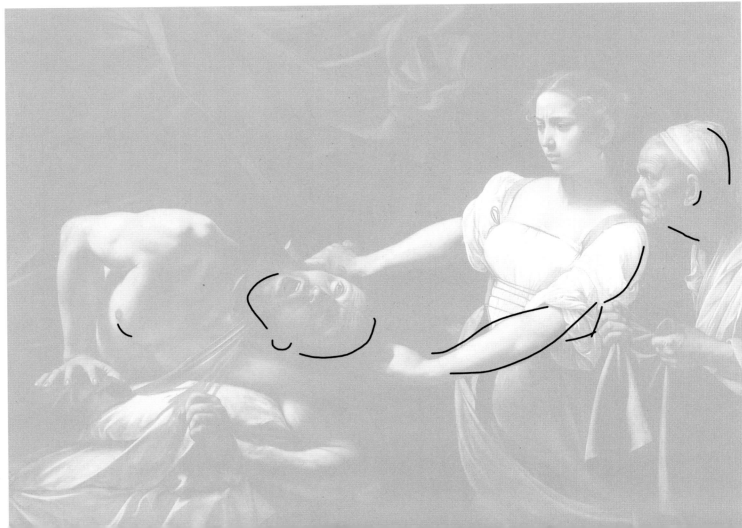

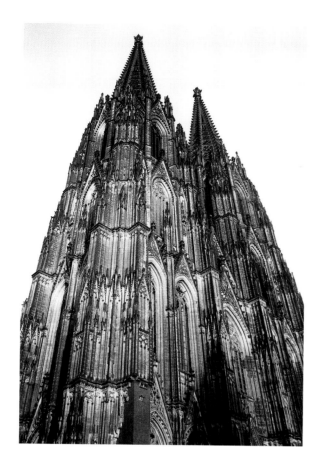

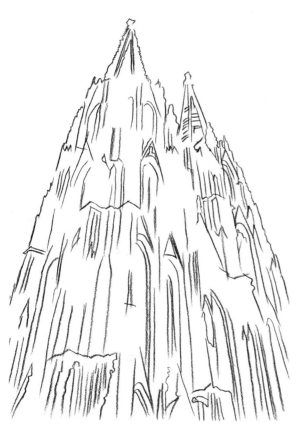

I think Caravaggio used optics in the most skilful way, in effect drawing with the camera. The new kinds of spaces seen in his works are the result of his method of construction, which I assume will one day be worked out by art historians with some knowledge of optics, although I have an intuitive idea of how he did it. I must point out here that Caravaggio made no drawings. None are known, and historians have found no written references to them. How, therefore, did he make such complicated compositions, without any mistakes or corrections? 'Intense, God-given talent that no one has today', say some people. He did indeed have terrific talent, but I'm sure he also had a tool that gave an optical base to his pictures.

If we look at this painting of Judith and Holofernes of 1598 we can begin to get an idea of how Caravaggio might have actually used his lens to create his carefully staged tableaux. On many of his canvases, this one included, there are a number of incised lines made with the wrong end of the brush in wet undercoat. These lines do not follow the forms precisely, and they do not show enough to be compositional drawings: only the key elements – the head, the arms – are marked. I believe that Caravaggio used this technique simply to record the position of his models so they could take a break. They could then resume their positions, and Caravaggio could project the image and adjust their pose until they fitted the incised lines.

He would not, of course, have needed all his models there at the same time. The complete tableau would need only to be set up once – to mark out the overall composition. After that, the models could come back one by one, as he worked on different figures. Caravaggio's models are not always looking where you would expect – but the intended object of their gaze would not have been there!

There is a parallel here with Andy Warhol's drawing of Cologne Cathedral (*left*), drawn by tracing the projection of a photograph (*above left*). His skill was to know which lines were the most important. The drawing would not have looked like this if he had stood in front of the cathedral and drawn it straight from life.

Looking at Caravaggio's *Calling of Saint Matthew* (1599–1602), I think of him as like a film director. Lighting, costumes, gestures – all would have been carefully staged. It is clear that the window on the back wall is not a source of light. It has been painted out, to avoid the problems of 'contre-jour' – against the day, or against the light – difficulties that are familiar to any modern cameraman. Instead, there is a single light source, very strong from the right. A tableau is set up with careful lighting – it would take some time to do.

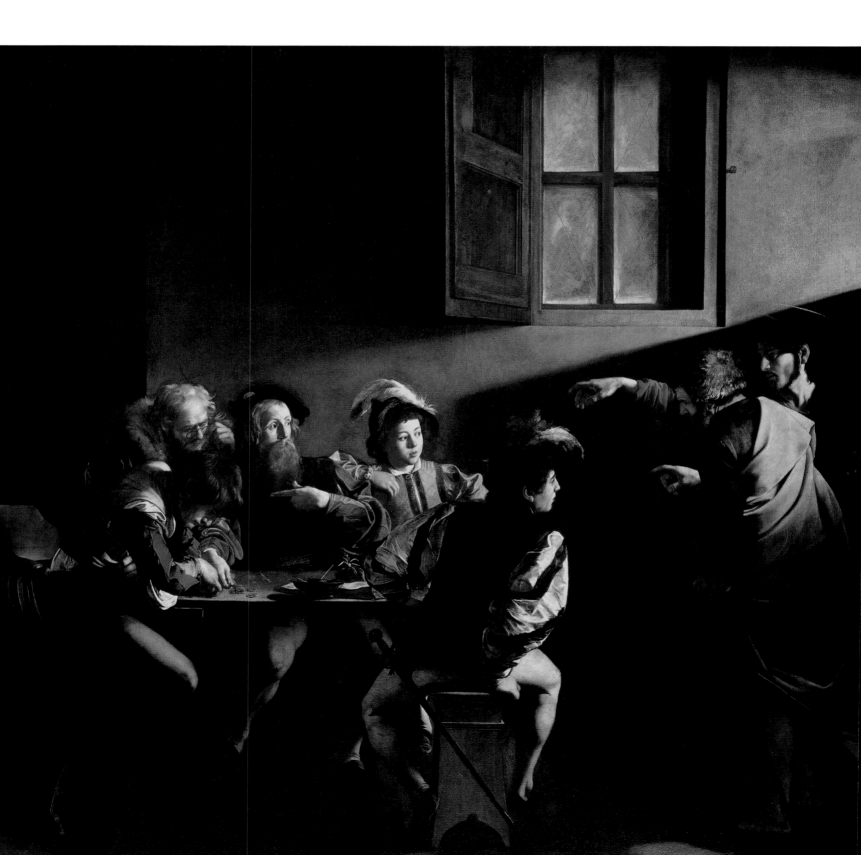

One can imagine him saying, 'Raise your hand so it catches the light, move your face a little more this way, let's change the colour of that cloak to a lighter hue, it will catch the light better and show off his shoulder. A white feather in his hat would stand out against the dark wall. Make sure the foreground figure has a white sleeve.'

Caravaggio is, indeed, a master at setting 'the scene', telling the story across the painting – not in too much depth. The eye goes back and forth over the surface of the picture, not into it. The wall sets up depth as fixed.

Compare this picture with Piero della Francesca's *Flagellation of Christ* (1450s). Piero is not a director with actors in front of him in the way that Caravaggio is. He moves arms and hands in accordance with his knowledge of the laws of geometry and perspective, the way he *knows* the figures to be, not the way he *sees* them.

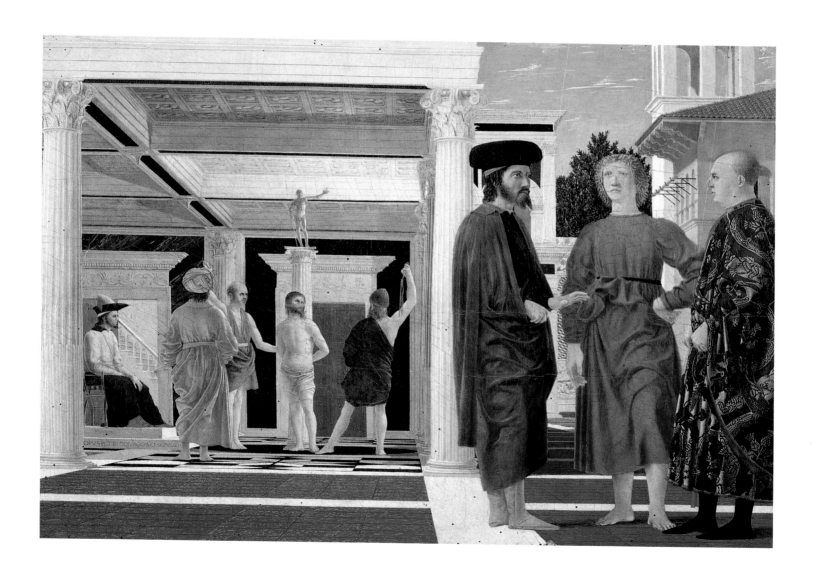

Caravaggio's heightened naturalism and use of strong lighting were enormously influential and soon spread to the rest of Europe, particularly to Spain and the Netherlands. One question we could ask is how come so many artists could do it so well and so quickly, without awkwardness? Here are four paintings done by Velázquez in a three-year period. You can see his very rapid development. The earliest two pictures (*above*) seem very posed, the first one even a little stiff. But the two later ones seem fresher, as if the artist had 'captured' a moment. Like Caravaggio, he used humble people as models (probably illiterate people as well, if the historian is looking for the written accounts of those working for him). Velázquez has also used a white tablecloth (*à la* Caravaggio), thus avoiding the Lotto pattern problem. All the paintings have very strong lighting. Notice the deep shadows from the objects on the table and from the knife resting on the white dish; also, the tilted copper pan with its accurate shine. Just try putting a few objects on a white tablecloth at home and see what kind of light is needed to make such dark shadows. The point is that it is an unnaturally strong light that has been used here, one whose source is outside the picture, like a theatrical spotlight. With the exception of direct sunlight, you don't get such a strong light naturally, certainly not in scenes that are inside apparently darkened rooms like these; but you need such strong light to use optics.

1617–18

1618

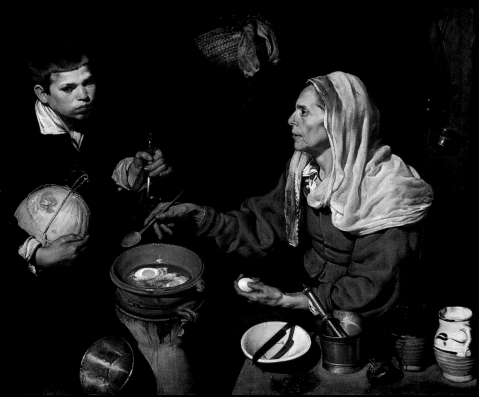

1618

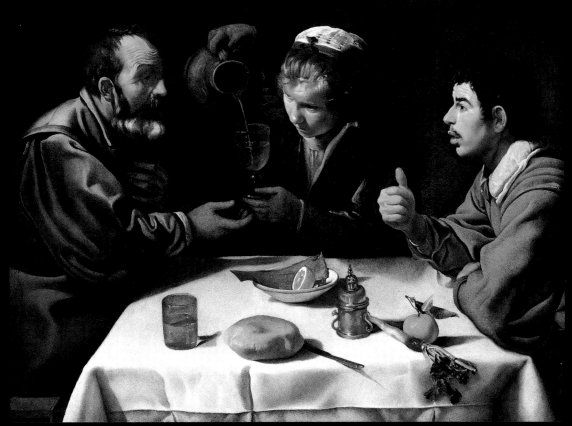

1618–19

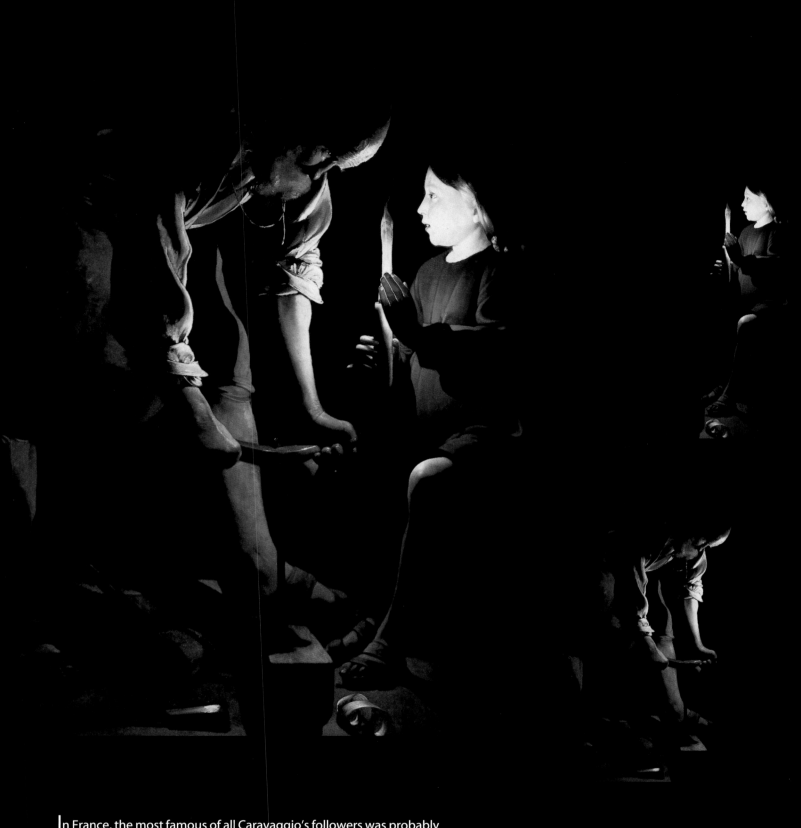

In France, the most famous of all Caravaggio's followers was probably
Georges de la Tour, who produced a number of stunning candlelight scenes.
Take this painting, *St Joseph the Carpenter* of 1645, for example. Could that
candle really produce all that light? Once again, the source of light seems to
be outside the picture, as it must be if you use optics – if the source of light were
in the setting, it would cause flare in the lens. Joseph and the girl were probably
painted separately, each lit by a shielded light source in place of the other figure.

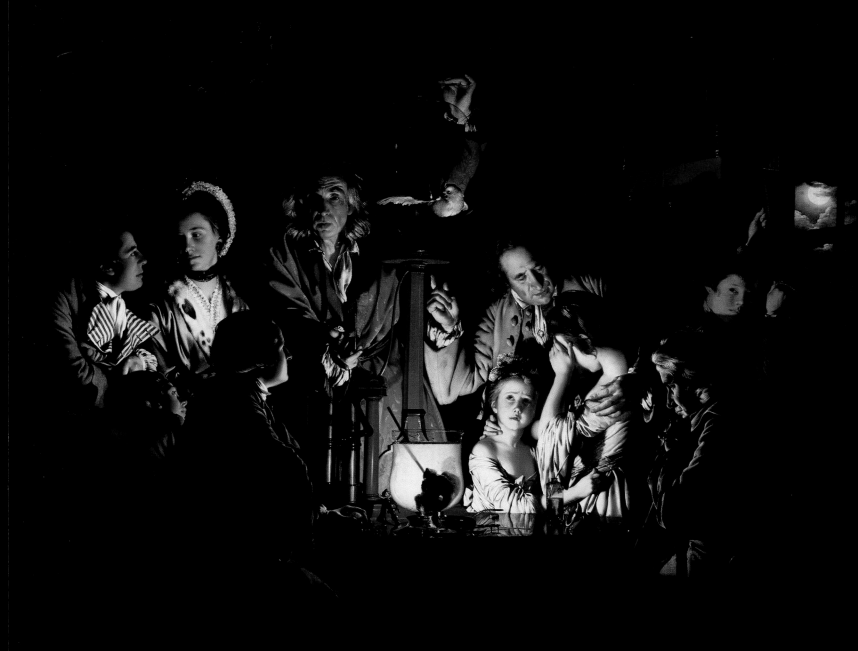

Joseph Wright of Derby's picture of a scientific experiment of 1767–8 is another example of a carefully staged tableau where the source of light is problematic – is it really that glass of sulphur? Wright was friendly with some of Britain's leading scientists and no doubt would have had access to some of the most sophisticated lenses of the day. In any case, by the eighteenth century lens technology had developed so much that camera obscuras could be bought in a shop, and they are known to have been used by artists, among them Canaletto and Reynolds. Once again, I am not suggesting that all artists used optics, only that the lens had become so dominant that its image was now the model for all painting. Until at least the invention of photography, its naturalistic look would be the goal of art, and the principal criterion by which pictures were to be judged.

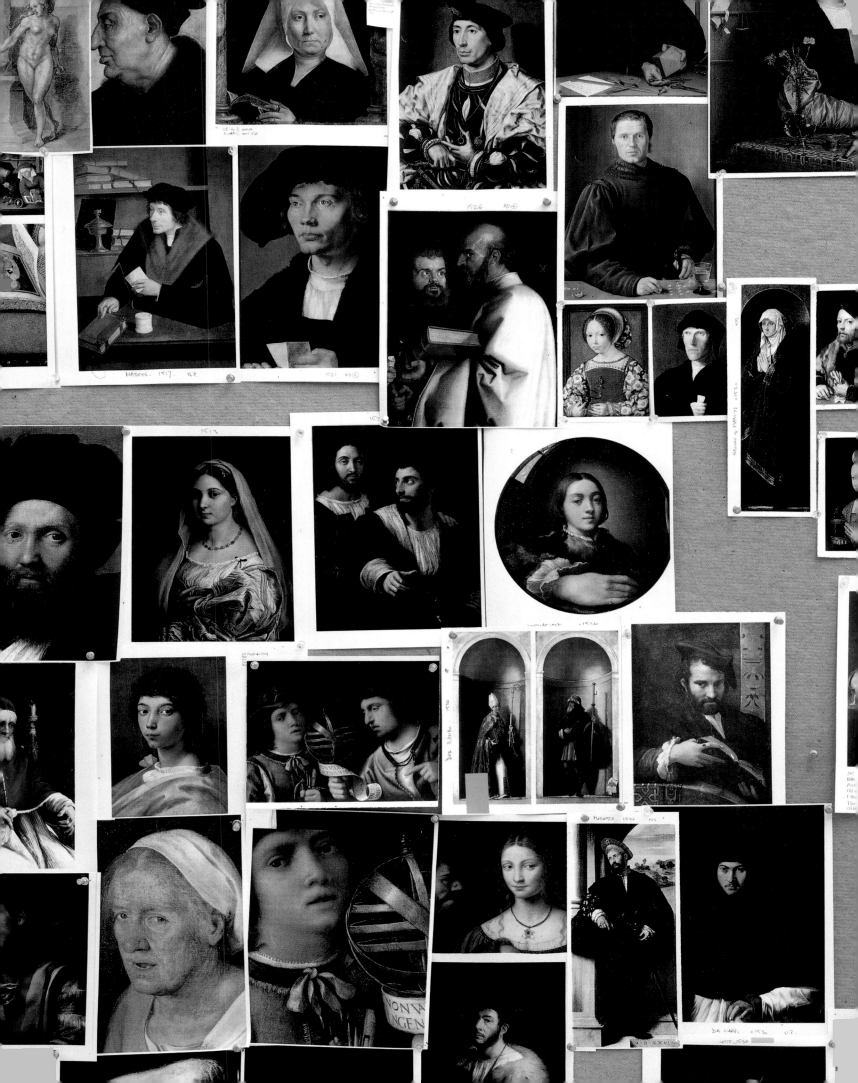

It is worth repeating here, I think, that optics don't make marks – they only produce an image, a look, a means of measurement. The artist is still responsible for the conception, and it requires great skill to overcome the technical problems and to be able to render that image in paint. However, the moment you realize that optics had a deep influence on painting, and *were* used by artists, you begin to look at paintings in a new way. You see striking similarities between artists you wouldn't normally associate; you notice big differences between painters who are traditionally grouped together; and you see distortions and discontinuities in pictures that are difficult to explain unless optics had been used in some way.

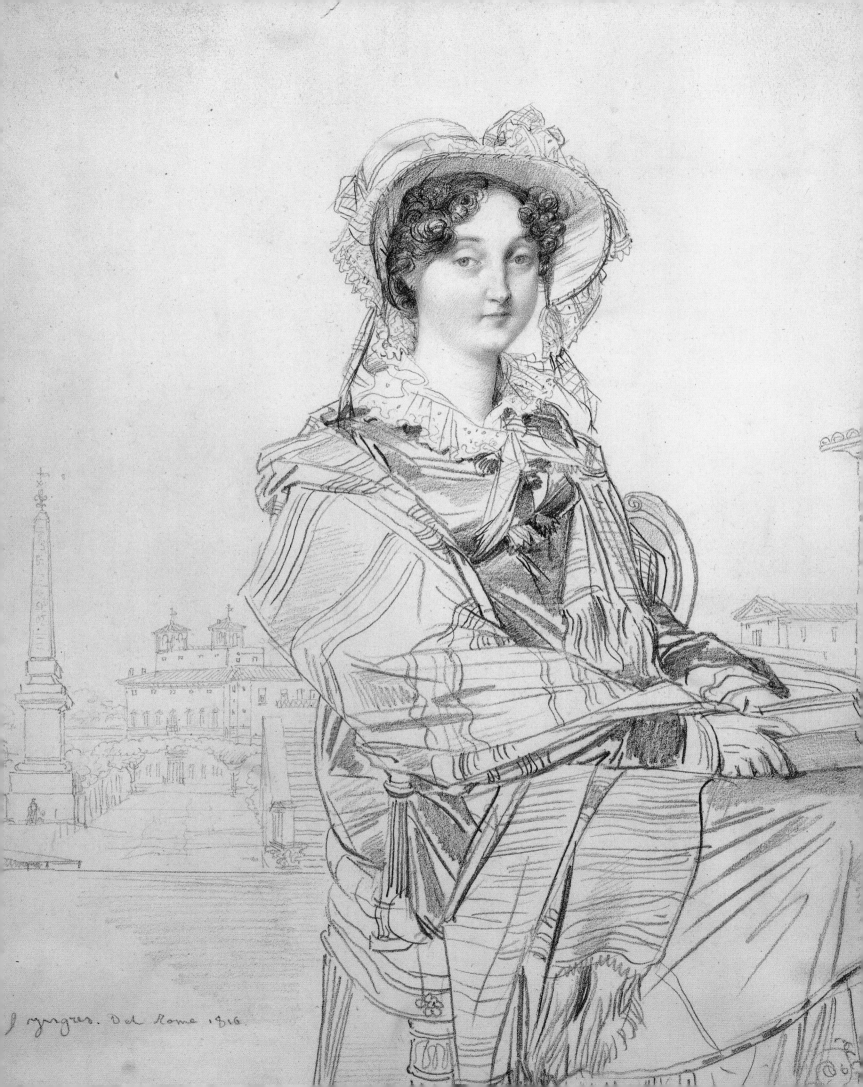

Iohn More Sr Thomas Mores Son.

Ingres opposite. Holbein on the left. Warhol below. Compare the lines of the clothes on Ingres and Holbein. They are made quickly without hesitation and seem different in style from the faces. The drawings are confident and 'accurate'. Follow the lines on Holbein's sleeves. They are made quickly in one go, like tracing, following the folds and giving volume. The lines in Andy Warhol's wad of money are similar, no alterations, every one in a place that seems just right. Each artist, of course, had a different 'touch'. Ingres, a master of the pencil, shows the most subtle variations; Warhol, hardly any. Nevertheless, a similarity can be seen in all three drawings I think.

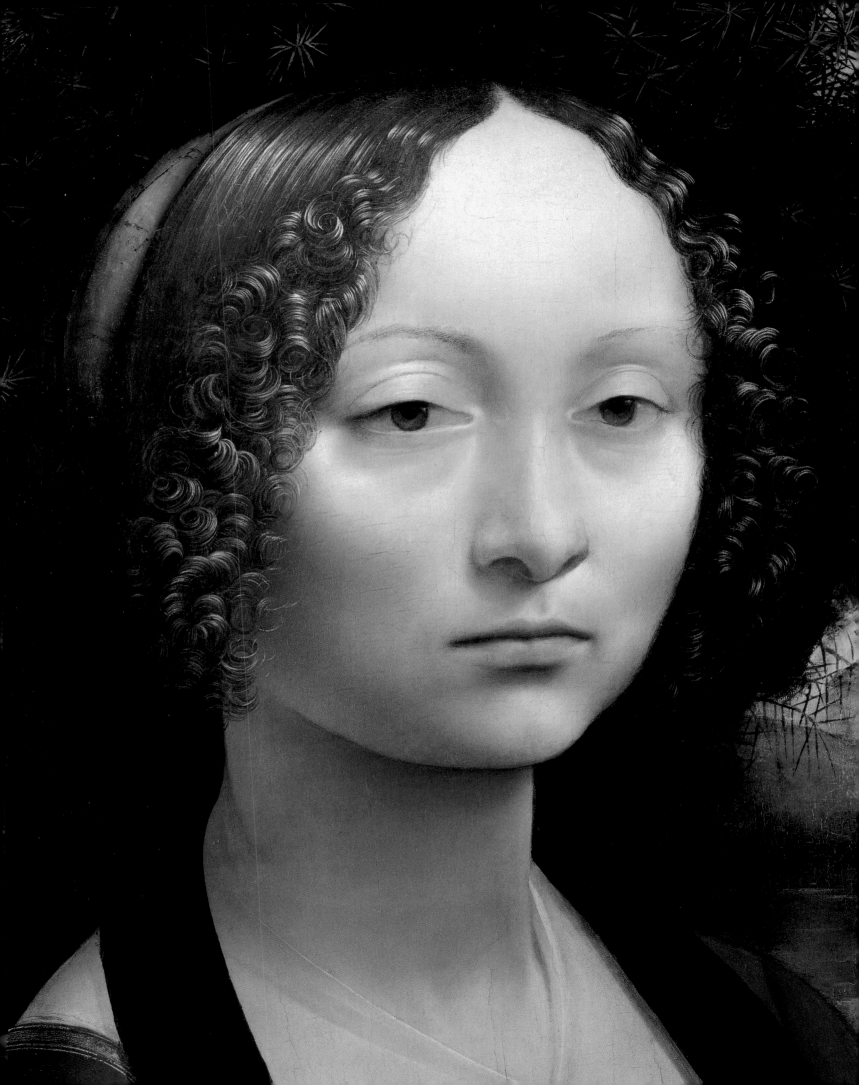

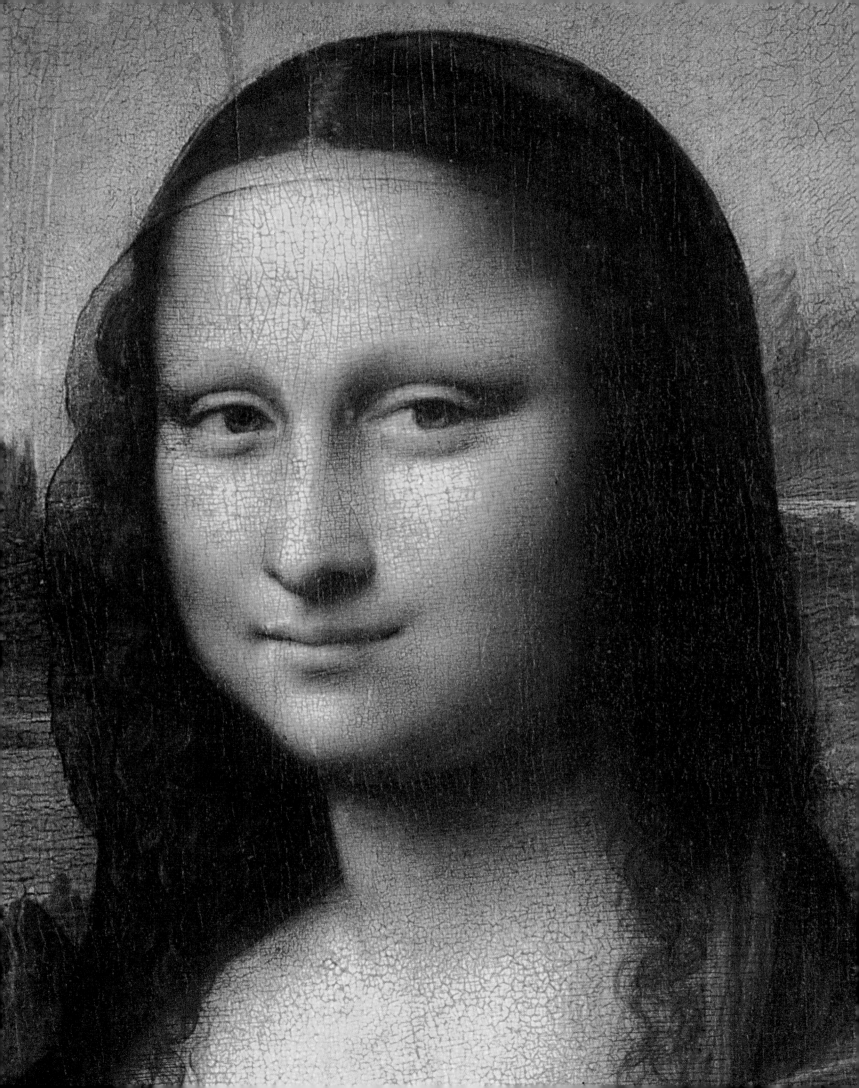

c.1427–8 Masaccio

1450 Andrea del Castagno

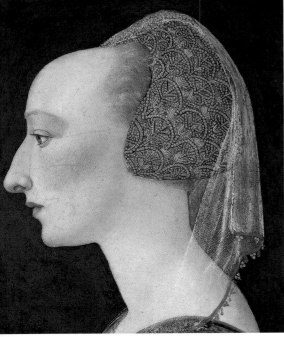

1460–70 Unknown Florentine artist

On my wall, our old friend the *Mona Lisa* (1503) stood out. Hers was the earliest portrait to have such very soft features. The subtle shading around the eyes and mouth are completely different from anything that had appeared before, including Leonardo's own portrait of Ginevra de' Benci painted almost thirty years earlier. Turn back and have another look at them together. The lighting on the *Mona Lisa* is certainly different from the 1474–6 portrait: it is strong from above, causing the shadows under the nose and chin.

Did Leonardo use optics for the *Mona Lisa*? I don't know, but what is certain is that he had seen clear images of the three-dimensional world on a flat surface and in living colour. He certainly knew about lenses (what didn't he know?). In his notebooks, he describes the camera obscura and images produced by it, and provides drawings of mirror-grinding equipment. Is it too far-fetched to imagine that he had seen how beautiful the projected image was and wanted to re-create the look himself? Perhaps that was enough for him, and his drawing skills did the rest. His phenomenal abilities as a draughtsman are well known, and he would have needed only to see the projected image to re-create its look.

On this page we have three portraits from the fifteenth century, and opposite we have portraits by Giorgione and his followers which were painted in the sixteenth. Masaccio is an interesting case, on which I will expand later, but what I want to show you here is the very different look of Giorgione's heads – the softness in the modelling, what a photographer might call 'soft focus'. The innovator, a few years before, was Leonardo.

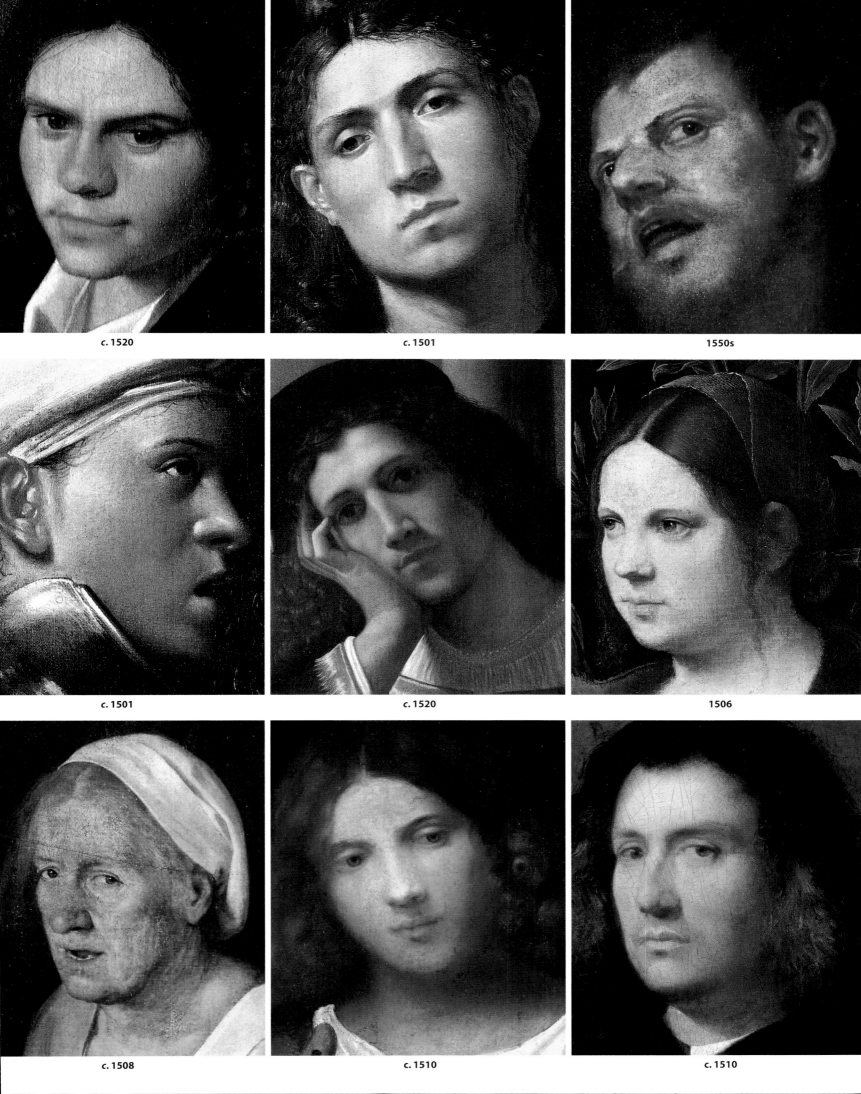

c. 1520

c. 1501

1550s

c. 1501

c. 1520

1506

c. 1508

c. 1510

c. 1510

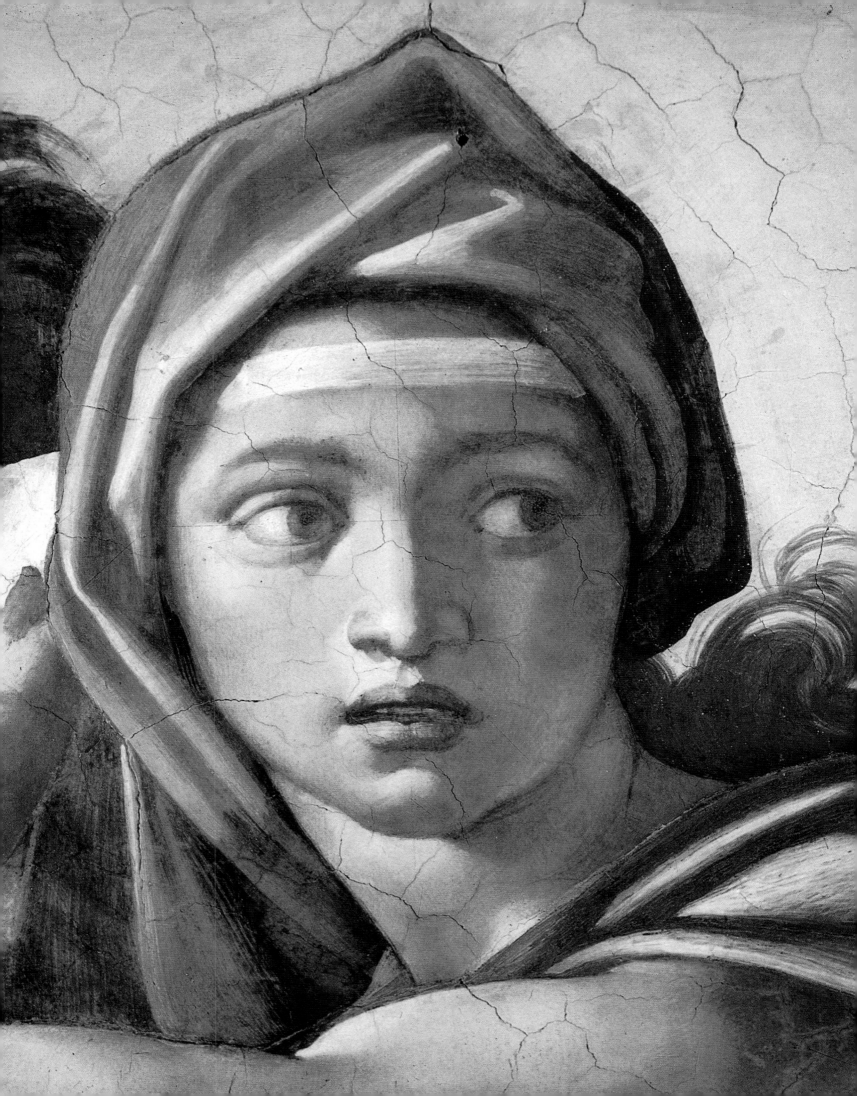

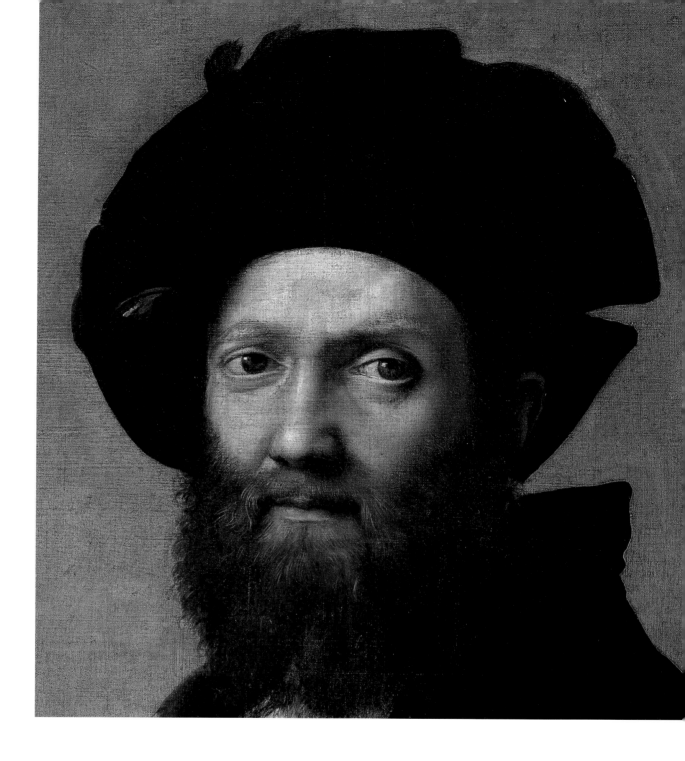

How does Michelangelo fit in? He certainly knew about tracing, an essential part of fresco-painting; and he had also seen Netherlandish art, which he dismissed as being too much about the real world. He also felt that oil painting was for amateurs; you can 'correct' things with oil, unlike with fresco. Comparing these two portraits – a detail from Michelangelo's ceiling for the Sistine Chapel of 1509–12 (*opposite*) and Raphael's portrait of Baldassare Castiglione from 1514–16 (*above*) – they do seem very different in style and conception. Raphael's face looks much more modern. Can this difference be explained merely by the different mediums being used, fresco against oil?

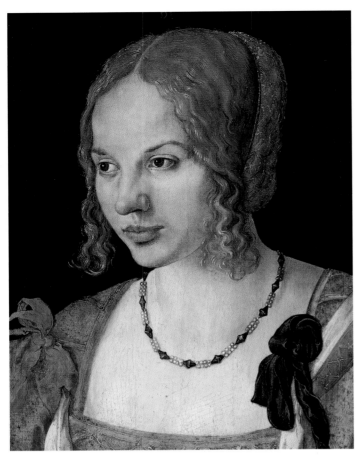

1505

1506–7

Above are two pictures by Dürer that have been together on a page for fifty years in Erwin Panofsky's life of the artist. Though painted just a year or so apart, they look very different. The hard linear style of the 1505 portrait of a Milanese girl, similar to that seen in the 1499 portrait of Oswolt Krel opposite, has become softened in the 1506–7 portrait of a young woman, which is dominated by chiaroscuro effects of light and shade. Compared with the two earlier pictures, this young woman looks 'photographic'. Something has caused the change. Dürer was very interested in technology, especially that of making pictures, as his woodcut of a drawing machine on page 54 demonstrates. I suspect that he came across optics some time between the summer of 1505 and early 1507, when he was in Venice. He may have been shown the method by Giovanni Bellini, who, according to a contemporary account, disguised himself as a nobleman to sit for Antonello da Messina and thereby learn his secrets, and who sponsored Dürer when he was in Venice (Antonello, as we have seen, introduced Netherlandish techniques to Italy). Dürer wrote to his friend Pirkheimer that he was going to Bologna 'to learn the secrets of perspective'. Some historians believe that he went to visit Luca Pacioli, who had been Leonardo's close companion. Dürer didn't write down what these secrets were – perhaps he was sworn to secrecy.

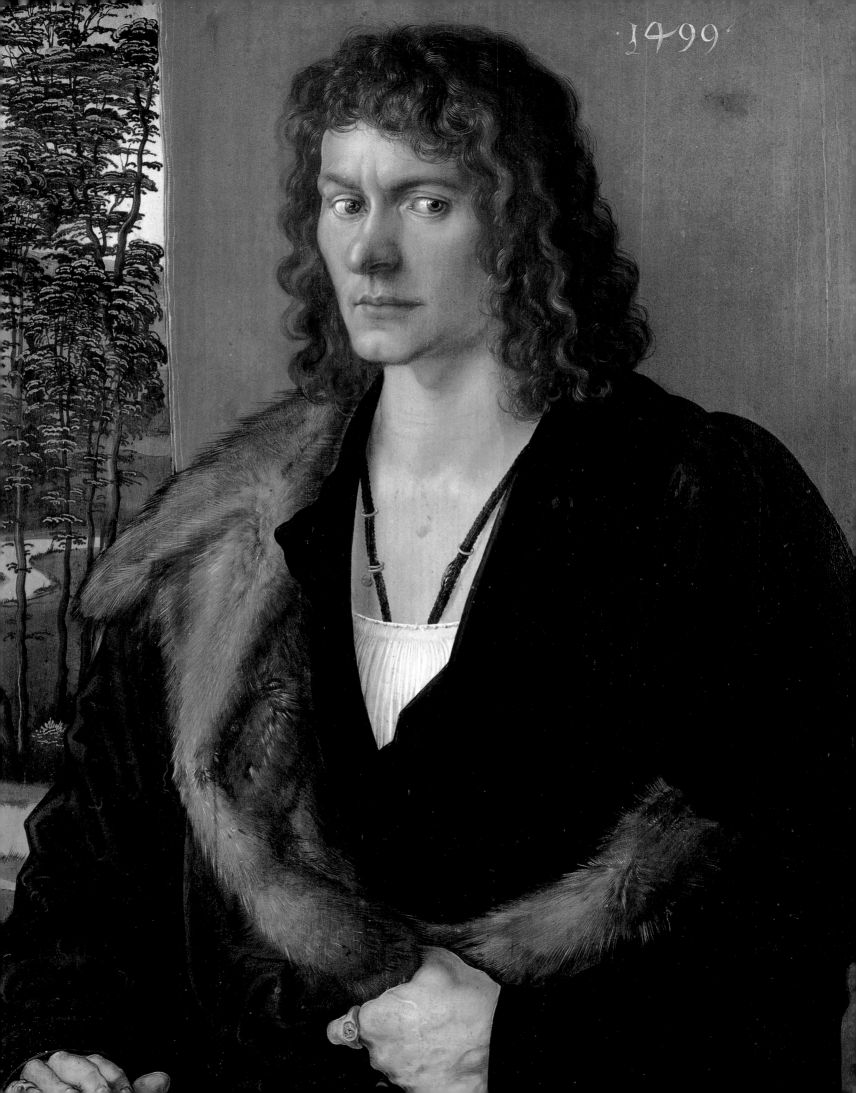

·1499·

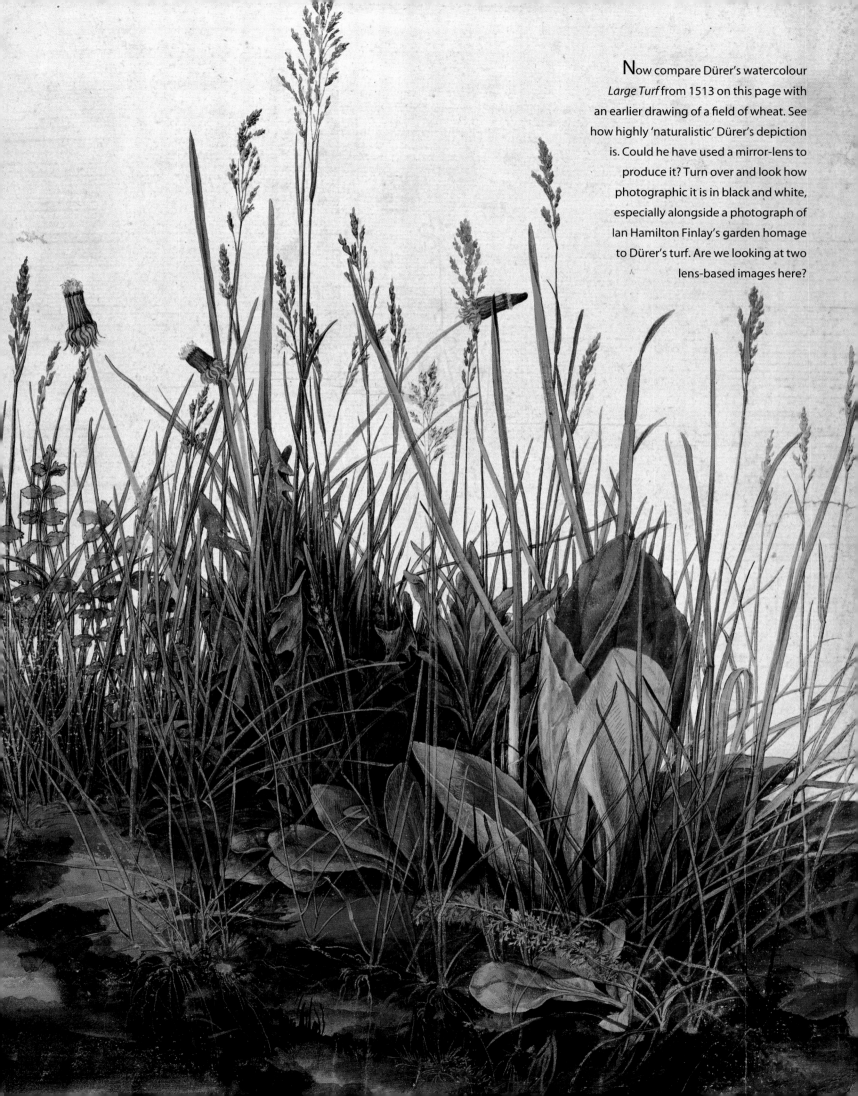

Now compare Dürer's watercolour *Large Turf* from 1513 on this page with an earlier drawing of a field of wheat. See how highly 'naturalistic' Dürer's depiction is. Could he have used a mirror-lens to produce it? Turn over and look how photographic it is in black and white, especially alongside a photograph of Ian Hamilton Finlay's garden homage to Dürer's turf. Are we looking at two lens-based images here?

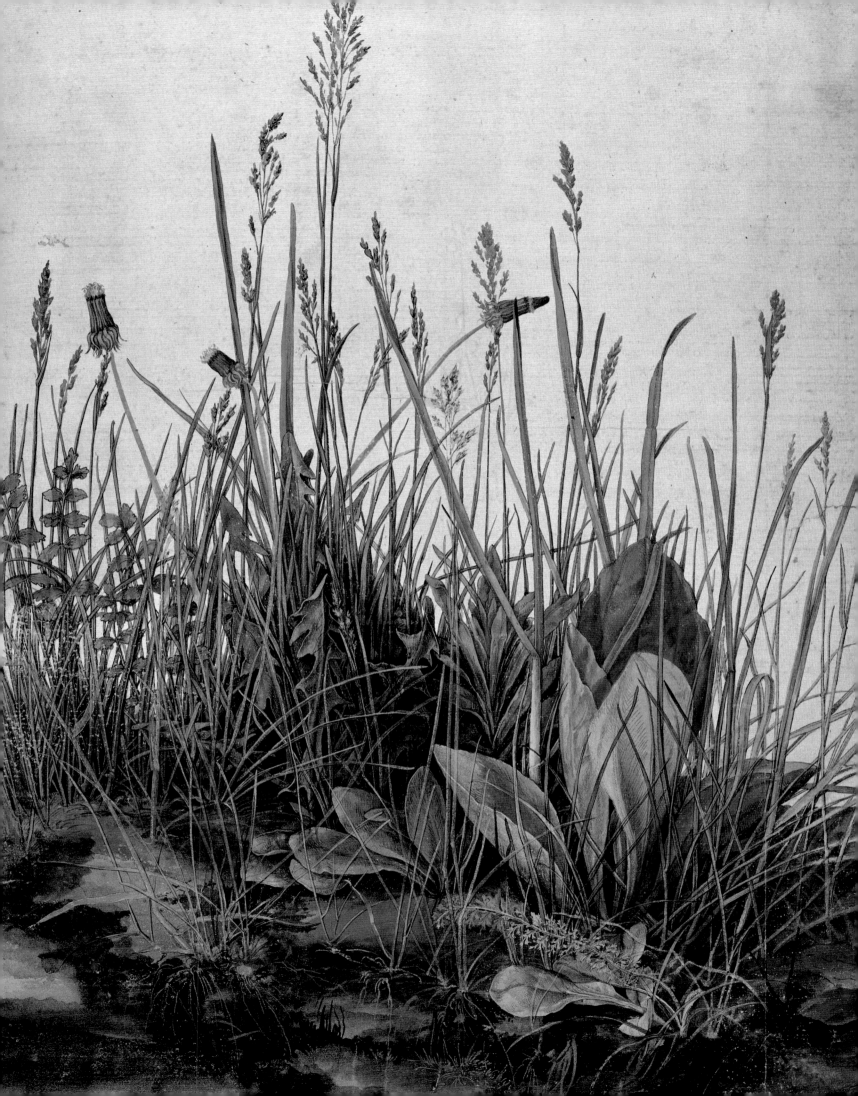

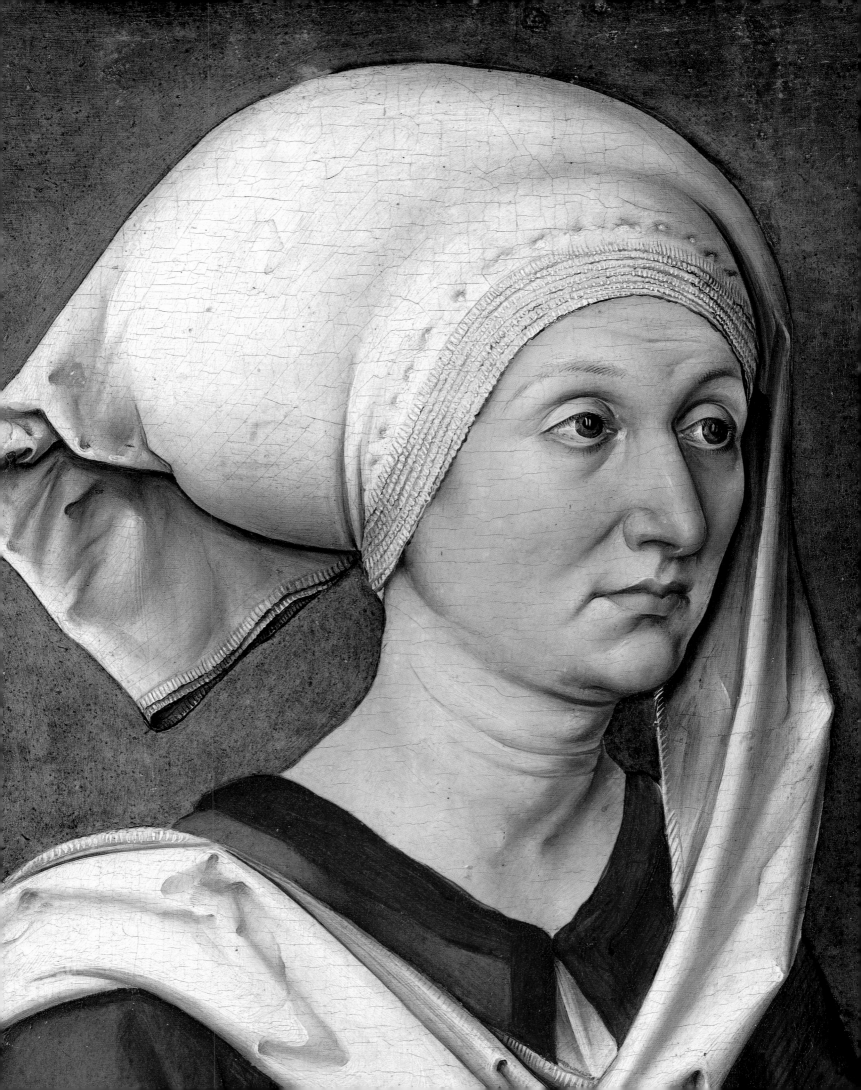

1633 Frans Hals

Dürer opposite and Hals above. Two great portraits, but I would like to discuss the differences. Dürer's portrait (painted before his 1505 visit to Venice) is linear and awkward, the lighting seems even, there are no really harsh shadows. We know Dürer was a great draughtsman and left thousands of drawings. Frans Hals, by contrast, left not a single one. His woman seems uncannily 'real'. There is a very strong light source causing the deep shadows round the nose and the back of the collar. The details on the hat follow the form perfectly. Any painter will know how difficult the ellipse of that collar would be to paint; but there are no charcoal marks on the canvas, no corrections. His brushwork is often loose, but it is precisely placed – optics don't make the marks. Contrast his portrait with the one by Rubens, where the collar has a much looser feel. It could easily have been eyeballed.

< **1490** Albrecht Dürer

1623–5 Peter Paul Rubens

Rubens's sketch for his large altarpiece *Virgin and Child enthroned with Saints* shows the eyeballing tradition perfectly. Rubens, of course, was a master draughtsman and left many superb drawings. He could render forms and volumes convincingly with just a few strokes of the brush. Look at the architectural details here: the lines are freely drawn and approximate – they do not follow the curves precisely. A marvellous lively picture, with a wonderful sense of space, but no optics.

Above is Poussin's *The Birth of Venus* of 1638–40; opposite is *The Death of Cleopatra* by Guido Cagnacci from 1658. The comparison I'm making here is that the Poussin is much more linear. You can see how the picture was drawn and composed carefully on the canvas – it doesn't look like a 'real' scene. Notice the stylization in the folded draperies. The Cagnacci, on the other hand, has an optical look. Notice the immaculate foreshortening of the arms of the chair, and the precise highlights in the embossed gold. Also, look at the strong shadows and single direction of light, again seen against a black background. Optics create contrasts of light and

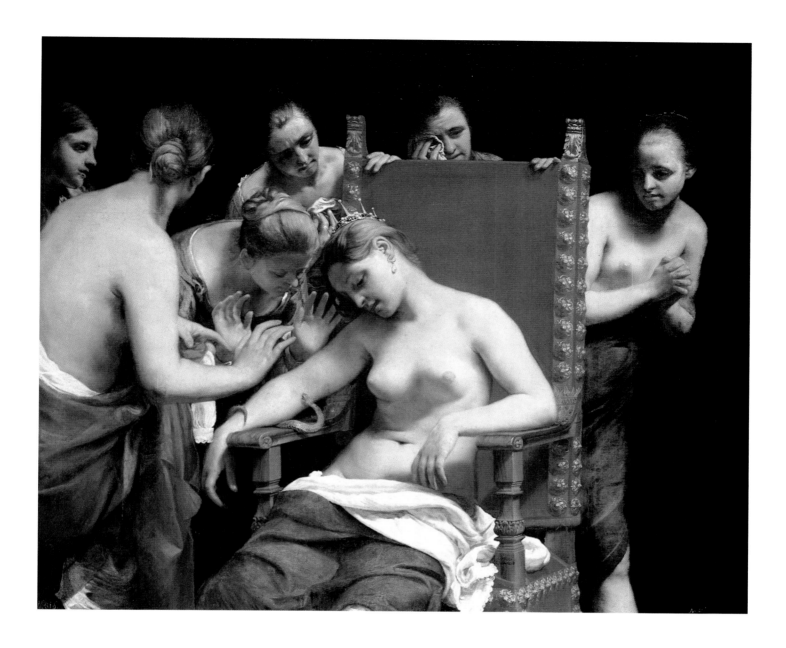

shade like this – a deep chiaroscuro – illuminating the figures. The composition of the Cagnacci is very similar to those of other optical works, with the figures virtually on the same plane – there is very little recession in space. Once again, this could be related to the lens' depth of field. Cagnacci seems to have used the same model for each girl, moving her round the chair to assume the different poses – the artist as director again perhaps? Print the picture in black and white and it has an extremely 'photographic' look.

For me there is a strange similarity between these two pictures painted a hundred years apart. Above is *The Haarlem Patrician Pieter Jan Foppeszoon with his Family* (*c.* 1530) by Marten van Heemskerck, and on the right, a double portrait of a boy and a girl by Judith Leyster from 1635. The earlier picture is contemporary with Holbein's *The Ambassadors*. Once again, it is a group seated round a table up close to the picture plane, like in Caravaggio or early Velázquez. Though the figures are depicted with great realism, they are sharply and unnaturalistically silhouetted against the background. The sky looks as if it has been added later. It makes me think of Caravaggio's *Basket of Fruit* (*pages 110–11*), Raphael's *Portrait of Baldassare*

Castiglione (*page 139*) and Velázquez's *Bacchus* (*page 161*). Was the sky originally a dark background? Where is the light coming from? Look at the objects on the table all separated from one another (is this a normal arrangement?). This painting has all the hallmarks of the mirror-lens/collage technique. The various elements of the composition are painted separately and combined in an uneasy space right up to the surface of the picture. Perhaps each head was drawn separately, too, though the children could have been done together. How long do you think they would have stayed in that position?

It is said that Leyster was Hals's assistant. Look at her children's poses: again, they are fleeting – how long could they have been held? Would the boy have held the cat or the eel in his right hand? There would be a good reason for either, but the eel would be harder to hold; and there is an uneasiness in the pose not unlike that of the left-handed drinkers on pages 118–19. To me, the painting looks like a late Victorian 'snapshot'. It is part of the burst of great naturalism that swept through Europe after Caravaggio. The Utrecht School, Hals, Velázquez, Cotán – all are from this period. How did it happen? Where did the skills come from? It seems to have appeared with little draughtsmanship (Leyster, like Hals, is not known to have made any drawings).

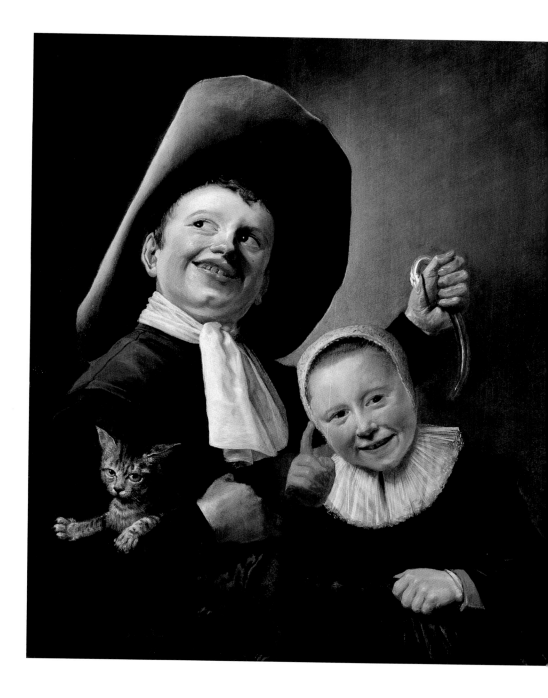

Again Frans Hals, this time from 1626–8. The foreshortened hand alone is amazing. How could it be painted with such confident dash and yet be so 'right', so utterly 'believable'? And, once more, how long could it be held in that position? The skull, too, is a masterpiece of economy. Compare it with van Gogh's more laboured skull from 1885, groping for the form until it is felt as solid. This doesn't have the vivid freshness and careful illumination of the Hals, where the teeth catch the light so convincingly. Could Hals really have eyeballed this? There seems to be a solid structure beneath his fluid brushmarks. I must remind you that there is no charcoal underdrawing here – nothing but painted marks. A beautiful painting, with an optical base.

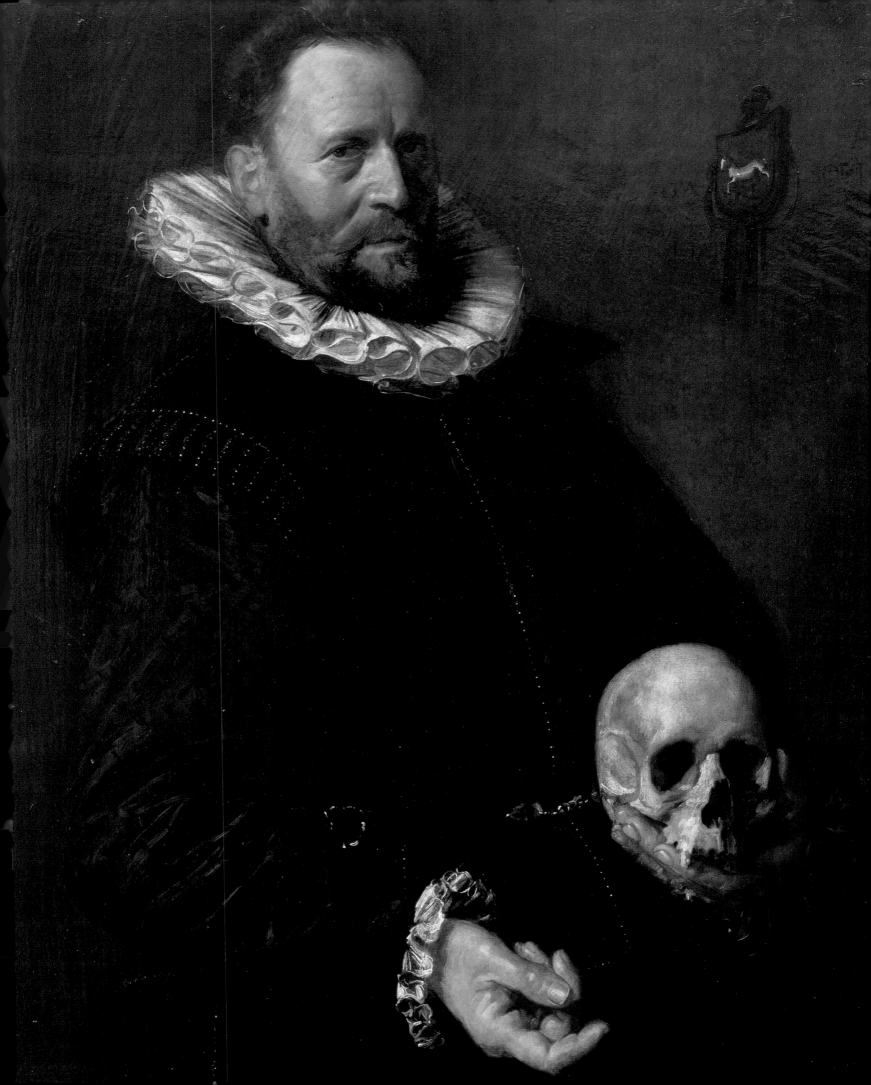

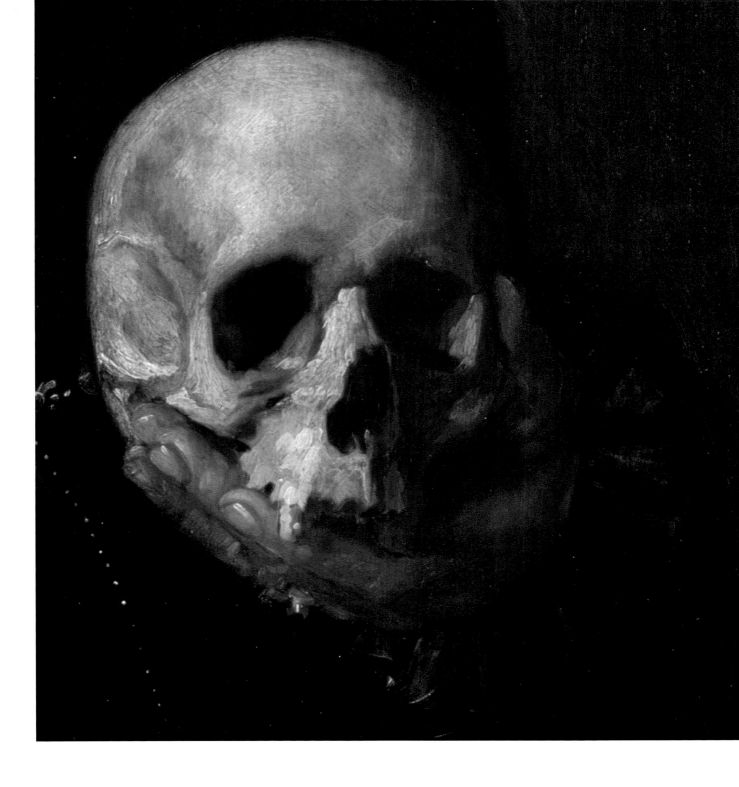

This 1611 portrait is an earlier painting by Frans Hals, with less brushwork than he was to develop later. Let's look at the detail of the skull and the hand holding it. What we can see clearly is that a black line goes round the skull *and* the hand, defining an area of lighter tone, not the forms within it. The line does not seem groped for, but appears to have been done in one go, rather like the 'traced' lines in Ingres's or Warhol's drawings. I think Hals had a remarkable talent, perhaps like a very good caricaturist who has an eye for the essentials. Yet he painted with an uncanny precision.

1631

1645

c. 1640

1654

That Rembrandt would have known about optics seems clear to me – his students certainly did. But the point I'm making here is simple: Rembrandt transcended the 'naturalistic' look with his emotional power. No artist before or since has put as much into faces as he did.

We can see in the X-ray of the old man on the right how Rembrandt began his portraits with a rapid notation of strong contrasts, an intense light causing the deep shadows. The underpainting is miraculous in its economy, yet the finished head is deeply moving, simple and unfussy, with a subtle treatment of expression around the eyes and mouth that suggests warm and lengthy scrutiny of a fellow human being.

1654

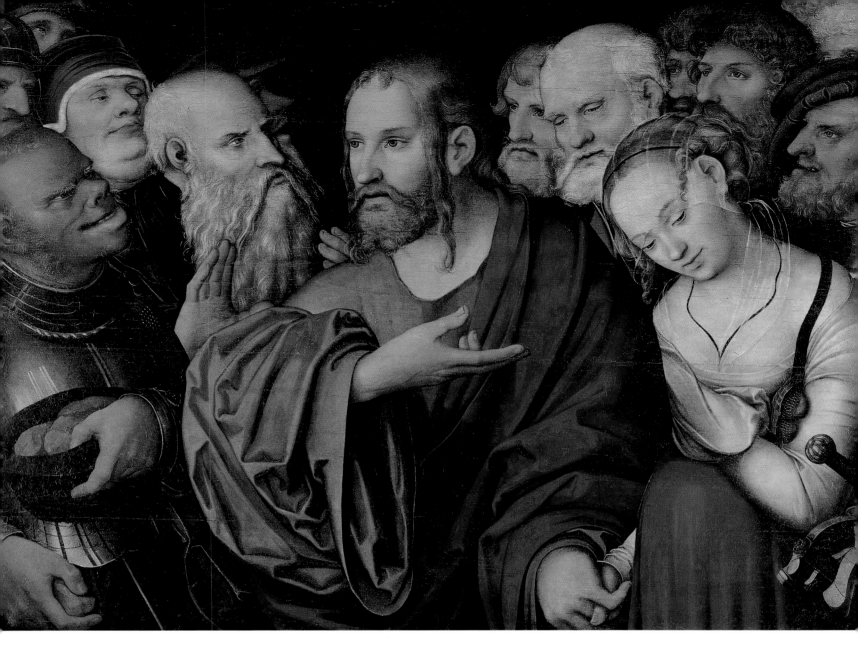

Cranach the Younger on the left; Velázquez on the right. Painted about a
hundred years apart, the expressions are very different. Compared with Cranach's,
Velázquez's faces seem 'modern', real – they all have fleeting expressions. The
face in the middle is smiling, not only with his mouth but with his eyes, and the
lines of the face have an uncanny accuracy. Would they have been this accurate
if Velázquez had eyeballed them or painted them from memory? Again, the scene
is filled with very careful lighting, one that does not relate to the background, as
though the figures were in a studio and the setting were added afterwards.

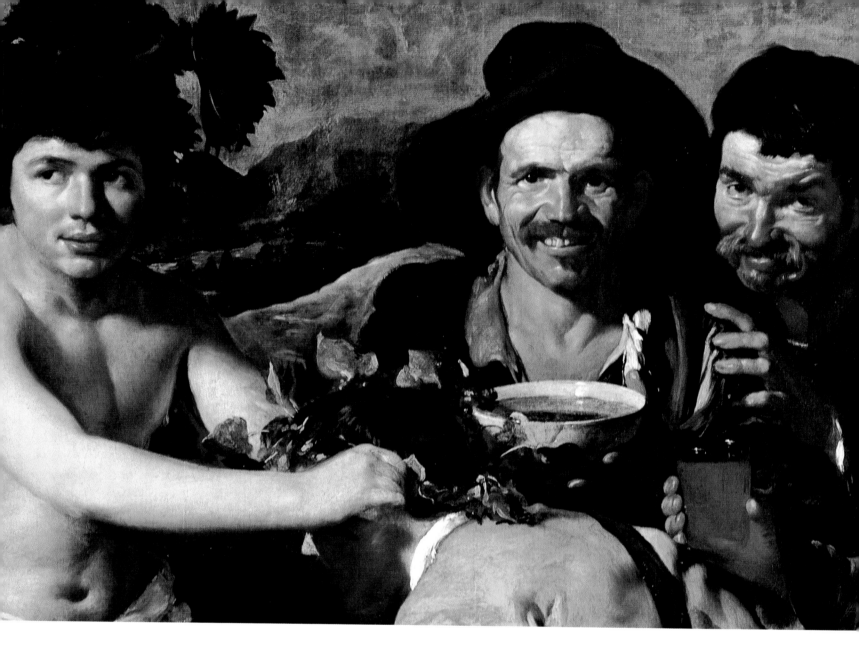

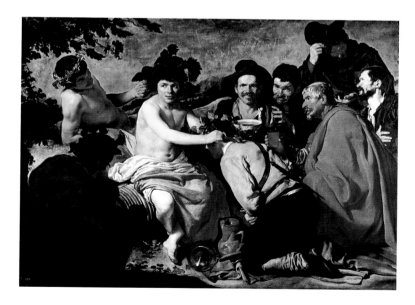

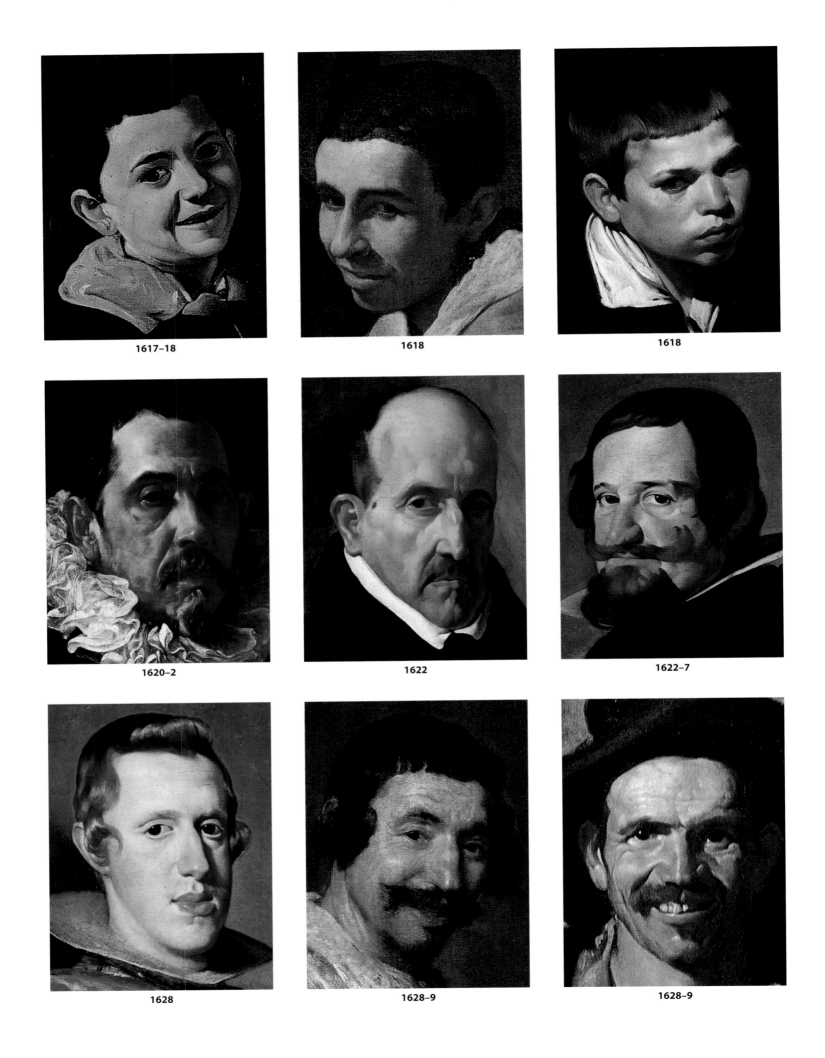

1617–18

1618

1618

1620–2

1622

1622–7

1628

1628–9

1628–9

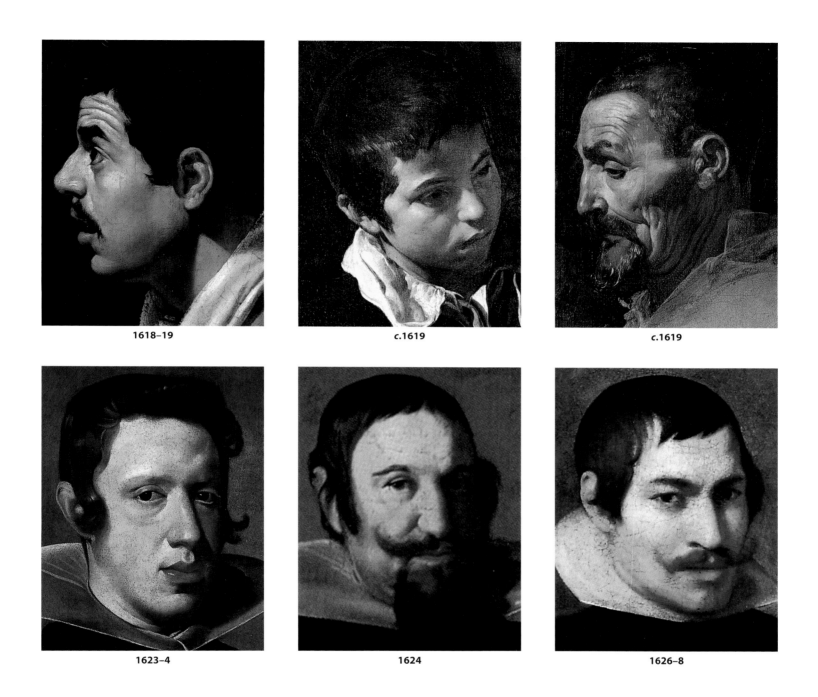

1618–19 c.1619 c.1619

1623–4 1624 1626–8

Look at the same face from *Bacchus* taking its place at the end of a sequence of portraits painted by Velázquez over a ten-year period. It is clear how quickly he developed in the first few years, and was soon able to catch even the most fleeting of expressions. The final face has a lively smile, with an open mouth that is perfectly related to the other features. Likenesses are achieved by placing the eyes, the nose and the mouth correctly – everything else then just falls into place. Mouths are especially difficult to do. As John Singer Sargent said, 'A portrait is a painting with something wrong with the mouth.'

Spanish and Dutch: Velázquez below and Gerrit van Honthorst opposite. Both works were painted in the 1620s, and both show fleeting expressions and gestures. Velázquez has a marvellous eye and brush – he is bolder, less fussy, less literal than van Honthorst. But both have an accuracy that to me suggests some use of optics. The globe in the Velázquez is as perfect as Holbein's one hundred years earlier. Eyeballed? Just compare it with Rubens's architecture several pages back. Velázquez was so skilful that he needed only a few strokes – minimum use of optics can still produce maximum effects.

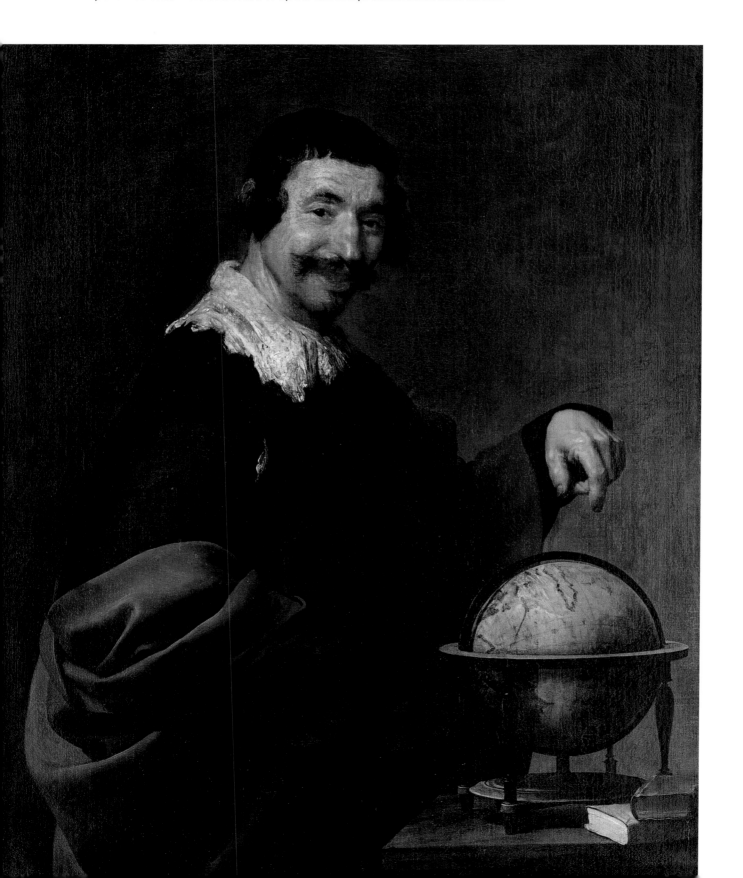

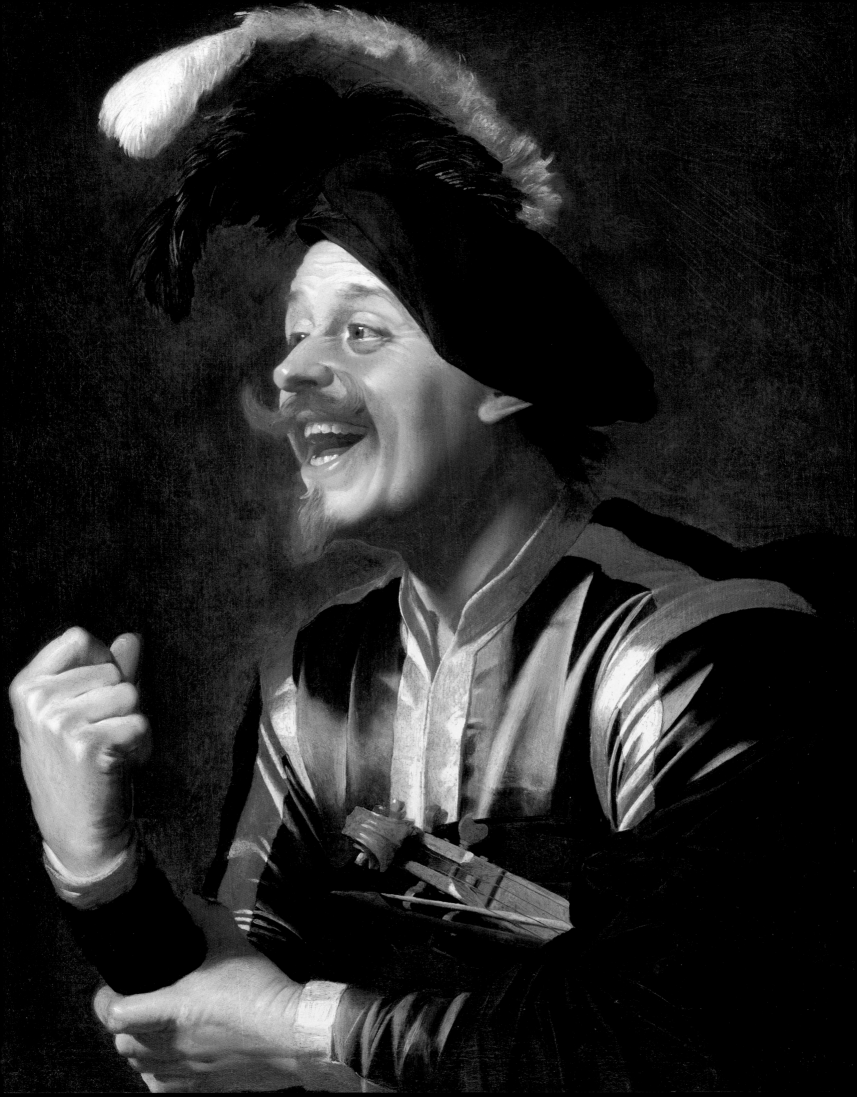

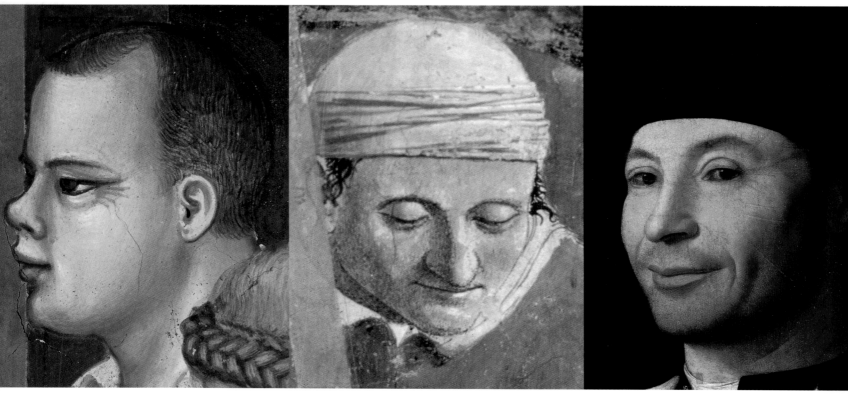

1303–6 1452 1470

Smiles, smiles, smiles. We recognize photographs of smiling faces as being
only fractions of a second. Smiles do not last, so you don't have long to
scrutinize them. Artists who 'eyeball', and need more time to fix the essential
features, tend to record more static expressions. Even with the help of optics,
the artist must be very quick, making just a few key marks, to record a fleeting
moment. Only those with a high level of skill and experience, and perhaps
professional 'actor-models' (who could strike a pose and hold it that little bit
longer), could hope to capture a smile.

The earliest smile here is by Giotto and dates from 1305. It is just a hint of
a smile. Piero's man of 1452 has a warm expression on his face, only barely

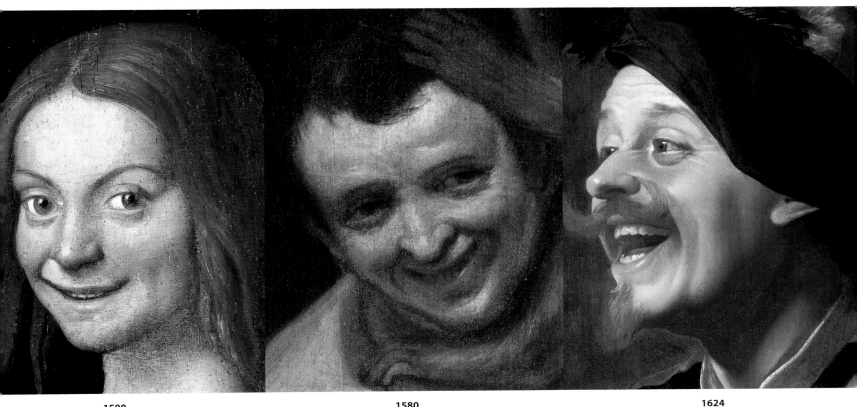

1500 **1580** **1624**

a smile. In 1470, Antonello depicts a man with a rather sinister smirk, and in 1500 Caroto paints a cheeky grin. These are all expressions that can be held for a short while without changing, and can be repeated ('Say "cheese"' is the photographer's way of getting a smile). Carracci's 1580 portrait has a more fleeting quality, and its tonalities do have something of the photograph, while van Honthorst's laughing man is a convincingly fleeting moment. When I first saw this picture in black and white, I recognized its snapshot quality at once. The eyes relate to the open mouth perfectly. They must have been seen simultaneously, and a skilful artist with a projection could have made enough quick notations to plot the relationship between them in just a few seconds.

1636–40 Peter Paul Rubens

To see the clear difference between eyeballed and lens-based images, compare these faces. Rubens, we know, was a great and prolific draughtsman, while van Honthorst and Velázquez left very few drawings. The lighting in their paintings seems different, much brighter, much stronger, more like the way a photographer would light his subjects today. Rubens could have painted his picture from memory, or eyeballed it, whereas the other two faces have a precision, an immediacy, a 'look' that suggests they were done in a completely different way.

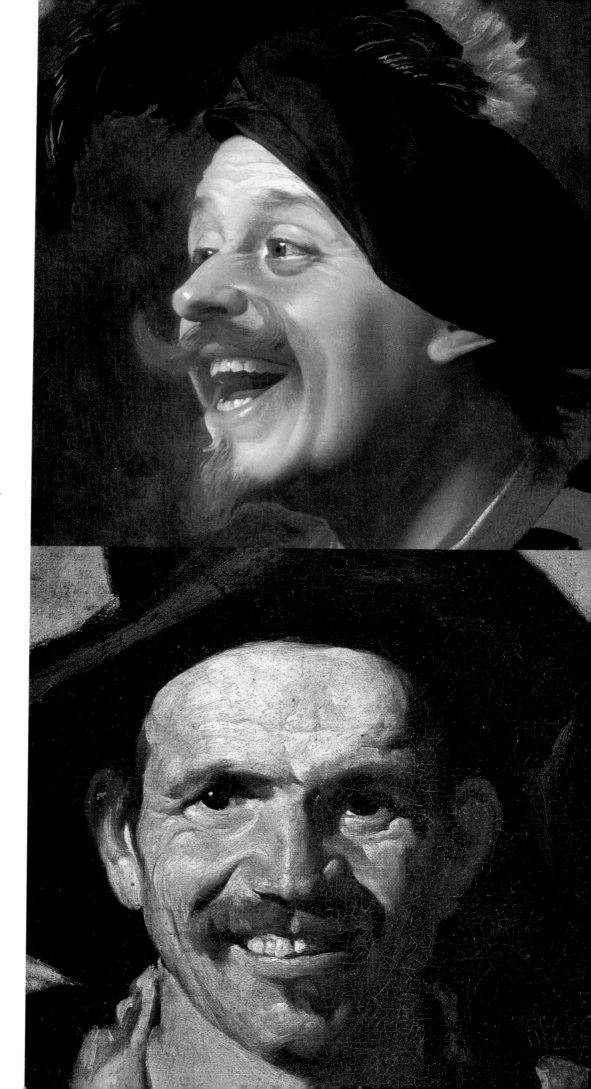

1624 Gerrit van Honthorst >

1628–9 Diego Velázquez >

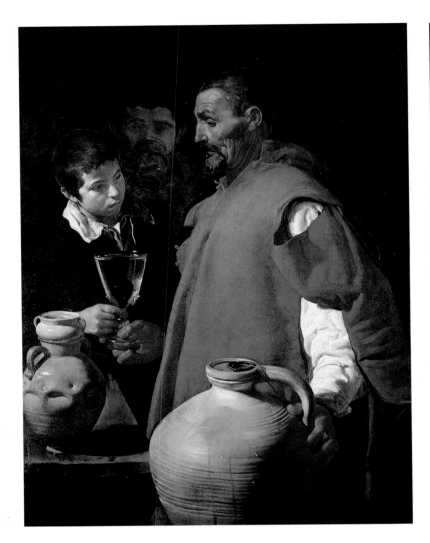 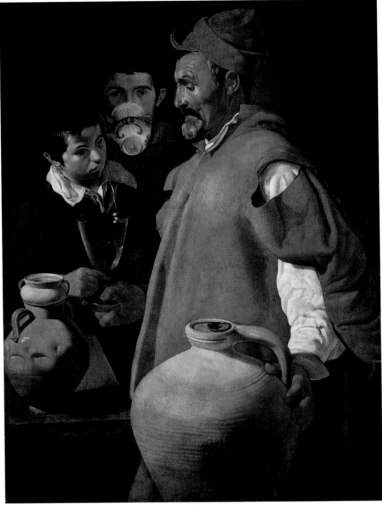

The training of young artists in the seventeenth century (and before) involved copying pictures. To copy a picture is to study it. Painting techniques would be developed quickly from copying the master. But how were the copies done? On this page we have two versions of Velázquez's *Waterseller*. Other than the addition of a hat on the waterseller, the second painting is a very, very precise copy of the first, which dates from some time around 1619. All the small lines on the odd and imperfectly shaped water pot are identical (we checked this by putting a transparency of the copy over the original). This would have been impossible if it had been copied by eyeballing. It could have been traced, but as far as I know there exist no tracing drawings. Could optics have been used, rather like I think van Eyck used a mirror-lens to transfer his drawing of Cardinal Albergati?

The images on this page may give us a clue. The X-ray of Velázquez's portrait of a young man from 1618–19, shown on the left, reveals that the picture's underpainting contains the portrait of another man (*bottom left*). What is interesting is that this head is the exact mirror image of a portrait in another of Velázquez's paintings, *Musical Trio* of 1617–18 (*bottom right; see also page 126*).

Now distortions. The huge difference between the sizes of the shoulders of the man above (workshop of Rogier van der Weyden, *c.* 1440) and those belonging to the lady on the right (Parmigianino, 1524–7) is amusing, but not immediately obvious. The Parmigianino appears very 'natural', with strong side lighting, and each part looks 'realistic'. The lady's left arm seen on its own has the correct proportions; her right arm seen on its own has the correct proportions; her head and neck seen on their own have the correct proportions – but when put together, the shoulders become massive, as large in relation to the head as van der Weyden's shoulders are small.

Chardin's famous *Return from the Market* has been admired from its first exhibition at the Paris Salon in 1739. This version, according to scholars, is the last of the three existing ones, yet its early provenance is not known, unlike the other two. Let me point something out here. It is without doubt one of Chardin's masterpieces, the paint is superb in itself. But the girl seems very tall indeed, her arm looks very long and she seems to have two elbows.

In the other two versions her elbows are slightly altered so they look 'right', as is the perspective on the cupboard. Chardin signed all three near the elbow. This one from the Louvre is dated 1739, after the other two. But could this one really be the first, kept in the studio and used as the model for the other versions, hence the lack of knowledge of its provenance?

1624 Diego Velázquez

Look at these two full-length painted portraits – Velázquez on the left, Hals opposite. Both figures seem to be excessively tall in relation to their small heads. Hals's gentleman, especially, seems very oddly proportioned. How many viewpoints are there here? Again, we seem to be viewing the face almost straight on, yet the boots, too, are also seen straight on – we are not looking down on them. We know Hals painted heads separately from bodies – busy burghers had lots of

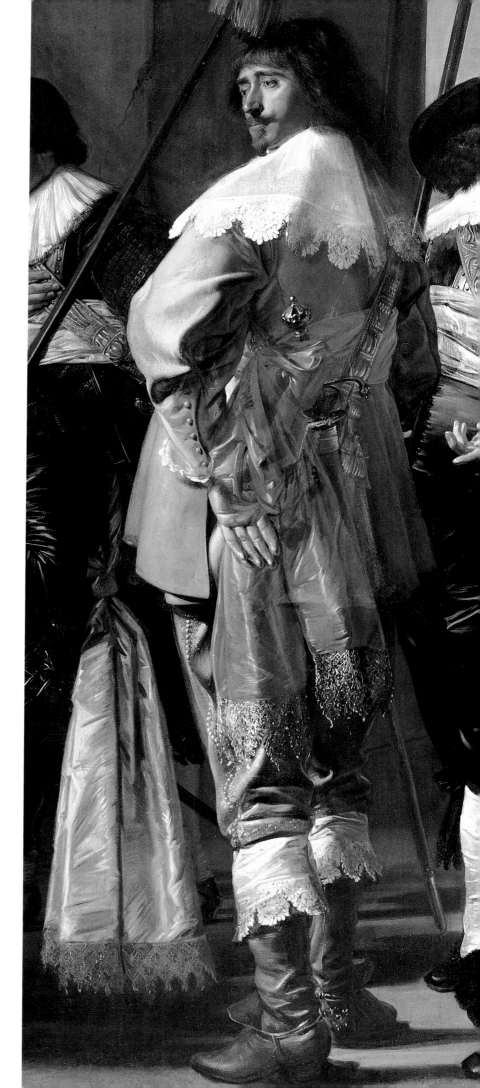

important things to do – isn't it likely that Velázquez would have done the same thing when painting aristocrats who were unwilling to stand for a long time? I'm sure both artists painted these two figures in several 'exposures' and then pieced them together. To illustrate what I mean I have done the same thing using photographs of segments of Charles Falco, all taken straight on. You can make someone look taller or shorter like this, but taller is more flattering.

1636 Frans Hals >

Of course artists would sometimes use distortions for effect. Fragonard's girl on a swing from 1767 has far greater movement than the one in the photograph below (admittedly a still from a movie). The position of the legs in Fragonard's picture are odd anatomically, yet are obviously useful for creating the sense of movement. The photograph is static by comparison.

You don't notice or care about the problems in Fragonard's anatomy, but you do in van Dyck's portrait of a Genovese lady and her son, painted around 1626. The proportions here seem very odd. Why? Although we think we are looking up at the woman from a low position, her face is seen straight on – we do not see the underside of her nose, as we should – and yet the boy's face is also seen straight on. Now look how far away the heads are from each other, even though they're supposed to be holding hands. And where are the lady's feet? It's only when you see this that you notice how huge she is – if she stood up she'd be about twelve feet tall!

It hardly seems possible that both the mother and son were sitting in front of the artist at the same time. They must have been painted separately and pieced together as a montage. And the lady's face must have been painted at a different time from her dress. There are certainly many viewpoints here. One begins to realize that any full-length portrait must have at least two viewpoints: to get the detail in the face you have to be quite close, to see the whole figure you have to move back some distance, or paint it in sections, with multiple viewpoints.

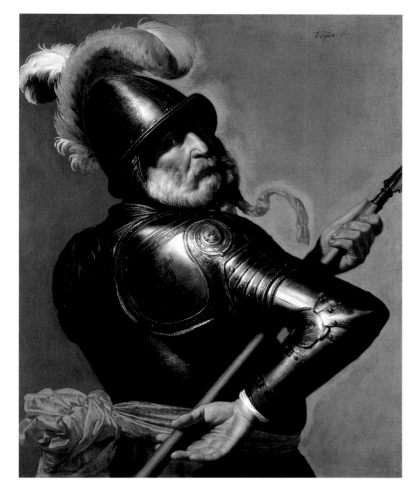

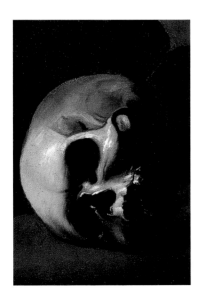

These two paintings are from around the same date, and both use strong, theatrical lighting. What are notable here though are some odd distortions. Zurbarán's *St Francis at Prayer* (*opposite*; *c*. 1638–9) has a skull on the table that seems 'squeezed up'. It has a very small forehead (*far left*). Could this be caused by optics? When it is squeezed in the other direction by about 10% (*left*), it looks more proportional, more 'right'. A slight tilt in the angle of the canvas would have caused this.

A similar thing can be seen in van Bylert's man in armour (*above left*; *c*. 1630). The armour is beautifully articulated, yet his arm seems to be in a very awkward position. Again, we squeezed it, this time vertically (*above right*) and it seemed more comfortable and the back looked more 'normal'. Does all this matter? These distortions are not at first very obvious. I have been looking at these paintings in the Norton Simon Museum for a long time and hadn't really noticed these things. Does the average viewer? Yet once you do see them they just don't go away.

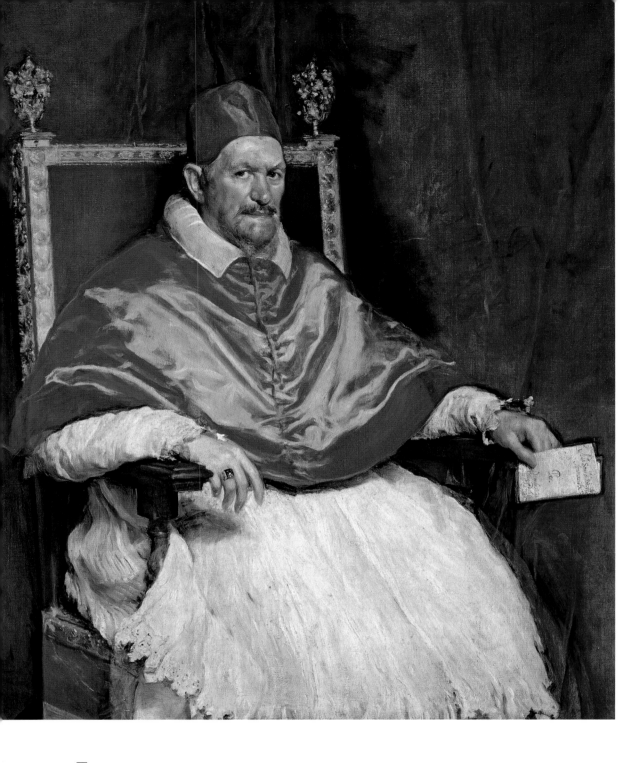

These two works, made within five years of each other, show that not all lens-based painting need look the same. Cagnacci's strange rope vase of flowers from around 1645 is just like a colour photograph. It must have taken some time to paint. There's our dark background again and our strong lighting, which accurately picks up the detail of the frayed rope and flowers. Perhaps it was a 'show-off' piece – 'Look how real I can make it!' – a claim most artists would understand. Above is Velázquez's magnificent 1650 portrait of Pope Innocent X. Velázquez doesn't seem to have depicted his elevated subject with as much detail as Cagnacci painted his humble flowers. Even so, the head is very accurate indeed. It seems alive. The shine on the satin is simple and always in the right place. It is a very different technique from Cagnacci's, yet equally 'naturalistic' and equally based on the optical view of the world.

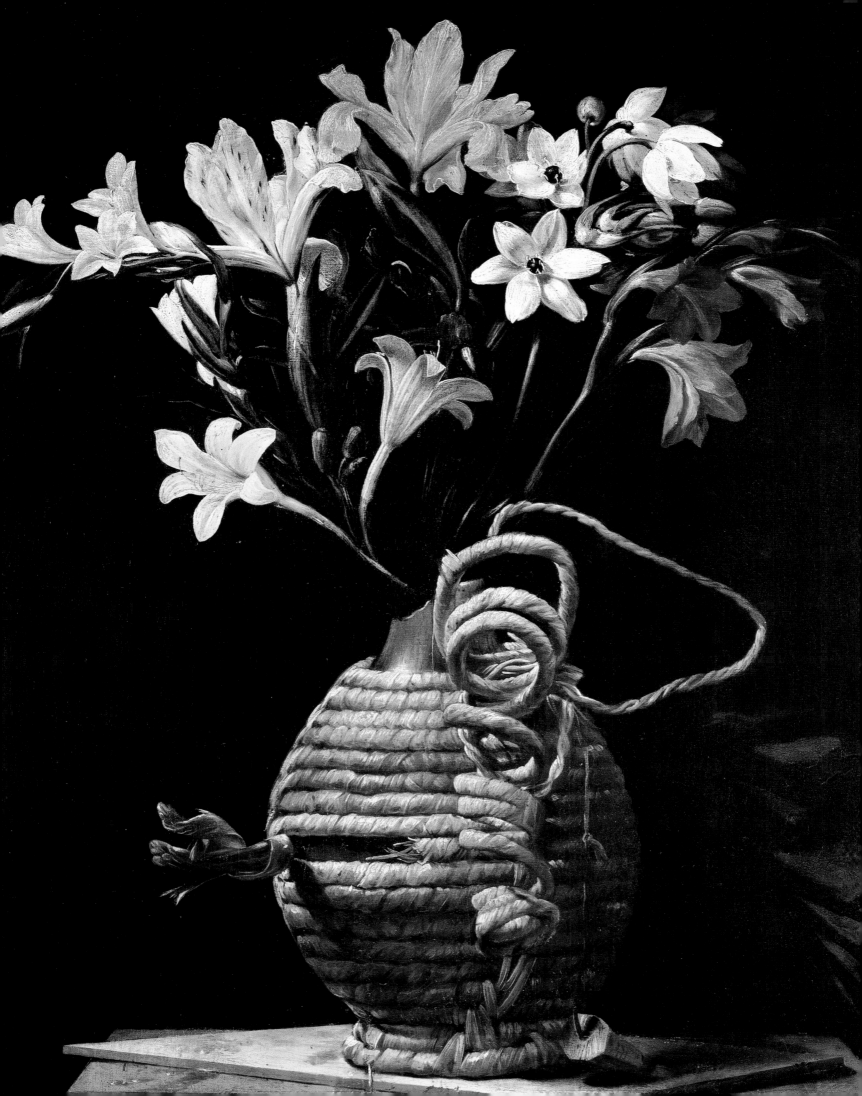

There are many unanswered questions, and this book can be no more than an introduction to a vast subject. Though I have no doubt that the central thesis is correct, there is certainly more to be uncovered, and this could have an impact on the story as I have outlined it here. For example, I have identified the first use of optics as having been in Flanders about 1430 – there is solid evidence. Nevertheless, I am troubled by Masaccio, working in Florence a decade or two earlier. His portraits are less meticulously painted than van Eyck's, but this could be attributed to his medium, fresco. They do, however, have a similar look, and Masaccio was the first Italian painter to give faces in a crowd a true individuality (as in the Flemish crowds).

The end of the story (which has not, of course, ended yet) is also problematical. We know that the advent of chemical photography had a profound impact on painting – that it sparked a revolution against the optical image (Impressionism, Cubism). There is now a new technological revolution in the making of images. What effect will that have?

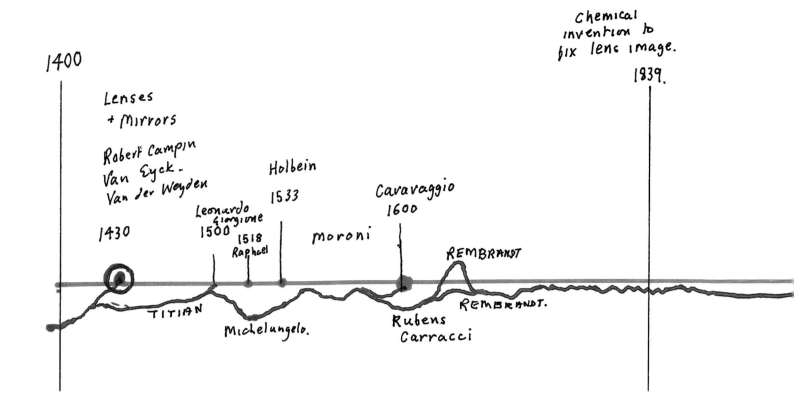

1400

Lenses
+ Mirrors

Robert Campin
Van Eyck -
Van der Weyden

Holbein

1533

Leonardo
Giorgione
1500
1518
Raphael

Caravaggio
1600

moroni

1430

REMBRANDT

TITIAN

Michelangelo.

Rubens
Carracci

REMBRANDT.

This is my attempt at explaining what I think has happened. The red line is the lens-based image, the green is the 'eyeballing' tradition. Before 1430, the red should perhaps be pink, partly because we can't be sure that this was the very first appearance of optics in painting, and partly because mirrors and lenses definitely existed before this – their effects may have been known to some artists.

I am suggesting that at moments in its history the green line was close to the red, influenced by what artists observed through the lens. The first of these moments was around 1430 in Flanders. Other artists saw the results and were immediately affected. The influence of the new art spread. The knowledge of how to do it became the subject of much rumour among guild craftsmen. Slowly, word got out, but, apart from some exceptions (Antonello da Messina, for instance), the 'secret' was more or less contained in northern Europe. But then Hugo van der Goes's *Portinari Altarpiece* is sent to Florence in the 1480s, and we begin to see increasing evidence of optics in Italian art.

By 1500 Leonardo is writing about the camera obscura. Certain artists like Giorgione and Raphael begin to experiment with optics, while others such as Michelangelo prefer to stick to eyeballing. By Caravaggio's time, mirrors and lenses have been around for at least 170 years, and scientists such as Giambattista della Porta are instructing artists on how to use them. Suddenly, there is an amazing burst of naturalism.

For four centuries, eyeballing closely follows the lens. This is not to suggest that all artists were using lenses, only that they were all trying, to various extents and with differing results, to emulate the naturalistic effects – the 'look', the 'looking like' – of lens-based images. Sometimes certain sensitive individuals, such as Rembrandt, cross the line, transcending mere naturalism to produce paintings that not only depict exterior reality but also reveal inner 'truths'. Throughout, however, they continue to follow the example of the optical.

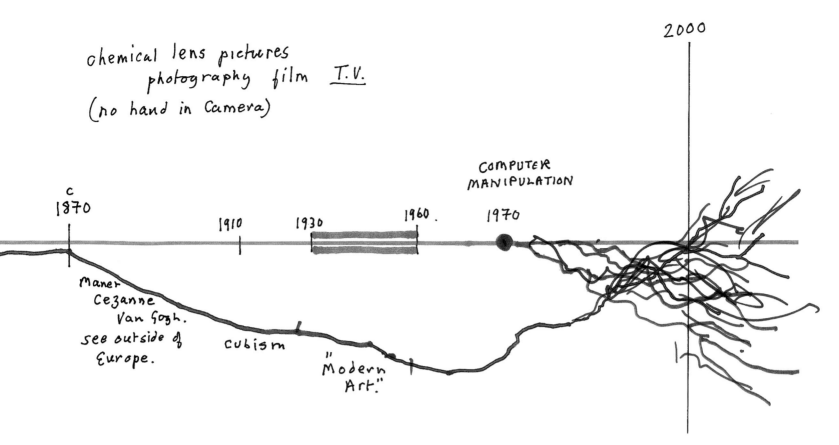

chemical lens pictures
photography film _T.V._
(no hand in Camera)

2000

COMPUTER
MANIPULATION

c
1870

1910 1930 1960 . 1970

Manet
Cezanne
Van Gogh.
see outside of
Europe.

cubism

"Modern
Art."

Then comes the invention that fixes the lens image with chemicals (photography), doing away with the need for the artist's hand altogether. The lens now spreads much faster than before, but at first photography is still restricted to the relatively wealthy. Within twenty-five years or so, however, its impact has made itself felt much more widely. Vanguard painting now wants to distinguish itself from the lens and so steers the green line sharply away from the red. This is the birth of modern art. Awkwardness returns. Advanced painters begin to look outside Europe and towards the art of the Far East, which offers alternative ways of seeing.

But the lens, carried on by photography (and academic painters), remains dominant, eventually to become film and television. The gap widens, Cubism being the first style of painting to suggest a new way of representing the world far removed from the lens' veracity. Around 1930, though, the red line gets thicker. Movies are now everywhere – the most vivid depiction of reality possible, it was thought. This is the period when modern art suffers its most serious attacks, especially from the great tyrants – Hitler, Stalin, Mao – who all demand lens-based pictures and use them to consolidate their power. It is also the period of the world's bloodiest conflicts, way beyond anything previously known. Are these things connected? Certainly, control of the media was essential for the slaughter.

In the 1970s the computer arrives and changes the lens picture. (Technology always seems to have an effect on depiction.) Computer manipulation means that it's no longer possible to believe that a photograph represents a specific object in a specific place at a specific time – to believe that it is objective and 'true'. The special position, even legal position, that photography once had has gone. (Manipulate – 'to use the hand'.) The hand has returned to lens-based images. The computer has brought the photograph closer to drawing and painting once again. Its software uses terms like 'palette', 'brush', 'pencil' and 'paintbox'. So where are we now? Do the lines criss-cross, or jumble up?

On these pages we get before, during and after. Giotto's still-life
arrangement from 1300 – a detail from a fresco – has no hint of optics.
Pieter Claesz's seventeenth-century wine glass and silver bowl is a chance
to show off how realistically he can paint. Manet's detail from *The Bar at
the Folies Bergère* from 1881–2 demonstrates the return of 'awkwardness'
to European painting.

The limitations of the optical image. Compare the remarkable verisimilitude of Caravaggio's 1596 bowl of fruit (*opposite*) with the new awkwardness of Cézanne's 1877–8 apples (*below*). Now place the opened page some distance from you. The farther away you go from the book the more difficult Caravaggio's apples are to see, to read; Cézanne's, on the other hand, get stronger, clearer. Caravaggio's image goes into the picture, Cézanne's comes out at you – it occupies your space. What is going on? A one-eyed (monocular) vision of the lens against a two-eyed (binocular) vision – a more human vision.

1618 Diego Velázquez

Lens and post-lens. By around 1870 – that is, after photography has taken over lens-based images – awkwardness returns. But notice again how Cézanne's portrait, like we saw with his apples, can be 'read' at distance. To see what I mean, again take the book and prop it up on the other side of the room. Even from twenty feet away, the boy still seems close to the viewer, on the surface, whereas the Vélazquez is much farther away in depth and it is difficult to make out the image clearly. Cézanne's

1883–5 Paul Cézanne

innovation was that he put into his pictures his own doubts about how objects relate to himself, recognizing that viewpoints are in flux, that we always see things from multiple, sometimes contradictory, positions. It is a human, binocular vision (two eyes, two viewpoints, and therefore doubt) that functions here, in contrast to the tyrannical, monocular vision of the lens (Vélazquez), which ultimately reduces the viewer to a mathematical point, fixing him to a particular spot in space and time.

These two pictures – Henri Fantin-Latour (1890) opposite and Édouard Manet (1882) on the right – have been together on the same page for the last forty years, in Ernst Gombrich's *Art and Illusion*. Gombrich wanted to show how 'difficult' it must have been for people to accept Manet's awkward style when they were used to academic portraiture like the Fantin-Latour. Today, I see 'lens' and 'no lens'. It seems so perfectly clear.

These two pictures were painted a few years apart, Bouguereau's bather (*above*) being later than Cézanne's. The Bouguereau is an example of 'academic' salon painting, which Cézanne thought was dishonest madness. We can actually smile at it; it seems so absurd – that wave about to crash down on the girl who isn't the slightest bit concerned about it. In fact, the wave looks to us today rather like what we would call in film a back projection; this is what it *must* be. We can see clearly that she is reclining on a kind of platform (with the edges made to look like rocks), and she has no real connection with the water.

The Bouguereau is a window beyond which is illusion and fantasy. The Cézanne is more like a Poussin composed carefully on the canvas. We are aware of paint on a canvas surface. His bathers somehow occupy the viewer's space. In the end, Cézanne's vision of painting triumphed over the academic and opened up new ways of seeing. Bouguereau's was finally dismissed as something silly.

But today the 'artificial' Bouguereau is in fact closer to most of the vast number of images that people see: photographs, movies, TV. So what way of seeing and representing has really triumphed? The photographic image! The Bouguereau painting also contains a few things that we can see at the beginning of the twenty-first century but which we might not necessarily have noticed before. Look how the edges of the nymph have been softened to blend in with the sea. They are not crisp, sharp lines. This is something that today's computers can do when you want to superimpose one photograph on top of another: you just use the line-softener tool in Photoshop. And thus, after more than a hundred years, the artist's hand is returning to correct the camera, taking us back to where we once were, before we got seduced into believing the 'truth' of the photograph. What a difference from nineteen hundred to twenty hundred. At the start of the century most images were still made individually by hand by artists. At the beginning of a new millennium very few are, yet millions of people see the world through images made with a lens. But are these images the honest depictions of reality we once thought they were? Has photography, for so long seen as vividly real, as untouched by the human hand, dulled our vision, diminished our ability to see the world with any clarity?

In this respect, the film *Who Framed Roger Rabbit?* was far more than a cute movie for children. It worked on many levels, but what was particularly interesting was the way it placed the drawn against the photographed. The first part of the film showed a drawn character (Roger) in a photographed world; the second showed a photographed character (played by Bob Hoskins) in a drawn world (Toontown). What was really new was the way the drawn figure had had its edges softened to create a better illusion of being in the same space as the photographed (note I say 'photographed' here and not 'real'). And the photographed character, too, had had his edges softened in the drawn world – he didn't seem 'stuck on'. Before *Roger Rabbit*, all attempts at putting drawn characters alongside photographed characters, such as Disney's *Mary Poppins*, were hampered by the fact that the drawn figures always had hard edges.

But the computer manipulation of images is making things easier. Think of *Jurassic Park* – a very fine blending of drawn dinosaurs (now looking amazingly like photographs) with a photographed landscape in what seemed like a seamless fit. The fascination of that film for me was that it was made with a camera, which is supposed to capture reality, but was about dinosaurs, which we know do not exist. So was that 'real'?

The computer is changing the way we make and understand images, too. With its help, multiple viewpoints – multiwindow perspective – can now return to pictures. It also brings back drawing, the artist's hand, to the lens image, though it is hard to escape perspective altogether (if perspective were reversed, when you played video games, you would always be aware of killing yourself).

The 'problem' of perspective is one that has reoccurred and has been discussed at many different times in the last six hundred years. But today it hardly seems important to imagemakers, though it is deeply connected with optics. It is now almost a hundred years since art journals last addressed the question of perspective in any meaningful way.

Cubism was seen as the first rearrangement of pictorial space since the Renaissance. In 1912, Jacques Rivière wrote:

> Perspective is as accidental a thing as lighting. It is the sign not of a particular moment in time, but of a particular position in space. It indicates not the situation of the objects, but the situation of a spectator … hence, in the final analysis, perspective is also the sign of an instant, of the instant when a certain man is at a certain point. What is more, like lighting, it alters them, it dissimulates their true form. In fact, it is a law of optics – that is, a physical law.
>
> Certainly, reality shows us those objects mutilated in this way. But in reality, we can change position: a step to the right, a step to the left completes our vision. The knowledge we have of an object is … a complex sum of perceptions. The plastic image does not move: it must be complete at first sight, therefore it must renounce perspective.

As I said in my introduction, the computer was essential for this book, for it allowed colour printing to become cheaper and more widely used. I would not have been able to construct my *Great Wall* without having a colour photocopier and printer to hand in my studio (otherwise, I would have had to rip up all my books). I needed the wall to give me a sweeping vision. In a book, the pages turn over on themselves and so visual effects are cumulative (like in this book) – you can't see everything at once. I could have fed all the pictures into a computer and looked at them on screen, but the scrolling up and down would have constantly altered an edge beyond which I couldn't see. But by sitting and looking at the wall, scanning it, I was able to piece together the contrasts and similarities that appear here. High tech was needed, but, as usual, a pair of scissors and a pot of glue (or drawing pins) were also necessary. High tech needs low tech – they are permanently joined, although I should point out that the hand, heart and eye are far more complex than any computer can ever be.

Human vision is different from an optical projection. In the twenty-first century we have become more aware of our visual perceptions. There is a profound difference between a reflected image in a mirror and projected image from a mirror. The first needs the body and changes with the viewer's position. But the projection is from a mathematical point in the mirror – the world as no body saw it. Are we now more aware of this?

The pictures in this book end in the nineteenth century. The twentieth century was explosive in every sense, but also dismal. While painting did experiment with a changing perspective – Cubism (unfortunately named), growing out of Cézanne, was a big break from the past – film arose at the same time, and in the end it dominated the century. Here, it was believed, was the most vivid picture of 'reality' ever made. It moved, and then it talked. Yet film, video and television are all time based, and are more ephemeral than was first thought. The vast majority of films made in Hollywood have already disappeared because of storage and archival problems. Dust to dust. I notice that Hollywood occasionally issues lists of the '100 greatest movies'. The point is not what's on the lists, but that the lists have to be made at all. The movies' mass audience needs them. The movie buff is, by definition, a scholar. The fame of the movie star is fleeting, crowded out by whatever is now.

In mid-century, people believed that Cecil B. DeMille had replaced Alma-Tadema; at the beginning of the new century, Alma-Tadema is still with us (a popular poster at the Getty Museum is proof of that) and Cecil B. DeMille is becoming harder to see. With paintings and books you don't need batteries or a machine. A painting is a physical, crafted object; a film is not. Still pictures don't move, don't talk, and last longer. Film and video bring their time to us; we bring our time to painting – it's a profound difference that won't go away.

We are going to see the last six hundred years differently in the twenty-first century. It's inevitable: every age sees the past differently and it becomes its present. The more one can see the past the more one can see the future. There is a great deal to be learnt from past images. As I left the Royal Academy's 'The Genius of Rome' exhibition in January 2001, I was stopped in the street by a student at the Royal Academy Schools. He asked me if I would give a talk at the schools. I explained that I was in London only for a few more days, but I asked him what he thought of the show. 'Overwhelming', he said, wearily, as though the pictures had been painted by mythical demi-gods far beyond his own abilities. He had no idea how the paintings had been achieved. The knowledge had not been passed on. I walked with him to the National Gallery, realizing that here was an indictment of an art history that seems to have no concern for teachable techniques. If science did not pass on its knowledge to the young we would soon be in a dark age. Isn't this irresponsible? I mention this for all those people who think my thesis takes away some of the magic of Art. It does not. Indeed, for me, my investigations have meant the rediscovery of skills (with optics) and methods that can enrich the future.

The power of still images will endure. The well-made will be loved and therefore preserved. If I mention 'Henry VIII' an immediate picture comes to mind – a picture made by a great artist, Holbein. The handmade image is a human vision. There is a great big beautiful world out there, with us in it. A new vision of it is now possible, with the computer helping to destroy the tyranny of the lens. Some have already observed that the new digital cinema is a sub-genre of painting. Exciting times are ahead.

FIRST OF ALL, I consider that the 𝔖𝔢𝔠𝔯𝔢𝔱𝔰 of Nature ... are not spoken of, least every man should understand them *As Socrates and Aristotle willeth,* for he affirmeth in his book of 𝔖𝔢𝔠𝔯𝔢𝔱𝔰, that hee is a breaker of the celestiall seale that maketh the 𝔖𝔢𝔠𝔯𝔢𝔱𝔰 of Art and Nature common; adding moreover that many evils betide him that revealeth 𝔰𝔢𝔠𝔯𝔢𝔱𝔢𝔰.... *In things proper,* therefore, and in 𝔰𝔢𝔠𝔯𝔢𝔱𝔢𝔰, the common people do erre, and in this respect they are opposite to the learned.... *Now the cause of this concealement* among all wise men is the contempt and neglect of the 𝔰𝔢𝔠𝔯𝔢𝔱𝔢𝔰 of wisedome by the vulgar sort, that knoweth not how to use those things which are most excellent. *And if they do conceive any worthy thing,* it is altogither by chance and fortune, & they do exceedingly abuse that their knowledge, to the great damage and hurt of many men, yea, even of whole societies: so that he is worse than mad that publisheth any 𝔰𝔢𝔠𝔯𝔢𝔱, unlesse he conceale it from the multitude, and in such wise deliver it, that even the studious and learned shall hardly understand it. *This hath beene the course* which wise men have observed from the beginning, who by many meanes have hidden the 𝔰𝔢𝔠𝔯𝔢𝔱𝔰 of wisedome from the common people.

ROGER BACON (*c.* 1212–94)

the **textual evidence**

This part of the book is a collection of quotations and images that I have selected from the many documents which have helped me develop and establish my thesis. They are divided into four groups. The first deals with the apparatus of optical projection: the camera obscura, the camera lucida and the mirror. The second is a collection of passages from old books that contain contemporary accounts of optical projections, of their potential as an aid to artists, and of artists actually using them. Next are a few texts – some old, some modern – explaining why projections would have been kept secret; and the last group is a selection of writings by modern art historians that have informed my investigations.

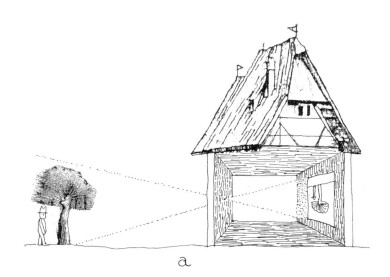

a

THE APPARATUS OF OPTICAL PROJECTIONS

The Camera Obscura

The camera obscura is a natural phenomenon, and has a long history. In its simplest form it is nothing more than a small hole through which light passes from a sunlit garden into a dark room, projecting an inverted image onto the wall opposite the hole. The size of the hole will affect the sharpness of focus and the brightness of the image.

In the fourth century BC, Aristotle wrote about the phenomenon, having observed the crescent-shaped images of the sun during a partial eclipse formed on the forest floor – the apertures through which they were cast were the small gaps between overlapping leaves. In China, at about the same time, the Mohist philosophers were recording their observations of images of pagodas, projected through gaps in window blinds.

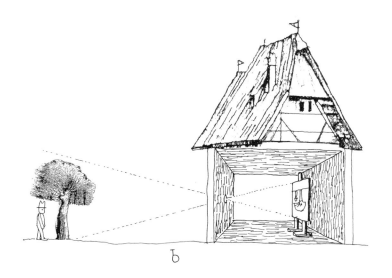

b

THE ROOM CAMERA OBSCURA

a A small hole in the shutter of a darkened room will make an inverted and upside-down image of the scene outside. The image has no exact position of focus.

b A lens makes a much brighter image, but a movable screen is required in order to obtain a sharp picture.

c When reflected by a mirror onto a screen, the image is still upside down but now is the right way round. Sharp focus is achieved by moving the mirror backwards and forwards.

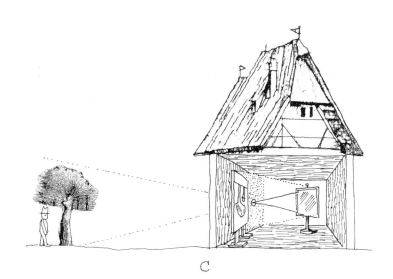

c

One of the earliest known illustrations of a box camera obscura, from Johann Zahn's *Oculus artificialis teledioptricus*, 1685. Such pictures of the camera obscura have obscured our vision!

The frontispiece of Christopher Scheiner's *Oculus*, 1619, showing various effects of the room camera obscura

The Camera Lucida

After 1800 the armoury of optical devices available to the landscapist increased considerably beyond the Claude Glass and the camera obscura. The most prominent of the new instruments was the camera lucida invented by the important optician, physicist, chemist and physiologist, William Hyde Wollaston. Patented in December 1806, it inspired numerous variants and rivals. Its central feature is a prism with two reflecting surfaces at 135°, that conveys an image of the scene at right angles to the observer's eye placed above it. The observer carefully positions his pupil, with the aid of a small viewing aperture, in such a way as to perceive the image and at the same time, to see past the edge of the prism to the drawing surface below. The draughtsman can thus contrive to watch the point of his pencil tracing the outlines of the reflected image. In its basic form, the camera lucida is not a particularly easy instrument to use and requires a certain amount of experimentation and practice before mastery is achieved. It also requires two auxiliary lenses, hinged in such a way that one could be swung below the prism and the other in front, to cope with various problems of focus. These difficulties were far outweighed by the advantages: not only was it conveniently portable, but it also operated in virtually any lighting conditions. Not surprisingly, numerous attempts were made to obviate the problems of such a useful device, and it was the progenitor of plentiful offspring, British and foreign, including the Laussedat Camera Lucida, the Abbe Camera Lucida, Nachet's Drawing Prism, Amici's Camera Lucida, Abraham's Improved Sketching Instrument, and Alexander's Graphic Mirror. The last of these was an instrument which relied on partial reflection, so that the image and the 'point of the pencil can clearly be seen at the same time' without the tricky manoeuvring of the eyehole to see into and past the prism. However, it did require a hinged

An early nineteenth-century camera lucida attached to a drawing table

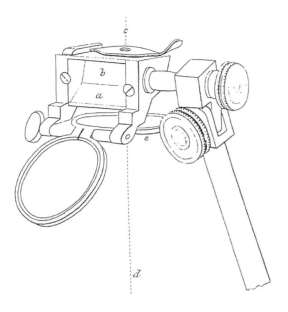

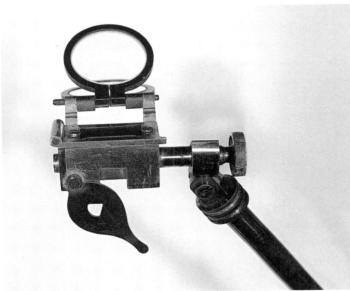

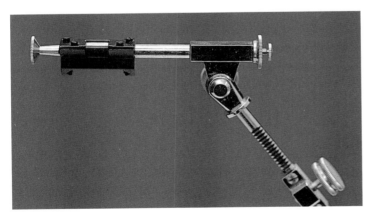

Top: A nineteenth-century drawing of a camera lucida
Middle: The upper part of an early nineteenth-century camera lucida, showing the eye-piece, prism and lenses
Bottom: The prism of a modern camera lucida

glass 'shade' to control the brightness of the incident light if the vividness of the reflection was not to obscure the drawing surface.

The camera lucida and its close variants proved their worth in a number of specialist capacities, including technical drawing, the copying of images for publication (particularly for encyclopaedias), and the drawing of images in microscopes. It also worked well in the right hands – and in the right eyes – for the portrayal of landscapes. Sir John Herschel, the son of Thomas Sandby's friend and a major scientist who was to become deeply involved in the invention of photography, achieved splendid results over a number of years with his camera lucida. His experience in using optical devices no doubt helped, as did his obvious manual dexterity and artistic skill. His drawings often contain detailed technical measurements of coordinates relating to the width of field, axes and angles of view, as well as more descriptive notes of colour. That the use of a camera lucida did not guarantee a successful representation is shown amply by W. H. Fox Talbot's confessedly miserable efforts. Had Talbot possessed his friend's skill, or that of his wife, Constance, he might not have felt the need to fix the image by chemical means and thus to invent photography.

from Martin Kemp, *The Science of Art*, 1992

Mirrors

It is only since the early part of the 16th century that mirrors have become articles of household furniture and decoration. Previous to that time – from the 12th to the end of the 15th century – pocket mirrors or small hand mirrors carried at the girdle were indispensable adjuncts to ladies' toilets. The pocket mirrors consisted of small circular plaques of polished metal fixed in a shallow circular box, covered with a lid.

The method of backing glass with thin sheets of metal for mirrors was well known in the Middle Ages at a time when steel and silver mirrors were almost exclusively employed. Vincent de Beauvais, writing about 1250, says that the mirror of glass and lead is the best of all 'quia vitrum propter transparentiam melius recipit radios.' It is known that small convex mirrors were commonly made in southern Germany before the beginning of the 16th century, and these continued to be in demand under the name of bull's-eyes *(Ochsen-Augen)* till comparatively modern times. They were made by blowing small globes of glass into which while still hot was passed through the pipe a mixture of tin, antimony, and resin or tar. When the globe was entirely coated with the metallic compound and cooled it was cut into convex lenses, which of course formed small but well-defined images. It appears that attention was drawn to this method of making mirrors in Venice as early as 1317, in which year a 'Magister de Alemania,' who knew how to work glass for mirrors, broke an agreement he had made to instruct three Venetians,

leaving in their hands a large quantity of mixed alum and soot for which they could find no use.

It was, however, in Venice that the making of glass mirrors on a commercial scale was first developed; and that enterprising republic enjoyed a rich and much-prized monopoly of the manufacture for about a century and a half. In 1507 two inhabitants of Murano, representing that they possessed the secret of making perfect mirrors of glass, a knowledge hitherto confined to one German glass-house, obtained an exclusive privilege of manufacturing mirrors for a period of twenty years. In 1564 the mirror-makers of Venice, who enjoyed peculiar privileges, formed themselves into a corporation. The products of the Murano glass-houses quickly supplanted the mirrors of polished metal, and a large and lucrative trade in Venetian glass mirrors sprang up. They were made from blown cylinders of glass which were slit, flattened on a stone, carefully polished, the edges frequently bevelled, and the backs 'silvered' by an amalgam. The glass was remarkably pure and uniform, the 'silvering' bright, and the sheets sometimes of considerable dimensions. In the inventory of his effects made on the death of the great French minister Colbert is enumerated a Venetian mirror 46 by 26 inches, in a silver frame, valued at 8016 livres, while a picture by Raphael is put down at 3000 livres.

from James Paton and A. S. Murray, *Encyclopaedia Britannica*, 1883

SELECTED REFERENCES TO OPTICAL PROJECTIONS AND PAINTING

ALHAZAN 965–1038

Alhazan is the name by which Ibn al-Haitham was known in medieval and Renaissance Europe. He was an Arab scholar who supplemented the ancient Greeks' knowledge of optics with his own researches. When his manuscript was translated into Latin a century or so after his death, it sparked off a blaze of enquiry into optics in thirteenth-century Europe.

The proof that light and colour are not mixed in the air or in transparent objects is that when many candles are in one place in distinctly separate positions and they have all been placed in front of one hole that goes through to a darkened area and there is opposite to the hole a wall or an object that is not transparent there will appear on that object or wall the light of those candles, clearly representing the number of them and each one appears opposite one candle going in a straight line through the hole. If one candle is covered over only the light of the candle opposite is put out and if the cover is removed the light returns. It is possible to prove in an hour the following: that if the lights were mixed in with the air they would be mixed with the air in the hole and ought to cross over intermingled and would not be separate afterwards. We do not find this is so. The lights therefore are not mixed in with the air but each is projected in a straight line, these lines are equidistant, in front of the objects themselves and to positions opposite. Each image of light is projected along those lines and can be prolonged in the air for an hour. They are not mixed in with the air but only pass through its transparency, nor is the air affected by them and does not lose its own form. What we have said about light, colour and air must be understood about all transparent objects and surfaces.

Opticae thesaurus

SHEN KUA 1086

Though Chinese scholars like Shen Kua knew about optical projections at the same time as their European counterparts, interest in it seems to have died out by the twelfth century. This may be due to the fact that the Chinese had no native glass industry until after the arrival of Jesuit missionaries in the seventeenth century.

The burning-mirror reflects objects so as to form inverted images. This is because there is a focal point in the middle (i.e. between the object and the mirror). The mathematicians call investigations about such things Ko Shu. It is like the pattern made by an oar moved by someone on a boat against a rowlock (as fulcrum). We can see it happening in the following example. When a bird flies in the air, its shadow moves along the ground in the same direction. But if its image is collected (like a belt being tightened) through a small hole in a window, then the shadow moves in the direction opposite to that of the bird. The bird moves to the east while the shadow moves to the west, and vice versa. Take another example. The image of a pagoda, passing through the hole or small window, is inverted after being 'collected'. This is the same principle as the burning-mirror. Such a mirror has a concave surface, and reflects a finger to give an upright image if the object is very near, but if the finger moves farther and farther away it reaches a point where the image disappears and after that the image appears inverted. Thus the point where the image disappears is like the pinhole of the window. So also the oar is fixed at the rowlock somewhere at its middle part, constituting, when it is moved, a sort of 'waist', and the handle of the oar is always in the position inverse to the end (which is in the water). One can easily see (under the proper conditions) that when one moves one's hand upwards the image moves downwards, and vice versa. [Since the surface of the burning-mirror is concave, when it faces the sun it collects all the light and brings it to a point one or two inches away from the

mirror's surface, as small as a hemp seed. It is when things are at this point that they catch fire. This is indeed the place where the 'waist' is smallest.]

Are not human beings also rather like this? There are few people whose thinking is not restricted in some way. How often they misunderstand everything and think that true benefit is harmful, and that right is wrong. In more serious cases they take the subjective for the objective, and vice versa. If such fixed ideas are not got rid of, it is really difficult to avoid seeing things upside down.

Meng Chhi Pi Than

ROGER BACON *c.* 1212–94

Like Galileo's theories 350 years later, Roger Bacon's ideas were considered dangerous by the Church. In 1268, he sent his Opus majus *to Pope Clement – then newly elected – who was sympathetic to Bacon's ideas. Sadly, Clement died soon after the manuscript arrived at the Vatican, and his successor took the side of Bacon's opponents. As a result, Bacon was imprisoned in Oxford and kept under close surveillance for the rest of his life.*

Mirrors can be arranged in such a way that as many images, of whatever we wish, would appear in the house or in the street and anyone catching sight of them will see them as if they are real, and when he runs to the place where he sees them will find nothing. For the mirrors will be placed, out of sight, in such a way that the position of the images is in the open and appears in the air at the point where the visual rays join the perpendicular, so that those seeing them run to where they see the images and think that something exists where there is nothing, but only an apparition. And thus, in accordance with things of this sort, matters that we have touched on about reflection and others similar could become not only useful to friends and things to fear for our enemies, but also a strong source of philosophic consolation so that all the emptiness of fools may be blotted out by the beauty of the miracles of science and men may rejoice in the truth, putting aside the falsities of magic.

Perspectiva

WITELO *c.* 1275

Witelo (Vitellio) was a younger contemporary of Bacon's, and was at the Vatican when Bacon's Opus majus *arrived there. His own* Optikae *seems to have drawn on both Bacon and Alhazan. The passage presented here is in an abridged form of the original so it can be more readily understood. The original Latin describes the optical geometry at length, and is peppered with references to a very misleading diagram. This version closely follows the full translation, omitting only the geometrical description. Witelo's proposition is made all the more confusing because it cannot possibly work as described – no*

convex surface can project an image by reflection. The last two sentences, however, suggest that Witelo's instruction to take a 'convex cylindrical mirror' is a deliberate deceit and that he intends a different type of mirror to be used (see the next section on secrecy to find out why he might have done this). As I have learned, only a concave spherical mirror will, in practice, project an image. Significantly, the next part of Witelo's book is a lengthy discourse precisely about that type of mirror. Substitute a concave mirror for a convex cylindrical mirror in Witelo's description and it matches my mirror-lens set-up exactly.

It is possible to set up a cylindrical or convex pyramidal mirror in such a way that one could see, in the air, things outside not in sight.

Take a convex cylindrical mirror … let it be stood upright on its pedestal, somewhere in a spacious house, so that … it stands vertically above the floor of the house. Let a line be extended through the centre of the mirror to touch the wall of the house and mark the wall above this point and quite close to it … Let the wall be broken through here, and let the hole be made larger on the other side of the wall, just as usually happens with the windows of a house.… I say that if we centre our observations on a point below this hole … the entire opening will be seen quite clearly outside the mirror. Let a panel, with a picture somewhere on it, be set next to the hole outside the wall, positioned in such away that the picture cannot be seen directly. Nevertheless, with visibility so arranged, the image of the picture will be seen reflected in the air from the surface of the cylindrical mirror.

I seriously believe that in a similar way it is possible to set up pyramidal convex mirrors. From spherical convex mirrors, such a reliable image would not result as from the mirrors proposed. The proposition is complete. The eager enquirer should be on his guard for in this current theorem which we have presented we have made use of an example so that by the circulation of this book the way may be open to the earnest mind of the seeker after diverse skills.

Optikae

LEONARDO DA VINCI **1452–1519**

Leonardo was acquainted with the optical texts of his day – and his notebooks contain numerous entries on optical projections. His own experiments, like those of Alhazan, were in a darkened chamber with a small hole – a 'pinhole' camera obscura. Though he makes no reference in his notebooks to projections from a mirror (or if he did, it has been lost), he did design machinery for grinding and polishing concave mirrors. Machines produce much better optical surfaces than hand methods, but there are no records of their use until the early seventeenth century.

All bodies together, and each by itself, give off to the surrounding air an infinite number of images which are all-pervading and

each complete, each conveying the nature, colour and form of the body which produces it.

It can clearly be shown that all bodies are, by their images, all-pervading in the surrounding atmosphere, and each complete in itself as to substance, form and colour; this is shown by the images of the various bodies which are reproduced in one single perforation, through which they transmit the objects by lines which intersect and cause reversed pyramids from the objects, so that they are upside down on the dark plane where they are first reflected.

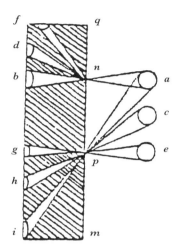

The images of objects are all diffused through the atmosphere which receives them; and all on every side in it. To prove this, let *a c e* be objects of which the images are admitted to a dark chamber by the small holes *n p* and thrown upon the plane *f i* opposite to these holes. As many images will be produced in the chamber on the plane as the number of the said holes.

Prove how all objects, placed in one position, are all everywhere and all in each part

I say that if the front of a building – or any open piazza or field – which is illuminated by the sun has a dwelling opposite to it, and if, in the front which does not face the sun, you make a small round hole, all the illuminated objects will project their images through that hole and be visible inside the dwelling on the opposite wall which may be made white; and there, in fact, they will be upside down, and if you make similar openings in several places in the same wall you will have the same result from each. Hence the images of the illuminated objects are all everywhere on this wall and all in each minutest part of it. The reason, as we clearly know, is that this hole must admit some light to the said dwelling, and the light admitted by it is derived from one or many luminous bodies. If these bodies are of various colours and shapes the rays forming the images are of various colours and shapes, and so will the representations be on the wall.

How the images of objects received by the eye intersect within the crystalline humour of the eye

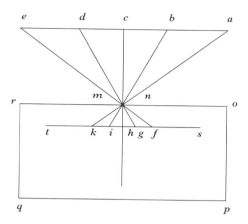

An experiment, showing how objects transmit their images or pictures, intersecting within the eye in the crystalline humour, is seen when by some small round hole penetrate the images of illuminated objects into a very dark chamber. Then, receive these images on a white paper placed within this dark room and rather near to the hole and you will see all the objects on the paper in their proper forms and colours, but much smaller; and they will be upside down by reason of that very intersection. These images being transmitted from a place illuminated by the sun will seem actually painted on this paper which must be extremely thin and looked at from behind. And let the little perforation be made in a very thin plate of iron. Let *a b c d e* be the objects illuminated by the sun and *o r* the front of the dark chamber in which is the said hole at *n m*. Let *s t* be the sheet of paper intercepting the rays of the images of these objects upside down, because the rays being straight, *a* on the right hand becomes *k* on the left, and *e* on the left becomes *f* on the right; and the same takes place inside the pupil.

Notebooks

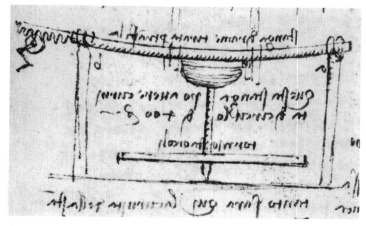

A potter's wheel for making mirrors with a large focal length, from Leonardo's *Notebooks*

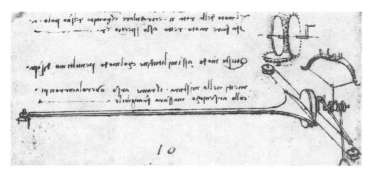

Various machines for grinding mirrors, from Leonardo's *Notebooks*

GIROLAMO CARDANO **1550**

This is the first reference to a camera obscura with a lens.

If you wish to look at those things that are in the street, place a convex lens in the window when the sun is shining brightly, then having blacked out the window you will see the images carried through the opening onto the opposite surface, but with muted colours. Therefore place a very white paper in the place where you see the image and you will achieve the desired effect with amazing results.

De Subtilitate

One of the earliest known representations of the pinhole room camera obscura, from Gemma Frisius's *De radio astronomico et geometrico liber*, 1558

GIAMBATTISTA DELLA PORTA **1558**

Della Porta's Magiae naturalis *not only provides the most comprehensive account of optical projections before the eighteenth century, it was also a very popular book. The first edition, in four books, was published in 1558. It was republished thirty years later, now expanded to twenty books. The passages reprinted here are from the first English translation (1658).*

THE SEVENTEENTH BOOK OF NATURAL MAGICK:
WHEREIN ARE PROPOUNDED BURNING-GLASSES,
AND THE WONDERFUL SIGHTS TO BE SEEN BY THEM.

Now I am to come to Mathematical Sciences.... What could seem more wonderful than that, by reciprocal strokes of reflexion, Images should appear outwardly, hanging in the Air, and yet neither the visible Object nor the Glass seen?...

To see all things in the dark, that are outwardly done in the Sun, with the colours of them.

You must shut all the Chamber windows, and it will do well to shut up all holes besides, lest any light breaking in should spoil all. Onely make one hole, that shall be a hands breadth and length; above this fit a little leaden or brass Table, and glew it, so thick as a paper; open a round hole in the middle of it, as great as your little finger: over against this, let there be white walls of paper, or white clothes, so shall you see all that is done without in the Sun, and those that walk in the streets, like to Antipodes, and what is right will be the left, and all things changed; and the farther they are off from the hole, the greater they will appear. If you bring your paper, or white Table neerer, they will shew less and clearer.... *Now will I declare what I ever concealed till now, and thought to conceal continually* [my emphasis – note the secrecy]. If you put a small centicular Crystal glass to the hole, you shall presently see all things clearer, the countenances of men walking, the colours, Garments, and all things as if you stood hard by; you shall see them with so much pleasure, that those that see it can never enough admire it. But if you will

See all things greater and clearer,

Over against it set the Glass, not that which dissipates by dispersing, but which congregates by uniting, both by coming to it, and going from it, till you know the true quantity of the Image, by a due appropinquation of the Centre; and so shall the beholder see more fitly Birds flying, the cloudy skies, or clear and blew, Mountains that are afar off; and in a small circle of paper (that is put over the hole) you shall see as it were an Epitomy of the whole world, and you will much rejoyce to see it: all things backwards, because they are neer to the Centre of the Glass, if you set them farther from the Centre, they will shew greater and upright, as they are, but not so clear. Hence you may,

If you cannot draw a Picture of a man or any things else, draw it by this means;

If you can but onely make the colours. This is an Art worth learning. Let the Sun beat upon the window, and there about the hole, let there be Pictures of men, that it may light upon them, but not upon the hole. Put a white paper against the hole, and you shall so long sit the men by the light, bringing them neer, or setting them further, until the Sun cast a perfect representation upon the Table against it: one that is skill'd in painting, must lay on colours where they are in the Table, and shall describe the manner of the countenance; so the Image being removed, the Picture will remain on the Table, and in the superficies it will be seen as an Image in a Glass. If you will

That all shall appear right,

This is a great secret: many have tryed it, but none could obtain it: For some setting Plain Glasses obliquely against the hole, by reverberation against the Table, they could see some things somewhat direct, but dark and not discernable. I oft-times by putting a white paper obliquely against the hole, and looking just against the hole, could see some things direct: but a Pyramis cut obliquely, did shew men without proportion, and very darkly. But thus you may obtain your desire: Put against the hole a convex Glass; from thence let the Image reflect on a Concave-glass: let the Concave-glass be distant from the Centre, for it will make those Images right, that it receives turned, by reason of the distance of the Centre. So upon the hole and the white paper, it will cast the Images of the Objects so clearly and plainly, that you will not wonder a little. But this I thought fit to let you understand, lest you fail in the work, that the Convex and Concave glasses be proportionable circles: how you shall do this, will be here declared often. I shall shew also,

How in a Chamber you may see Hunting, Battles of Enemies, and other delusions.

Nothing can be more pleasant for great men, and Scholars, and ingenious persons to behold; That in a dark Chamber by white sheets objected, one may see as clearly and perspicuously, as if they were before his eyes, Huntings, Banquets, Armies of Enemies, Plays, and all things else that one desireth. Let there be over against that Chamber, where you desire to represent these things, some spacious Plain, where the Sun can freely shine: Upon that you shall set Trees in Order, also woods, Mountains, Rivers, and Animals, that are really so, or made by Art, of Wood, or some other matter. You must frame little children in them, … and you must counterfeit Stags, Bores, Rhinocerets, Elephants, Lions, and what other creatures you please: Then by degrees they must appear, as coming out of their dens, upon the Plain: The Hunter he must come with his hunting Pole, Nets, Arrows, and other necessaries, that may represent hunting: Let there be

Horns, Cornets, Trumpets sounded: those that are in the Chamber shall see Trees, Animals, Hunters Faces, and all the rest so plainly, that they cannot tell whether they be true or delusions: Swords drawn will glitter in at the hole, that they will make people almost afraid…. I have often shewed this kind of Spectacle to my friends, who much admired it, and took pleasure to see such a deceit; and I could hardly by natural reasons, and reasons from the Opticks, remove them from their opinion, when I had discovered [uncovered] the secret.

How without a Glass or representation of any other thing, an Image may seem to hang in the Air.

Before I part from this Image hanging in the Air, I will shew how you may make the Images of all things seem to hang in the Air, which will be a wonder of wonders; chiefly being done without the apparition of a Glass, or a visible Object. But first we will examine what the Antients writ of this matter. One *Vitellio* describes the business after his fashion, thus:

> Fasten the segment of a Cylinder in the middle of the house, set upon a Table, or Stool, that it may glance perpendicularly upon the ground; then place your eye at some hole or chink that is somewhat distant from the Glass, and let it be fixed, that it may not move here and there: over against the Glass break the wall, and make it like to a window: let it be Pyramidal in shape, and let the sharp point be within, and the basis without, as men use to do, when a Picture or any Image is placed for the eye to look upon; but let it be reflected on by the superficies of the Pyramidal Glass, that the Picture placed without, which your eye cannot see through the hole, may seem to hang pendulous in the Air; which will cause admiration to behold. A Pyramidal Convex-glass will do the same, if you sit it so that it may represent the same Image. It may be done also by Spherical Convex and Concave.

But the matter promiseth more in the Frontispiece written upon it, then it will performe in the conclusion. Wherefore the Image will be seen without the Glass, but by means of the Glass; so that the thing beheld in the Glass, will seem to be without it. But he [Witelo] is foully mistaken here, as in other places.

<div align="right">Natural Magick</div>

DANIEL BARBARO **1568**

Barbaro's Della Perspettiva *is the earliest book of artists' techniques I have found that mentions projections.*

Make a hole in a window of a room … as large as a spectacle glass. Then take a glass that is convex on both sides, not concave, like the spectacles of youths who are short-sighted. When this glass is fixed in the hole, shut all the windows and doors into the room so that no light enters except through the glass. Then take a piece of

paper and place it in front of the glass so you see clearly on the paper everything that is outside the house.... Here you will see the forms on the paper as they are in reality, and the gradations, colours, shadows, movements, clouds, the ripples of water, the flight of birds, and everything else that can be seen. This experiment needs clear and bright sun, because sunlight has great power in making things visible.... Seeing, therefore, the outline of things on the paper, you can draw with a pencil all the perspective that appears there, and then shade and colour it as nature displays it to you, holding the paper tightly in place until you have finished the drawing.

Della Perspettiva

This detail from an imaginary view of Archimedes using 'burning mirrors' (concave mirrors) to destroy the Roman fleets shows a man using such a mirror to project his head into the air. From Alhazan, *Opticae thesaurus, with Vitellionis thurinopoloni opticae libri decem*, 1572

HENRY WOTTON **1620**

Wotton was Provost of Eton College, and a close friend of Sir Francis Bacon's. This passage is from one of his letters to Bacon, following an encounter with the astronomer Johannes Kepler.

To the Lord Bacon, Viscount St Albans
Let me tell your Lordship a pretty thing which I saw coming down the *Danuby*, though more remarkable for the Application, then for the Theory. I lay a night at *Lintz*, the Metropolis of the higher *Austria*; but then in very low estate, having been newly taken by the Duke of *Bavaria*: who, *blandiente fortunâ*, was gone on to the late effects: There I found *Keplar*, a man famous in the

Sciences, as your Lordship knowes, to whom I purpose to convey from hence one of your Books, that he may see we have some of our own that can honour our King, as well as he hath done with his *Harmanica*. In this mans study I was much taken with the draught of a Landskip on a piece of paper, me thoughts masterly done: Whereof enquiring the Author, he betrayed with a smile it was himself, adding he had done it, *non tanquá Pictor, sed tanquam Mathematicus*. This set me on fire: at last he told me how. He hath a little black tent (of what stuffe is not much importing) which he can suddenly set up where he will in a field, and it is convertible (like a Wind-mill) to all quarters at pleasure, capable of not much more then one man, as I conceive, & perhaps at no great ease; exactly close and dark, save at one hole, about an inch and an half in the *Diameter*, to which he applies a long perspective-trunke, with the convexe glasse fitted to the said hole, and the concave taken out at the other end, which extendeth to about the middle of this erected Tent, through which the visible radiations of all the objects without are intromitted, falling upon a paper, which is accommodated to receive them, and so he traceth them with his Pen in their natural appearance, turning his little Tent round by degrees till he hath designed the whole aspect of the field: this I have described to your Lordship, because I think there might be good use made of it, for Chorography: For otherwise, to make Landskips by it were illiberall; though surely no Painter can do them so precisely.

Reliquiae Wottonianae

CONSTANTIN HUYGENS **1622**

Constantin Huygens, a poet, lived for a while in England, where he made the acquaintance of his countryman and renowned inventor Cornelius Drebbel. Drebbel made a number of camera obscuras, but none have survived.

I smiled when you said in your last letter that I should beware of Drebbel's magic, and I reproached him for being a sorcerer. But, I assure you, finding nothing but nature in what he does, I do not need to keep my distance. Old Degheyn will be pleased to hear that I will bring back the instrument with which Drebbel displays that beautiful brown painting, which is definitely one of the masterpieces of his sorcery.

to Zijne Ouders, 17 March 1622

I have at my house Drebbel's instrument, which without doubt produces, by means of reflections in a dark room, the admirable effects of painting; it impossible for me to describe the beauty in words; all painting is consequently dead, because here is life itself, or something of a higher level, if words were not missing. Because the figures and the contours and the movements come together so naturally and in a greatly pleasing manner. The

Degheyns are marvellously pleased, but our cousin Carel will be enraged.

to Zijne Ouders, 13 April 1622

Huygens's account of the artist Torrentius feigning surprise on being shown the projection in a camera obscura is from his unfinished autobiography.

I observed this at the home of my fellow townsman, when on some occasion, surrounded by men of not inconsiderable standing and intellect, he approached me eagerly … as if in pleasure at seeing my viewing device, by which the images of things outside were brought into a closed place onto a white board; having recently brought this from Drebbel in England, I was using it for the most exact and detailed projection of a picture. At this point, Torrentius, bearing himself as modestly and affably as I have described, looking rather closely at the moving images, asked me if, indeed, the men whom he was seeing on the board were appearing live outside the room.

I agreed this was so rather quickly, somewhat distracted, as happens, by entertaining my friends with a variety of projections. Soon after he had gone, as I was considering his ingenuous question and his pretended ignorance of something no one does not know today, I began to suspect, with good reason, that his experience of discovery was a great pretence, because he had taken such care to seem deeply ignorant. Indeed, I dared to assert to the Degheyns standing around that the cunning man, equipped chiefly with this aid, had made a copy in his painting, which the crowd in its enthusiasm would have loved to ascribe to his own insight and judgment. In addition, the close likeness to these shadows in Torrentius's picture, confirmed it, as did the exactitude of his skill to the true image of the subject and its, as they declare, 'completeness', about which spectators wish in every way to be pleased. I am rather surprised at the folly of so many of our painters who are ignorant of, or neglect to this extent, the aid of something both pleasurable and useful for themselves.

JOHN HARRIS **1704**

The following is a clear and comprehensive description of a camera obscura from Lexicon technicum, *a technical/scientific encyclopedia.*

OBSCURA *Camera*, in Opticks, is a Room darkened, all but in one little Hole, in which is placed a Glass to transmit the Rays of Objects to a piece of Paper or white Cloth: By it are made many useful Experiments in Opticks, serving to explain the Nature of Vision; and among which, the following one deserves a particular Description.

To Represent all outward Objects in their proper Colours, Distances and Proportions, on a White Wall, a Frame of Paper, or Sheet hung up for that purpose in a Darkened Room.

This most Wonderful and Glorious Experiment, tho' it be very common, will yet well deserve to have a clear Account given of it here; for I don't remember to have read a plain and intelligible Description of its *Apparatus* any where; neither is it so easie to do it with Advantage, as those perhaps who never tried it may imagine; what follows therefore you may relie on as the Result of my own repeated Experience.

Procure a good Convex, or Plano-Convex Glass, such an one as is made use of for the Object Glass of a Telescope; and if you have a good Telescope that draws about 6 Feet, you may unscrew its Object-Glass, and it will serve your turn very well: And indeed a Glass that draws about that length (tho' 4 or 5 Foot will do pretty well) is the fittest on all Accounts to make this Experiment withal; for if you use a small Glass whose Focus is not above a Foot, or thereabouts distant from the Hole, the Representation of your Objects will be very small, and the Figures hardly large enough to be distinguished: To which likewise may be added, that not above one Spectator can come to look on it at a time, and even he not without some Trouble.

On the other hand, if you make use of a Glass which draws 15, 20, or 25 Foot, either your Hole must be very large, and then so much light will come in as will hinder the Objects from being visible on the Wall, Paper &c. or if the Hole be but small, so little Light will come in, that at the Distance of 15 or 20 Foot from the Window, you will have hardly Light enough to see the Representation distinctly; such large Glasses likewise are not easily had every where, nor are they every ones Money; but a Glass that draws about 6 Feet, is very proper to be made use on in this Case.

Having gotten such a Glass, make choice of some Room which hath a North Window, tho' an East or West may do well enough (but a South one will not, for a Reason to be given below) and let it be well Darkened, so that no Light can come into it, but at the Hole where your Glass is placed, or at least but very little. Then make a hole in the Shutter of the North Window of about an Inch, or an Inch and $\frac{1}{4}$ in Diameter, and leave open the Casement if there be one, for there must be no Glass without your Hole. Then fasten the Glass with its Centre in the Centre of the Hole, by some small Tacks to the Shutter, so that no puff of Wind blow it down and break it; and at the Distance that you know your Glass draws, hang up a White Sheet; or if you do not know exactly the Focus of the Glass, move the Sheet too and fro till you find the Objects are represented on it very distinctly, and then you may fasten it there by Nails to the Ceiling, &c. Then will whatever is without the Hole, and opposite to it, be represented on that Sheet with such exquisite exactness, as far surpasses the utmost Skill of any Painter to express. For if the Sun shine

brightly on the Objects (as indeed this Experiment is never made well when it doth not) you will have the Colours of all things there in their Natural Paint, and such an admirable proportion of Light and Shadow, as is impossible to be imitated by Art; and I yet never saw any thing of that kind that comes near this Natural Landscape. But if the Sun do not shine, the Colours will be hardly visible, and all will look dirty, dark and confused; therefore I advised a North Window, that you may have the Meridian Sun shining on your Object in its greatest Splendor, that so the Experiment may be in its utmost perfection: But you must by no means have the Sun shine on or near the Hole, for if it doth, all will be confused.

Another thing in which this Representation exceeds Painting is, That here you have *Motion* expressed on your Cloth. If the Wind move the Trees, Plants or Flowers without, you have it within on your Lively Picture; and nothing can be more pleasant than to see how the Colours of the moving parts will change as they do without, by their being in various Positions obvered to, or shaded from the Light. The Motion of any Flies or Birds, is painted also in the same Perfection: And the exact Lineaments of any Persons walking at a due Distance without the Glass, will be also expressed to the Life, and all their Motions, Postures and Gestures, will as plainly appear on the Cloth, as they do to any ones Eye without.

In a Word, nothing is wanting to render it one of the finest Sights in the World, but that all things are inverted, and the wrong end upwards. To remedy which, several Methods have been thought on, as double Convex-Glasses, &c. but none, in my Opinion, are so well, nor so easie, as to take a common Looking-glass of about 12 or 14 Inches Square, and hold it under or near the Chin, with an Acute Angle to your Breast: For if you do so, and look down into it, you will see all things upon the Sheet inverted in the Glass; (*i.e.*) in this case, restored to their Natural and Erect Position; and this Reflection also from the Glass, gives it a Glaringness that is very surprizing, and makes it look like some Magical Prospect, and the moving Images, like so many Spectrums or Phantasms. And no doubt but there are many Persons that might easily be imposed upon with such Scene, and who would believe it to be no less than downright Conjuration,

And I have made use of this Experiment to convince some Credulous Persons that those are abused and imposed upon, who see Faces in the Glasses of some Cheating Knaves amongst us, who set up for *Cunning Men*, and Discoverers of Stolen Goods, &c. And have satisfied them that much more may be done by this and some other Optical Experiments, and that without the help of the Devil too, than by any of the clumsie Methods used by these Vermin.

If the Glass be placed in a sphere or Globe of Wood (having an Hole as large as the Glass bored thro' it) which like the Eye of an

Animal may be turned every way to receive the Rays coming from all Parts of the Objects, it will be of good Advantage to the Experiment; and such ready fitted are now commonly sold by Mr. *Marshall* at the *Archimedes* on *Ludgate-hill*, and are called *Scioptricks*.

ROBERT SMITH **1738**

Smith describes a method of drawing onto glass, for transfer onto paper, or directly onto thin paper. This use of back projection corrects the reversal of the image by a lens.

For drawing copies of prints or paintings, or the perspective of solids, by tracing the out-lines of their pictures formed by the lens; let the original be placed without doors at a proper distance, and let its picture be received upon a sheet of paper or upon a large plane glass, left unpolished on one side. This glass being fixt upright with its rough side turned from the window, it is easy with a black lead pencil to trace upon it the out-lines of the pictures. Then having strained a sheet of fine paper over the glass, the strokes of the pencil will appear through it, when held against the sky-light; and thus the picture may be drawn upon the paper. The easiest way of making the image distinct upon the glass when fixt, is to place the lens in a tube that shall slide within another short tube fixt in the window-shutter.

But to save the trouble of making two draughts, we may proceed in this manner. Having strained the drawing paper upon a smooth board, let it be laid upon a small firm table, to be placed under the lens in the window-shutter; and let an inclined looking-glass, to reflect the picture upon the paper, be fixt over the table.

A Compleat System of Opticks

Giovanni Francesco Costa, 'Veduta del Canale verso la Chiesa della Mira', 1750 (detail). In the foreground, an artist and his assistant view the scene through a camera obscura. The parasol is to shield the lens from direct sunlight, which would cause flare.

A mezzotint of George Desmarées's *Portrait of the Court Painter Franz Joachim Beich*, 1744, showing the artist with the everyday tools of his trade, including a box camera obscura. The putto on the left holds either a lens or a mirror.

COUNT FRANCESCO ALGAROTTI **1764**

Algarotti is unstinting in his praise for the beauty of the image produced in a camera obscura, and maintains it was widely used by artists.

OF THE CAMERA OBSCURA

We may well imagine, that, could a young painter but view a picture by the hand of Nature herself, and study it at his leisure, he would profit more by it, than by the most excellent performances by the hand of man. Now, nature is continually forming such pictures in our eye. The rays of light coming from exterior objects, after entering the pupil, pass through the crystalline humour, and being there refracted, in consequence of the lenticular form of that part, proceed to the retina, which lies at the bottom of the eye, and stamp upon it, by their union, the image of the object, towards which the pupil is directed. The consequence of which is, that the soul, by means as yet unknown to us, receives immediate intelligence of these rays, and comes to see the objects that sent them. But this grand operation of nature, the discovery of which was reserved for our times, might have remained an idle amusement of physical curiosity, without being of the least service to the painter, had not means been happily found of imitating it. The machine, contrived for this purpose, consists of a lens and a mirror so situated, that the second throws the picture of any thing properly exposed to the first, and that too of a competent largeness, on a clean sheet of paper, where it may be seen and contemplated at leisure.

As this artificial eye, usually called a Camera Optica or Obscura, gives no admittance to any rays of light, but those coming from the thing whose representation is wanted, there results from them a picture of inexpressible force and brightness; and, as nothing is more delightful to behold, so nothing can be more useful to study, than such a picture. For, not to speak of the justness of the contours, the exactness of the perspective and of the chiaroscuro, which exceeds conception; the colours are of a vivacity and richness that nothing can excel; the parts, which stand out most, and are most exposed to the light, appear surprisingly loose and resplendent; and this looseness and resplendency declines gradually, as the parts themselves sink in, or retire from the light. The shades are strong without harshness, and the contours precise without being sharp. Wherever any reflected light falls, there appears, in consequence of it, an infinite variety of tints, which, without this contrivance, it would be impossible to discern. Yet there prevails such a harmony amongst all the colours of the piece, that scarce any one of them can be said to clash with another.

After all, it is no way surprising, that we should, by means of this contrivance, discover, what otherwise we might justly despair of ever being acquainted with. We cannot look directly at any object, that is not surrounded by so many others, all darting their rays together into our eyes, that it is impossible we should distinguish all the different modulations of its light and colours. At least we can only see them in so dull and confused a manner, as not to be able to determine any thing precisely about them. Whereas, in the Camera Obscura, the visual faculty is brought wholly to bear upon the object before it; and the light of every other object is, as it were, perfectly extinguished.

Another most astonishing perfection in pictures of this kind is the diminution of the size, and of the intenseness of light and colour, of the objects and all their parts, in proportion to their distance from the eye. At a greater distance the colours appear more faint, and the contours more obscure. The shades likewise are a great deal weaker in a less intense or more remote light. On the other hand, those objects, which are largest in themselves, or lie nearest to the eye, have the most exact contours, the strongest shades, and the brightest colours: all which qualities are requisite to form that kind of perspective, which is called aerial, as though the air between the eye and external objects, not only veiled them a little, but in some sort gnawed, and preyed upon,

them. This kind of perspective constitutes a principal part of that branch of painting, which regards the foreshortening of figures, and likewise the bringing them forward, and throwing them back in such a manner, as to make us lose sight of the ground upon which they are drawn. It is, in a word, this kind of perspective, from which, assisted by linear perspective, arise *'Things sweet to see, and sweet deceptions'*.

Nothing proves this better than the Camera Obscura, in which nature paints the objects, which lie near the eye, as it were, with a hard and sharp pencil, and those at a distance with a soft and blunt one.

The best modern painters among the Italians have availed themselves greatly of this contrivance; nor is it possible they should have otherwise represented things so much to the life. It is probable, too, that several of the Tramontane masters, considering their success in expressing the minutest objects, have done the same. Every one knows of what service it has been to Spagnoletto of Bologna, some of whose pictures have a grand and most wonderful effect. I once happened to be present where a very able master was shewn this machine for the first time. It is impossible to express the pleasure he took in examining it. The more he considered it, the more he seemed to be charmed with it. In short, after trying it a thousand different ways, and with a thousand different models, he candidly confessed, that nothing could compare with the pictures of so excellent and inimitable a master. Another, no less eminent, has given it as his opinion, that an academy, with no other furniture than the book of da Vinci, a critical account of the excellencies of the capital painters, the casts of the finest Greek statues, and the pictures of the Camera Obscura, would alone be sufficient to revive the art of painting. Let the young painter, therefore, begin as early as possible to study these divine pictures, and study them all the days of his life, for he never will be able sufficiently to contemplate them. In short, Painters should make the same use of the Camera Obscura, which Naturalists and Astronomers make of the microscope and telescope; for all these instruments equally contribute to make known, and represent Nature.

An Essay on Painting

GEORGE ADAMS *c. 1765*

Adams was the King's instrument-maker, and this is from his catalogue. By the mid-eighteenth century, one could buy a portable camera obscura in a shop.

A CATALOGUE OF OPTICAL, PHILOSOPHICAL, AND MATHEMATICAL INSTRUMENTS, MADE AND SOLD BY GEORGE ADAMS

Small cabinets with a collection of opaque and transparent objects
Scioptric balls
Camera obscura in boxes
Adams's improved book camera obscura
Magic lanthorns
Ditto smaller
Pictures for the larger
Ditto for the smaller
Prisms
Ditto mounted on a ball and socket
Frames and stands for ditto
Zogroscopes or machines for viewing perspective prints, &c.
Box and glasses for looking at prints
Concave and convex mirrors
Black convex glass mirrors (recommended by Gray the poet)
Cases with glass sides for experiments on refraction
An artificial eye
A solid glass cube
A semicircle and prism to determine the angles of refraction
An heliostate for directing the sun's rays into a dark room, and keeping them on the same spot for several hours together

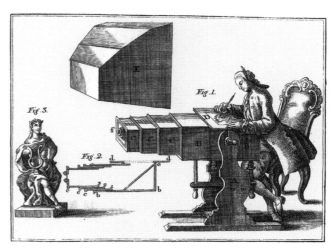

G. F. Brander, 'Drawing with the help of a camera obscura', 1769

ANTONIO ZANETTI **1771**

Zanetti was librarian at St Mark's Cathedral in Venice, and was one of several contemporary writers who described Canaletto's use of the camera obscura.

By his example il Canal [Canaletto] taught the correct use of the *camera ottica*; and how to understand the defects that occur in a painting if one follows too closely the lines of perspective, and especially aerial perspective, as they are seen in the camera, and if one does not know how to modify them when they offend common sense. Those learned in this will understand what I mean.

Della Pittura Veneziana

GEORGE ADAMS **1791**

More from George Adams: his observations on the camera obscura as an aid to artists.

Various have been the methods used to facilitate the practice of perspective, as well for those who understand, as for those who are ignorant of that art; and though some have supposed that the warmth of imagination and luxuriance of fancy, which impels the mind to the cultivation of the fine arts, is not to be confined to mechanical modes, yet upon enquiry they will find, that the most able and accomplished artists are often obliged to have recourse to some rules, and to use some mechanical contrivances to guide and correct their pencil. So great is the difficulty, and so tedious the operation of putting objects in true perspective, that they trust mostly to their eye and habit for success; how well they succeed, we may decide from the portraits drawn by the best artists, and the different judgements formed concerning them. Mr Eckhardt has well observed, that there is no artist who will be hardy enough to say that he can delineate (by the eye) the same object twice with exactness, and preserve a just and similar proportion of parts in each. In one of the figures we shall find some of the parts larger than the other: both cannot be right: yet supposing them both perfectly the same, neither may be conformable to nature. Add to this, many situations of an object occur, which no eye, however habituated, can represent with accuracy…. The methods most generally in use are (1) the camera obscura (2) the glass medium or plane (3) a frame of squares.

Geometrical and Graphical Essays

GEORGE ADAMS **1794**

In this lecture, Adams gives a commentary on optical projections.

We are able by the assistance of glasses to unite, in one sensible point, a great number of rays proceeding from the same point of an object; the rays thus united in a point form an image of that point of the object from which they proceed; this image is *brighter* in proportion as there are more rays united, and more *distinct* in proportion as the order in which they proceed, is better preserved in their union. On placing a polished and white plane at the place of their union, you will see this image painted in all it's proper colours, if no adventitious light is permitted to disturb or render it confused….

You see what a beautiful and lively picture of all the objects before the window is exhibited on the screen. It may with propriety be termed nature's art of painting. You have perspective here in perfection, or a just diminution of objects in proportion to the distances, the images being all in proportion to the respective apparent magnitudes of the objects seen by an eye at the hole in the window. The colouring here is just and natural, the lights and shades perfectly just, and the motions of all objects are perfectly expressed; the leaves quiver, the boughs wave, the birds fly, &c. as in nature, though much quicker, and in a lesser scene. From the camera obscura, the painter may learn his imperfections; he may see what he should do, and know what he cannot perform.

Lectures on Natural and Experimental Philosophy

W. H. WOLLASTON **1807**

A description of the camera lucida – by its inventor.

Having a short time since amused myself with attempts to sketch various interesting views, without an adequate knowledge of the art of drawing, my mind was naturally employed in facilitating the means of transferring to paper the apparent relative positions of the objects before me; and I am in hopes that the instrument, which I contrived for this purpose, may be acceptable even to those who have attained to greater proficiency in the art, on account of the many advantages it possesses over the *Camera Obscura*.

The principles on which it is constructed will probably be most distinctly explained by tracing the successive steps, by which I proceeded in its formation.

While I look directly down at a sheet of paper on my table, if I hold between my eye and the paper a piece of plain glass, inclined from me downwards at an angle of 45°, I see by reflection the view that is before me, in the same direction that I see my paper through the glass. I might then take a sketch of it; but the position of the objects would be reversed.

To obtain a direct view, it is necessary to have two reflections. The transparent glass must for this purpose be inclined to the perpendicular line of sight only the half of 45°, that it may reflect the view a second time from a piece of looking glass placed beneath it, and inclined upwards at an equal angle. The objects now appear as if seen through the paper in the same place as before; but they are direct instead of being inverted, and they may be discerned in this manner sufficiently well for determining the principal positions…. But those who are conversant with the science of optics will perceive the advantage that may be derived in this instance from prismatic reflection; for when a ray of light has entered a solid piece of glass, and falls from within upon any surface, at an inclination of only twenty-two or twenty-three degrees, as above supposed, the refractive power of the glass is such as to suffer none of that light to pass out, and the surface becomes in this case the most brilliant reflector that can be employed.

There is another circumstance in this construction necessary to be attended to, and which remains to be explained. Where the

reflection was produced by a piece of plain glass, it is obvious that any objects behind the glass (if sufficiently illuminated) might be seen through the glass as well as the reflected image. But when the prismatic reflector is employed, since no light can be transmitted directly through it, the eye must be so placed that only a part of its pupil may be intercepted by the edge of the prism.… The distant objects will then be seen by this portion of the eye, while the paper and pencil are seen past the edge of the prism by the remainder of the pupil.

Description of the Camera Lucida

JOHN RUSKIN **1843**

Ruskin's observations on the similarity in tonality between the projected image and the works of the old masters.

Now the finely-toned pictures of the old masters are, in this respect, some of the notes of nature played two or three octaves below her key, the dark objects in the middle distance having precisely the same relation to the light of the sky which they have in nature, but the light being necessarily infinitely lowered, and the mass of the shadow deepened in the same degree. I have often been struck, when looking at a camera-obscuro on a dark day, with the exact resemblance the image bore to one of the finest pictures of the old masters, all the foliage coming dark against the sky, and nothing being seen in its mass but here and there the isolated light of a silvery stem or an unusually illumined cluster of leafage.

Modern Painters

ÉTIENNE-JEAN DELÉCLUZE **1851**

Soon after the invention of photography, French painter and critic Delécluze observes the similarities between the daguerreotype and the works of various earlier artists.

[Meissonier's] paintings, remarkable for their quality, small size and the exactness of the likeness, will, I believe, mark an unusual time in the history of art: a period when the influence of the daguerreotype had a serious influence on the studies and completed works of artists. Whenever Meissonier embarked on a career as an artist, the very clear talent he showed was never in doubt; but it seems evident that seeing daguerrean prints provided him with material for reflection, the results of which, altered, guided and perfected the way he views and imitates nature. The daguerreotype, by arriving in the world with its rectitude and slightly brutal boldness, had the effect of a sage who tells the truth bluntly; it was both admired and rejected by all. However, after the initial astonishment and fits of rage, thought-

ful artists realized that the representations produced by the daguerreotype were proof that certain of the great portraitists were right, artists such as Bellini, Leonardo da Vinci, Raphael, Hans Holbein and Ingres, who, until then, were criticized for drawing lines which were too perfectly defined and for a lack of variation in the volume. Indeed, I should be greatly astonished had Meissonier not been struck by the similarity in aspect between the paintings of the men I have just named and the results obtained from the instrument invented by Mr Daguerre.

Salon of 1850

EUGÈNE DE MIRECOURT **1855**

I had noticed, before finding this passage, that some of Ingres's later portraits lacked the subtle tonality of earlier paintings. As this change came after the invention of chemical photography, I suspected he might have used photographs for these paintings, with little or no reference to the live model.

M. Sudre, our most distinguished lithographer, produced this picture, with the most remarkable talent. Each proof of his work sold for no less than 100 francs. He is the only one whom M. Ingres, very proud of his reputation, permits to reproduce his works, as young Nadar is the only photographer to whom he sends people of whom he wants to have a perfect likeness. The photographs of Nadar are so marvellously exact, that M. Ingres, with their help, composes the most admirable portraits without any need of the original's presence.

Ingres

GLASS, OPTICS AND SECRECY

Artists are generally secretive about their methods – even today. Painting is a private activity, and artists, in general, see no need to explain how their work is done, preferring to let it speak for itself. Skills and techniques may be taught – but by example, and by endless practice. It was ever thus. Some aspects of the painter's craft may be written down, and they often were, but these are mostly formulas for mixing mediums and varnishes, methods for preparing a canvas or panel, etc. – things that can be precisely described and must be precisely repeatable. Skills of hand and eye cannot be taught this way. The use of optics is a skill of hand and eye, more easily demonstrated than explained in writing.

At the dawn of the Renaissance, the skills of the various crafts and trades were the collective property of their practitioners. The guilds were often fiercely protective of local expertise, particularly if this was the foundation of their prosperity (see Chloe Zerwick, below, on the restrictions imposed on the Murano glassworkers). Today, high-tech industries protect their expertise with draconian non-disclosure agreements. Not much has changed!

For something as seemingly 'magical' as a projection there were other pressing reasons for secrecy. Scholars realized that some aspects of their knowledge could be abused by the irresponsible or the unscrupulous, and took pains to conceal such things (see Roger Bacon's instruction to his fellow scientists, for example, and William Romaine Newbold's commentary on Bacon's use of ciphers and codes). There can be no doubt that optical projections would fall into this category. One hundred and fifty years before van Eyck and Campin, the conservatives in the Church had made such caution obligatory – for fear of excommunication or worse (Grant). The inquisition still cast a shadow over scientific and technical innovation two hundred years later (see Clubb on della Porta; and Galileo's recantation).

There were ways of imparting information on 'dangerous' topics, however – through codes, ciphers and riddles. Codes and ciphers can only be disentangled by those in possession of the key. Riddles, on the other hand, using word substitutions or otherwise jumbling the meaning, can be accessible to those who already understand the topic, but of no help to anyone else (see della Porta; and Kaspar Schott's remarks on the Italian's subterfuge).

ROGER BACON *c.* 1214–94

OF ART AND NATURE

First of all, I consider that the secrets of Nature contayned in the skins of Goates and sheep, are not spoken of, least every man should understand them. As Socrates and Aristotle willeth, for he affirmeth in his booke of Secrets, that hee is a breaker of the celestiall seale that maketh the secrets of Art and Nature common; adding moreover that many evils betide him that revealeth secretes.... And they are no longer to bee tearmed Secrets, when the whole multitude is acquainted with them ... For that which seemeth unto all, is true, as also that which is so judged of by the wise, and men of best account. Wherefore that which seemeth to many, that is to the common people, so farre forth as it seemeth such, must of necessitie bee false. I speake of the Common sort, in that Sence, as it is heere distinguished agaynst the learned. For in the common conceytes of the minde, they agree with the learned, but in the proper principles and conclusions of Arts and Sciences they disagree, toyling themselves about meere appearances, and sophistications, and quirks, and quiddities, and such like trash, whereof wise men make no account. In things proper therefore, and in secretes, the common people do erre, and in this respect they are opposite to the learned, but in common matters they are comprehended under the lawe of all, and therein consent with the learned. And as for these commyn things, they are of small value, not worthy to bee sought after for themselves, but in regarde of things particular and proper. Now the cause of this concealement among all wise men is the contempt and neglect of the secretes of wisedome by the vulgar sort, that knoweth not how to use those things which are most excellent. And if they do conceive any worthy thing, it is altogither by chance and fortune, & they do exceedingly abuse that their knowledge, to the great damage and hurt of many men, yea, even of whole societies: so that he is worse than mad that publisheth any secret, unlesse he conceale it from the multitude, and in such wise deliver it, that even the studious and learned shall hardly understand it. This hath beene the course which wise men have observed from the beginning, who by many meanes have hidden the secrets of wisedome from the common people.

WILLIAM ROMAINE NEWBOLD, *The Cipher of Roger Bacon,* **1928**

It was only during the twenty years from 1237 to 1257 that Bacon enjoyed comparative freedom and possessed sufficient money for the prosecution of his scientific work. During those years he made what he regarded as scientific discoveries of the utmost importance, and it is extremely probable that the telescope and the microscope, in some form, were among them. Thereafter, for thirty-five years or more, he worked, when permitted to work at all (for at least some of those years were passed in prison), under severe restrictions, closely watched by suspicious and hostile eyes. The majority of his contemporaries, and very many among those of position and power, would have seen in his achievements conclusive proof of commerce with the devil, and many, even of the more enlightened, would have found in his teachings equally good reasons for sending him to the stake. He must, therefore, as a mere ordinary precaution, have been compelled to keep these discoveries secret, either locked up in his own breast or at most communicated to a few trustworthy friends. What would have been his reaction against such circumstances as these? What course of action would they have driven him to adopt?...

Bacon's reticence about his discoveries, even before he entered the Franciscan Order, was not entirely, nor, I think, chiefly, due to fear of persecution; it was grounded in his most sacred convictions. He was profoundly religious; in everything he saw the hand of God. The mere fact that the secrets of Nature had then so long been hidden is to him conclusive proof that God wills it so to be. The solitary scholar who succeeds in lifting a corner of the veil has, he believed, been admitted by God to His confidence, and is thereby placed under the most solemn obligation conceivable to make no use of his knowledge which God would not approve. Especially must he be careful not to betray it to the vulgar. God has indeed Himself, with special regard for this contingency, directly inspired scientific men, when writing of their discoveries, to conceal them either in obscure language such as was used by philosophers, or in peculiar technical terms such as were used by alchemists, or *in cipher*.

EDWARD GRANT, 'Science and Theology in the Middle Ages', **1986**

Suspicious of the emphasis on philosophy and secular learning that had occurred during the 1260s and fearful of the application of Aristotelian philosophy to theology, traditional and conservative theologians, inspired by Saint Bonaventure, sought to stem the tide by outright condemnation of ideas they considered subversive. Since repeated warnings of the inherent dangers of secular philosophy and the perils of its application to theology had been of little avail, the traditional theologians, many of whom were neo-Augustinian Franciscans, appealed to the bishop of Paris, Étienne Tempier, who responded in 1270 with a condemnation of 13 propositions, which was followed in 1277 by a massive condemnation of 219 propositions, any one of which was held at the price of excommunication.

Controversial and difficult to assess, the Condemnation of 1277 looms large in the relations between theology and science. Except for articles directed specifically against Thomas Aquinas, which were nullified in 1325, the condemnation remained in effect during the fourteenth century and made an impact even beyond the region of Paris, where its legal force was confined. Hastily compiled from a wide variety of written and oral sources, the 219 condemned errors were without apparent order, repetitious, and even contradictory. Orthodox and heterodox opinions were mingled indiscriminately. A number of the errors were relevant to science. Of these, many were condemned in order to preserve God's absolute power (*potentia Dei absoluta*), a power that natural philosophers were thought to have unduly restricted as they eagerly sought to interpret the world in accordance with Aristotelian principles.

DAVID C. LINDBERG, *John Pecham and the Science of Optics: 'Perspectiva communis'*, **1970**

The second half of the thirteenth century saw three great authorities on optics. Bacon was considered dangerous by the Church and was suppressed; Witelo described projections but disguised the means achieving them (see page 206); the third, John Pecham, was the most influential. Like Bacon and Witelo, Pecham studied at the University of Paris, but he was a zealous conservative who supported the Bishop of Paris's condemnations of 1277. This, perhaps, accounts for his surprise appointment as Archbishop of Canterbury two years later. His Perspectiva communis *was very widely read, and was adopted all over Europe as the standard (official?) textbook on optics. It makes no mention of projections.*

The *Perspectiva communis* was by far the most popular of all medieval treatises on optics, doubtless because of its broad scope and introductory character. One indication of its popularity is the large number of extant manuscript copies. Without going beyond standard bibliographical works, texts or monographs dealing with Pecham and his contemporaries, and easily available catalogues of manuscript collections, I have located sixty-two copies – one from the thirteenth century, twenty-nine from the fourteenth century, twenty-six from the fifteenth century, two from the sixteenth century, one from the seventeenth century, and three for which I have no date. An exhaustive search of manuscript collections would doubtless turn up several more. Nonetheless, sixty-two manuscripts is an exceptionally large number of extant copies of a medieval work on optics, particularly in view of the fact that Pecham's treatise is largely geometrical and thus has no appreciable philosophical, theological, or medical content. No other medieval optical work is extant in nearly as many copies, and we are forced to conclude that the *Perspectiva communis* became the standard elementary optical textbook of the late Middle Ages.

The *Perspectiva communis* retained its popularity long after the advent of printed books. It was printed first about 1482 or 1483, nine times in the sixteenth century (including a translation into Italian), and for the eleventh time in 1627. By contrast, Witelo's *Perspectiva* was printed three times in the sixteenth century, Alhazen's only in 1572, and Bacon's not until 1614.

Lectures on the *Perspectiva communis* were included in the curriculum of many universities during the fourteenth through sixteenth centuries. By the 1390s, and continuing at least to the middle of the fifteenth century, the *Perspectiva communis* was the basis of regular lectures at the University of Vienna. In 1390 for the M.A. degree the University of Prague required a student to attend lectures on the *Perspectiva communis*, and Douie claims that it was used as a textbook at Paris as well. The statutes of the University of Leipzig in the fifteenth century repeatedly refer to '*perspectiva communis*,' based on Pecham's book, as a topic for lectures; and the editor of the Leipzig (1504) printed edition, Andreas Alexander, explains that he has been appointed by the faculty of arts at Leipzig to lecture on perspective and hence has prepared the book for the use of students. In his *Cursus quatuor mathematicarum artium liberalium* (Alcalá, 1516, 1523, 1526, and 1528), used at the Universities of Paris, Alcalá, and Salamanca, Pedro Cirvelo paraphrases the *Perspectiva communis* in its entirety. Sedziwój von Czechel, who lectured on the *Perspectiva communis* at Cracow early in the fifteenth century, points out … that the *Perspectiva communis* was so named because of its common use in the schools; and in 1489 Albert Brudzewski, one of Cracow's most distinguished astronomers, was still lecturing on the *Perspectiva communis*. Finally, at the University of Würzburg, the *Perspectiva communis* was the basis of lectures as late as 1594–95.

The Venetian glassmakers' guild was formed in the early 1200s. In 1291, the glass industry was forced by the authorities to move from the city to the nearby islands of Murano – where it has remained to this day – so that both the danger of fire from the furnaces in the city itself might be eliminated and the glassmakers more effectively controlled. It was not such a hardship, since Murano was a summer resort where Venetian aristocrats had villas. Only an hour's row from Venice, the lagoon between was studded on warm nights with gondolas going to and fro. Though Venetian control over the glassmakers and their families was strict, these craftsmen were highly regarded. Many were given patrician standing, their daughters being permitted to marry noblemen.

Control was crucial to Venetian trade because the glassmakers were privy to many jealously guarded secrets regarding the construction of furnaces, the formulas and proportions of ingredients, and the making and handling of tools. Glassmakers at that time relied on trial and error, using their eye, their judgment, their past experience, and the knowledge handed down from glassmakers before them. Venetian glassmakers were not allowed to leave Murano; in fact, escape was a crime which carried the death penalty. There are stories of relentless assassins following fleeing glassmakers – in one case, to the very gates of Prague. Yet many glassmakers somehow did leave, emigrating and setting up manufactories in the Tyrol, Vienna, Flanders, Holland, France, and England. It was not until the 17th century that a book written specifically to instruct glassmakers was published by a Florentine, Antonio Neri. His book, *L'Arte Vetraria* (The Art of Glass), printed in 1612, made available to everyone secrets which had long been carefully guarded.

GIAMBATTISTA DELLA PORTA, *De Furtivis*, **1563**

Men call secret codes in literature those writings that are constructed in such a way that they cannot be interpreted by anyone except him for whom they are intended. But if we consider correctly we will clearly see that this name applies to those writings that the people of our time commonly call riddles. If those examining the works of our predecessors can work out something in their mind, we will say that these secret writings are nothing other than codes, by which we reveal things obscurely and briefly to those knowing something of the subject and by whom we wish the subject explored. Indeed, we call them codes because they highlight writings, words and sayings with characteristic signs in advance and draw the attention of the reader to the ideas in the marked passage. But if we observe the uses of these codes we will say that they are employed in many situations, among them, sacred matters and the knowledge of secret things: so these hidden secrets should not be revealed, our ancestors used often to cloak and disguise them with obscure signs and symbolic figures so they should not be violated by the profane or those not fully initiated.

LOUISE GEORGE CLUBB, *Giambattista Della Porta: Dramatist*, **1965**

The two greatest tourist attractions of Naples about the year 1600 were, according to contemporary report, the baths of Pozzuoli and Giambattista Della Porta. Certainly Della Porta was one of the most famous men in Italy.… He wrote on cryptography, horticulture, optics, mnemonics, meteorology, physics, astrology, physiognomy, mathematics, and fortification, and when he died at eighty, he was preparing a treatise in support of his claim to the invention of the telescope. In his spare time, Della Porta wrote plays.…

[There was] a hair-raising event in Della Porta's life, one that was to influence everything else in it, from his scientific aims to his daily habits. It inevitably caused suppression of facts and dissemination of lies by his family and friends, perhaps deliberate destruction of letters, and left to posterity as a record of his life only fragments of a colourful mosaic.

The cataclysm was a brush with the Inquisition. It was only that – nothing to compare with the horrors in store for Campanella, Bruno, and the other unfortunates who could not or would not abandon their research or alter their views to suit the censors. But it was enough to frighten Della Porta, to make him modify his investigations and conceal the incident as much as possible.

No one knows exactly when it happened. A record made by the notary Joele in 1580 of Inquisitional activities before that year notes 'Item: le ripetitioni per Gio: battista dela porta,' referring to the re-examination of testimony required by Rome in all inquisitional trials. Amabile declared that imprisonment in Rome ordinarily preceded such re-examination, and that if Giuseppe Valletta, in his study of the Holy Office in Naples, neglected to mention any incarceration in his brief account of Della Porta's sentence, it was because Valletta was less concerned with accuracy than with expounding his thesis that the Neapolitan Inquisition's function was primarily preventive, not punitive. The trial and probable imprisonment must, in any case, have taken place before November 1579, for by that date Della Porta was in Naples, free to accept Cardinal Luigi d'Este's invitation to join him in Rome. The immediate cause of Della Porta's being hauled before the Inquisition was a denunciation by some fellow Neapolitans who were scandalized by his growing reputation for magic and by the titles of *Indovino* and *Mago* bestowed on him by the populace.…

The denunciation must have been made between 1558, when Della Porta's first work appeared, and 1578, when Toscanò praised his poetry. Apparently not wanting to omit so famous a name from his roster of celebrities, yet recognizing the imprudence of lauding the forbidden lore on which the fame was based, Toscanò compromised by praising Della Porta only for his literary hobby, though he had never published a line of poetry or drama. However uncertain the date, the watchdogs of the true faith surely snapped at him. Della Porta was summoned before the tribunals in Naples and Rome, perhaps briefly imprisoned, and charged by papal order to disband his academy and refrain from practicing illicit arts.

GALILEO GALILEI, 'Recantation to the Tribunal', **22 June 1633**

I, Galileo Galilei, son of the late Vincenzio Galilei of Florence, aged seventy years, tried personally by this court, and kneeling before you most Eminent and Reverend Cardinals, Inquistors-General in all the Christian Republic against heretical depravity, having before my eyes the Holy Gospels, and placing my hands upon them, do solemnly swear that I have believed, always believed, and with God's help will in the future believe all that the Holy Catholic and Apostolic Church does hold, preach and teach. But since I, after having been ordered by this Holy Office to abandon the false opinion that the sun is the centre of the world and does not move, and that the earth is not the centre of the world and does move, and not to hold, defend or teach in any way whatsoever, either in speech or in writing, the said false doctrine, and after being informed that the said doctrine was contrary to the Holy Scripture, have written and printed a book in which I treat the same already condemned doctrine and bring forward arguments with much efficacy in its favour, without arriving at a solution, I have been judged vehemently suspected of heresy, that is, of having held and believed that the sun is the centre of the world and immovable and that the earth is not the centre and moves.

Nonetheless, wishing to remove from the minds of your Eminences and all faithful Christians this vehement suspicion reasonably conceived against me, with sincere heart and unfeigned faith, I curse and detest the aforesaid errors and heresies, and generally all and whatever other error, heresy and faction contrary to the Holy Church; and I swear that in the future, I will neither say nor assert, in speech or in writing, such things as may bring upon me similar suspicion.

KASPAR SCHOTT, Magia universalis naturae et artis, **1657**

Porta either mocked or deceived us. He admits that he could not propose more obscurely what he was not able to disclose more clearly. I would not dare to say he sold us smoke. For what he promises can be done with the aid of a concave cylindrical mirror, as I know and will show in a little while. For I think he wished to say, in substance, the same things as we do but he wished by changing and altering words to make the matter as secret as possible, to hide important and outstanding knowledge so it did not spread among the common people. He himself admitted that he did this in the preface to his twenty books with these words:

> We have veiled amazing and exciting things with a certain device, just as by changing words and abbreviations we have obscured evil and unpleasant matters; not so that the cleverest people should not be able to work it out and understand; not so clearly that the ignorant crowd should misuse it; nor so obscurely that the enquiring mind should not find out; nor so clearly that they don't get things back to front.

JOSHUA REYNOLDS, Discourses, **1786**

If we suppose a view of nature represented with all the truth of the *camera obscura*, and the same scene represented by a great Artist, how little and mean will the one appear in comparison of the other, where no superiority is supposed from the choice of the subjects. The scene shall be the same, the difference only will be in the manner in which it is presented to the eye. With what additional superiority then will the same Artist appear when he has the power of selecting his materials as well as elevating his stile.

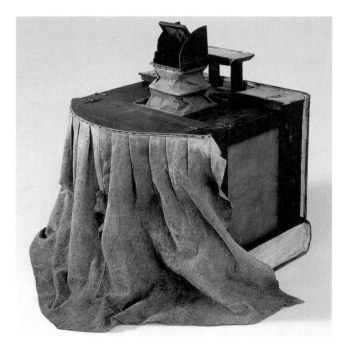

Reynolds's camera obscura, which was disguised as a book when it was folded up

SOME MODERN TEXTS

On where artists got their mirrors

HEINRICH SCHWARZ, 'The Mirror of the Artist and the Mirror of the Devout', **1958**

Painters and glass and mirror-makers were closely connected in the fifteenth century and, as in Bruges, even united in the Guild of St Luke, the patron saint of both professions.

DIRK DE VOS, *Rogier van der Weyden: The Complete Works*, **1999**

The lost register of the guild of painters and mirror-makers ... to which the manuscript illuminators, tempera painters, makers of playing cards, toys and wallpaper also probably belonged, was opened after the guild received its royal charter in 1424.

On Holbein

JANE ROBERTS, *Drawings by Holbein from the Court of Henry VIII,* **1987**

The manner in which the series of Holbein drawings are now kept at Windsor is naturally very different from that of earlier times. Whereas the drawings are now venerated, and rightly so, as exquisite works of art, it is likely that their primary function was as preparatory studies, made while the artist was in the presence of his subject, and used by him to work up a finished portrait in oils or, for a miniature, in tempera. The fact that the drawings have survived at all is therefore fairly surprising, when numerous similar preliminary studies must have been destroyed once they had served their purpose....

The relationship of drawing to oil painting, in those cases where both survive, is the subject of several detailed and on-going studies, in particular by Dr Maryan Ainsworth of the Metropolitan Museum of Art, New York. Dr Ainsworth has noted that although the one Windsor drawing in which the outlines are pricked is closely related to the oil painting in New York, the pouncing marks revealed in infra-red reflectography of the picture do not conform to the pricked lines of the drawing. In a few cases it has been possible to demonstrate that the facial dimensions of drawing and painting are virtually identical, but the precise method of transfer from the drawn to the painted surface is still unknown. And thirdly in this list of uncertainties it is sometimes the case that where a painting corresponds very closely to the related drawing, the painting is unlikely to be the product of Holbein's own brush. This is particularly evident with such oft-repeated subjects as the portrait of Queen Jane Seymour.

We have few contemporary accounts of the artist's working methods. One of the most precious is the report sent back to England from Brussels following the visit of Holbein and Hoby to interview and take the likeness of Christina of Denmark, who was at the time being considered as a possible bride for Henry VIII. The finished portrait, now in the National Gallery, London, was worked up on the basis of a three-hour sitting. Because of its size, it is highly unlikely that Holbein had the London panel in Brussels, and much more probable that the finished painting was worked up in England, following the artist's return. Holbein's preparatory work for a painting was entirely professional. He worked quickly, efficiently, and with an economy of line that has ensured that his portraits are as alive today as they were in the past. Unlike other portraits of the time, they appear to be of people full of life and character, hence their enduring fascination....

It has often been suggested that Holbein availed himself of a tracing device to assist in the taking of likenesses, once his London practice had become firmly established. It is known that other Northern artists of the time (such as Dürer) made use of such aids, and it is highly likely that Holbein did so too. Indeed, the poor quality of late drawings ... could perhaps thereby be explained. The possibility of the addition of ink lines to these and other drawings by later retouchers has also been the matter of much discussion. Any final conclusions on this topic must be made as a result of a close study of the under-drawing to the related painted portraits. For instance it appears that in [some drawings] the sharp chalk lines around the nose and mouth were only added after the rest of the drawing had been completed, as a final gesture of simplification, and that these shorthand and even crude lines were transferred (presumably via an intervening sheet of carbon paper) onto the panel to be painted, as the bare outlines onto which the oil glazes would later be applied, and from which the finished image would finally emerge.

The relationship between [the drawing of Archbishop Warham] and the Louvre painting is very precise [*see overleaf*]. The measurements of facial features in the two are extremely close. However, the method of transference used by Holbein is not known to us: the lines are not pricked, nor have they been gone around with the stylus. In spite of surface abrasions [this drawing] remains one of the finest of the Windsor series. The drawing is unequalled for its penetrating characterisation.

Top: Hans Holbein the Younger, *Drawing of Archbishop Warham*, c. 1527
Bottom: Hans Holbein the Younger, *Archbishop Warham*, 1527, oil on panel, Musée du Louvre

On Moroni

MINA GREGORI, 'Moroni's Patrons and Sitters, and His Achievement as a Naturalistic Painter', **2000**

When I speak about Moroni's 'Lombard eye,' what do I mean? When I observe typically Lombard trends in his work, to what am I referring? And where I allude to a realistic approach, what kind of realism is intended? A few defining statements will allow us to set the painter in his historical context....

We must take as our lead the writings of Roberto Longhi on Caravaggio's Lombard antecedents, and especially his famous essay of 1929, which had and continues to have such widespread influence. The point of departure for research must be the empiricism of Foppa and Donato de' Bardi, itself founded on a tradition not based (like that of Florence) on drawing. Foppa's paintings are distinguished by the presence of light as phenomenal reality (in the strict sense), singled out by the painter in particular circumstances and resulting in the gray tonalities that he brought with him to Brescia, where they are later adopted by Moretto. In the transition to the sixteenth century and the 'maniera moderna,' the trends that were already evident in Foppa asserted themselves among the Brescian painters Moretto, Savoldo, and Romanino (the last not considered by Longhi in his survey). Close as they were to Lorenzo Lotto, who was so profoundly important for his borrowing of 'northern' visual culture, and in their divergence from Venetian painting (as was peculiar to the mainland territories of the Veneto and particularly intense in the two principal border cities, Brescia and Bergamo), they devised a new painterly vision. This consisted of augmenting the power of the eye and the perception of optical phenomena, and avoiding the abstract function of drawing. They observed reality and rediscovered anatomical form as something seen rather than drawn, or altered, as it would be with Caravaggio, by the light and shadow that are empirically present.

But the defining element of these works – namely, light – is not only an expression of style but the vehicle for visual perception and the discovery of reality. The paintings of Caravaggio's precursors help us to understand that the primacy of painting affirmed by Leonardo lay in its double essence as art and science; and it is thus much more understandable that in Lombardy in the sixteenth century, painting – as Svetlana Alpers has written of Holland in the seventeenth century – should have been conceived for the first time as a perceptual model for our knowledge of the world.

On Caravaggio's incised lines

KEITH CHRISTIANSEN, 'Caravaggio and *"L'esempio davanti del naturale"* ', **1986**

Caravaggio's practice of incising lines in the preparation of his pictures, possibly with a stylus or other pointed instrument, is a well-known phenomenon.... These incisions are presumed to be unique to Caravaggio, but there is no consensus as to their function. Marangoni compared them to the incised lines created in frescoes by tracing a cartoon onto the wet plaster with a stylus. According to Longhi, they were probably used to record the pose of a model or to establish the relationship of various areas of a composition, thereby facilitating reposing the model at a later sitting. Spear interpreted them as guidelines, a notion that Moir has recently taken up. However, we still know too little about artists' techniques in general to be able to interpret adequately the novelty of Caravaggio's supposedly unique method, and thus far no one has attempted to study these incisions in a coherent fashion....

There can be little doubt that the incised lines were in some respect guidelines that had the virtue of remaining visible where a drawing would have been covered up as work progressed, but what exactly is their function?... Here, an analysis of their presence in two pictures may serve to explicate the method.

The first, and chronologically the earlier, picture, is the *Judith and Holofernes*, perhaps painted just prior to the commission for the lateral canvases in the Contarelli Chapel. Incised lines define the position of Judith's left arm (the position of the arm was lowered somewhat in the finished state) as well as her shoulder. A pair of intersecting lines to the right of her elbow seems to have been intended as an indication for the placement of the rolled-up sleeve. An incised line traced the loose skin on the neck of the old maid and another indicates a preliminary position for her head (not including the scarf). The placement of Holofernes' head, which is crucial to the composition, is indicated by a line around its back, another around the ear, and another around the chin and right cheek (typically, for Caravaggio, the beard is not indicated). There is one small incised line positioning his foreshortened chest and two others that define, in a very general way, the fall of drapery across the bed. There were probably more incised lines beneath the paint layers, but it can hardly be fortuitous that those still visible, and hence most emphatically inscribed, position the salient elements in the picture's overall design. It is indicative of their function that they are concerned with the placement of key elements rather than with their description. Moreover, the selective nature of these lines argues for their having been taken either from an already developed composition or directly from three posed models; the latter seems the more likely.

On Caravaggio's mirrors

ROBERTA LAPUCCI, 'Caravaggio and his "small pictures portrayed from the mirror" ', **1994**

Baglione's mention of 'small pictures portrayed from the mirror' has been interpreted by Bernard Berenson, and again by Agnes Czobor, as an allusion to self-portraits, executed by the painter early in his career, due to the fact that the first nudes 'display a light from the bodies', they seem captured indirectly from a mirror and the warmth of an immediate presence is missing. The muscles, nerves, bone structure present instead in later works are missing. It has been proposed therefore that the painter executed a continuous series of his own reflected image to save on the expense of a model; the truth however is that the physiognomies of his early paintings vary enough to be able to identify today a number of different models.

The use of optical illusions was part of a widespread tradition in the late sixteenth century, in the execution of self-portraits, in the 'display of various viewpoints of the same figure in a single picture', and, as we shall see, in the reproduction of a limited portion of reality as it presents itself: what Roberto Longhi had described as 'blocked portions of a universe'.

Despite Leonardo da Vinci's research, the study of light on behalf of painters never constituted a true science (*scientia*). Nevertheless, towards the end of the sixteenth century, art took on the role of spreading the new scientific discoveries at a more comprehensible level. These years saw in particular the emergence of a curious interest for problems of geometry and astronomy on behalf of Cardinal Francesco del Monte and his brother Guidobaldo. Their *Specola* survives to this day in the former Del Monte villa, now villa Boncompagni Ludovisi. In general, Caravaggio's passion for particular phenomenons has been analysed by critics in relation to his sojourn with the Cardinal, as a stimulus and direct projection of the interest of his patron.

Baglione remarks, however, that 'he made a few small pictures portrayed from the mirror. And the first was a Bacchus with a few bunches of grapes, painted with great diligence, but in a slightly dry manner', now accordingly connected to the Galleria Borghese's *Sick Bacchus* (*Bacchino Malato*); therefore the use of mirrored images is demonstratively a sector of research which he had already explored under the patronage of Del Monte.

The ambition of inventing a machine or a means to achieve the perfect imitation of nature seems to have been a phenomenon that developed in Northern Italian culture during the late Renaissance, through the use of three different types of instruments: perspective instruments, optical systems (they formed

reduced representations of the world in its form of light, chiaroscuro, and colour through the use of mirrors and lenses), and magic games. The Lombard-Venetic circles were particularly receptive to perspectival and optical studies in connection to artistic practices (theatre and painting). In Milan, Girolamo Cardano, the Borromeo family doctor, scientist to the French court, professor of mathematics, and, not surprisingly, astrologer … and player, acted as magician in squares during his spare time, making monstrous creatures appear in a dark room and, through the use of concave mirrors and lenses, he displayed in the interior of this same room the reflection of passers-by on the street.

On Vermeer's lens

PHILIP STEADMAN, *Vermeer's Camera: Uncovering the Truth Behind the Masterpieces,* **2001**

Allan Mills, an astronomer and expert on early optics, has also questioned whether the camera obscura could have been usable by artists, including Vermeer, in the 17th century. He argues that the quality of images produced by single lenses would have been so poor at this period, as to render them valueless for painters. Mills assumes that Vermeer's lens would have been no more than 4.5 cm in diameter, the size of a spectacle lens. He made a series of experiments with a modern lens of this size (of better quality glass than that of 17th-century lenses, but otherwise comparable), which he used to project images of a rectangular grid of lines drawn on a board. The results showed up some serious deficiencies. There were two main problems, both of them around the edges of the image. Here the lines became slightly curved, and the image became progressively less bright and poorer in focus – the effect known as 'vignetting'. Mills also argues that such lenses would have had too limited a depth of field to allow the whole image of a room like Vermeer's to be in focus at once. Mills concludes that these difficulties would have been so great as to have made direct tracing of the images to achieve accurate perspective outlines a practical impossibility. Proponents of the contrary view could well have been misled by the images seen in modern cameras. Vermeer could only have obtained his perspectives by geometrical construction.

These points must obviously be taken seriously, but note their implications. The various failings of camera obscura lenses, which Mills demonstrates, were not overcome to any significant extent until the invention of photography…. Set on one side for the moment any question about Vermeer: the logical conclusion of Mills's argument is that the camera obscura

would have been of little use for tracing, or for observing fine detail in images, to all of the thousands of other users of the camera – painters, draughtsmen, commercial artists, and engravers – up to the 1830s. Were all these people unable to trace or pick out detail? Clearly not.

All this is not to say, by any means, that the images in simple camera obscuras are faultless. Problems of vignetting and loss of focus were clearly in evidence at the edges of the image produced by the cubicle-type camera in the BBC reconstruction – they occur in all single lens cameras. But to believe that this renders them unusable is to underestimate the skills that most artists would surely have for interpreting, improvising, and compensating for any deficiencies. It is the mistaken idea that working from a camera obscura is like taking a photograph which leads – I would suggest – to such a misconception.

I have mentioned earlier how it is perfectly possible for a user to readjust the camera obscura – working from inside, in a booth- or tent-type – to bring different parts of the scene into sharp focus at different times, where a photographer would want all parts focused simultaneously. The most serious of the image distortions produced by a simple uncorrected lens occur, as Mills shows, around the edges. But the effects of vignetting can to an extent be overcome in the camera obscura by refocusing so that the periphery is in focus (and the centre not) – although brightness is still lost towards the edges. This is achieved by moving the lens away from or towards the projection screen. A further possibility is for the lens to be *tilted* (while the screen remains fixed). This has no effect on the perspective, but can bring a band right across the entire image into sharp focus, following what is known to photographers as the Scheimpflug rule. If the lens is tilted about a horizontal axis this band is vertical; if tilted about a vertical axis, the band is horizontal.

What is more, in the image cast by a large lens, it is possible to select just a central section for copying – as I believe Vermeer did. Any remaining slight curvature of what should be straight lines near the edges of a composition can be rectified by hand in the tracing or on the canvas. Camera obscura images are not perfect. But they *are* usable. It should be remembered too that the main reason for people first imagining that Vermeer might have used a camera was precisely that he appears to reproduce some of its optical deficiencies.

As mentioned earlier, some critics (including Mills) have based their doubts in part on the supposition that Vermeer's would have been a small box camera. Its screen would have been too small to trace images at the size of the paintings – with the exception of the two Washington panels – and its image too faint to give sufficient detail or to be used indoors. The historical evidence on larger cameras and the full-size reconstruction built by

the BBC argue strongly against this position. That demonstration depended crucially, nevertheless, on using a lens of something like 10 cm diameter – four or five times the area of those tested by Mills in his experiments. Were lenses of such a size readily available in Holland in the 17th century?

The answer is yes. Some were made as conventional hand-held magnifying glasses. One such can be seen on the table in the Verkolje mezzotint portrait of Leeuwenhoek. It looks to be about 8 cm in diameter. Magnifying glasses were commonly used in the Dutch cloth trade – in which Vermeer's father had worked – for inspecting the weave of delicate fabrics. Otherwise large lenses were being made, increasingly as the century progressed for use in telescopes. Even as early as the 1580s an English writer, William Bourne, had described the manufacture of 'perspective glasses' up to 12" (30 cm) across. Constantijn Huygens, according to Monconys, possessed telescope lenses of 13.5 and 32.5 cm diameter. The Royal Society has in its collection today three telescope lenses made by the younger Constantijn with diameters of 19.5, 21, and 23 cm, as big as dinner plates, all of which are dated 1686.

Telescope lenses of these dimensions are specialized pieces of equipment, of course, and those made by the Huygens brothers, although not without their faults, were probably the finest of their time. (Also, the Royal Society lenses were produced after Vermeer's death.) It is nevertheless clear that the technology and skills *were* available in the middle of the century for grinding lenses of the more modest size that Vermeer would have needed. We know that lenses were being made commercially in Delft when Vermeer was working. Montias, for example, mentions one Evert Steenwijck, a spectacle-maker and lens-grinder in the city, who was producing telescope lenses as early as 1628. Evert was the father of Pieter Steenwijck, an acquaintance of Vermeer's father. Further, the Huygens brothers were in correspondence with Johan de Wyk, another lens manufacturer in the city, in the years 1664 and 1665.

One of the consequences of supposing that making pictures with a camera obscura is like taking a photograph is the idea that images copied from it must be like snapshots, catching whatever happens fleetingly to be in front of the lens. Thus Arthur Wheelock says that the composition of *The Little Street* suggests the use of the camera, because the buildings are cut by the frame at 'architecturally inexplicable places'. Wheelock uses this as a point in favour of the camera hypothesis, but elsewhere he turns the argument the other way round – to contend that the extreme refinement and purification of Vermeer's compositions show that the painter used optical apparatus only as a source of first visual impressions. The paintings, that is, are much too carefully considered to be 'snapshots'. But this is to miss the ways in which the camera could have served Vermeer in that very work of refinement and purification. The camera has the power to transform the three dimensions of any scene instantaneously into a two-dimensional arrangement of shapes on the viewing screen. It is an instrument with which the finest points of composition can be weighed.

It is certainly true, with reference to paintings like *The Little Street* or *View of Delft*, that a topographical artist cannot change the buildings which are in front of him. If he wants to manipulate their positions or shapes, he can do this only on his canvas. But the same does not apply to a spatial arrangement of figures and furniture like one of Vermeer's interiors, which can be deliberately set up, using the camera as an aid to composition.

On Canaletto

GIOVANNA NEPI SCIRÈ, *Canaletto's Sketchbook,* **1997**

Ever since their appearance, the drawings have posed the problem of Canaletto's use of the camera obscura. The fact that he, a man of the eighteenth century, used this tool is confirmed by his own contemporaries including Zanetti, Algarotti, Mariette and Sagredo....

Hadeln and Parker held that the artist had used the camera obscura in the early phases of his work or for quick annotations, and seem to confirm Moschini, who published the *Sketchbook* immediately after it was donated to the Galleries. The publication of Pignatti's facsimile in 1958, however, questioned these affirmations. After making experiments with an eighteenth-century reflex camera, conserved in the Correr Museum (bearing the name A. Canal), Pignatti concluded that the drawings could in no way have been drawn with the camera obscura. He admitted that the artist could have used it, at most, to draw the *scaraboto* or overall view that furnished the 'panoramic scheme that was later subdivided in the various "sections" of the drawing: those that were "in front" and those that were "behind" the page...'.

This thesis, taken up by Constable, Zampetti and Links, was strongly contradicted by Gioseffi. The latter recalled that, in addition to the reflex model used by Pignatti, eighteenth-century artists had had various cameras at their disposal including a series of apparatus 'the observer could be inside'. He himself had a camera of this type made and, experimenting with it, reached the conclusion that the drawings obtained were very close to those of Canaletto's sketchbook. This procedure explained certain deformations, such as the elongated dome of San Simeone Piccolo or the sectioned drawings of buildings that could not fit on one page.

④ That is the lens alone, or a pinhole
(nature) all are upside down.
 so
Lens or PINHOLE REVERSED
 MIRROR
CONCAVE ———————— CORRECT

 The secret of the concave lens
was lost. So something happens
between 1434 and Della Porto
writing in 1550.
 Think now of Van Eyck's floor.
The convex mirror makes the
room like this,

 they know the lines of
 the floorboards are
 straight so they correct
 them and draw it the
way it is in Mr & Mrs Arnolfini's
room. ↓

 Meanwhile in Italy,
 perhaps not yet seeing
 the convex mirror,
 The mathematicians
 make the floor
 different.

the **correspondence**

Many of my ideas took shape as part of an ongoing dialogue with art historians, curators and scientists around the world. This edited selection of the notes, articles and letters written to clarify my thoughts tells the story of my investigations as they developed over more than a year.

Royal Academy magazine
Summer 1999

'The coming post-photographic age – or Joshua Reynolds had a camera obscura that folded up to look like a book' by David Hockney

What I am about to say is speculative on my part, but is based on visual evidence and my experience of drawing.

I have always deeply admired the drawings of Ingres. I first came across them more than forty years ago as an art student in Bradford. They were held up as an ideal in drawing: sensitive, full of character and uncannily accurate in their physiognomy.

In January I saw the Ingres exhibition at the National Gallery three times, bought the catalogue and after a little dallying in Paris, returned to Los Angeles. I read the catalogue from cover to cover and noticed that it rarely, if at all, talked about technique. It was fascinating about the characters Ingres portrayed but an artist might ask another question, 'How was this done?'

I had been intrigued by the scale of the drawings: why so small, almost unnaturally small, for such accuracy? I looked at them and then blew some up on a Xerox machine to examine the line more closely. To my surprise they reminded me at times of Warhol's drawing – lines made without hesitation, bold and strong – but I knew that essentially Warhol's were traced. Could these have been done the same way?

The faces in the portrait drawings by Ingres have likenesses that one feels are true. Like real faces, each is very different, but likenesses are achieved by the relationship between the eyes, nose and mouth. Mouths are especially difficult to draw and paint (as John Singer Sargent said, 'A portrait is a painting with something wrong with the mouth'). The mouths on these drawings were most clearly seen but were drawn very, very small. To anyone who has drawn faces from life they seem uncanny. I found myself fascinated by them and kept studying the reproductions.

I looked closer and closer and began to think that some mechanical device must have been used here. I remembered many years ago buying a camera lucida: I tried it for a day and forgot about it. So I asked my assistant Richard to nip down to our local art store and buy one – I knew they would have one. Using it, I made a drawing of him. It is a very simple device – quite small, really just a prism, but it enabled me to place the eyes, nose and mouth very accurately. I then drew from direct observation.

It is merely a tool to place positions very precisely. You still have to be extremely observant and skilful with the pencil, and only Ingres could make drawings like this. When I first suggested my theory to art historians they seemed horrified, as though this knowledge would diminish the work. Why, I don't know. Who else made drawings as good as these? Ingres witnessed the birth of photography. His rival Delaroche, upon seeing the daguerreotype, made the statement 'From today painting is dead'. He perhaps meant that the hand inside the camera had been replaced with chemicals.

I think the history of photography and painting in the 19th century has yet to be explored. People hide things – trade secrets as it were – but it is interesting to note that Degas, a great admirer of Ingres, was fascinated with photography. Cézanne did not care for Ingres and his work is very unphotographic. It seems to me that there is an interesting story here, and not just about the biographies of the sitters. Delaroche couldn't have foreseen that his remark about photography wasn't going to apply for ever. Few people can see that, even today.

The period of chemical photography is over – the camera is returning to the hand (where it started) with the aid of the computer. All images will be affected by this. The photograph has lost its veracity. We are in a post-photographic age. Even in movies this is happening, in *Jurassic Park* and the new *Star Wars*. What it means I do not know. There is a deeply disturbing side to all this, yet also a thrilling one. There is a minimum of two sides to everything – and perhaps an infinity of sides; exciting times are ahead.

Martin Kemp to DH
Oxford
25 August 1999

Dear David

The *Nature* piece has appeared. They provide me with no offprints – hence the photocopy.

Let's keep in touch. I intend to follow up Ingres, and am also interested in something on your ways of seeing.

Ever
Martin

Nature magazine
5 August 1999

'Lucid looking: David Hockney's drawings using the camera lucida' by Martin Kemp

What are we to think when one of the greatest draughtsmen of our age resorts to a drawing device patented in 1806 and primarily intended to provide assistance to amateurs? The artist in question is the renowned British painter, maker of photoworks, stage designer and master of the pencil David Hockney. The device is the camera lucida, invented by William Hyde Wollaston, physician turned chemist and optician, as a way of overcoming his inability to depict admired scenery.

The camera lucida stood in a long line of descent from various optical drawing devices, ranging from mechanical perspectographs to lens-based camera obscuras. Indeed, its name played on the fact that it did not need the 'dark chamber' of the camera obscura and could be used in any light conditions. The convenient and readily portable camera lucida used a four-sided prism, two faces of which were set at 135°, to send a twice-reversed image to the eye via two internal reflections. Wollaston explained how a draughtsmen could simultaneously see both the object to be portrayed and a horizontal drawing surface, providing the eye is 'so placed that only a part of its pupil may be intercepted by the edge of the prism'. This difficult trick was facilitated by a hinged eyehole, while supplementary lenses helped with the problem that the eye was required to focus on both the object and the image plane.

Used by some professional draughtsmen, including the sculptor Sir Francis Chantrey, as well as by countless hopeful novices, the camera lucida

largely passed out of service with the spread of photography. Wollaston's prism was a demanding device to use requiring considerable ocular control. Even then, an unskilful artist would achieve only 'lamentable results' – to quote William Henry Fox Talbot, whose failure to produce decent landscape drawings with the camera proved to be a powerful goad to his invention of calotype photography. By contrast, the astronomer Sir John Herschel, adept at using his eyes with telescopes and well equipped with draughtsmen's skills, achieved beguiling results.

Hockney, who has been consistently concerned with issues of seeing, representation, perspective, space and the camera, has recently seized on Wollaston's invention to undertake a series of drawn portraits. Unlike an inexperienced artist who is likely to attempt a laboured tracing of contours, Hockney uses the instrument as a sighting device, briskly demarcating key points of the features, such as the corners of the eyes and the line of the mouth. The advantage is that such key registers of expression can be rapidly established before the sitter's expression freezes or sags. Removing the device, he then delineates the shades and highlights through an intense process of observation and depiction, in which his gaze incessantly 'tick-tocks' from face to paper at intervals of no more than two seconds. Being portrayed by Hockney is, as I can testify, to be machine-gunned by an ocular marksman of the first order.

The results share something of the quality of the photographs, while not looking like photographic images. They remain, recognizably, drawings in Hockney's style, yet they are discernibly different from the entirely 'freehand' portrait drawings from earlier in his career. They exhibit a combination of fresh immediacy (the short exposure) and unrelenting intensity (the long exposure) that entirely validates the artist's surprising adoption of the camera lucida.

The results also feed back into the history of the device. Hockney took advantage of his recent visit to London from his home in California to scrutinize the portrait drawings by the French neoclassical artist Jean-Auguste-Dominique Ingres, then on exhibition at the National Gallery. His intuition is that Ingres used a camera lucida to facilitate the making of drawn likenesses of visitors to Rome in the second decade of the nineteenth century. It is a happy intuition that, in my capacity as a historian, I hope to explore further.

reproduced in M. Kemp, *Visualizations: The Nature Book of Art and Science*, 2000

Two Bunch Palms
20 September 1999

'The coming post-photographic age: part II' by David Hockney

Earlier this year I studied, and then wrote about, Ingres's use of optics in his works. I had made the connection by observing the drawing of the clothes, which at times reminded me of Warhol's drawings, lines made without hesitation (not groped for), essentially traced. Warhol used photographs, which did not exist in Ingres's youth, but cameras, of course, did.

I made some drawings using, as a measuring device, a camera lucida (patented in 1806, but the optics must have been known before). It has taken me six months of intense work to use it skilfully but I am intrigued by the results. I began to see similar effects in the work of other artists.

I note that art historians today seem reluctant to discuss 'tools of the trade', especially optics. There seems to be a thick opaque glass curtain drawn down on the subject. Yet tools and techniques have effect built into them and can't be ignored easily.

Let me say now that the use of them diminishes no great artist. They require a lot of skill to use and can really only be used for measurement or linear descriptions of difficult-to-draw objects: lutes foreshortened; patterns on fabrics following folds; folded draperies; architectural curves; foreshortenings in rooms; and the human figure. Optical devices do not make marks, only the hand can do that.

I have been looking at the work of Caravaggio. It is known he used mirrors. 'Art as a mirror of life' is a phrase Gombrich uses. What is the history of mirrors? We know they were rare and very expensive. The one on Mr and Mrs Arnolfini's wall was a very rare thing in 1434 – mirrors reflect, reflections can be traced. No real self-portraits could be made without mirrors, so the history of mirror-making should interest the historian of pictures. It was easier to make small convex mirrors before flat ones. They were made by blowing small globes of glass into which, while hot, was passed through the pipe a mixture of tin, antimony and resin or tar. It was cut when cooled and then formed small but well-defined images. This was probably the first time for centuries a room with full figures was seen reflected.

Flat mirrors were harder to do and very expensive. In the inventory of effects made on the death of the great French minister Colbert is enumerated a Venetian mirror 46 inches by 26 inches in a silver frame valued at 8,016 livres, while a picture by Raphael is put down at 3,000 livres.

The Netherlands was a centre of mirror-making and lens manufacture. Their attitude to perspective was not mathematical like the Italians' but appeared to be intuitive. Life through a mirror was certainly seen by the van Eycks in the mid-15th century, their clarity of vision must be related to it.

Netherlandish artists went to Lombardy. One of the Brueghels was doing flower pieces in Milan during the 16th century. They are well, even minutely, observed and today look 'accurate' to us.

Caravaggio was trained in Lombardy in the 'lowly' art of still life. Perhaps he was introduced to lenses in this period. The historians tell us that Caravaggio's 'naturalism' burst on the scene about 1590. They interpret it as a great change from Mannerism, and the classical geometry of Italian painting. 'Never before had anything been seen like this', etc. And I point out that the critics first complaint was that the saints looked like ordinary people: Bacchus like the boy next door, St Peter like the old man down the street. No noble saints with flowing graceful robes infused with a divine aura.

It is said that Caravaggio was true to nature, that his paintings had an immediate and powerful impact – they looked like real people in the real world, as indeed they do. We still think so today.

He worked in cellars with his own lighting, obviously carefully arranged. Strong chiaroscuro occurs as it would from one strong source of artificial light. The darkness of the room would be necessary for any use of lenses. It is said he only painted what was in front of him (this would be true of all len-based picture-making, including photography today). He used models from the street. Of course he would if he wanted them to pose and keep still – aristocrats wouldn't be too keen to do this.

My point here is that the method means the boy next door *is* a saint, the old man down the street *is* St Peter – the method demands it – it is built into it.

He did not paint frescos – impossible with this technique and his only ceiling is a canvas in oil paint stuck on, not part of the plaster. One can understand why.

In 1525 Dürer makes a woodcut of two draughtsmen plotting points for the drawing of a foreshortened lute, telling us really how difficult it is to do.

His contraption is complicated, with strings and holes made in a screen – and needs two people to do it.

Well, 70 years later, without drawing, Caravaggio paints a boy playing a lute very beautifully foreshortened, and to show his skill he adds a violin with bow on a table with perfect foreshortening, and a book of music with curled paper and readable music perfectly following the curve. To any draughtsman, eyeballing that accurately is virtually impossible. Perhaps you have to be a practitioner to know this. Art historians don't draw today. Ruskin would have noticed things like this, as he used the camera obscura himself.

The impact of Caravaggio's pictures was immense – 'How real', etc. And I realize that Cardinal del Monte, who owned his gypsy fortune-teller and boy playing the lute, would have felt that the boys were actually in his room. It was like a mirror reflecting them, and cheaper than a real mirror. I can understand his delight. (Personal foibles are a driving force of life. The Cardinal shared his room with a lot of boys).

This, of course, leads us to Velázquez (Spain ruled the Netherlands, so he would have known about lenses and mirrors, and Rubens suggested he go to Rome – to see art – and no doubt new techniques). Velázquez paints with a much looser brush, yet there is always an accuracy in the elaborate clothes – patterns following curves accurately, etc. The use of optics here could also account for what to me have sometimes looked like heads out of proportion to the bodies (I'm speaking of the single full-length portraits) yet so convincing in their naturalism that we take them in easily.

The flow of my thought is that it seems somewhere between 1525 (Dürer's engraving) and 1595 (Caravaggio's boy with a lute) a lens was developed that, combined with the natural phenomena of a camera (hole and dark room), became a tool for artists. This, it seems to me, would explain the newfound naturalism of these painters, and the thrill people had when looking at them.

Everything I have read about Caravaggio points to this. He is, of course, an immensely talented painter, with great natural skill who would have taken to these devices rather thrillingly. He could set up his studio in any dark room with equipment that could be carried. He would also develop naturalistic skills with his careful observation.

Helen Langdon's recent biography does not deal with technique much, but there are enough clues for a reader like myself to notice. She points out that Baglione, a contemporary and admirer of Caravaggio and his early biographer, refers to his use of mirrors and other optical devices, but then goes no further, saying his descriptions of optical devices are overcomplex (for whom?). Neither Caravaggio nor Velázquez left many drawings. They did not use that technique – they left that to the Carraccis and their academy – there seems to me a perfectly understandable reason for this.

The later critics of Caravaggio condemned him for his naturalism – too down to earth, no lofty heavens, no clear geometry, no soaring angels – indeed, his angels do look as if they are suspended from ropes.

After Velázquez, a naturalism occurs in all European art, figures are not drawn 'awkwardly', at least not in highly professional painters. We won't see it again until 1870. In comparing Caravaggio with Velázquez, one can see that the hand, no matter what optics are used, counts a great deal. Observational skills are admired (as indeed they are in photography).

To come back now where I started my enquiries, Ingres, we know he witnessed the invention of the chemical process of fixing the projected image on glass, then on paper – now known as photography. It was regarded as 'the truth' – the pencil of nature. The skills of the hand were not needed, yet other visual skills were. This really represents 'reality' or the visible world as we think we see it. It dominates all representations of the world today – east and west, north and south.

It's about 1870, when the photograph was being established as a cheap form of portraiture, that painting begins to move away from the lens. Ingres died in 1865. His last self-portrait has the tonality of the photograph – compare the forehead of M. Bertin (1834) with the forehead in the self-portrait and one can see the effect on painting of the daguerreotype.

Painters looked outside Europe, for new ways of seeing and discovered Japan (via the print) – and therefore China, the original source, and saw an anti-lens way of seeing. The story from then on is clear. The lens moves on into photography – then film and television.

The moving image for the masses flourished quickly, but it is easy to forget that it had existed before the cinema, and in colour. Rooms were built overlooking Italian city squares where, in the dark, visitors could watch the activity and life in the square projected onto a wall. A representation of the visible clearly seen, yet all on a flat surface.

Photography, film and television developed out of the painter and his lens. It caused painting to turn away from the visible world or to try and see it in totally new ways like Cubism (TV was reality).

It is possibly only now at the end of the 20th century that we can see the flaws in accepting this dominance of the photographic. The movie and television, being time-based, are more ephemeral than was thought. Most of the movies made in Hollywood do not now exist. The mass of them were shown once, stored carelessly, rotted, and physically disappeared. The great ones (the ones that are loved) have, like great paintings, been stored carefully and studies are now being made to preserve their physical condition. Nevertheless, like music, another time-based art, the past has to be edited rather ruthlessly since we have to live in real time. The power of still images is still with us. If I mention Henry VIII, an immediate image of him comes to the mind, an image made by a great artist (possibly with the use of a lens), Holbein. To mention Princess Diana, a fog of images might occur, but not a memorable one was made. Mrs Siddons will be remembered better – she was painted by artists of talent.

It seems to me that art history has missed something. A grand revision of the last 500 years is needed. Scholars who realize that tools give effects, that mediums have certain subjects built into them (early movies loved fires, like television today), could begin to give us a very different story, even explaining what seems like a loss of art. People still see what Gombrich called the mirror of reality, pictures about now – television. The deep desire to make and see images is still with us.

I mentioned in my previous note that the camera was returning to the hand; where it started – with the aid of the computer, yet it is still hard to escape perspective (if perspective were reversed, playing video games one would be constantly aware one was killing oneself).

Gombrich compares a Cézanne still life with its (new) awkwardness to a Dutch still life with its seemingly perfect vision. Surely Cézanne can be seen as anti-lens – he looked with two eyes not one, which opened up unphotographic vision. The rise and interest in the power of colour in art perhaps had connections with the monochrome of what seemed like the most vividly real representations of the world in photography.

There have been excellent portraits made in the 20th century by the still camera, but not that many memorable ones, and none that can probe character like Rembrandt. Film and video bring its time to us. We bring our time to painting. It is a profound difference that will not go away.

Two Bunch Palms
21 September 1999

'The technique of Caravaggio' by David Hockney

The more I look into Caravaggio and think about optics the more I think his tool had to be a quite sophisticated lens.

As I have suggested, many painters used a lens after a certain date, common knowledge, so not commented on very much. If one went to a photographer today, and described what happened, one wouldn't say, 'Well there was a black box with a bit of glass in the middle on a stand and a cord which he pressed.' One would say, 'Oh, they were very nice, made me a cup of tea, set me at ease, chatted wittily, etc., etc.'

References, anyway, to Caravaggio's 'glass' surely mean a 'lens' – a telescope is a spy glass, a mirror is a looking glass, etc. (I mention this for the historian of pictures who wants everything in writing so they don't have to look very hard at the pictures and deduce methods, which, as I have pointed out, have subjects and ways of seeing built into them.)

He travelled a lot, so the equipment had to be portable, not really very big. So I suggest a lens that is not much bigger than two cans of beans.

Some lenses are more sophisticated than others. Compare the results of a throwaway camera (cheap plastic lens) with a photograph of exactly the same subject, lighting and film taken with a Leica. One will be fuzzy edges, all colours tending towards murky green. The other will be sharper and have richer and more varied colours. Common knowledge you might say – but I mention it for those who want it in writing etc., etc.

The lenses were all handmade, hand ground, etc. Caravaggio's would never leave his person, unless he was using it. In the highly competitive world of painters no wonder he carried a sharp sword in those violent times.

He worked in dark rooms – cellars – very common in those days (not too many people lived in large rooms with large windows – remember the small panes of glass with lumps in the middle – flat glass was more expensive). He used artificial lighting, usually from top left. He would use models from the street – who else would sit still for him for so long? – and was known to work very fast. How long can you hold your arms outstretched, even resting on a stand. Try it, you begin to ache under the arms.

So the supper at Emmaus was set up carefully in a cellar, lit carefully, and then he put his lens in the middle on a stand and hung a curtain (thick material in those days) round it. The room is now divided into a light part and dark part. He is 'in the camera' and the tableau is projected clearly with telescopic effects (notice the rear hand is bigger than the front hand nearer to you).

He covers the canvas with a rich dark undercoat that, being wet, reflects light back. He takes a brush and with the wrong end draws guidelines for the figures in the composition to enable him to get the models back in position after resting, eating, pissing, etc.).

The foreshortening is so good, so real, or what we think of as real (because of telephoto lenses), that it has to be done this way. (Hold your own arms out, etc., etc.) He rapidly paints on the wet canvas, skilfully, and with thin paint knocking in difficult bits, and then with his virtuosity he can finish by looking at the scene in reality – take down the curtain – turn the canvas round and put in the final details.

If it took a week, think of all the coming and going, resting, eating, shitting, etc. If it took longer, there's even more coming and going, resting, eating, etc.

All this sounds perfectly plausible to me. Say there was no lens, then give a reasonable explanation. There are no drawings, no notes.

Good night.
Advice: look at van Dyck again, carefully.

Two Bunch Palms
21 September 1999

'Notes on lost knowledge' by David Hockney

The more I think about lenses and painting, and after using the camera lucida, I think one aspect to look for, especially in Velázquez, are the expressions on the faces.

In his *Bacchus* (1628–9), the fleeting looks and open mouths would have been very difficult to 'catch'. Compare Cranach with this.

Bacchus himself seems to be glancing away and the man with the dish of wine has an expression that cannot be held too long. His mouth is open in a semi-smile, causing the eyes to narrow with wrinkles round them. This kind of expression has to be caught fast. The mouth and eyes relate marvellously and I think could only be done by a virtuoso painter with the help of a lens.

All the other faces have lively expressions, transient really. I've drawn a lot of faces lately and understand the difficulty.

MK to DH
Oxford
26 September 1999

David

Text and pics arrived OK. I'll send a commentary – all really fascinating.

Yours
Martin

DH to MK
Los Angeles
28 September 1999

Dear Martin

Here is a suggestion perhaps overlooked. Who would have the first lenses? It is assumed that the world of science would have them first, but surely the world of images was more important and powerful. Surely the King of Spain and the images they knew were possible would come *before* the telescope and microscope, entering a more secretive and competitive world.

My first title, 'Joshua Reynolds had a camera obscura that folded up to look like a book', gives us a clue. I know how secretive artists can be. The world of science is by definition more open. David Graves has located mention of a book published in 1558 that would be worth looking into.

In the Holbein the objects on the table include a globe with the word 'AFFRICA' perfectly following the curve – go see it. It certainly can't be 'eyeballed'. Would not this suggest a lens as well? Again they would be very secretive about this, almost like state secrets today, and I'm sure Caravaggio

dying on the beach would have thrown the lens into the sea rather than let it fall into the hands of rivals.

Also I would point out that the image does not have to be the right side up to draft and block in the composition. Many artists know the advantages of working upside down – everything is equalized in a way. The mirror could then be how he sees the real scene – merely looking in it to get his composition right when he is working from observation.

Not all artists know this, but I do know that Malcolm Morley, when he was doing his photo-realist work, preferred it upside down. Could this also be Lawrence Gowing's point about Vermeer – everything as painted equally – not so in mathematical Italy.

Just thoughts, but perhaps non-practitioners never think like this.

My excitement grows.

David Hockney

MK to DH
Oxford
28 September 1999

David

Response to your faxed paper, which I was delighted to receive.

I think it is tremendously important and exciting that an artist who has spent a lifetime (sorry, sounds posthumous!) translating the seen scene into painting, with all the intensity of 'eyeballing' and experiment that is involved, is subjecting the 'old masters' to radical scrutiny. The observations you are making and the ideas you are proposing can play a vital role in helping us to look more intensively at paintings – in dialogue with the evidence available to historians. Although some historians may feel more secure without the visual challenges you are proposing, I will do the best for my part to respond openly. Not least, it is exciting for a mere historian to see how your present concerns are integral to the quest on which you have been engaged since your debut as a professional artist.

I have some general points and some detailed observations:

General
The eye itself (or what was thought to be the working of the eye) has been a kind of model for painting since the time of Alberti's *On Painting* in 1435, in which representation is founded on a simple notion of how the 'visual pyramid' works and its relationship to the representation of things in space using light, shade and colour. The camera obscura as the specific model for the eye is inherent in Leonardo's treatment of the eye's optics, though he increasingly realized that the complexities of the eye and the intellectual acts of seeing meant that any simple model that the eye simply sees what is 'out there' does not work. The fully fledged notion of the eye as a camera obscura with a focusing lens does not become apparent until Kepler in 16??.

Early lens technology was relatively rudimentary, and limited to simple magnification, not least for spectacles, with major problems of aberration. The great impetus came in the early 17th century with the telescope and microscope, most specifically with Galileo's intensive and successful efforts to make lenses that would deliver better pictures of the moon than the rudimentary telescopes that rapidly spread across Europe after their first outings in the Netherlands and Venice. (Did you know, by the way, that telescopes were initially touted and patronized as military and naval

'spyglasses' for the seeing of distant enemies?) Phil Steadman in his forthcoming book on Vermeer shows that good, largish lenses were available to the painter – and Vermeer was a friend of the great microscopist van Leeuwenhoek.

I would not put all my eggs in the lens basket, particularly in the earlier periods. There were other ways of achieving perspectival foreshortening, and each case needs to be looked at on its merits. It was possible, for instance, to foreshorten lettering by perspectival construction. I think the general rule is that the more difficult and complex the form, the less likely it is that geometry was used, and the more likely that an optical device would have been of service. See also below.

Mirrors are an important part of the story, optically and technically. One impetus for development came from attempts to devise better 'burning mirrors' – i.e., concave and, ideally, parabolic – for soldering metal and military purposes. Good mirrors became prized objects – Velázquez had quite a collection. However, mirrors cannot be used for practical acts of picture-making in the same direct way as lens- and prism-based devices.

Specific
I don't quite see the relevance of Brueghel's flower pieces. If you are wanting examples of interchange between the Netherlands and Italy, there is no shortage of earlier instances, not least Antonello da Messina in Venice. Do you know his magical *St Jerome* in the National Gallery, London?

I'll chase up the Caravaggio references, especially Baglione, which are not known to me. I'll let you know in due course. The Caravaggio lute does pose important questions, since as you say, you don't do it by 'eyeballing'. He must have either used perspectival geometry of the kind that is found in Ludovico Cigoli's treatise, which was being written in Rome at the same time, or, as you argue, an optical instrument. There's no hard evidence, but Caravaggio's 'speed' and what we know of his temperament would incline me to think that he used a direct technique rather than bothering with lots of geometrical procedures.

The question of the foreshortened arm in the *Supper* also raises important questions, as you have identified. I take your point about posing, and the model you propose has the enormous virtue that it provides a concrete way of thinking about how the artist achieved his ends. Historians tend to analyse the ends without thinking about the means. In the absence of documentary evidence, your model must remain a hypothesis, but, unlike other models, it is based on real considerations of practicalities. The large distant hand could arise for 2 (or possibly more) reasons. The first is, as you suggest, a quirk of an optical device, in the manner of a telephoto lens. The second is that he may have been reluctant in terms of 'pictorial good manners' to follow the full implications of the foreshortening by including a greatly diminished hand, just as Mantegna did not follow the diminution of Christ's head in the Brera picture – similarly, Uccello in his fallen knight. In this instance, I am inclined to favour the second explanation – but that does not invalidate your hypothesis about his use of optical devices.

Your rectification of the Holbein skull is very neat – something of the kind was achieved for the National Gallery show after the painting's restoration. Obviously, he needed an optical means to achieve the anamorphosis. I don't think any lens-based device is needed here, since there were simple techniques of using a distorted squaring system (see my book), such as was known to Leonardo and to German artists of the period. There are signs in Holbein's drawing of his use and interest in geometrical perspective of the Dürer kind, and it is reasonable to think that he would

have used some of the kinds of drawing devices that Dürer illustrates. I don't see Holbein using a lens-based camera obscura at this stage for historical and technical reasons. Your arguments about lens-based devices don't NEED the Holbein skull.

Concluding thoughts

There will always be some measure of problems in relying upon the pictures as your main (and, in some cases, only) evidence. The means are inferred from the pictures and then made to account for effects – which is potentially circular. However, in many cases, the historian is faced with doing just this, since independent documentation does not survive. The GREAT MERIT of what you are bringing to the field is your sense of how something might have been achieved given the realities of 'eyeballing' and picture-making. I find this dialogue fascinating – no one has a monopoly of rightness in these matters – certainly NOT the art historian – and it is a privilege for me to see the way in which your questioning is all of a piece with your own visual impulses as expressed in your art over the years.

I hope you don't regard any of all of this as too pedantic – but that's my job!

Martin

Gary Tinterow to DH
Metropolitan Museum of Art, New York
29 September 1999

Dear David

Well, I have found one thing that will, I think, encourage you. Phillip Pearlstein also thought that Ingres may have used a camera lucida. In Joseph Meder/Winslow Ames's (Meder died in 1934, I think) *The Mastery of Drawing* (1978), Ames cites Pearlstein's 'Why I Paint the Way I Do', published in the *NY Times* in 1971. I am sending you xeroxes of the relevant passages. Hope this helps!

All best
Gary Tinterow

> Pearlstein gave an example of the art-historical involvement of the modern artists and of the travel to every corner of the world which has extended the beaten paths of the Grand Tour: 'Before coming to Tikal, I visited the Mayan ruins in the Yucatan, and so have been reading *Incidents of Travel in the Yucatan* by John L. Stephens … the book is illustrated with engravings made from daguerreotype views and drawings "taken" on the spot by Catherwood. The drawings were "taken" by the use of a device called the camera lucida … a very common tool for nineteenth-century draughtsmen and artists. It allows the artist to see an apparent superimposition of his subject on the surface of his paper by means of a simple arrangement of prisms … Catherwood's drawings of jungle ruins bring to my mind … Ingres's drawings of Rome … and I wonder now if Ingres didn't use the gadget himself (Oh! Disillusion).'

Los Angeles
30 September 1999

'More notes on lost knowledge' by David Hockney

Vermeer's *The Art of Painting* depicts a painter 'eyeballing' a girl. But this of course is not Vermeer – he is painting the depiction. Step back and we get a different picture.

I am suggesting there are two traditions, one of the lens and one of 'eyeballing' – the Carracci school. The lens depicts the Carracci school. The Carracci school does not depict the lens school.

I keep saying lens because the camera is a natural phenomena like a rainbow. It occurs in nature. It is not an invention. The lens is an invention.

I remember seeing a photograph of some children in Belfast holding rocks and milk bottles and looking very angry. The picture's subject had quite an effect on me, until I saw another picture, where a photographer had stepped back and one saw a row of a dozen photographers photographing the children. The children were performing for the lens – a very different emotion overcame me. Is not something like that going on here – and in lots of other pictures of artists? They do not reveal their methods. Perhaps this was OK before 1926 (the Heisenberg principle) but surely is not possible now.

What was really happening here? The 'reporters' were not outside an event, they were participants. There is no neutral viewpoint – the observer affects the observed.

The 'press', or media as it is called now, is the last group claiming a neutral viewpoint. But isn't there a contradiction here. If Western technology depends on Heisenberg's equations, then those equations affect everything. The two traditions, the secret hidden one of the lens is colliding with the 'eyeballing' Carracci tradition. It is failing.

Something is happening at the end of the dismal 20th century, either a wider vision on catastrophe, or a wider vision is catastrophe, but the old hidden ways don't work.

The lens has become very common, from being a highly secret and rare thing. Is vision being 'democratized'? Is this its effect?

Perhaps I should call all this 'Lost Hidden Knowledge', or so it seems, if one takes a step back.

Is it something we do not want to know?

Television news will not tell us that the audience for television is getting smaller. It is against the interests of 'the media'. Painting in Vermeer's day was seen by very few people. They were generally educated or 'connoisseurs'. A friend said, 'Yes, the rest of the people were kept in the dark', but it is the lens that points to the light from a dark room. Camera obscura is 'dark room'. Who was in the dark?

It is only in this century that images are everywhere, even if they are not very memorable. In Flaubert's story 'A Simple Heart', Félicité, the servant girl, worries about her nephew who has left France. He has gone abroad. She has only seen one picture of 'abroad' and not many pictures, if any, of 'France'. The picture depicts a monkey carrying off a girl (I made an etching of this in 1973, it fascinated me), so Félicité worried. The Greeks knew about the natural phenomena of the 'camera' but did not trust it. Research here might reveal their reasons.

Do we want to know?

Wasn't it Gombrich who said perhaps there was no such thing as 'Art' but there were 'Artists'?

So what is 'Art History'? Is it the history of 'depiction'? What is 'Art Practice'? The lens is the dominant way of seeing but maybe we are beginning to see around this.

Good night.
D. Hockney

MK to DH
Oxford
1 October 1999

David

Finally back home after dealing with all the 'institutionalism' – everything that does *not* matter – and with the chance to continue the dialogue. By hand – hope you can read it – because my computer won't drive my printer at present. So much for technology! Various somewhat random thoughts, with the hope of something coherent emerging in due course.

Expressions
There was a tremendous burst of artists working with extreme, fleeting expressions in the early 17th century: Caravaggio (esp. the *Medusa*), Bernini (*Anima damnata*), Rembrandt (the early self-portrait, as in National Gallery show), Velázquez … They were very much taking up the theme of Leonardo (e.g., shouting heads of warriors for his lost *Battle of Anghiari*). The question is to what extent great artists could 'fake' the fleeting expression or whether they needed an instrument to help the 'freeze'. Leonardo, we know, carried small notebooks to capture unusual physiognomies and animated expressions. I think he would remake expressions on the basis of his rapidly drawn records, his knowledge of facial structure, and his ceaseless graphic experiments. For Leonardo the highest aim was to RE-MAKE nature on the basis of understanding, rather than direct IMITATION. It may be (and this is thinking 'out loud') that the characteristic look of early 17th-century characterization of expression is founded upon a different kind of directness – that, compared with Annibale Carracci, who revived the Leonardo approach, Caravaggio, Velázquez, and others strove for a more direct approach that would deal with *what* the eye sees rather than reconstructing *how* it works in terms of perspective theory. In this, the camera obscura etc. would have a vital role to play as a model. It occurs to me that there may be something *big* in this, as you rightly say. It *is* possible that the history of naturalism – conceptually and optically – needs to be rewritten in the light of your challenge to historical orthodoxy. It needs a lot of thought.

The artist and the historian
The artist, looking at other artists, has a strength and a freedom that the historian can't claim. The strength is that the artist has done it. Knows how difficult it is. Knows, by practice, how to do it. Can look at other artist's work and say 'If I had to do that, I would do it as follows …'. The freedom is that the historian is bound, as a point of *method*, to build systematically from what is documented, what happens to have survived in the form of evidence. The historian has to fill in the undocumented gaps, but has to do so with great restraint, only going into realms of speculation when the evidence won't deliver the necessary results. Paintings are, in one sense, 'visual evidence', and it is in deciphering this evidence that the artist and historian *should be* engaging in the same business. Does the artist, looking at art of the past, suffer from weaknesses to offset (in any degree)

the strengths and freedom? The weakness (or rather danger) is that the artist believes so much in his/her practice that he/she sees all artists through his/her eyes, assuming that how he/she would do something is what an artist of the past *actually* did. In the light of this, where your arguments are *most* compelling is where you use the 'evidence' and the paintings to say that the very best (or only) way to have done such-and-such is to use lens-based devices.

Secrecy
This is a tough one for a historian. It's always possible, faced with an idea for which there is no written evidence, to say that it was a secret, and therefore no evidence was recorded. This is, in one way, obviously true, but for the historian it could be used to justify anything – e.g., that Leonardo was a woman, wore a false beard etc., etc.! The literature on mystical sects is full of wild ideas which cannot be demonstrated to be right or wrong. The biggest argument you have for secrecy is that a number of 'your' painters – Caravaggio, Vermeer, Velázquez, Chardin – were clearly artists who thought incredibly deeply about ways and means but left *no* record of their views and techniques. Interesting!

Geometrical construction versus 'cameras'
In general, faced with the foreshortening of a regular object, like a lute, a Renaissance and post-Renaissance artist was faced with 2 possibilities: (1) to do the whole thing by perspective geometry to varying degrees of precision and elaboration; (2) to use an optical device, such as those illustrated by Dürer and others, or a 'camera' of some kind. My strong conviction is that all the earliest examples (up to at least 1550) were done by geometry, using the methods outlined by Piero della Francesca and exploited most strikingly by designers of *intarsia* (inlaid woodwork) decorations, such as the *studiolo* at Urbino (a city in which Piero worked). I think if one looks at the instruments in the Holbein *Ambassadors*, they appear very like those in *intarsia* work. I take your point about the inscription on the globe, but it could be done through geometrical foreshortening techniques *or* perspective devices. If lens-based devices did all the work, it's difficult to know why so many artists and theorists took so much laborious trouble with perspectival *geometry*. I think the argument becomes different after *c*.1550, above all when portraying complex objects (hands, lace, etc.) which cannot be readily done by geometry. In all this, it's a *balance* of judgement, in which your intuitions and my historian's methods are in dialogue (not dispute). By the way, the references given by David Graves are very relevant to what happens after *c*.1550.

The observer and the observed
The notion in 20th-century physics that the intrusion of the observer (or the act of observation) is an integral part of how the phenomenon is manifested is very powerful – both in its own technical field (e.g., whether light is seen as wave-like or particle-like) *and* as a wider metaphor. Your Belfast photo is very relevant. I always wonder about war photography (the Napalmed child screaming in the desolate Vietnamese road) and photographs of skeletal children staring with large eyes into lenses that are nourishing *our* appetite for witnessing horrors. In portraiture, the sitter never just sits. He/she is affected by the act of observation, to say nothing of all the setting-up of the visual experiment. You say that the press are the last ones to claim the neutral viewpoint. But, oddly, the central belief in much scientific orthodoxy is of the neutral, disinterested, value-free nature of empirical observation and scientific logic – 'oddly' because it is science

that has demonstrated the introduction of the observer as affecting the phenomenon. It seems to me that there are lots of ways in which the lens (camera, or whatever) is the intrusive observer. It does its own thing (its own translation according to its own properties). It is something that someone determines to use on a particular subject in a particular way. It is something that causes a reaction from the animate subject. (The biologist refers to the property of an organism to react as its 'irritability' – nice use of the word).

I've written about aspects of 'observer' and 'observed' in an essay in a book of photoworks by Susan Derges (a brilliant maker of photograms from nature). I'll send you a copy when the publisher provides some copies.

Running out of steam – too late – so many issues, all interlocked. Optical, perceptual, cognitive, imaginative, political, scientific, universal, personal. That's why painting is a *big* thing, even for a mere observer like me.

Yours
Martin

DH to MK
Los Angeles
1 October 1999

Dear Martin

Thank you for your handwritten fax. Yes, I can read it. I too have noticed the burst in the 17th century of different expressions – transient in a way Dürer couldn't do. This to me confirms the lens, it's just not possible without it. It means capturing the mouth in relationship with the eyes and the muscles round it.

When were open mouths first seen? Giorgione in 1501 has a kind of grin in a portrait that could be done by a great painter like he was, but might also indicate a lens.

I have learned a great amount in the last six months of drawing faces, and it took all that time, making on average one drawing a day, sometimes two, but the intensity involved is very tiring.

I think another thing to look for are armour or complicated patterns on fabrics that follow the folds. You hardly ever see this in Titian and what you do see could have been eyeballed by as great a painter as him. They certainly happen in Holbein – indeed, he seemed to like to show it off. The curtain behind the *Ambassadors*, tablecloths going over edges, etc. to my practical eye means a lens.

I am probably one of the last people trained in the old art school ways. I went to Bradford School of Art when I was 16. You could leave grammar school if you had done GCEs, as they were then called, and they wanted me to stay on, as most scholarship boys did, to go to university, but I was determined to go to art school.

My training was really in the Carracci tradition. Drawing four days a week from a life model. It teaches you to look. The method was quite simple. Students arranged themselves in a semicircle round a model with an easel, or a donkey (a bench with a stand to lean the drawing board on). After we had worked silently for half an hour, the teacher would start at one end, sit down, look at the drawing and then in the corner of your paper start drawing a shoulder or arm. I watched and realized he'd seen more than I had, and I never drew badly again. I was led to believe (lost knowledge) that Ingres had used a plumbline and had held up a pencil with his thumb to make difficult measurements. Four years of this at that age is actually an excellent education for a young person full of curiosity. In the past, they

would have started at a younger age, so discipline was easy and expected, just like Bradford Grammar School.

I then witnessed the decline of this system, when I was at the Royal College of Art. The Department of General Studies had taken over, and drawing from life was not compulsory by 1962. I hated the change and told the Professor of Painting that it was his job to profess painting. I even failed the course because I hadn't attended enough lectures – neither had most of the other students, but they had taken the trouble to go and sign in. I thought it a waste of time (they were not about art history), and when I was told I couldn't have a diploma, I told them I could engrave one for myself – and anybody else for that matter.

They gave me one in the end but to this day no one has ever asked to see it. I knew they wouldn't. Why bother when you can look at paintings. It's only dentists and brain surgeons who put them on the wall, to put us at ease.

I think the lenses would appear in different places at different times but artists would recognize their advantages immediately. It would also be very visible if they didn't have one – awkwardness, as I have suggested, would be obvious.

I am looking carefully through Velázquez and can now see (I wouldn't have spotted this without all the portraits of the last six months) his development as he got better at it, starting like Caravaggio with half figures (never seen much before the lens). He quickly realized what to note for the faces, very fast and then memory can play its part in someone so observant. One also notices his models are old women, young and old people, who I'm sure were pleased to have a good meal and wine for their work.

By 1625, his *Bacchus* (as I said before) shows this very well. He would begin to look at the world like a lens sees it, and probably at the end of his life could paint in this style from memory. Certainly there is a quick development and the later paintings are far more sophisticated.

Caravaggio, Velázquez, Frans Hals, Vermeer, de Hooch, Chardin, and, I think, Hogarth did not leave behind many drawings – if they had I'm sure they would have been carefully looked after.

Chardin was secretive and embarrassed about not drawing but there is such poetry in everything he set up, why does it matter?

It is the presence of the photograph in our day that has made optical devices seem easy. As you know they are not, although tracing from a photograph, a flat and still surface, is relatively easy.

You have to know a lot of drawing to use the camera lucida well. I know it was made for landscape, perhaps Ingres used them for his views of Rome. I know the catalogue suggests he didn't do them, but I don't see why. They are very skilful and spatial compared with Sir John Herschel's, and show a marvellous 'touch' with a pencil. The obvious points we see were all he needed. The lines are often then drawn with a ruler and it was this method, minimum time spent peering through it, that suggested its use for plotting eyes and mouths, and then intense scrutiny.

All my sitters said it was an intense experience they had, with my concentration extending into them. To look at someone's face that intently for 3 hours is an odd experience, especially for the sitter who has never been drawn before.

In London I like taking the tube from Earls Court to the West End, giving me a chance to look at faces without people worrying. I'd think, 'There's an interesting mouth or eyes or nose sometimes.' You can't do this on a bus with everyone facing the same way and in taxis I'm usually alone or with someone at my side. I am 100% sure about my thesis, nothing I have discovered in pictures or writing has convinced me otherwise.

Wouldn't van Dyck use all the latest technology he could to make sure he got the proportions right for Bernini; and the lace, following the form of his shoulder perfectly indicates this. As you say you can't really do that with geometry.

I'm going to keep on looking at pictures for clues (I'm off to Australia tomorrow but it won't stop me). Don't worry, they will fax any observations you have on to me there, so carry on using this fax number. I've made a lot of slides for the New York lecture. Is it possible you could come? David Graves is coming for five days, and I'm told there are plenty of art historians there.

It's interesting that people are prepared to believe the secretive Caravaggio over honest Albrecht Dürer. He seems to be the only great artist who actually depicted drawing devices. It's also interesting that Rembrandt wasn't so secretive and had a lot of students. He can't have used a lens for those great self-portraits but he might have done for the helmets and armour. Anyway, isn't it his great humanity (like Picasso) that makes him tops.

It's interesting that only Picasso made marvellous portraits out of Cubist ideas. He could paint a pretty girl, and you know she's pretty with soft skin (Marie Thérèse Walter), or an intellectual girl (Dora Maar), with not many sensual curves – her mind being more interesting to Picasso. The faces are not distorted, certainly not like Bacon's (he couldn't paint a pretty girl) and Braque simply wasn't a portraitist at all.

I'm preparing for Down Under now, and will give a talk in Canberra. Gregory wittily said, 'Oh you do it off off Broadway first – and then Broadway.' I like his droll view of life.

Yours still very excited
David H.

MK to DH
Oxford
2 October 1999

Dear David

Many thanks for 2-stage fax. My machine ran out of paper and out of memory (problems with which I can sympathize). I'm making these notes while reading your pages, in the hope that you will receive them before your departure for 'Oz'.

Open mouths
Lots, of course, in earlier art, most spectacularly in Donatello's *Lo Zuccone* (the last of his remarkable prophets for the Campanile of Florence Cathedral. Portraiture is another matter. Open mouths were not (for the most part) good manners, especially for 'ladies'. The most animated and conversational of the early portraits were by Antonello da Messina working in Venice – probably the first 'speaking likenesses'. Showing teeth would not have been approved. There were lots of social rules that condition expressions, which are partly innate but also very social in formation. I reckon I can tell a young American (mainly students) almost instantly by the shapes their mouths adopt – much more teeth (esp. women) than the British. Perhaps a combination of social conditioning *and* dental practice.

Traditional training
I do still believe in skill and basics, hand and eye. Not to produce traditional works but, as a much-repeated quote from Reynolds says, 'learning how to see'.

Ruskin believed this, and understood it totally. The Bradford set-up you describe could be that of almost any European academy from the 18th century onwards. There's a good selection in an exhibition catalogue *The Artist's Model* (ed. Bignamini and Postle) at Kenwood some years ago. The semicircle was devised on the basis of a $^1/_2$ anatomical theatre, especially for life drawings, probably with a Professor of Anatomy in attendance on occasions. ('Donkey' is an interesting word. The Italian word for a trestle is *capra* – a goat.)

Drawing from life and casts persisted in some art schools longer than at the Royal College, in Scotland for example, and at the Ruskin School in Oxford (they still study anatomy).

On the Royal College
It's interesting that the kinds of programmes on the College on television here claim all their rebels as their own (including you, as you will know from your interview). The Rector, and the programme generally, made no attempt to disguise that what is important is not really the training, or the certificate, but *being there*, as part of the legend of the place. What you say is fully in keeping with this.

Awkwardness
This is an interesting criterion. Using an optical device does not dispel awkwardness – a poor draughtsman still produces 'miserable' efforts (to quote W. H. Fox Talbot), but the argument that even a good draughtsman would produce some feeling of awkwardness without a lens is very interesting. This awkwardness could be so small as to be beyond description but produce a very definite, even huge effect. The ability of the human eye/perceptual system to discern the most minute difference in curve, angle, interval is awesome. A friend in experimental psychology at St Andrews was researching tilt (not surprisingly, for aircraft companies who are interested in artificial horizons in cockpits). He found that the ability of subjects to discern minute changes in the angle of a horizontal line was finer than any theoretical model of how the retina works. I wasn't surprised.

Doing it from memory
This is what François Boucher claimed when he spoke to Reynolds, saying how he did not need the model anymore. I'm sure that certain draughtsmen, with a special kind of facility, can fake the drawn-from-life effect, but the more elaborate the pose, the detail, the expression, the less such fakery works. However, some artists transcend every rule. Leonardo could make an 'action' drawing of a spirited dragon which looks as much as if it were drawn from life as his studies of cats.

Ingres
I think you are right; one of the difficulties is that someone with such a magical touch as Ingres covers the traces of the optical device better than an artist who uses it in a more literal and laboured way.

I know what you mean about faces in the underground, or on trains when there are front- and back-facing seats. I sometimes think of casting my own face into someone else's configuration as a way of thinking their thoughts – a creepy exercise. After some time it seems as if you've seen the person somewhere before. There's been a lot of good research on facial recognition. It's a staggering skill.

[…]

Yours ever
Martin

DH to MK
Sydney
5 October 1999

Dear Martin

The reason I go on about the lens and its beginning in painting is that the lens is dominant *today*.

We are lovers of pictures, we are looking at master works from the past that give us pleasure and occupation for the mind, but do remember millions of others are looking at the world through a lens today. The general belief is that it is the real world they are seeing. There is an enormous vested interest in this view, even though we know intellectually this is not true.

The debates here about digital television are all about political power, so the theme is big.

I hope I'm not boring about this but it has gripped me.

Love
David H.

DH to MK
Sydney
6 October 1999

Dear Martin

I have just been looking through a book (I'm sure it's available in England): *The Art of the Portrait: Masterpieces of European Portrait-Painting 1420–1670*, by Norbert Schneider.

If you can get hold of a copy, here are my comments.

In the text on page 6:

It remains a source of continual astonishment that so infinitely complex a genre should develop in so brief a space of time, indeed within only a few decades of the fifteenth century, especially in view of the constraints imposed upon it by the individual requirements of its patrons.

'Remains a source of continual astonishment' – What does he mean? Could not this indicate a new tool, and its spreading quickly round Europe?

(Did you get the account by Count Algarotti that David Graves sent me, admittedly from the 18th c. ,when we know the lens existed?)

Anyway if you get the book in front of you here are my comments:

The frontispiece is undated by Agnolo Bronzino, a portrait of Bia de' Medici. Look at the sleeves, all the folds in the satin (no awkwardness). The chain around her neck, and the chain she is holding in her hand, also the medallion on the chain, with the portrait on it. Compare with the Titian on page 7 (1532/3). His looser painting of the fabric could be eyeballed, but not the Callet of Louis XVI (1783) on the opposite page.

The Holbein on page 8 (1532), with the tablecloth pattern so accurately going over the edge, the satin sleeves and glass vase seem very 'unawkward' to me. The faces of the two Canons on the opposite page (1544) seem almost contemporary compared to the portrait at top right on page 13.

I'd never thought about the Bellini Doge (1501) in the National Gallery here on page 10. Could all that pattern on his hat and coat be geometry? The black-and-white picture on page 11 seems almost 'photographic'.

On page 15. The van Eyck drawing reminds me of the accuracy of Ingres again, especially round the mouth and eyes.

Jump ahead a bit now. Compare the Pope with his prefects (1475) on page 22 with Raphael's Pope with his prefects (1518–19) on page 97. Isn't one mathematical and one optical? In Raphael's portrait the Pope holds quite a large lens in his hand, and look at the detail of the bell on page 96. (Is this geometry or optical? There is certainly no awkwardness here.)

This would all suggest an overlapping of mathematics and optics, whereas the Piero on page 48 and 49 suggests mathematics and eyeballing.

The Pisanello on page 52 and 53 suggests eyeballing.

How would you explain the Leonardo on page 54? The pose is a very difficult twist of the neck, could it be a combination of things?

Wouldn't these tools overlap? I found with the camera lucida that I only used it for measurement in the face, and the clothes were always eyeballed. I had to combine, although I could learn to adapt it to elaborate clothes as well but the neck would be awkward.

Page 67, the Lorenzo Lotto head (1506) seems amazingly clear with a very good relationship of eyes to mouth – slightly open.

On page 71, the portrait by Moretto da Brescia had great detail in the clothes and the curtain behind him (*c.*1530/40) – compare back with the Piero on page 48.

The pattern on the Cranach (page 83) dress is not as elaborate on following the folds as in the Bronzino chain.

Browse through the book. It seems to me they will use any technique available, and constantly overlap.

What do you think?

David Hockney

Sydney
6 October 1999

'More thoughts on the lens' by David Hockney

The chemical process of photography was in place by 1839–40. The development of printing on paper with fixative was certainly in place by 1850. By about 1865 there were portrait photographers in every major city in Europe and the United States. The cheap portrait had arrived. It's spread was very quick and obviously came first to the merchant class of the booming times.

Could one use this parallel with the earlier spread of the lens for painted portraiture by hand? The centres then were certainly the Netherlands and Italy. England imported its skilful artists from these areas. Holbein, van Dyck, Rubens.

Is not the human appeal still the same? Would not this be the reason for its spread. My suggestion that it's use overlapped with eyeballing and geometry might also suggest the reason for the attacks on Caravaggio, who used it without overlapping. Poussin thought he had ruined painting. Why? What did he mean? That he wouldn't come out of his cellar, was the jibe made about him.

Looking again at the Holbein portrait of Georg Gisze [*see pages 62–3*], one notices on the tablecloth a small cylindrical object between the glass vase and the wooden pestle. It's got a small door opened, yet its top is slightly not parallel to the surface, especially when compared to the base of the glass vase.

Could these be faults caused by a different projection? It seems to me a practical explanation.

Notice as well in the bottom corner the tablecloth dips and yet the money holder showing the coins is slightly skew-wiff, yet perfectly seen with its shine on the pewter very well done.

It's a beautiful picture anyway, by a marvellous, skilful, highly observant artist.

It's amazing what happens when one knows more about what to look for.

Still working

Sydney
6 October 1999

'The painter and his lens' by David Hockney

The lens began with the hand, or, as I said, the hand was in the camera, and it is returning to it now.

But one can see the absolute subjectivity of vision reflected in the painter's use of it.

Velázquez simply had a fantastic eye for rich colour and tone that the lens does not necessarily give. Only the painter's eye and his connected hand does this. Hence the amazing differences between painters' use of it.

I have mentioned the difference between Caravaggio and Velázquez, or the similarities – especially early Velázquez with figures seated round a table which would be simpler to plan with a lens, but its use would train the painter to see that way and in the end he may not have needed models in front of him. The eye and hand had coordinated themselves with the heart and came together in the great masters.

Marco Livingstone to Richard Schmidt
London
6 October 1999

Dear Richard

David rang me yesterday from Australia, but I don't know where to find him so I'm writing you instead.

He was wondering if I had had any feedback yet from art historians. Could you tell him that Helen Langdon phoned me at length today to say that she found his ideas very interesting, but that, as a non-practitioner, she did not feel equipped to come to any immediate conclusion. She also says that there is nothing in the literature on Caravaggio about him having owned a glass. What she will do, however, is to get some references and texts together for him, including a long technical report that was made on the *Supper at Emmaus*.

This morning I was reading the catalogue of last year's Pieter de Hooch exhibition, written by the director of the Wadsworth Atheneum, Peter Sutton, and it occurred to me to write to him. He has replied immediately, expressing an interest in reading David's text, which I am sending to him now.

Marco Livingstone

DH to MK
Sydney
7 October 1999

Another thought struck me this afternoon in the Art Gallery of New South Wales. The rational French sensed the problem of the lens and produced Impressionism and Cézanne, the turning-point of our 1870 position. The literate English looked back and got a date approximately right, and called it Pre-Raphaelite, but did not connect it to the lens. Raphael's life covers the date we are looking for 1483–1520. So does Andrea del Sarto's (1486–1530), highly admired in Victorian England.

The French followed their intuitions, especially Cézanne, but there is a connection now seen, or at least by me, to the concept of Pre-Raphaelitism and Cézanne, but one is literary, the other is visual. Perhaps others have made this connection before, but it seems very clear to me now.

The lens was used for portraiture, just as I have in the last six months. Photography's best use was for portraiture. It was not great for landscape, or space, as I put it, but perspective hardly applies to the face. I have argued before that the only exception to the rules of composition in photography (always look at the edges of the picture when photographing) is a face placed straight on. Who cares about or even sees the edge?

If there are eyes seen, we have to look at them, we cannot help it.

David

MK to DH
Oxford
7 October 1999

Dear David

Your recent faxes from Sydney leave a mere historical trundler gasping for breath. So many observations, so many ideas and so many radical proposals. After days of office drudgery, it is wonderful to be involved in really intense looking and a series of questing intuitions.

I have not got the Taschen book to hand, and will respond to your detailed observations in due course. Some of the portraits I know, but I *don't* want to respond from memory unless I'm really sure. The 'hinge' you recognize between the geometrical and optical, with the possibility that the door may be half open (i.e., displaying both geometrical and optical in varying proportions) is a very potent notion. It seems clear to me that we can look at portraiture in Italy *c.*1470 (e.g., Piero della Francesca) and characterize it as essentially geometrical in its most accomplished modes. Equally, it seems apparent that something very dramatic happened in the 17th century to the 'visual texture' of naturalistic representation – the movement of form, the passing of expressions, the play of light across surfaces and space, the relationship of colour and tone. I am happy to think that the 'camera' played a vital role, both as a direct tool and as a model for naturalism. The mirror (convex, lamp-black and silvered) also weighs in. Where the naturalism of Jan van Eyck and his contemporaries 'fits' needs (for me) further thought. The most vivid of Jan's portraits have the fleeting reality of mirror images – I suspect that we should be looking at the mirror and the glass (both see-through and reflective) as the model, not, at this early date, the lens.

If I'm reasonably secure about 15th-century Italy in the geometrical mode, and 17th century in the optical mode, I'm less sure about the supreme acts of naturalism in between, such as Raphael's *Pope Leo X and Companions*

– but the presence of the lens in the Pope's hand does not harm your case! Andrea del Sarto made a copy of the Raphael and was said (by Vasari, I think) to have declared that it was the most difficult thing he ever had to do – eyeballing the eyeballed, or eyeballing the 'opticked'.

Your 'awkward' and non-awkward differentiation is very telling, though it's clear that a rotten draughtsman can produce something compellingly 'awkward' with the best optical aids in the world. The question is, can a great artist produce something non-'awkward' without any optical assistance? On the basis that great artists can be so indecently good as to do the 'inconceivable', I think they can.

The Bellini *Doge Loredano* in the National Gallery is wholly astonishing – one of my 'desert island pictures' (not good conservation practice!). When I was a student, in the days before computerized uniformity of lighting, I used to watch the benign Doge on days of mixed sun and cloud. He breathed – the warm glazes over the white priming moving and pulsing against the cool opacity of the blue background. That's something no camera and no geometry *and* no colour theory can teach. As Paolo Pino said in 16th-century Venice, that's the true 'alchemy' of painting.

The question of which kind of tool (I'm picking up points in no set order) was used is a tricky matter of judgement. Even if we suspect direct optics rather than constructional geometry (or 'simple' eyeballing), there are various possibilities – the window or 'veil', the Dürer-type instruments, the Cigoli perspectograph (see my book). If the artist wants to establish, quickly and accurately, salient points in a face while in a particular configuration, the mechanical devices could have done the job. I think, by the way, your intuition that the various devices (optical and mechanical) could best be used for mapping key reference points rather than for laborious tracing is tremendously important. Historians (including myself) have tended to assume that cameras etc. were used for detailed tracing – which is daft, when you think that we know perspectival projection was used to lay down enough salient points to allow the laying in of the overall form (a kind of dot-to-dot process).

I like the overlap idea re: the hinge with the door open to various degrees. In a picture with a mixed look, I'm wondering if it is a question of the artist painting different kinds of things with different kinds of acquired schemes, rather than *actually* using both geometrical and optical models – and that brings me back to my point in a previous fax about the ability of some really accomplished artists to 'fake' the effects.

Poussin v. Caravaggio
Poussin believed in the *moral* probity of design – as an expression of the higher beauty embedded in nature. It was geometrical in concept, if not very accurately so in practice. There's more Piero than Jan van Eyck in Poussin. The 'superficial' character of Caravaggio's naturalism (all light on surface) was visually abhorrent and morally repulsive. What you are doing is to throw the lens into the works, like a spanner into a smooth-running historical machine. I'm all in favour of it!

Re: the spread of the naturalistic portrait in the early period, and the social grip of photography after 1839. There is something profoundly right here – though the social location and the scale of diffusion are quite different. The painted portrait (even allowing for copies) is essentially an exclusive act, in which the artist becomes (in the Renaissance and Baroque) the employed servant of the moneyed sitter. The photographic image enters a market in which the mass audience was already asserting its economic power – the diorama, the panorama, the illustrated encyclopedia, the physiognotrace, etc.

But the idea that conditions exist at some times for the naturalism portrait to spread like a bug seems fundamentally right.

Trust in the lens
I have written about 'taking it on trust' in naturalistic imagery – of which photography is that most committed to trustworthiness. I think the trust arises from 2 directions:

(1) a fundamental perceptual/cognitive force that enables us to see coherence in the sensory world and to make accurate judgements as to (say) the size and location of a chair so that we can walk round it or sit on it. The naturalistic (esp. photographic) image *plays* to this inherent and *necessary* mechanism, without corresponding in a simple and naïve way to how we see.

(2) our acquired knowledge that a photograph is (basically) formed by something real in front of the camera leaving a matching trace on a recording surface. We *know,* of course, that a photograph can be a fake (like the famous Cottingley Fairies, photographed by 2 girls, who fooled Conan Doyle), and, now, that it can be manipulated digitally. But we want to be able to trust the photograph, since we *want* to be eyewitness, by proxy, to something real.

We all do it, though we *know* better. We're perceptually addicted to the illusion of reality in whatever medium, just as we can be addicted to drugs (or fags?). But in the visual case, there's no cure – not even Cubism!

Your idea that the lens could 'train' painters corresponds nicely to my idea of the lens-based image as a *model* for a new kind of naturalism. *Yes.*

Let me respond in due course to the Impressionism–Pre-Raphael–Cézanne idea. It's big and needs more stepping back and conceptual agility than I can achieve at the end of a fragmented day.

Ever
Martin

MK to DH
Oxford
11 October 1999

Dear David

Thoughts on 'another thought' as promised. The idea of the 'rational' French and the 'literate' English looking in different directions – down both sides of the conceptual mountain of the advent of photography – is wonderful. It provides a great hypothesis which is very powerful and like all great hypotheses it promises a great deal of major brainwork mashing up previous assumptions, testing, probing, manipulating. Clearly Pre-Raphaelitism wasn't *caused* by photography. It is one of many retrogressive, revivalist movements in Europe, the first of which, the German Nazarenes, pre-dated photography. The Pre-Raphaelite response to photography was complex – just as Ruskin first exalted in its realism only to become impatient with its inflexible un-selectivity. In a sense they tried to 'out-optic' photography by asking for a piety of detail equivalent to the unblinking naturalism of 15th-century masters like Jan van Eyck, Memling, Perugino and Bellini. They used ever more vivid media, the new synthetic pigments and Robson's new white-ground painting wet-in-wet. The motivation is, as you say, infused by a literary-ness and a literal-ness deeply associated with a particular kind of storytelling (not the grand continental 'Histories').

Above all, the literary quality and language – like symbolism – is founded on the idea of the religious *text* (esp. the Bible) and on the medieval notion of the 'book of nature' which is to be read in reverent detail for its divine meaning. Photography could do the naturalistic bit (*without* colour) to some degree, but it could not produce the moral text, unless through the use of costume and contrivance (as in Julia Margaret Cameron and Oskar Rejlander).

The French did have their Pre-Raphaelite tendencies. I am thinking of Delaroche or Flandrin. And artists like Courbet (the meaty nudes) and Degas used the camera as tools for their particular ends. But, as you say, Impressionism and Post-Impressionism do things in paint for the eye's active seeing in a way that the more literal scrutiny of the Pre-Raphs and photography do not. It may be that the French sensed that the way 'forward' was to use paint to cajole the eye into doing much of the work – exploiting the 'beholder's share', just as Vermeer, Velázquez and Chardin had done. By trying to 'out-optic' photography, the Pre-Raphs drove art into a narrow corner where the spectator is left to look and admire but can take no perceptual exercise of an imaginative and non-prescribed type. That's why Pre-Raphaelitism (for all its magic) led to a blind end, only to find photography and non-photographic painting pursuing their own vigorous courses. Only once the consequences of non-photographic painting had worked through – total abstraction, minimalism, abstract expressionism – could painting again look seriously at the photographic, lens-based image, without getting hooked on the polarity which dictates that lens-based painting = cheating. If this is true, and it's where I'm getting after your Pre-Raph/Cézanne thoughts, it makes exciting sense of how *you* have consistently rewritten the kind of looking that goes into watching 'nature' and making a painting (or print or whatever). What I need to think further about is how this rewriting of the relationship between painting and looking (I'm thinking especially of pools and splashes) interacts with the kinds of new content that you were and are introducing ('Pop' etc., though I don't like these terms). The looking didn't come without content, or vice versa. Not an easy one, this. Any thoughts?

For my part, at the start of term, it's a miracle that I'm thinking at all. (Even if not altogether clearly). Hope 'Oz' is OK. I do hope to hear in due course.

Warmest regards
Martin

DH to Helen Langdon
Canberra
11 October 1999

Dear Helen Langdon

Thank you so much for your e-mail which I eventually received on my brother's farm about two hours west of Canberra (on the edge of the outback).

I'm in correspondence at the moment with Martin Kemp, who seems quite excited by the observations and ideas, although he is an art historian who has written extensively about optics.

It's slightly disturbing to me that historians have little practical knowledge of how optical things might be used. Optical devices certainly don't paint pictures. I saw the Vermeer exhibition in The Hague and spent two hours one evening alone with the director (Frederic Parc). He told me of

the little holes, etc., which they assumed were for string for the perspective. What I didn't understand was why this invalidated use of a camera. He really couldn't have done a pattern folding round a tablecloth without a lens. Wasn't his great friend a maker of telescopes or microscopes? My point was that in Titian one rarely finds patterns following clothes with uncanny accuracy, and one can see in him they certainly could have been 'eyeballed'.

I might point out that in Raphael's portrait of Leo X (1520) he holds quite a large lens in his hand, and in his left hand at that. In fact, I'm finding quite a lot of left-handed people in portraits of a certain period.

I was surprised no Ingres scholar had heard of, let alone seen, a camera lucida. Shouldn't there be in a rigorous discipline, a knowledge of techniques and methods?

You suggest Caravaggio could have used Dürer's method, but it was very cumbersome and as you can see needed two men to work the machine.

It's a naïve idea that 'optics' are a kind of cheat. They are not easy to use, and I have suggested to Martin Kemp they would overlap with 'eyeballing', especially with good draughtsmen.

I have also pointed out that although it might look to the historian that the scientists had lenses first, I think it might be the other way round, as the world of images was more important at that time, but by its nature science is an open thing. Painters and picture-making were far more secretive.

If one doesn't accept the idea of the lens, one has to defend feats of incredibly difficult 'eyeballing', for my point about a sudden lack of awkwardness in European art from *c*.1500 to 1870 is simply not answered.

Caravaggio's boy with the lizard could not, I believe, be done without a lens. How long could he hold that expression?

For the last six months I have been making portraits with a camera lucida. You use it very quickly to capture what are really 'fleeting' expressions by notations only, and then look with intense concentration for a few hours. To 'eyeball' this you would have to have a very good visual memory, possible I suppose, but again there is an 'accuracy' in the features that belies this.

In Velázquez's *Bacchus* the man holding the cup of wine has a fleeting expression. He could not hold it very long. The wrinkles round the eyes balance perfectly the open mouth. A virtuoso painter could 'capture' that expression but without optics you just wouldn't get that kind of accuracy.

I am finding some art historians are very open to my observations, others simply silent.

When van Dyck painted the triple heads of Charles I for Bernini, wouldn't he have used every technological technique available to him, to make sure his measurements were accurate? Also the lace, perfectly following the form of his shoulder is very difficult to do without optics.

If his assistants painted the clothes without optical devices, they were very clever indeed, nearly as skilful as the master. Would this have been the case? Lively heads are of course the most difficult thing to do, but 400 portraits in England in 7 years is one a week – quite a pace for anybody.

I believe there is a rather exciting story here that gives a better account of the development of European painting and our problems today with an 'Art' that seems remote from most people.

A friend in England saw a TV programme on van Dyck, and near the end someone pointed out that compared with early portraits these seemed more like photographs. I don't suppose the TV people made the connection that they were using a lens, like van Dyck probably had. They just assume the 'old masters' could draw better than anyone today.

I am taking part in the Ingres Symposium at the Met in New York on October 22nd. Gary Tinterow invited me, for like me he'd seen a method at work in the portrait drawings, but just didn't know what was used.

I'm now perfectly prepared to stick my neck out and take on the art historians of New York because I learned a great deal from my experience of the last six months. I'm basing my observations on careful scrutiny of his drawings and my own experience – what else is there?

All the painters I have had correspondence with react with 'well it had to be done that way'. Perhaps art historians should look into practice a little more than they do.

I enjoyed your book on Caravaggio and then read the previous biographies and found myself making notes and reading between the lines. Isn't it odd that only honest A. Dürer gives us pictures of devices used for difficult depictions.

The lens school depicts the Carracci school (Vermeer's *Art of Painting*), the Carracci school doesn't depict the lens school (overlapping?).

I may be in London mid-November, perhaps we could have an afternoon at the National Gallery.

Yours sincerely
David Hockney

Peter Sutton to DH
London
12 October 1999

Dear Mr Hockney (care of Mr Livingstone)

I read with interest your text 'The coming post-photographic age: part II'. Its premise, namely that artists throughout history have availed themselves of the information provided by optical aids and scientific devices, is irrefutable. My own area of interest, Northern Baroque painting, offers ample support for the idea. You allude to Dürer's role in disseminating knowledge of perspective north of the Alps with his publication *Underweysung der Messung* (1525) and his illustration of how to use a drawing grid. Early accounts of the working methods of the Rembrandt pupil and gifted Leiden *fijnschilder* Gerard Dou (1613–75) suggest that he employed a grid, lenses and mirrors to make his finely executed little paintings. (A show of Dou's art is planned for next year at the NGA, Washington, and Dulwich). According to Arnold Houbraken (*De Groote Schouburgh*, 1753), Dou used a 'frame strung criss-cross with threads' to draw from life. J. von Sandrart (*Teutsche Academie*, 1675) recollected that Dou wore eyeglasses when he painted, and Houbraken subsequently suggested (embellishing Sandrart's story) that he used a magnifying glass to achieve his minutely detailed effects. Roger de Piles (*Abrégé de la vie*, 1699) further claimed that Dou used a convex mirror to reduce the scale of his small pictures, and J.-B. Descamps (*La Vie des peintres*, 1753–64) claimed that he used a screen with a convex lens. The latter is an unworkable device that may only be an imaginative conflation of the comments of de Piles and Houbraken or a misunderstanding of the instrument, but a screen with a concave lens was described and illustrated as a compositional aid as early as 1635 by Jan Bate.

The science of perspective, its mathematical bases as well as its practical applications, was widely published in the North by Jean Pelerin (1505), Jean Cousin (1560), Simon Stevin (1605), Gerard Desarques and Abraham Bosse (1648) and, perhaps most influentially for artists, by Jan

Vredeman de Vries (*Scenographiae, sive Perspectiva*, 1560; and *Perspectiva*, c.1604–5) and Hendrick Hondius (*Instituto artist perspectivae*, 1622). So I would caution you from suggesting that the approach to perspective was 'intuitive in the Netherlands'; if anything, it was more rigorous in its codification than in Italy, although Alberti and Brunelleschi were its (re)discoverers. The city of Delft around 1650 was not only a site for the manufacturing of high-quality lenses but also the artistic center of the perspectival experiments of the architectural painters G. Houckgeest and E. de Witte and the genre painters Carel Fabritius, Peter de Hooch and Johannes Vermeer. It is unlikely to be a coincidence that the perfecter of the microscope, van Leeuwenhoek, was a trustee of Vermeer's estate. There has been much debate about whether Vermeer used the camera obscura. While he may not have painted directly from the device, I personally believe that features of his art (the fuzzy halated highlights in the foreground, the principal plane of focus on the back wall where every nail and chipped passage of plaster is visible, and the convergence of parallel lines towards the edges of his compositions) point to knowledge of how lenses transform visual data. The unrivaled visual fidelity of the camera obscura would have been of interest to any artist striving for a naturalistic appearance in his paintings. The illusionistic painter and creator of the famous Perspective Box in the National Gallery, London, Samuel van Hoogstraten, wrote about the camera obscura in his *Inleyding tot de hoog schoole de schilderkonst* (1678): 'I am sure that the sight of these reflections in the dark can give no small light to the vision of young artists; since besides gaining knowledge of nature, one sees here what main and general characteristics belong to a truly natural painting (*een recht natuurlijk schilderij*)'. He goes on to correctly observe, 'the same is also to be seen in diminishing glasses and mirrors, which although they distort the drawing somewhat, show clearly the main coloring and harmony'. The notion of art as a mirror of nature (as Gombrich well knew) descends from topoi advanced in classical writings on art; Hoogstraten wrote, 'A perfect picture is like a mirror of Nature in which non-existing things (in the painting) appear to exist and deceive in an acceptable, pleasing and commendable fashion.'

As I have suggested, it is difficult to prove that a given painting was executed with the aid of an optical device but there are several Dutchmen whose works suggest knowledge of lenses and mirrors. Jan van der Heyden (1637–1712) was a painter of unprecedentedly naturalistic and finely detailed city views. Again I do not think it was a matter of accident that his older brother manufactured and sold mirrors and that he himself was technologically creative – he invented the modern firehose and perfected street lighting in Amsterdam. Van der Heyden painted at least one painting (*A View of the Town Hall, Amsterdam*, Uffizi, Florence) which includes deliberate distortions in the architecture that were 'corrected' when the scene was viewed through a lens or ring (now lost) attached to the original frame. The detailed, smooth surfaces and uncannily true tonal balances of his cityscapes also suggest knowledge of mirrors or lenses. Later eighteenth-century *vedute* painters like Canaletto also are assumed to have used the camera obscura.

So it's a rich subject for exploration.

All the best
Peter C. Sutton

Svetlana Alpers to DH
New York
12 October 1999

Dear David Hockney

Thanks for your fax and your skeleton thesis.

Responding to it is complicated – bound to be a surface thing in response to the grip the thesis has on you, or you on it, in a manual as well as mental sense. But here goes.

Yes, I am sure that optical devices have played a real role in the making of 'realistic' images. And it is often artists, or might I say practitioners like yourself, who get on to this. An artist called Konstam published something on Rembrandt's use of mirrors in the *Burlington Magazine* some years back. Gombrich put him in touch with me and I am afraid I was not too welcoming.

There is documentary evidence that Rembrandt owned a large mirror – it was carried through the streets once and broken. Velázquez also is on record when he died as having possessed mirrors. I think that I have always bracketed the use of devices in looking/considering what painters made, despite the fact that the studio and the making of art are really at the heart of what interests me.

Could it be that your interest in this – 'this' being the role of optical devices – is that you are an artist who presses a device hard or, better put, *repeatedly*, to see what it produces, what it gets you. The device as a basis for repetition is what I am getting at. (I think of your panoramic photographic spreads which I like so and which for me were related to the mapping impulse, as I've called it, in Dutch painting. The Dutch in the seventeenth century were also, by the way, repeaters.)

So, as to the use of optical devices, yes, you must be right. But various questions come to mind.

(1) As you yourself say, how far does the device take an artist – only the hand can make art (and one might add the artist must look through/at the image made by the device so the hand/eye/mind combination is uniquely his/hers not that of the device) (tho see my remarks on repetition above – that might be the answer – Velázquez, by the way, was not a repeater. I am working on him just now and have been thinking about that.)

(2) If Rembrandt (an obsessive draughtsman) was also aided by a device, how does that place him in relationship to the history that you are tracing?

(3) It seems to me the point is that there was an interest in optical devices on the part of European painters of a certain persuasion (van Eyck and Vermeer, but not Piero, let's say) – their painting is consistent with the deployment but can't be defined by it. And, no, I don't believe that trusting to the device is what allowed Caravaggio to 'cast' street people or the boy next door as saints. The device had the bonus of letting him do that, it did not make him do that.

(4) As for Cézanne as being anti-lens – and Cubism also – OK, but if one cut things differently one could argue that they are both continuing a European tradition of representational depictions of the world seen (that is, if the world seen can be seen also without a camera eye). Put it that way it is abstraction (or whatever one calls it) that is the short-lived odd man out from the dominant tradition.

(5) I could not agree with you more about the situation today. Painting –

though as a viewer/historian not a maker – is the medium I care for and I despair about it today – I like your point about our bringing our time to painting.

So – I hope you don't find this all too negative. Send me more if you wish

Cordially
Svetlana Alpers

DH to MK
Sydney
14 October 1999

'Notes on Cotán'

The Spanish still-life painters of the early 17th century seem to have used optics, not geometry.

The fruit still life of Juan Sánchez Cotán of 1602 [*see page 106*] has a cabbage hanging by a piece of string with a beautiful cut melon (the fruit equivalent of the lute) and a cucumber.

How long did this picture take to make? How long would the cabbage stay in the state it is in in the picture – a day at the most in Spain.

I think what must be said now is how the optics would be used. I found out for myself that a minimum time (two minutes) was all that was needed for a maximum gain – or should I say a major difference.

Perhaps the historian is imagining that optics then were almost like a photorealist of the 1970s – projecting a photographic slide. This would not have been the case. Intense observation is still necessary, but the 'difficult' drawing bits – the shadows in the cabbage, and the marks on the melon would be all a skilful artist would need to give a very 'realistic' representation.

How long does a peeled lemon look fresh? How long does a brioche last before it begins to sink? One must remember that Cézanne painted wax flowers because of the length of time he was taking.

Isn't this the problem of 'catching' an expression?

We are now so removed from these devices that only a practitioner can begin to see how little they need to be used to make a difference. We are dealing with painters of great skill. I think some people are misinterpreting my thesis as an attack on the *hand*. Far from it. The hand and eye (and heart) are essential for the paintings I am talking about. The hand is with the camera, as I said. It's the chemicals that cause the problem. Photography was the removal of the hand (and therefore surely the body of the spectator). Our pictorial problem today.

MK to DH
Oxford
17 October 1999

Dear David

Finally, Sunday evening, some relenting of commitments and a chance to respond. I hope you got my musings of the Pre-Raphaelite/Cézanne see-saw.

Did you see the 'Spanish Still Life' (almost wrote 'stiff life') show at the National Gallery, London, a few years ago (if not I'll try to get a catalogue for you)? Very impressive – a revelation. I knew Zurbarán, the extraordinary super-presence of a few discrete objects lit (as it were) from within. But Sánchez Cotán (early) and Melendez (late) were eye-openers for an

eyeballer. Yes, it's not 'stiff life' or gradually 'dying life', and not even still in the sense of lifeless – more stilled for a moment. It's that sense that the contemplative time for the artist's intensity of looking is in dialogue with a particular moment of the existence of an organic, perishable thing. That's what you have seen. I know *absolutely* what you mean, though I had never thought about it in quite that way.

It's the same dilemma – the perishability – that Leonardo faced in his anatomical work, particularly in the Italian climate with no preservatives. What he wrote was:

'To you who say that it is better to witness an anatomy than to see such drawings, you would say justly, if it were possible to see all these things that are in such designs if they were demonstrated in a single figure … and a single figure will not endure that long, since it is necessary to proceed step-by-step with several bodies until complete understanding is obtained. This I replicated twice to see the differences'. (It might be worth thinking that fruit and vegetables go 'off' quicker in a hot country like Spain!)

What this quotation highlights is:

(1) the impossibility of simply eyeballing a complex organic object that is mutable and perishable.

(2) the need for a strategy to combat the changefulness of transitory appearance. What Leonardo did was to make a *synthesis* of a series of studies, using his miraculous draftsmanship to make us think that what we are eye-witnesses to one *actual* specimen.

Judging when synthesis is the name of the game and when optical devices are the tools is, for the historian, a question of looking at documentary evidence in conjunction with visual intuition. I say 'in conjunction with' and not 'before' intuition, because it's often the case that intuition *triggers* the search for evidence. That's why what you are doing has so much *historical* mileage.

Your point about how little such devices need to be used – your original conjecture about Ingres – seems entirely right to me. For the artist, they can be vital means to an end and in no way stand in conflict with 'heart' or 'hand'. If Sánchez Cotán used optical devices, it would in no way have hindered the *sacramental* quality that he shares with many of the other Spanish still-life painters – the sense that the objects are placed and characterized with a reverence equivalent to the vessels, wine and bread on an altar in a Catholic Mass. They are *very* Catholic paintings, compared to the obvious materiality and storytelling morals of still-life paintings in the Protestant North. If Cotán and Kalf used the same instruments, this would just prove your point that the devices do nothing to mask 'heart' and 'hand'.

[…]

Ever
Martin (computer printer still kaput)

DH to MK
Los Angeles
2 November 1999

Dear Martin

I'm back in California now after a rather exhausting trip to New York and Australia. After the Ingres Symposium the jet lag caught up with me and the adrenaline drained, so my normal energy just sank.

New York is not my favourite city, but I had an interesting time looking at real paintings.

Two artists I'd like to discuss with you now are Juan Sánchez Cotán and Frans Hals. Here are two paintings said to be by Cotán [*see pages 106 and 107*]. One is in San Diego, and the other is in the Art Institute of Chicago. I mentioned the first painting in a previous letter to you. I saw it in the National Gallery show 3 or 4 years ago. The question I asked was how long the cabbage or melon would look like that with that strong light on it? If they were in sunlight neither would look like they do in the picture for very long. I've even thought of setting up this still life exactly the same way and photographing it every 10 minutes for a day. I think it would tell an interesting story.

It's perfectly clear in the two pictures that the cabbage is exactly the same, so is the cut melon and the quince, it must have been copied (through a lens?).

How long would it take to paint this set-up? Supposing he set it up to begin with like it is in the picture, whatever the source the light is very strong to cast such strong shadows and would therefore probably be quite warm. He could of course paint the cabbage first and quite quickly or his notations (of shadows) were quickly achieved, and then a good visual memory could achieve the rest, even with a fresh cabbage. The same with the melon, added after the cabbage, for this too would not last long in that strong light.

Don't we have again here religious people (he became a Carthusian monk at 40) who would have known about lenses but were still secretive about them?

Talking about secretiveness in artists, I saw a show in New York of a British painter, Jenny Saville. They were very large nudes that she says are from photographs. They must have been blown up (projected) very large, but no one in the gallery (I knew two of them well) could tell me how they were made. I doubt whether the artist would show anybody either. Or, I ask, would historians find in say Roy Lichtenstein's studio anything in writing that told you about his methods for constructing big pictures. As I said, generally artists are still very secretive about methods.

But back to Cotán. I took these reproductions from a catalogue, *Spanish Still Life: The Golden Age*. Although they don't really show us the previous 'ungolden age' and there is no mention anywhere of possible uses of lenses. There are strange interpretations of the symbolism (religious) which I'm now beginning to think all comes out of Panofsky and his way of looking that has hindered 'Art History'.

Forget 'Art History' for a minute and let us think of the 'history of pictures', which would surely include how they were made, taking nothing for granted (eyeballing all the time, Panofsky seems to think).

So to Frans Hals. I looked at the ones in the Met and the Frick, and I bought the Royal Academy catalogue of ten years ago. The text mentions he never made a drawing, and there seems to be no charcoal base on the canvas. They are painted fast. Here I'm sure optics are used. The individuality of the faces, the smiles and open mouths. Actually realizing how they were done has made me admire them even more. He understood what was possible and what he was doing. If you have the catalogue (RA, London, 1990), on page 169 is his 1623 picture *Buffoon playing a Lute*. On page 168 are other paintings by his contemporaries of the same subject. Dirk van Buburen and Louis Finson. They, too, have no 'awkwardness' of drawing, but are simply not as lively as Frans Hals's, frozen like a photograph whereas Hals seems to have captured a longer period of time, in something that is essentially fleeting.

All this is the same period as Velázquez and just after Caravaggio (and just after Cotán).

I looked through the whole catalogue. As I said, I admire them enormously. Only Rembrandt got more into a face than this, and they certainly approach his level. Nevertheless, they have an 'optical' look. Once one begins to see it, it seems to become quite obvious, and what is interesting is the different way artists use it. Compare Vermeer with Hals, both I'm sure using optics, but with a different attitude to space and time.

Another note by the way about the Raphael *Pope*. I'm told the Pope would never have been left-handed (sinister or devilish idea). Yet if you were looking at a book like that you would use your right hand to hold a magnifying glass – try it yourself.

All the best. My energy is returning.
David H.

DH to MK
Los Angeles
3 November 1999

'More notes on Cotán'

I think one thing to look for with early work with lenses is a dark background. The still life with quince and cabbage would be quite close, meaning they would have trouble with 'depth of field'. This might be why the cabbage is hung up, to make all the objects on the same plane.

I must admit I tend to see reasons like this (practical), rather than religious symbolism. He might have simply 'invented' the window frame, or steps as the other still lifes seem to have. Again the steps would help overcome the 'depth of field' problem. The whole still life would not have been set up *à la* Cézanne, but bit by bit because of the short lives of vegetables and fruit (remember Cézanne used wax or paper flowers because of this problem).

There is an interesting reproduction of a lost painting (see enclosed picture) where you can see parts of a bunch of asparagus below the ledge, which he must have then covered, but now shows through. This could signify he either painted on steps – like in the other picture and then decided where to put the base. It's certainly odd that they are there if the whole thing was set up, as they wouldn't be visible to his eye.

I'm now working on armour from Piero (geometry) to Caravaggio. As one seems to move towards much-more-difficult forms to draw, the highlights are 'in the right place', suggesting lenses. I'll send you them later.

I'm coming to England in mid-November to draw some guards at the National Gallery. Perhaps we could meet and look at all the stuff I've got.

I gave a lecture at Columbia University on 'Lost Knowledge'. Linda Nochlin, who had heard my Ingres bit at the Met, came and said she was sure I was right. She told me she believed Courbet used lenses.

All the best
David H.

MK to DH
Oxford
3 November 1999

Dear David

Good to hear again from you. A complex, difficult, wonderful, insane, infuriating, rewarding and contradictory place, New York. All that cultivation and barbarity compressed into the constrained grid, squeezed into vertical extrusion. I hated it until I was there for some months as visiting Professor at the Institute of Fine Arts – living in 'the Village'. Discovering the 'local' New York, the small communities which have shaped areas into microcosms of ethnic diversity, full of desperate humour. But *not* restful.

Writing this in a Chinese restaurant in Woodstock (where I live). After a demoralizing day of institutionalism. I decide, for once, not to cook for myself. At the next table a man with a laugh like a car vainly trying to start on a frosty morning. Thinking of Sánchez Cotán and Frans Hals. Funny business, this art. He's not the 'Laughing Cavalier' that's for sure. An odd title. The Hals portrait in the Wallace Collection (have you seen it?) is definitely not laughing – not outwardly at least. More a case of one of those expressions moving subtly from one thing to another, almost an ironic smirk – but that's not quite it. I know what you mean about the *fleeting* – very different from the set-piece standard expressions used by 'history painters' – like the 'Terror', 'Pain', 'Joy' etc. in Charles le Brun's 17th-century formulas. (Nicely outlined in J. Montagu, *The Expressions of the Passions*). Have you seen Franz Xavier Messerschmidt's physiognomic sculptures? You're right about Hals's speed. There's a spectacular portrait in the Fitzwilliam (Cambridge, UK) using no more than 5 or 6 pigments (black, white, ochre, vermilion, umber??) that is painted with such urgency that the paint has dripped and run down the canvas. It's without drawing, but, unlike many painters/paintings that did not use drawing, it's very thin, very *alla prima*. Indecently good. The Scottish painter Raeburn, of whom I'm very fond, put the *alla prima* brushwork on top of a lot of neurotic manoeuvring. But not Hals. He went straight to it – unless technical examination reveals (or has recorded) something I have missed. It would be really notable if the free-est and most spontaneous of portraitists used optical devices – THAT would prove your point that the use of instruments in the *right* hands produces extraordinary artistic results, not dreary, mechanical imitation.

The abiding question in my mind is to what extent really great artists could achieve the fleeting expression with utter conviction by working at it on the canvas (i.e., slowly) rather than using optical devices. There's a great quote by Delacroix which says something like he's 'working to keep the spontaneity'. The questions you are asking, the insights you are bringing are very important – opening up questions that have barely been asked – because, as always in such cases, nobody wanted to ask them because of preconceptions.

I agree completely about Hals in comparison with Buburen, Finson & co. They have a literalness which relies upon *knowing* how to achieve a desired expression in advance of the painting. With Hals, you feel it is happening as he paints. Unnerving. He's a very different painter from Rembrandt, and now unfairly underrated by comparison. I can *see* why you relate to Hals. He has a directness that the encrusted Rembrandt's don't. They're just different. Now finished my meal (pretty good). More on Cotán at home.

The *Still Lifes* are remarkable. He was a revelation in the National Gallery show. Hanging vegetables are odd, game, yes, but not vegetables, unless they are being dried. It looks like a contrivance for the array in the painting. They do have an extraordinary sense of living freshness. In the 2 paintings with the 'same' cabbage, there are two issues: the effect of freshness; and the identical forms. It was possible, using a variety of techniques (including a sort of carbon paper) to transfer a drawing from one canvas to another. If they are exactly the same size, some system of transfer is almost certain. This does not mean that the outlines of the fresh cabbage were not laid down rapidly in the first instance – the image of the cabbage 'cooking' under the lights is a nice one.

If Cotán did use optical devices, it would make sense of the super-real quality his objects possess – almost more tangible than the real thing. The camera obscura does just that – making objects assume an uncanny look of concentrated 'real-ness'. Your projected experiment with the drooping cabbage sounds great – like a conceptual work of art – do you know John Hilliard's work *A Camera Recording its Own Condition?* Something like that, only it's the condition of the cabbage. Still life into rotting life. The cut melon would dry out even quicker than the cabbage would curl. The question is not whether the objects would endure long enough for the period of painting, but how to keep the illusion of freshness. Even if a lens was used, other strategies need to be adopted to ape the moistness, the sheen, the colour. Still life (not highly regarded these days) is deceptively difficult in terms of the range of visual effects – textures, colours, translucency, sheen …

I agree about the Panofskian tendency – though it's unfashionable in recent art history. Panofsky was great, and really looked at things – the Dürer monograph is a classic – but the formulaic application of his method was awful, turning pictures into textual puzzles. Visual art must begin and end in really intense looking. For the historian, there's lots of words in between, and it's easy to forget that if pictures are only 'texts', the artists would write and not paint. It seems odd to have to insist that 'visual art' is about the irreducibly *visual*, but it's necessary to say so these days.

By the way, the Grand Canyon paintings remain with me – bright and burning in my memory.

Did you speak in NY? Any reactions to your ideas?

Very best wishes
Martin

New fax just arrived. More tomorrow.

Bing McGilvray to DH
Boston
4 November 1999

Dear David

'Moving Shows', *c*.1290 (from the internet)

Arnaud de Villeneuve (1238–1314). Also known as Arnold of Villanova, was a practising physician and wrote on alchemy. A magician and showman in his leisure time, Villeneuve used the camera obscura to present 'moving shows' or 'cinema' by placing his audiences in the darkened room and would have the actors perform outside. The image of the performance would be cast on the inside wall. Villeneuve would often enact wars, or the hunting of animals with the actual noises of such, which would be heard from inside.

Love
Bing

DH to MK
Los Angeles
6 November 1999

Dear Martin

Not only now do I totally believe the lens idea, but I'm beginning to realize why the lens was not talked about: heresy.

Could this be why Alberti does not go into it very much?

Notice the 'moving shows' *c*.1290 (typed page). Would not the Church see instantly that it needed to control the idea of those moving images.

Why does Leo X have the lens in his left hand – sinister – codes – clues to others. Perhaps even Dürer's machine for drawing lutes was to say we do without lenses, but in England (Holbein) it was possible (to defy the Church and use optics).

The Reformation broke the power down. By 1600 lenses are being used everywhere. Lenses and the Church. It's just some ideas.

The control of moving images today is where power lies!!

Good night
D. H.

DH to MK
Los Angeles
7 November 1999, 1.00 am

Here is the story, and why art historians have had trouble finding written records about the lens.

Let us start with knowledge of optics from Al Hazan (1080).

Arnold of Villanova does his show with his 'cinema' in 1300. Others had written to the Pope about lenses. Roger Bacon from England – told to get back to Oxford and shut up. Villanova's show is the work of the devil, the lens is from the devil; the small group of highly educated people who control things – the Church realizes the key is the lens.

The only lenses allowed are spectacles, only needed for old men reading (very few people in the 13th century) and never seen by the peasants – not needed for walking in the street but for reading.

Knowledge of optics and lenses is restricted. Only a small group in Rome, and then the Netherlands.

Dürer's two engravings are a cryptic message. 'Images can be made this way' – but they knew about the lens.

Holbein in England (far from Rome and ready to rebel) uses it – certainly for the *Ambassadors*. There are no drawings by Holbein of instruments, superbly depicted in the painting – the high tech of its time. The lens creates the anamorphic skull (not geometry), a kind of warning, a kind of clue, we know about this in 1533. Twenty years later they tell Rome to piss off. Not a theological argument but interference with knowledge and control.

Della Porta publishes his *Natural Magick* about 1570 (spelling is not standard at this time – good for me and magick) and by 1600 the lens is out again.

Why didn't Leo X wear spectacles to look at the Bible in Raphael's portrait? The lens in his left hand not because of mirrors, but a sign to the educated few who see the picture.

Remember this isn't 'ART' as we see it now in a museum, this is about PR, politics and control. Nevertheless a beautiful painting, its message now irrelevant to us (or maybe not).

Seen this way, the Renaissance emphasis on mathematics and perspective with lines, soon gives way, through the Church, to the lens. This can be seen in Raphael.

Leonardo must have known all this. Perhaps that's why he writes backwards. Mirrors were *very*, *very* rare in his day, so only very, very few can get his message. A very small world indeed.

The Reformation smashes this to bits. The Church hands out the lenses, the very best to Raphael, the Venetians. Cardinal del Monte gives the talented Caravaggio a better lens. (It's absurd to think he got it from the Rome Better Lens Supply Company).

Heresy kept the lenses secret. Later Galileo had to shout about them (that's science) and we know what happened.

Velázquez gets his better lens in Rome from the Pope and does his superb portrait 150 years after Raphael. It's still pretty secretive, but spreading. Good artists were very privileged people – important imagemakers. By the 18th century it's all out. The Protestant world caring less about secrets, and *voilà*, we are almost at today.

Is this too pat?

I think it's near the right track, and evidence can be found if we look.

Good night
D. Hockney

MK to DH
Oxford
7 November 1999

Dear David

Silence the result of 3 days in Scotland, where I worked for almost 30 years and where my son is researching musical acoustics. Looking at your *Tired Indians* in the Gallery of Modern Art. I'll try faxing the card I wrote.

Re. Cotán. I take your point about the practical insights you bring to looking. It's like the chair in your painting, meeting the practical needs of the actual work – yet my instinct is that it's never entirely one thing or the other – the form or the content – the practical expedient or the symbolic meaning. The trigger for the discussion may be one thing, but it 'sticks' for more than one reason, and can itself induce more content. The problem is that any description makes the process too linear and much too slow.

I did write something on Piero della Francesca and refraction and reflection. I'll look it out and send it. There was a great deal of discussion of reflections from convex and concave surfaces in medieval optics – and much on refraction and lenses. The armour in Piero's altarpiece in the Brera is astonishing – more overtly geometrical than Jan van Eyck. Given his obsession with getting things optically right (down to the last fingernail), it's not surprising that he was a slow painter. On the scaffolding in the Arezzo Chapel, you could see that he used cartoons for tiny details that only he, God, and the modern conservator would ever see. A kind of lunatic, like Leonardo.

I'm glad to hear that Linda Nochlin gave your Ingres theories a positive reception. She's a lively and adventurous historian.

Your universal story of the lens conspiracy and the Church – suppression and acceptance – is amazing. A mere historian would not dare to do this. We're not good at inserting secrecy within our narratives, because if it's secret, you can't see it. There was resistance, even in the era of early telescopes and microscopes, to the delusion of lenses. How could you trust something that so distorted plain sight?

There remains a question in my mind about the availability of lenses, above all lenses of decent quality. My friend Phil Steadman, who has been doing some great work on Vermeer, has done some research on this for a book to be published by Oxford University Press. I'll see if he will send us something on lenses.

The question of optical shows is fascinating – what Sir David Brewster in the 19th century called 'Natural Magic' in his book of letters to Walter Scott. The Jesuits in the 17th century were great exploiters of magic by science (esp. Athanasius Kircher). Arnold of Villanova is a predecessor, but there is no evidence of such things known to me in the 15th and 16th centuries, until della Porta. This would correspond to your narrative.

We know, from Alberti himself, that he made some 'miracles' of painting, in form of some kind of box/peep show. There were not, I think, camera obscuras, but they seem to have used optical trickery of some kind. Generally speaking, I think the importance given to geometry in the 15th and 16th centuries is less to suppress knowledge of lenses, than to show that paintings possessed an intellectual, 'scientific' base. This meant going below superficial appearance, and to the underlying mathematics of space and proportion. Being able to *show* the geometry was crucial in the rise of the theory of art – intellectually and socially. It may be that lenses, cameras, etc. were hidden because of this desire, but I'm inclined to think that actually *using* geometry was important to them. It was certainly important to Piero and Dürer. I don't see Dürer's machines as ways of creating false leads to draw the reader away from thinking about lenses. Dürer really liked technology, and it's difficult to see why he would not be happy to brandish his mastery of lenses. He was very much part of reformist circles in Germany, and is unlikely to have been cowed by Rome. But I don't see Dürer as crucial to your argument, in any event.

Now need to get some food. Commentary will be resumed. I'll send this so far, conscious that your main argument needs more thought on my part. Lots more to come … I need to look at the Raphael again …

Martin

MK to DH
Oxford
9 November 1999

Dear David

Correspondence resumed … In term time it's difficult to think of 'real' things rather than the mechanics of the institution. Resuming thoughts on your earlier fax, before looking at the latest.

The Raphael
There is a marvellous drawing by Raphael of the head of the Pope. If any Raphael drawing was made with a lens, this would be a candidate. I will see if I can xerox and send a copy (not 'til Friday). It may be odd for me to offer a *practical* explanation for Leo's holding of the lens in his left hand, when you offer the iconographical. How about an explanation which involved Leo needing his right hand to turn the pages of the manuscript, and thus holds the lens in the left? If a lens was used for the drawing, perhaps it was this lens!

Leonardo's mirror writing is not all that difficult to read – beyond the erratic handwriting and abbreviations. The explanation is that: (a) left-handers can often write in reverse, naturally, especially if they have been taught to write right-handed (there was an article in *Nature* on this); (b) he was using very smudgeable materials – slow-drying inks, soft chalks, etc. The right-to-left movement was natural. But there is one aspect of Leonardo that is grist to your mill. He did work on devices for grinding mirrors – I'll look up the details, which are in my library at work. There are

many diagrams of camera obscuras in his manuscripts, but none which combine the pinhole with the lens. There is a drawing by him of an artist using a pinhole and drawing frame (window) to draw an armillary sphere. His drawings of the 'platonic' solids and their variants for Luca Pacioli's *De divina proportione* seem not to have been plotted through geometrical perspective but drawn using some kind of device. Again, I'll look out the illustration when I go to my office on Thursday or Friday. The fact that Leonardo showed an armillary sphere as the subject for a device, indicated that drawing aids were considered especially useful for objects that are difficult to 'eyeball' – like the Holbein globe (which *is* very impressive).

Your story, overall, throws up all sorts of thoughts and possibilities. The great emancipation of 'natural magick' occurred in Counter-Reformation and Baroque Italy (especially in Jesuit circles) – della Porta, Kircher, Niceron (anamorphoses). Interestingly, in Protestant North there was a great suspicion of visual 'magick'. Saenredam, the great church painter, undertook a series of drawings to disprove claims that divine images could be seen in slices of tree-trunk.

Secrecy
The earliest phase of the development of the telescope was not involved with astronomy, but the military/naval 'science'. The telescope was seen as a hugely important device in seeing the enemy (troops or ships) at distances beyond the scope of the unaided eye. It was literally a 'spy-glass'.

Many thanks for the news item from the website. It would be interesting to think about doing more on this – beyond the small *Nature* piece. Let's review possibilities when you are in England in mid-November. It will be good to meet. Correspondence is not like a face-to-face (eyeball) exchange of ideas.

Now knackered, after consuming day.

I'm happy to keep providing the minor historical niggles as you shape your grand scheme.

Ever
Martin

DH to MK
Los Angeles
9 November 1999

Dear Martin

As I keep repeating, the use of optics does not necessarily mean that fantastic clear images (like a projected slide) are needed. We are talking about imaginative clever artists, just as I used the camera lucida for two minutes (you can't really trace a living face) and then worked hard for two hours, so with others. A good artist doesn't need that much help from them and would know how to use the deficiencies, they have imagination after all.

You have made the point many times that the average art historian has too little knowledge of them, it seems more widespread than you thought, although some like you are very excited and can see its relationship for today.

I'm reading Panofsky's essay 'What is Baroque?' He says, 'Caravaggio wanted to get rid of the worn-out formula of the mannerists. He began with still-life painting and gradually proceeded to rendering human figures of a realistic character'.

This is almost childish, as though he knew the past and future, it's as

though Picasso says, 'Hey, Georges, aren't you fed up with all this post-impressionism. What about us going off to Spain and doing some Cubism?'

I agree, a face-to-face would be exciting now – eyeballing ideas, as you say. We seem to have become pen-friends, as they used to be called, and if you can put up with my smoking a bit, I'll cut it down with you, but I find they help the mind, at least for me. I look forward to some meetings.

I'm coming in a week or so. I'll bring the slides and colour pictures I can make on my Canon copier, but it does get more and more interesting to me, and my admiration for the artists I talk about all the greater. There are a lot of blind people about, as I'm sure you've noticed.

Your interest I find very thrilling.

As ever
David H.

DH to MK
Los Angeles
9 November 1999 (continued)

Dear Martin

Another thought: the diagram I made with the first draft, the period 1920 to 1960, is the period of mass murder in Europe, which can only occur with control of the mass media (the lens) as part of it. Hitler, Stalin and, even against his country's tradition, Mao all wanted lens-based realism in painting, plus a deep awareness of the power of film and photography.

Lenses and mirrors have great power.

David H.

Los Angeles
10 November 1999

'An attempt to sum up the ideas' by David Hockney

I began with an examination of Ingres's drawings. I used a camera lucida to make some portraits. They convinced me that Ingres had made use of it, but I pointed out optics don't make marks, only the hand aided by the eye and heart can do that.

It led me back to Caravaggio first and then forward to Velázquez and the Dutch 17th century, but where did it begin?

Renaissance knowledge of optics seems to have come from the Islamic scholar Al Hazan. Mirrors, especially convex mirrors, were made in southern Germany and the Netherlands around 1350. Showing more of the world than a flat mirror of the same size, they were objects that for the first time (in centuries) reflected quite a lot of space, including whole rooms with people in them. It is from this time that individuality of human faces begins to be apparent in paintings, especially in northern Europe.

Yet knowledge of lenses was known in Italy, but of course confined to a few scholars, all within the Church. To watch the development of the portrait (here I mean a face with individuality) is fascinating, for certainly by 1500 they had developed almost a 'modern' look (Bellini, *The Doge*).

Artists travelled about. Dürer made two visits to Venice. Holbein moved from Basel to England. Netherland's artists went to Lombardy.

Dürer is the only great artist to have depicted mechanical devices to aid

in the drawing of difficult things. Lutes foreshortened, figures foreshortened – difficult-shaped objects.

It seems to me now that lenses would have appeared in the Netherlands and Venice, and therefore, with travel, in Lombardy.

Certainly Jan van Eyck's *Man in a Red Turban* of 1433 and 'Mr and Mrs Arnolfini' in 1434 seem very closely observed. Hugo van der Goes's *Portinari Altarpiece*, *c*.1476, shows a man smiling and another with his mouth open (essentially fleeting expressions) and with sturdy workmen's hands in great detail. These details were noticed by Italian painters, as the work was sent to Florence in 1485. They would have known the difficulties of 'capturing' these expressions, open mouths and smiles being difficult to 'catch', for they have to relate to the eyes.

If the mouth moves so does the shape of the eyes simultaneously, so the problem is if the eyes take some time to draw, will the mouth relate to them by the time the artist is drawing that, assuming they started with the eyes? This aspect of portraiture will grow, and I think give us a clue to the use of the lens to make the quick notations necessary to 'capture' the fleeting.

The art historian's problem with all this seems to be documentary evidence. I'm not sure what this means. Written accounts, comments from sitters, etc. – yet paintings and drawings are themselves documents that tell us a great deal.

In the course of my research since my first notes last May, we (myself and friends and interested historians) have found plenty of things written about cameras (obscuras) and lenses and also found their connections to the occult and therefore to heresy.

Heresy might be taken lightly today but certainly wouldn't have been in the 15th century and 16th century – indeed, it was a matter of life and death.

I think this, combined with artists' inbuilt sense of secrecy, guild practices and so on, the handing down of skills and knowledge orally, accounts for some of it and I now suspect more can be found.

Looking at the diagrams of Caravaggio's incisions makes me feel my hunches of his working methods were not far wrong, and my experiments with optics tell me that each artist would use them in different ways – they would today if they were still in use.

I think there is an awareness at the end of the 20th century that some very modern mediums – film and television – have the severe shortcomings of being time-based arts. In 1950 it probably looked as though Cecil B. DeMille had replaced the Victorian history painters, yet today it's easier to see Alma-Tadema's work than his. You don't need a battery or machine to see it, and now we're acutely aware that technology has changed photography yet again. Its veracity – if it ever had it – seems altered for good.

There seem to me to be some interesting parallels. Not that long ago, who would have thought that in the history of the city of St Petersburg, for a short period (70 years) it would have been called Leningrad?

Perhaps in the longer period of the history of the lens-made picture, who would have thought that the chemical period (photography) would last only 160 years?

Never mind the millennium, just the change of century can make us now look back and realize that the 20th was, in Peter Gay's word, 'dismal'. It was certainly the most brutal and bloody, mostly this time over utopian politics, not religion.

What connections did pictures have with all this? Quite a lot I think.

The mass appeal of the moving image was used and controlled by far bigger tyrants than the Inquisition.

As we get further back from it, it seems to be clearer; the big break from 1870 now seems different, and in my early diagram a different joining-up seems to be ahead, or an awareness of this is growing. It certainly doesn't seem to be going any other way.

I suggested exciting times are ahead. Perhaps that's the optimist's view, but we all have pessimism and optimism to keep life bearable, and art has always contained both. However tragic it sees the human condition, the very fact that one can express it gives us optimism. Built into the very idea. Life goes on.

Oddly, although a lot of the world has got richer materially, we live in more negative times. Why? The need to have something to fight against. People like to fight, I've never been under the illusion it was otherwise. Yet for all its tragedy life has its joys, for myself, I've always tried to remember this – a weakness and strength of my own attempts at art.

MK to DH
Oxford
17 November 1999

Dear David

I've been searching for some time and space to reply to your latest faxes. Now, on Wednesday evening, listening to the Scotland–England game (football, or as the Americans have it 'soccer'). Having suffered, as a Scotland supporter, when England won 2-0 at Hampden, I'm now feeling better, as Scotland lead 1-0 at Wembley. Not your scene anymore, even if it ever was.

As you know, I entirely agree that a perceptive artist will imaginatively see how a device can be had to serve his/her ends in a non-literal manner, by not tracing but registering what is important. This insight provides a quite different basis for the historical analysis of the use of devices. Very important.

(Taking your fax in order).

Panofsky was a great art historian, but the passage you quote is no good – as you rightly say. One of the great problems for the historian is knowing the way that things went, and writing as if that way is somehow inevitable. It's like saying that such-and-such an artist or work is 'transitional' or that a work 'anticipates' another. The work made by the artist is simply itself, not designed to be part of an undetermined future. A work may contain unresolved elements, but that is a different story.

The power of the apparently 'real' in photographically based media is huge – as is the power of what is seen as 'scientific'. If it's done by instrument, without human intervention, if it's precisely measured, if it's set up to declare its scientific objectivity, it demands to be trusted. However much we may know about the unreliability and manipulation of the image, or the interpretative variability of scientific data, we *need* to trust it, because that is how our perceptual system is set up. The more apparently 'real' the image, the more potentially misleading it is. At least the artist is honest, seeing a corner of reality through a temperament (to almost quote Zola).

No one has really looked at convex mirrors as a model for vision in early art. Jan van Eyck was certainly fascinated by them, and there's a great Memling of *Vanitas* with a hand-held version. I've always wondered whether

the Giorgione *La Vecchia* (Venice, Accademia) is meant to be like a mirror – the image that Helen saw in the mirror and knew that she had been ravaged by time more conclusively than she had been ravaged by Paris.

There is a vital 'hinge' around 1500 – Bellini and the 2 Dürer images you sent. It is a new vision of how light (as much as form) can be rendered on a flat surface. Technique is obviously vital, the subtle glazes blending contours, smoking edges into disappearance, turning the form into the depth of the surrounding air. You can see this in the *Baptism*, to which Leonardo contributed in Verrocchio's workshop. The Verrocchio angel's hair is all rhythmic linearity, a metal-worker's vision of tensile curls. Leonardo portrays the sheen of light on the turbulent cascade of hair, not the hair itself. Even if lenses were used by Leonardo, Bellini, Dürer – the genius (as you insist) is the vision of how they can be used. Just think of Dürer's excitement at seeing what Bellini could do, having been brought up in the wiry German tradition.

The 'fleeting' expression of the *total* face is clearly vital. A smile without smiling eyes has a disturbing effect. By the way, I went to a lecture by Semir Zeki, eminent neurologist, to launch his book *Inner Vision*. (If I've told you about it, forgive the repetition). Apparently facial recognition (i.e., who someone is) and recognition of expression occur in 2 different centres of the brain. Some people can, exceptionally, recognize people but cannot read expressions, while others can see expressions but can't tell one face from another. Astonishing. It may explain why we can read a few marks as a smiling face, though it's not recognizable as anyone's face in particular. That we have a special, dedicated centre for expression helps explain how subtle and miraculous our abilities are to read what people are 'thinking'.

Re: paintings, drawings as 'documents' for the historian. Yes, of course, you are right. The problem is that the evidence of a written statement is different in kind and less arguable than the evidence in a painting or drawing. Let's suppose that we have a drawing that looks as if it was done with a camera lucida. A similar drawing carries an inscription by the artist, saying that it was done using a camera lucida. The first is subject to a judgement, while the second is self-evident. It's like thinking we recognize a long-lost friend, a recognition that is only confirmed by saying 'Are you so-and-so … ?' As an artist, you may rightly feel that your visual judgement of a visual thing was as good as a historian's reading of a verbal document. As a historian, I need to be more circumspect, but I absolutely do not endorse the general fear and timidity of art historians in making judgements on a visual basis. Sometimes I feel that my colleagues are ultimately scared by the idea of falling back on the visual – and most of them are certainly scared by real (living) artists. With or without cigarettes!

Only at page 5 of your remarkable history, and running out of steam fast after a sapping day – service to be resumed … , when I'm fresher and get a proper perspective (an interesting term). Off to bed – in lieu of more, I'm sending my latest monthly piece for *Nature* ['Slanted statistics: Petrus Camper and the Facial Angle', see M. Kemp, *Visualizations: The Nature Book of Art and Science*, 2000] – about a different device for certifying human character – through the fixed, bony components of the head.

Sorry I can't do more at this stage – this University, stultifyingly self-regarding, thuddingly complacent, terminally unimaginative and convolutedly inefficient, is really sapping my ability to do anything interesting.

As ever
Martin

MK to DH
Tokyo
28 November 1999

David

In Tokyo to judge an art-science colour prize for L'Oréal, the hair colour people! Picking up last threads of your final fax. For me, travel now makes time – no telephone calls, no e-mails, no remorseless flutter of paperwork, no faxes. Just seen a Rimpa show – screens to swoon in front of, and calligraphy to die for. No lenses, and a very different kind of eyeballing in which the hand–intellect nexus is primary. A mixture of chance and control, serendipity and structure, in which the hand and medium create analogies to the seen thing. Very different from the 'West'. A special kind of 'imitation'. Affinities sensed with your works? Back to your fax.

Who used drawing machines/perspectographs? Or were they just demonstration pieces? Did they work? The last first. Yes they did. One of my Italian friends made Cigoli's device (see my book), and it works superbly with a bit of practice. Yes, they were demonstration pieces, like some of the fancier, more aristocratic scientific instruments, which were made for patrons. It's difficult to plot their use, but I suspect that they *were* used, especially for portraiture. The pantographic-style device called the physiognotrace was certainly used, with operators setting up studios like precursors of photography. Saint-Memin had a lot of success in the USA, not least because multiples could be produced in various sizes and engraved. The other use of the devices was the projection of large-scale illusions on distant and irregular surfaces. The machines could be used as you have noted for lenses – i.e., for laying in key points. However, what they do is restrictedly linear, whereas the camera obscura produces that transformative magic with colour and tone, blending them into delicious harmonies.

I agree entirely that the same tool (e.g., lenses) will be used in quite different ways by artists (even at the same time in the same place). If using the devices was 'cheating' they would all produce the same exact scripts. It is this lack of similar results that makes the detection of their use so problematic. It comes down, in the last resort, to 'eye' (as a form of connoisseurship). Art historians today, at least these in universities *and* art colleges, don't like connoisseurship for a variety of intellectual and social reasons. They don't, for the most part, trust their 'eyes', with good reason – because they've never trained them.

The connection you pose between the characteristic media of the 20th century – the film and TV – and the 'dismal' brutalities of 'our' century is telling. The image, particularly as reproduced and transmitted, has always been annexed by power(s). The Church soon saw the power of printed images, as did monarchs, and other authorities. The great multisheet woodcut of Venice by Jacopo de' Barbari ('eyeballed' from the air in his mind) was sponsored by the maritime republic – Mercury inhabits Venetian air, and Neptune her seas. Much more effective than acres of wall paintings in the Doge's palace. What the photograph did was to bring the reproduced, multiple image within the reach of a huge public, from middle class to ruling. It could be used for power, but still photography had leapt out of the institutional bag, and could not be put back in. The moving image required (until video-cam) big industrial bucks and facilities. The dimensions of *trust* demanded by photographic images is extended by those that move – an additional sense of reality. Faced with an endless bombardment of images that move, we have to relearn to look at (contemplate) the static image – or

what is thought of as static – through our eye scans in an elaborate criss-cross dance, like a bee over its hive. Recently I timed the shots in a cinema commercial – almost no single shot was on screen for as much as a second. Instant visual fix followed by another, another. Powerful, hypnotic, but a kind of visual illiteracy with the richness of the single image. That's one reason why artists who provide instant fixes, such as Damien Hirst, work so well in our culture. Short attention span.

I agree that excitement lies ahead. The revolution in the making and transmission of imagery in recent times is as big as the revolution wrought by printing in conjunction with Renaissance naturalism. Is this good or bad? It has the potential to be both, to huge degrees. Everything from paedophilia to personal understanding, from surveillance and intrusion to the power of the individual over the collective. My fear is that we are not getting a proper cultural grip on all this – that we are stumbling blindly into a blinding glare of ill-understood images, flickering past too rapidly for our critical scrutiny. It's a big job for the cultural historian. It's a big job for the artist. We should be in the same base camp, with the same mountain range in sight.

As ever
Martin

DH to MK
Baden Baden
6 December 1999

Dear Martin

As David Graves has probably told you I collapsed last week. Gregory said I'd possibly over faxed myself. Anyway I'm recovering in the waters here and will be back in London on Saturday.

I saw the van Dyck show twice, also a small show in Duke Street with a painting in the window by G. von Honthorst called *The Laughing Violinist*. He is certainly laughing (not smirking like the cavalier) and it seems to me like a show-off painting – 'look what we can do now'. In black and white it looks like a photograph. If you are in London try and see it. 13 Duke Street, St James. It's signed and dated 1626.

David G. has done a lot of work at the Victoria and Albert Museum and British Library.

Looking forward to a meeting.

As ever
David H.

MK to DH
Oxford
2 January 2000

David

Back from Italy, resuming 'normal' activity. I've been working on a taxonomy of uses of optical devices, which is useful as an act of historical sorting. The categories are not watertight (a single work may involve one or more of the types of usage). What numbers 3–5 involve is what you have shown re: that the use of a device need not involve literal copying and that free-handlers of paint could have used optical aids. Anyway, here they are:

(1) Use for literal copying of contours to give outlines of the thing to be represented (especially perspectographs, frames, etc.). This is the predominant mode for amateurs.

(2) Use for the imitation of line, colour and tone, copied/transcribed as closely as possible (especially camera obscuras). Less likely for amateurs, since the demands on knowing how to achieve effects in paint are very high.

(3) Use for selective mapping, locating key prints rapidly, for subsequent acts of freehand drawing/painting (especially the camera lucida).

(4) Use for 'aping', imitating the visual effects of lens-based devices, such as: synthesis of tone; abstraction of patches of light and shade; use of 'circles of confusion' for highlights. This 'aping' is not done using the device directly for a particular work but using it as a point of reference.

(5) 'Faking it', that is to say knowing what a camera image can deliver, and using its 'lessons' to paint/draw freehand without direct reference, e.g., for fleeting expressions.

4 & 5 are closely related, but the attitude and extent/depth of use is different. 5 is much more selective.

We could, for instance, see Vermeer using 1 and 4, with a bit of 2, while Hals could use 3 with a bit of 5. It's up to you to decide your own recipe!

I largely dodged Millennium madness – listening to a remarkable Radio 3 day-long journey through 2,000 years of music, and passing the moment with Monteverdi's *Vespers* (1610) punctuated by neighbouring fireworks.

[…]

Looking forward to possibilities in 2000 – though what's in a date? The important moments for individuals arise within themselves and not by diktat of an arbitrary calendar. Anyway, happy New Year!

As ever
Martin

MK to DH
Oxford
12 January 2000

David

[…]

Two things I have been thinking about since my visit to the studio.

The images on the white board in your walk-in camera obscura are living Vermeers. The colour, tone, harmonization absolutely right. Seeing the image of, say, a face upside down tells me that the inversion, far from being a problem, is a stunning asset for an artist who sees how to use it. For someone like Vermeer, interested (obsessed) with how an abstract patch of paint acts as an analogue for the seen thing, constituting the illusion in context with the spectator's collusion, the way that the arrays of light and shade viewed upside down become detached from knowing the thing they originate from is strictly to be *used*. The patterns of light and shade that make 'nose' and 'chin' become detached from acts of recognition and naming of 'nose' and 'chin'. I'm sure Vermeer realized that. I think landscape/topographical artists like Berckheyde and Jan van der Heyden realized the same thing.

The second point concerns the marks discovered in Caravaggio paintings and illustrated by Keith Christiansen in the *Art Bulletin*. I'm sure you are right that they are not *preliminary* designs inscribed on the wet surface. They're so simple, without *pentimenti* and limited to schematic outline contours, that they wouldn't have played any useful role in a 'sketching' process. They must be 'mapping' marks, made as references to locations, like contour lines on maps, marking the presence of a major hill to be walked round. It's notable that they were made for 'difficult bits', like a wrenched head with an extreme expression, or a leg posed in an unsustainable position. They're locators, allowing things to be slotted in when studied and resolved. You believe that they are to locate lens-based studies within the stage-managed tableau. It could be possible to think of other methods to study the 'difficult bits', but the absence of such studies (drawings) is a problem. It's not a case, as they say, of your grasp of practicalities doing something that my guess does not accomplish. Again, my historian's instinct to need 'proof' kicks in. You will say that your understanding constitutes 'proof', and you are right. The notions of 'proof' are different, but they must be complimentary in any history of visual things that aspires to *visual* skills. *Very* salutary.

Ever
Martin

John Spike to DH
Florence
5 February 2000

Dear Mr Hockney

I would like to cite your views in my Caravaggio *catalogue raisonné* to be published next year in New York, Paris, Milan and Munich. My publisher, Abbeville Press, obtained your fax number from Gary Tinterow.

Could you make available a copy of your remarks at the Met Symposium? I would prefer to footnote your own statement instead of an article about you.

I was immediately convinced of the rightness of your views and I sent off a letter to the *New Yorker*. I'll enclose it.

With best wishes

Yours truly
John T. Spike

JS to *The New Yorker*
Florence
30 January 2000

Sir

Skeptics aside, David Hockney's theory about the old masters' use of optical devices has massive evidence in its favor. There are frescoes by Tommaso da Modena dating back to 1352 which show Dominican cardinals reading their tomes through eyeglasses and a handheld lens. Aren't mirrors optics? Seventy years after Brunelleschi used a mirror and a pinhole to draw the Baptistry in Florence in correct perspective, Leonardo said no artist should be without one.

The connection that Hockney draws between optical aids and

Caravaggio's darkened studio is nothing less than brilliant. The artist could have used mirrors to make his studio into a life-sized *camera obscura* just by following the directions given by Daniele Barbaro in his manual *La Pratica della Perspettiva* (Venice, 1562, and reprinted): 'Having made a hole in the window of the room from which you wish to observe, as large as a spectacle glass, then take an old man's glass, convex on both sides, not concave like the glasses of youths with short sight, and when it is fixed in the hole, shut all the doors and windows of the room etc …' (translation by Heinrich Schwarz). Monsignor Barbaro says this procedure is 'Molto Profitterole A Pittori, Scultori, et Architetti', and he was by no means the inventor. By the way, in 1605, when Caravaggio's goods were seized by his disgruntled landlady, the inventory listed two mirrors, one large and one convex.

John T. Spike

DH to JS
Los Angeles
7 February 2000

Dear Mr Spike

Thank you for your letter. I will get my secretary to send you the remarks from the Met. They were not written down. I do not speak from notes, but take my cue from the slides, but the Met made a video tape and a transcription of the text. My own speculations on Caravaggio will be sent as well. Please use them if you wish.

Yours truly
David Hockney

PS I am laying out a book with the visual evidence, which in the talks others found very compelling.

JS to DH
Florence
14 February 2000

Dear Mr Hockney

Thank you very much for sending me the transcript of your lecture at the Met Museum.

Your observations of Ingres's pencil ignoring the edges of forms, like a Warhol tracing, are both evidence and proof of your thesis.

Roberto Longhi always said that the real primary sources are not documents at all, but rather the paintings themselves. As right as he was, Longhi had to keep repeating himself because most art historians have an unholy fear of pictures. They're so hard to control, unlike the safely painted word. People seem not to realize that Ingres could be said not to have known some textbook or other, but the drawings speak for themselves.

I am sure you are right, too, about Caravaggio's use of optical foreshortenings. Next Saturday I am lecturing at the Ringling Museum in Sarasota, Florida, and I will cite your beautiful observation that in terms of painted perspective, 'melons are the equivalent of lutes'. The Museum has on view a newly discovered still life by Caravaggio which features a water melon with the top sliced off. As an expert on both Caravaggio and Italian still lifes, I can tell you that no other painter painted a melon like that before or 100 years

after him. The picture also has a squash wedge like one of the Sánchez Cotán's you discuss.

Which reminds me, your readers will ask you, 'If Bellini used an optical device *c*.1500, and Caravaggio *c*.1600, what happened in between?' In other words, why didn't Annibale Carracci use one in his famous *Beaneater*, which we consider a stab at realism?

The answer seems to be in part technical: optical devices evolved between Bellini (Leonardo's contemporary) and Caravaggio. You might wish to show if possible the difference between effects obtained from a mirror and from a lens.

And in part aesthetic: presumably the mannerists, like Gainsborough and Gauguin after them, were after different, non-optically rational, appearances. The scholar Heinrich Schwarz (whom I cited in my letter to the *New Yorker*) first postulated that photography was invented when it was invented only because Fox Talbot and other grand tourists thought that the monuments looked so beautiful in their camera obscuras they wished they could fix the image. The science wasn't new, only the aesthetics (which in turn had been conditioned by Canaletto's use of the camera obscura).

By the way, there is some discussion of his mirrors in Peter Robb's excellent new Caravaggio biography, called simply *M*, which has just come out in London.

With best wishes

Yours truly
John T. Spike

MK to DH
Oxford
19 January 2000

'Notes on Leonardo's mirrors and lenses'

David

As promised I've put together some notes on Leonardo on mirrors and lenses to accompany the images I showed you. As always, there are problems in interpreting Leonardo's notes and diagrams. Probably more than three-quarters of his written legacy is lost, and the surviving sheets often do not contain resolved discussions, but are in the nature of work in progress.

As you know, Leonardo was heavily involved with the geometry of optical phenomena, beyond his obvious interest in painter's perspective. He was aware of the medieval science of *Perspectiva* (optics) in line of descent from the Islamic philosopher Ibn-al-Haytham (Al Hayzan). He certainly knew Pecham's *Perspectiva communis*, and wrote out a translation of a passage from Pecham's introduction extolling the virtues of the 'divine' science of mathematical optics. Like the mediaeval texts, he concentrates on 3 areas: the eye, reflection, and refraction.

He was hugely interested in the geometry of light on convex and concave mirrors, and proposed an instrumental way of solving 'Alhazen's problem' – that is to say, the determining of a path of a ray reflected into the eye from a spherical mirror with a given light source. Together with elaborate studies of the geometry of reflection, there are also drawings of machines for the grinding of mirrors of precise geometrical curvature. Some

idea of the large dimensions of his planned mirrors is given by Codice atlantico 396vf, which indicates a curvature of 20 ells (approx. 1.2 metres).

Such studies not only involved delight in the mathematical beauty of the optical phenomena God has made for man's enlightenment but also possessed a practical dimension. Burning mirrors were a source of concentrated heat. Not least, Renaissance engineers were inspired by the story of Archimedes' legendary success in incinerating fleets of enemy ships at a considerable distance. Leonardo worked on burning mirrors in Rome after 1513, and recalled the way that Verrocchio, his master, had soldered the great *palla* on top of the dome of Florence Cathedral – presumably using concave mirrors to melt the solder.

The key point from our present perspective is that Leonardo developed a model for the eye in terms of a camera obscura, with a spherical lens placed just behind the aperture. The image of outside reality formed within the eye was not a direct model for the making of a particular painting, since Leonardo was in the business of remaking nature on the basis of his understanding of natural laws and effects (not least in biblical subjects, etc.) but the image formed in the 'eye-camera' set the standards for the naturalism to which he believed the painter must aspire in terms of perspective, proportion, light and shade, colour, etc. For the 'camera-eye' to become the direct model for a painting required a shift in assumption about the role of art, so that the literal imitation of 'raw' reality became an approved goal. The imitation, as you are arguing, could take the most obvious form of realism in Dutch art, but it could also include the composing of a *tableau vivant* in the manner you propose for Caravaggio.

With Leonardo, therefore, the technical know-how was there, the model of vision was there, and the notion of optical naturalism was there, but not the aim of literal imitation. To use a lens-based system involves more than a combination of technical means and an aspiration to naturalism. It involves a conceptual definition of artistic representation as literal imitation, together with a sense that an optical device which creates an image through the geometry of light delivers a more objective picture than the fallible human apparatus. Once this faith in the artificially made image became widespread, it could provide a model for objective naturalism even when not actually used to make a particular work. In this way, it is possible to see the 'age of the objective image' as extending from the Renaissance to the present day, with the domain of such images defined as Fine Art until the mid-nineteenth century, when their sovereignty passes to photography and later the cinema and TV. An interesting thought.

Ever
Martin
[Enclosed photocopies of Leonardo's drawing and commentary]

DH to MK
Los Angeles
18 February 2000

Dear Martin

I'm actually dictating this letter today, because I am tired. I'm going to the desert for a few days next week.

We've started work on the book. We're making a wall of 500 years of painting that will be 70 feet long. David Graves and I are piecing it all together. We think the visual side should be in the front of the book and then the text. This is our scheme at the moment.

We are emphasizing the early awkwardness with the arrival of mirrors and lenses and the return of awkwardness, but we have a rich visual story going on here and we are adding more to it all the time.

I think it will excite you.

Love
David H.

PS I'll be back to handwriting next week.

DH to MK
Los Angeles
1 March 2000

Dear Martin

Just to let you know we are laying out the visual side of the book with great care. It's amazing what we have found doing this, and even then it has taken some time to see things. We have found the first visual presentation of lenses and mirrors. Van Eyck, the mirror in the Arnolfini portrait and the lens in the portrait of Canon van der Paele (1436).

The invention of spectacles may be earlier than that, but the invention is really the frame, the lens must have come first – you couldn't make a frame first and then think what should we put in it so I can read this small type.

David Graves made a desk camera with a lens no bigger than Leo X's, and a small mirror at an angle. We get very clear images, especially with bright light. Robert Campin's 1430 portrait in the NG – the man with the red turban – which now looks to us the first really different and modern-looking face, could have been made this way – its size suggests it could.

We are all rather excited here, and the wall, I realize, is a great collage. David G. will bring two copies of the book back, one for Nikos and T & H, and one to show you and others.

Mirrors and lenses, there they were staring at us from van Eyck. I'd have been very embarrassed to have missed it. John Spike, a Caravaggio expert, wrote me, saying he thought I was spot on with Caravaggio. Also now it becomes apparent that the mirrors were always left – in Caravaggio's house, Velázquez's studio, etc. – but the dangerous bits, the lenses, were probably listed as 'precious objects', or still kept secret. It sounds plausible to me.

I hope the spring in Oxford brings you some cheer.

Love life
David H.

DH to MK
Los Angeles
2 March 2000

Dear Martin

Here is one of the pages [see page 177]. I saw the real painting in the RA van Dyck show. The woman is sitting down. We look at her face straight on, we look at the boy's face straight on. If she stood up she'd be about 10 feet high. Ask a lady to sit down and hold a child's hand.

How did this odd proportion happen? One explanation is he did it in bits with optics and then never noticed the discrepancies. The boy can't be a midget, and if he's standing on a platform he'd be swinging on her arms if she stood up.

Amusing, but it's amazing no critic noticed this.

Love
David H.

MK to DH
Oxford
2 March 2000

David

Many thanks for latest, which I will read and digest today. Enclosed is a letter from Philip Steadman at UCL. He is very good, very open.

Love
Martin

Philip Steadman to MK
London
10 February 2000

Dear Martin

I have been reading in the papers, and in the *New Yorker*, about David Hockney's excursions into optics, and his correspondence with you on the subject. Very interesting. I can go all the way with him (and maybe further) on Vermeer, as you well know. I am much less convinced about Caravaggio – at least judging from the journalists' accounts, which might well be garbling what Hockney actually thinks. The problem is the amount of light. Hockney imagines Caravaggio painting in a cellar or shuttered room lit just by candlelight, and using a lens in a curtain to form an image in a booth-type camera. One wouldn't get enough illumination to do this.

I think I could have predicted this *a priori*. But just to convince myself by experiment, I converted our living room in Olney into Caravaggio's studio last weekend. I set up a scene lit with four candles. I used the same lens (simple biconvex, about 9cm diameter) as we used in our full-size mock-up of Vermeer's studio and camera for the BBC film. All I got by way of an image was the (upside-down) candle flames themselves. You could JUST make out the tops of the candles; but everything else was blackness. Adding more candles would not, I think, have improved matters significantly.

Some people, as you know, have doubted whether cameras could ever have been used by artists indoors. The BBC demonstration (and other experiments) have shown that it certainly can be done. But to get a decent traceable image the size of, say, *The Music Lesson*, one needs a VERY well-lit room. Around 40% of the area of the window wall in Vermeer's studio was devoted to glazing by my estimates. The resulting daylight levels would have been many orders of magnitude greater than candle lighting. Even then Vermeer would have needed a reasonably large-diameter lens.

Do you think I should write to tell Hockney this? (But I don't know his address.) Perhaps you have already expressed similar doubts?

Are you still as frantically overloaded as you were? I am greatly enjoying UCL, but the pace and pressure are building up here too.

All the best
Phil

Dear Martin

Thank you for sending Professor Steadman's observations. Very interesting. I understand what he is saying about the amount of light, although if the candles are visible what he describes would happen. The source of light is never seen in Caravaggio, as it is in Dutch still lifes, but of course *is* in Vermeer, but I'm assuming the lenses Vermeer had were larger and more sophisticated. In fact, when people talk about the little spots of paint, for light etc., it suggests that he was enthralled by the projected image itself.

I based my speculation on contemporary accounts of Caravaggio's method. The number of candles would have been enormous (not 4) – or oil lamps provided by Cardinal del Monte. On the other hand, these contemporary accounts need not be reliable, but I'm assuming the dimmest image was all he would need. By Vermeer's time some difference has occurred.

We have set up here a desk camera with a lens 7cm in diameter and a small angled mirror. The images are very good, but only with daylight does one get a greater depth of field.

Tell Phil Steadman to try again with a hundred candles (Caravaggio was highly professional and would have been able to afford that) and hide the source of light and put a nude person there – also shield the lens, like one does with a camera today in bright light. He obviously had bright lights to make such deep shadows.

We have now arrived at about 1430 for the first modern face, and the size of the painting is about what we get on our simple device.

The book is taking good shape, full of contrasts that themselves pose questions. Comparing faces from Velázquez's *Bacchus*, that Honthorst we saw in December and then a Rubens, you can't help but see a big difference.

Do we have any idea how big lenses could be in 1600? The one we have made is no bigger than the one in the Raphael painting.

It would be great if you could come here, although I understand your commitments, but we will let you see the pages within the next month.

Love
David H.

PS I'm going to make my wall into a permanent piece and call it 'A Bigger Picture'. Perhaps I should show it at the RA.

Dear David

Thank you very much taking so much time out of your day yesterday to show me your optics project. It's absolutely clear to me from the examples you showed me that you're right about lenses having been used.

One picture especially intrigued me, since I realized in the taxi on the way to the airport that it contains within it 'scientific data' that can be extracted, which in turn could be extremely strong supporting evidence for your theory. Unfortunately, I can't remember the name of the artist, but the painting is the one from which you made an enlargement of a pattern on a table that appears to go out of focus as the pattern recedes into the distance. The painting contains all the information I need to calculate for you the diameter of the lens the artist used in his camera obscura. Basically, if you know the size of the original painting, and then make some reasonable assumptions about the size of the room (which will tell me the focal length of the lens) and the width of the table (from which I'll estimate the depth of focus), it will allow me to calculate the f-number, and hence the diameter of the lens. Aside from anything else, knowing the diameter and focal length of the lens would allow you to make your own camera obscura to accurately reproduce the original conditions the artist used five or so centuries ago.

Once again, thank you for taking the time to meet with me yesterday. As I mentioned, please feel free to call me if there are any optics questions you think I might be able to answer for you.

Sincerely
Charles Falco
Professor of Optical Sciences and
UA Chair of Condensed Matter Physics

Dear David

Very many thanks for 2 bouts of faxes. The 500-year wall sounds great. Getting the big picture, the grand sweep, the long *durée* (in the French sense) is always a problem for any historian but for a historian of visual things it involves not only the big conceptual, synthetic sweep but also the visual panorama. I think no one has really 'seen' the great visual sweep, like a huge scroll or enveloping panorama. In the massive *Oxford History of Western Art*, just emerging into the light of sceptical day, I devised schemes for chronological sweeps much broader than the normal successions of periods. I chose, following classical antiquity, sweeps from the fall of ancient Rome to the sack of Rome in 1527, from 1527 to the 1780s (industrial revolution, etc.), from the 1780s to 1914, and 1914 to the present. These divisions were based largely on the types and functions of images and their publics rather than on the basis of styles. Obviously a scheme devised according to your criteria is bound to be different – there is no single *right* way to define periods, which are artificial things anyway – but the reaching out to the big scheme is comparable. Historians spend most of their time defining differences – between the Renaissance and the Baroque, between Caravaggio and the Carracci, between early Caravaggio and late Caravaggio, between one painting and next – however, looked at from the total spectrum of world image-making, Jan van Eyck looks much more *like* Courbet than either resemble a Chinese image of an emperor, or an African carving of a deity. The aspiration of optical imitation in Western art is very exceptional. Its apparent 'normality' is because of the triumph of this way of representing in our century, above all as the result of the universal spread of photography, film, TV, etc.

Looked at from this big perspective, it is possible to say that from 1400 to *c.*1860 the *model* for painting was the optically founded record of the

visual array in a 'photographic' manner, and that all the variations (ideal imitation in the classical manner or 'rawish' naturalism in the Dutch manner) are variants around the central ideal of *mimesis*. In this way, the lens-based naturalism that you are stressing can be seen as the archetype even when it is not actually used by the artist. Also, in this way, the invention of photography and its public emergence in 1839 can be seen as a seamless extension of the conceptual goals that had been in place since the era of Brunelleschi.

[…]

I suspect that Philip Steadman will be reluctant to try 100 candles, which, regardless of expense in our electric age, would seem to threaten a domestic conflagration. It would be interesting to experiment precisely with how much or how little light is necessary if:

(a) all light sources are concealed from the angle embraced by the apparatus

(b) the 'chamber' is as dark as possible, with time for the accommodation of the eye (about $^1/_2$ hour)

(c) the whitest possible surface (i.e., gessoed panel or canvas).

I suspect the important thing is the *ratio* of light and dark, not the actual levels of light. The 'eye' is remarkable at working with ratios across a wide range.

I had been wondering how long it would be before Jan van Eyck and Robert Campin were enrolled in your conspiracy. Campin is a shadowy figure, in personal terms, but Jan was a social-climbing intellectual of the first order. It would be interesting if his knowledge of the optical texts of the late Middle Ages drew him into mirrors and lenses, while Brunelleschi and Masaccio went to the earlier parts of the treatises – on the geometry of the eye and the linear rays of light in direct sight.

You might be interested in the book that has just been published by the Met NY on the reconstructed perspectival *intarsias* from the Renaissance *studiolo* at Gubbio (the second made for Piero's *Federigo da Montefeltro* following the better-known Urbino one. 2 very pretty volumes, one by Olga Raggio (with a little essay by myself) and the other by Antoine Wilmering, the conservator. Lots of lutes etc. *Definitely* done by geometry of the Piero della Francesca type, if probably in a simplified, pictorial way. *Doing the geometry* was a vital part of the whole exercise, central to the intellectual thrust of the whole ensemble. This shows what *can* be done by geometrical perspective by someone who really knows what they are doing and has the motivation to keep at it. If you tell me that the *intarsia* makers used lenses, we *will* have an argument! There are geometrical drawings for such items – the *mazzocchio* hat-bands, the chalices (sometimes attributed to Uccello but probably later). These drawings (see *ca. 1492* catalogue) are absolutely covered with webs of incised construction lines. *Definitely* geometry. Which brings us back to how Holbein achieved his effects …

The 'Bigger Picture' should make a massive splash. I can't wait to see it. I'm in Chicago 1–18 April – very busy, but there might be a possibility.

Love
Martin

PS Your faxes dispelled my fatigue!

CF to DH
Tucson
3 March 2000

Dear David

I couldn't stop myself from doing some optics calculations based only on my memory of one particular image you showed me on Wednesday. That one painting I mentioned in yesterday's fax is, to me at least, the smoking gun that provides extremely strong *scientific evidence* for your theory. I would be surprised if this were the only scientific smoking gun to be found by careful study of those images on your studio wall.

For my calculations I assumed a Renaissance artist's studio with a lens, mirror, and canvas in what seem to me to be reasonable positions. From these simple assumptions, I was able to calculate some fairly precise properties of a lens needed for a camera obscura and, as you will see, arrive at some fascinating conclusions about the plausibility of such optics having been available at the time.

Anyway, assuming this studio configuration, the lens needed would have had a focal length of 2.18ft (665mm). It's easiest to appreciate the implications of this for your theory if we convert the focal length to another system of units, diopters. This lens turns out to be only 1.5 diopters. That is, it has the same minimal amount of curvature as on a pair of simple reading glasses (NB obviously, the higher the curvature, the more glass that needs to be removed to make it, and thus the more stringent the assumptions that have been made about the level of optics technology required). Since it is well established that the technology existed in northern Italy to produce spectacles before the end of the 13th century, for an artist after *c*.1400 to have had a 1.5-diopter lens of reasonable size is not remarkable at all. Which, of course, is precisely what you maintain is the case.

What about the size of the lens? Until I get copies of that particular painting you showed me, I'm again limited to making calculations based on plausible assumptions. If I assume the lens had a diameter of 3", the f-number would be approximately f9. An f9 lens focused on an object at 8ft would have a depth of focus of roughly 4". That value seems consistent with what I remember from the progressive blurring on the painting in question. Equally important, an f9 lens would have transmitted enough light to project a reasonably bright image for the artist to work with.

It's possible to go even further with this 'scientific supplement' to your theory. As just one example, making the reasonable assumption the lensmaker used simple flint or crown glass with an index of refraction of n = 1.5, the front and rear surfaces of this lens each would have had a radius of curvature of 2.2ft. In turn, this is enough information to calculate what the lens weighed.

To summarize this letter, from that one image alone it is possible to accurately estimate the focal length, diameter, f-number and even the weight of the lens the artist used to help him produce that painting. There is nothing remarkable about the properties calculated for this lens, so it easily could have been made with optical technology known to have been available no later than the end of the 13th century.

I hope you find the results of these calculations as fascinating as I do. As I mentioned earlier, I suspect there's more yet to be uncovered in those images in your studio that would allow optical science to provide additional support to your discovery.

Sincerely
Charles Falco

Dear David

As you will see in this letter, the scientific evidence for your theory is rapidly mounting. At this point there's enough evidence to convince any jury of physicists to convict Lorenzo Lotto of use of an unregistered camera obscura (a jury of art historians is another matter, of course).

Without even a single calculation – although they can and will be done – the attached blow-up of a different portion of Lotto's painting unmistakably shows *two vanishing points*. You, of all artists, in the world, will instantly appreciate what this means. We directly see at exactly what point in doing the sketch for his painting that he had to refocus his lens! A point that is at the same depth into the original scene as the other area of the image that I believe is due to exceeding the depth of field of a lens. All the pieces of the scientific story are consistent with each other.

Even without being an artist I can speculate that Lotto first used his camera obscura to sketch the pattern in the central section of the table without taking the time to refocus. He then continued to trace the pattern at the right edge, but found to his dismay he had exceeded the depth of field of his lens while still having too much of the pattern remaining to be traced. At that point, he had no choice but to refocus. But, after refocusing why didn't Lotto return to the center pattern, erase his tracing of the fuzzy image, and replace it with now-refocused image? The reason is, refocusing also changes the magnification. Since this effect is subtle, most people don't even know it exists, although this painting provides strong evidence Lotto was the first person in the world to discover it. In fact, it was because I knew of this effect that I searched the painting for evidence for it.

Unfortunately for Lotto's 16th-century tracing, but serendipitously for Hockney's 21st-century theory, that fuzzy central feature is over 6" wide on the original painting, so the small change in magnification when he refocused would have resulted in a noticeable mismatch between the bottom (near) and top (far) parts of the feature. Since he was tracing a very regular pattern consisting of straight-line segments, it would have been quite difficult to try to blend the two mismatched sections together. Had the happy couple chosen a floral rather than a geometric pattern for their tablecloth, it's quite likely I wouldn't be writing this fax. However, because the triangular-patterned borders are only 1" wide, that same change in magnification has a six-times-smaller effect on their widths than on the central pattern. Still, although the effect is small, it is absolutely unmistakable.

I believe the scientific evidence supporting your theory is compelling. Lorenzo Lotto used a lens to make this painting in 1556; of this there simply is no doubt. However, this is just one painter and just one painting. I can't help but wonder how much other optical evidence is to be found by close examination of the paintings on your studio wall.

More things keep coming to mind the more I think about your theory. One is that, even if perfectly fabricated, a simple lens will intrinsically exhibit various kinds of distortion. Consequently, another optical effect I suggest you look for is distortion of straight lines. At the least, I would count the presence of such curved lines that should be straight as circumstantial evidence a lens was used (the absence of curvature doesn't mean the contrary, since I can easily imagine an artist ignoring that particular feature in a projected image and simply drawing a straight line as straight). However, if such anomalous curved lines turn up in paintings, measurements of the degree of curvature – plus a few reasonable assumptions – would allow me to calculate some additional optical properties of the lens.

Sincerely
Charles Falco

Dear Charles
Thank you for your calculations, they have made me look again at that Holbein tablecloth (1532).

The edge of the tablecloth seems right but as you move up to the edge of the letter it seems to slightly change direction. Could this be something similar?

I had noticed the odd metal object not quite lying on the table but now I'm beginning to see that further up the cloth it doesn't quite gel.

What can you deduce from this?
Many many thanks.

Sincerely
David H.

Dear Martin

We are progressing with the book, and occasionally have visitors. We had a visit from a professor of optical science (University of Arizona) who was fascinated with the wall and the not-so-primitive camera that David Graves made.

We found a detail in a tablecloth in a Lorenzo Lotto painting *Husband and Wife*, c.1543, in the Hermitage, where the pattern goes out of focus quite clearly in the reproduction we have. Whether you can see it in the fax I don't know, but look up the painting.

I am also beginning to realize why it is only now that one can begin to see this revised history. I needed the jolt from the Ingres show to read the marks – pencil & brush – but one also needs a good library of art books, which, I have realized, were mostly made in the last fifteen years. Paintings rephotographed in good light. Cheaper colour printing – for instance, in earlier, black-and-white small reproductions of the Lotto, would the out of focus be visible? In the old days I'd have had to go to St Petersburg (I mean Leningrad) to see this, and then link it in memory with other pictures – think of how much travelling one would have to do to look at tablecloths – no wonder TV people, who want to travel, never see it.

Hope Oxford is getting warmer.

Love
David H. and David G.

CF to DH
Tucson
8 March 2000

Dear David

My secretary doesn't show up until 2pm today, but I'll send him to hunt down Holbein's *Georg Gisze* as soon as he appears. Even from the murky fax I think I can see what you mean about the table. It seems to bulge upwards out of the plane defined by the front edge of the table. I'll scan the painting and look and it in detail as soon as I have it.

Another point I thought I should mention is that it is possible to form images with curved mirrors – ideally, a minimum of two are needed – as well as with the lenses. Telescopes are probably the most common optical instrument using mirrors. This means that the 547mm f4 lens I calculated could have been produced either by a lens, or by two gently curved mirrors held in the proper relationship to each other. However, although it would have been very easy indeed to form those two curved mirrors, it seems to me to take a leap of faith to think someone in the 16th century would have figured out how to configure them as a lens. Still, it's a possibility you should be aware of.

Sincerely
Charles Falco

DH to CF
Los Angeles
8 March 2000

Dear Charles

Sending you an enlargement of the curious object on Georg Gisze's table. Notice you can see the edge of something curved through the little door. Could a Newtonian telescope be this small? I know they are much shorter than the standard type for the same magnification.

David G. and David H.

CF to DH
Tucson
8 March 2000

Gentlemen

Even though I still haven't managed to go to lunch yet (it's past 2pm here), I wanted to quickly compose a note in response to the sketch you sent a little while ago. In answer to your questions, *yes* an appropriate 'mirror-lens' could be the size and configuration of that object in front of Herr Gisze. Having said that, I hasten to add that, of course, that doesn't indicate it actually is such a lens.

I'm anxious to get the painting in front of me so I can see that funny door in clearer detail. Also, the painting will let me scale the object to get a reasonable estimate of its size so I can begin to calculate some optical properties, assuming it is a mirror-lens, to know better how plausible that possibility actually is.

But, right now I'm going to get some food. More later.

Sincerely
Charles Falco

DH to CF
Los Angeles
8 March 2000

Dear Charles

Lorenzo Lotto seems to have led us into a discovery into how Caravaggio worked. You may be able to help us here.

Look at *The Supper at Emmaus* in the National Gallery, London (you can, I'm sure, get a good colour reproduction from your Art Dept. Any book on Caravaggio will have it). I had suggested he had a kind of telephoto lens. He didn't need one. I now think what happened is that by Caravaggio's time they understood the problem of depth of field – a problem that, after all, won't go away, any photographer knows about it today.

Let's look at this painting. We now see he put a white tablecloth over the patterned one, to solve a problem. The outstretched arms of Peter on the right must have involved refocusing – wouldn't this account for the rather large hand at the back, bigger even than Christ's hand which is nearer to us? Surely by this date – 50 years after the Lotto painting – they would have developed a technique of moving the lens to solve these permanent problems. Can any calculations be done here? If we can sort this out scientifically it's a major achievement.

18 years ago I made some Polaroid 'joiners'. You may have seen some – Ren Weschler wrote an account of them in a book called *Camera Works*. I went in and out, moving all over the place to construct the pictures, as everything is in focus. *Pearblossom Hwy* was done the same way – an extremely elaborate piece of work. The appeal to the viewer is that you seem to be *in* the space, not outside, like with a single photograph.

Caravaggio could have planned his movements very carefully. My first hunch is probably too simple, but we have to start somewhere. Call me if you want. We are very excited here – it's another step.

Sincerely
David H.

CF to DH
Tucson
8 March 2000

Dear David

The scientific part of this story is branching off into so many directions that it's hard to quickly follow all of them. For example, instead of doing my real job (i.e., physics research), one thing I did this afternoon was to turn my office into a camera obscura using only a single, curved mirror as the optical component. That's right, just one gently curved mirror is all it takes to form an image, although the optical geometry if only one concave mirror were used would make it very difficult for an artist to work. However, throw in a second, flat, mirror and Caravaggio would be in business.

Optically, there's no difference between a concave mirror and a lens. The focal length of such a mirror is one half its radius of curvature, and the f-number is given by its diameter, just in the case of a 'real' lens. For example, Lorenzo Lotto's 547mm f4 lens could be replaced by a $5^{1}/_{2}$'-diameter mirror of radius of curvature $2 \times 547mm = 1.094m$. That is a very gentle curve (actually, you might have to look at it carefully to realize it wasn't supposed to be simply a flat mirror), and would be especially easy to fabricate starting with a piece of plate glass. Simply heat the glass and allow it to slump slightly.

On the painting front, my secretary finally returned from his quest after 5pm after having found the same book from which you scanned your own *Georg Gisze*, but also with a coarse-screened, small, b&w *Supper at Emmaus*. Unfortunately, even the printing of Holbein's painting in that particular book is too crude to see detail in that puzzling cylindrical object. However, I've scanned the entire image and will see if there are any optical clues to be found. First thing tomorrow my secretary will return to the library to hunt for a better Caravaggio. Unfortunately, I have a commitment tonight, so I have to leave now (although carrying various blow-ups of Holbein's painting with me to work on later this evening).

Sincerely
Charles Falco

CF to DH
Tucson
9 March 2000

Dear David

My secretary found a much better, but still rather coarse, copy of Caravaggio's *Supper at Emmaus* this morning. But, some more thoughts on a 'research strategy' occurred to me on the drive in to my office.

A seasoned photographer will have mastered the tilts, swings and shifts of his view camera to minimize intrusion of optical artifacts of the technical device into his photograph (e.g., to eliminate rapidly converging walls in a scene with a tall building), while early in his career the same photographer would have been less likely to have yet developed the skills to do this. If, as you speculated yesterday, the white sheet covering the patterned tablecloth in this version of *Supper at Emmaus* was Caravaggio's way of solving his depth-of-field problem, it indicates that by the time of this painting he had already mastered the camera obscura to the point where finding blatant optical evidence for his technique will be extremely difficult, if not completely impossible. If this is the case, it points toward studying Caravaggio's earliest work for optical artifacts that he hadn't yet figured out how to disguise. Unfortunately, the book I now have in my office isn't very complete (worse, it's in Italian), so I'm unable look up a chronology of his career to find appropriate paintings to study. Ideally, we're looking for paintings with geometric objects (e.g., tables windows, walls, etc.), rather than natural objects (e.g., arms or legs, trees, rivers, etc.), that extend deeply enough into the original scene to challenge a len's depth of field.

Beyond Caravaggio, I suggest concentrating your efforts on the very earliest example you've identified exhibiting 'photographic qualities' to look for optical clues. If we can find scientific evidence of the magnitude that Lotto gave us to prove that painters in, say, 1400 were using lenses, all subsequent painters then become suspect. That means that, rather than needing to find definitive evidence of a lens in every painting of that period, more ambiguous clues (e.g., the hands in *Supper at Emmaus* that don't seem to scale properly with distance) can then be used to help deduce each painter's techniques.

It seemed to me that an early example of use of a camera obscura changes the argument completely. Now art historians can say 'Painter X couldn't have used a lens because there's no evidence lenses even existed then'. That completely reverses the moment David Hockney can say 'There's now scientific evidence a lens was used for a painting during this much earlier period, and my eye as a painter says one was used by X in this particular painting'. At this point it would now be up to art historians to prove a lens wasn't used for a particular contested painting, rather than vice versa. The ball would be firmly in their court, as the saying goes.

Charles

DH to CF
Los Angeles
9 March 2000

Dear Charles

This is a van Dyck portrait of 1625 [*see page 177*]. How can this be explained? An example of odd proportion, possibly caused by optics? If she stood up she'd be 12 feet tall. We see the face straight on. We see the boy's face straight on. Yet we think we are looking up. Sit down with a child holding your hand and notice where his head is. They are here remote, physically and psychologically.

If the sitters had been in front of the artist together could it have looked like this? I would think not. Its 'naturalism' at first makes us accept it without questioning proportion. My point here is the use of optics *caused* this oddness. This was not like Madame Cézanne sitting still for hours. What do you think?

David H.

DH to MK
Los Angeles
9 March 2000

Dear Martin

Laying out the book is progressing, but new revelations are still going on. The Lotto painting has made us realize a few things.

Caravaggio uses white tablecloths, getting round a problem, and now we realize, it's not a telephoto lens but refocusing that would make that hand bigger at the back and, if you notice, bigger than Christ's hand in the middle.

Perhaps by then, 50 years after Lotto's painting, they understood how to overcome the depth-of-field problem, which after all is a permanent one. If one looks closely now at Holbein's Mr Gisze, the tablecloth at the front is accurate, but trace the lines from there, and the tablecloth seems to go off, like the lines in the Lotto.

The *Supper at Emmaus* is still intriguing. Try and visualize it spatially. Peter's thumb is bigger than Christ's thumb, which must be 2 or 3 feet in front of it. Refocusing alters magnification. My first hunch was pretty simple but a start. He might now have had marks on the floor where he would move his canvas. What do you think?

Hope the springtime is near in Oxford.

Love
David H.

CF to DH
Tucson
9 March 2000

Dear David

I'm sure someone knows who the boy in that van Dyck painting is, and thus his age when this painting was made. I'll guess that he was 5, which means, according to the almanac in my office, if he were an American he should be 3' 6" tall (42"). Since he was an underfed Renaissance European, I'll make him 40", which would place his head 22" above the seat of the chair. The boy is on the other side of the woman, separated by his outstretched arm, so he is approximately 22" further away from us than the centerline of the woman (i.e., 14" + 16"÷2).

In the portrait there appears to be the same amount of woman above the seat of the chair as below, whereas according to the measurements I just made of myself on my office chair there should be twice as much woman on the top side (i.e., 36" v. 18"). As for the boy, his head has the appearance of being roughly a third of the way between the seat and the top of her head, whereas it should be more like two-thirds (it's 22" from the seat to the top of his head, but only another 14" from there to the top of hers). Also, to my eye, the proportion of his head to his body looks more like that of a baby (i.e., a bit too large). So, the puzzle is to determine if there is a lens, and where it might have been positioned, that would compress the top half of the woman and compress the boy even more (and his body more than his head). The answer is, a very wide-angle lens located fairly close to the subjects and below the height of the seat.

To test this, I just set up van Dyck's scene in my office using a very wide-angle 17mm lens on a 35mm camera. As I expected – this is science, after all – it works. Although in the painting the boy's head appears to be level and looking straight into the lens, with my assumed set-up the lens is somewhat below his head. However, it's only approx. 1' below his head, and approx. $3^1/_2 – 4'$ away, so he only would have had to look down by approx. 15°.

Given how very odd the proportions in this painting look to my eye once you pointed them out, but how naturally they are reproduced by a very wide-angle lens, this certainly is very strong circumstantial evidence that, whether or not van Dyck used a camera obscura to sketch the scene, he must have used one to visualize it. Human perception just doesn't visualize things the same way a 17mm lens does.

Charles

DH to CF
Los Angeles
9 March 2000

Dear Charles

Ren is coming to LA this weekend. He arrives here on Saturday night and is spending Sunday and Monday here. Is it possible to come here on Sunday? I realize you spent only an hour or so with us, and you possibly only remember odd things.

We still go on looking. I have just received a catalogue from Fort Worth on Moroni, a portrait painter of the mid-16th century we have been interested in. We also took two versions of Velázquez's *Waterseller*, put one on a transparency the same size and found it's an absolute exact copy –

every detail fits perfectly. This strongly suggests an optical base again. We have also found an underpainting of a head that is an exact mirror image of another head in a early painting. Does this not suggest optics?

Yours
David H.

DH to MK
Los Angeles
10 March 2000

Dear Martin

We have got some very good pages now – very convincing I think – but still keep making discoveries. For instance, the Velázquez *Waterseller* (Apsley House, London) – the one with the drops of water on the 'sweating' pot in the foreground – has a replica certainly made at the same time, in a collection in Florence. Some say it's an earlier version by Velázquez himself – anyway the point is it's amazingly accurate in its copying although the waterseller now has a hat on his head, which suggests Velázquez did it (would his assistants add hats?).

We made a transparency of the Florence picture and it fits perfectly over the London one, including all those rims round the pot. Absolutely precise. How was it done? Also we found an X-ray of a small portrait. It showed underneath another head that relates to a head in an earlier painting. But it is a mirror image, so we made a transparency, turned it round and found it fits perfectly. Doesn't this prove mirrors and/or lenses are used here? I know about tracing and turning round the paper etc. – but the accuracy of the copy of that water jug is amazing.

Springtime is on the way.

Love
David H.

DH to MK
Los Angeles
12 March 2000

EUREKA EUREKA!!

Dear Martin

This afternoon was a 'Eureka' experience. With a shaving mirror and a cyclist's rear-view mirror – the one that fits on the helmet – David Graves made a mirror-lens based on that object in the Holbein portrait of Georg Gisze. He says it's a Newtonian telescope with no eyepiece and a hole in the side (like that Holbein object). We set it up and put a still life there, but when David moved it, I saw his white shirt with all the folds, as big as life, if not bigger. You don't need a lens at all – just two mirrors, not very big. We are now going to make one in a *small* can of beans. This is the secret knowledge. We think by the time of Vermeer lenses were common knowledge.

Come to the Mountain.

Love
David H. and David G.

MK to DH
Oxford
12 March 2000

David

Many thanks for latest (× 2). So that's what Archimedes was doing in his bath. Very interesting re. Velázquez – I don't have the relevant illustrations here, and will look them up at work. The question of assistants is not significant at this *early* stage of V's career, in any event.

The mirror trick sounds fascinating. What's that expression about a 'can of beans' – life's not worth it? Perhaps art is a can of beans and worth it. I'll look at the Holbein when I go into work. There remains the problem of secrecy, if such wonderful devices were widely available – it is the point at which you are probably most vulnerable to criticism from historian-adversaries, who will say 'surely there would be some record of their existence and use?' Using the secrecy argument is always tricky, because you can use it to justify anything (e.g., that Caravaggio was really a woman). You'll need to be at your best in sustaining this aspect of your argument.

I have found another lens for you. One of the spectators in Jacques de Gheyn's engravings of the *Anatomy Lesson of Dr Pieter Pauw*, c.1605, holds a magnifying glass in a circular frame. It is about as wide as a hand-span (though judging size is tricky in such images). I'll do a fax and detail on Monday.

Yes, let's come/go to the 'mountain'.

Love
Martin

CF to DH
Tucson
13 March 2000

Dear David

From *Optics: The Science of Vision* by Vasco Ronchi (1957):

When the invention [of eyeglasses] was made known to [late medieval] philosophers, it was examined by the standards of the prevailing theories and decisively rejected. Could any other verdict have been reached? Eyeglasses were transparent, to be sure, but they caused refraction and deformation …

Eyeglasses make figures look bigger or smaller than they would be seen with the naked eye, nearer or farther away; at times distorted, inverted, or colored; hence they do not make the truth known; they deceive and are not to be used for serious purposes …

In fact the entire philosophical and scientific world disregarded eyeglasses. That they were not abandoned and forgotten is due to the ignorance and initiative of modest craftsmen, whose minds were not preoccupied with the reasons for things and with theories …

In the meantime the study of optics developed, but in the absence of the key to the mechanism of vision the advances were rather slight.… It is obvious that those mathematicians who clearly understood how a hemisphere reflected a bundle of rays, like those coming from the sun or a star, could not discover any connection between that phenomenon and the figure of the star which they saw when they looked in a concave mirror turned toward the sky.

Which means, even though they didn't understand how to construct a mathematical theory of optics prior to 1600, the were using hemispherical mirrors to form real images.

To show how difficult it was in those conditions to describe even the most elementary experiments (for us today this is a highly useful exhibit), I shall quote a passage from Giovanni Battista della Porta's little work *On Refraction*. According to his statement, things should go like this: 'If the eye looks at an object in the water along a line perpendicular to the surface, the object leaps out without deviating and enters the eye; if this, on the other hand, looks along an oblique line, the object leaps out but deviates from the perpendicular in order once more to enter the eye.

This is undoubtedly a very strange way to depict the process of refraction at the surface of the water. Obviously Della Porta did not mean that the object literally came out of the water, but he did not know what else to say instead. [Note] the clumsiness of his terminology, which unmistakably betrayed the confusion and defectiveness of his concepts.… As is evident, della Porta does not know how to say all these things, simple as they may be.

This is significant – it says that, although mirrors and lenses were in actual use prior to 1600, people were so clueless as to how they worked that they had no vocabulary to describe even the phenomena they observed. Under these circumstances why would, say, one of Caravaggio's subjects be expected to record details? How would Caravaggio himself describe it?

In 1604, a Dutch maker of eyeglasses began to produce telescopes with a diverging eyepiece. These were copies of an Italian model of 1590 that had been brought to Holland. Among the learned the invention met the same distrust as had been customary with regard to lenses in general for over three centuries.

Charles

DH to CF
Los Angeles
14 March 2000

Dear Charles

It was a marvellous day for us yesterday, just the simple knowledge that a concave mirror is a lens has made me now start looking again at the Netherlands.

Your last fax is fascinating. I am rewriting my introduction to include this story, it gets more and more fascinating.

Love
David H.

DH to MK
Los Angeles
14 March 2000

Dear Martin

We seem to begin in a jumble but slowly get to simplicity.

'Mr and Mrs Arnolfini' has revealed something to us today. Very simple indeed. All the equipment needed is in the painting. My notion was first an

observation that a convex mirror showed a full figure and a whole room, especially if the rooms are quite small, the question always coming in my mind was how did he do that chandelier? We now think we know.

You will have noticed how in many paintings from the early Netherlands, and then by Antonello da Messina and then by others, the subjects all seem to sit at small windows with a ledge in front of them, I noticed this some time ago when I was doing portraits – 'Put your hands on the table' was my request, until I did the NG warders, where I abandoned that idea and eyeballed the clothes and hands.

We made a door with a square hole in it – outside is the strong California light. We placed a piece of paper next to the hole. Then with a simple shaving mirror (i.e., a concave mirror, the other side of the middle bit cut out of Mr and Mrs Arnolfini's convex mirror) placed on a stand in front of the hole we got an extremely clear image on the paper next to the hole. A concave mirror is optically a lens. That is all one needs. If you can make a convex mirror you can make a concave mirror – just put the silver on the other side.

Why are the pupils in that van Eyck drawing so small? The bright light outside the door! The sitter sees nothing but a round mirror with nothing he can see. Van Eyck makes the pencil drawing – or a pencil drawing of a chandelier. He then looks at the chandelier and realizes that to paint the beautiful shine he needs some paint that will blend better. 'Oil on wood' it says on the label in the National Gallery. He invented his paint using a binder that all the furniture-makers used – oil on wood in the damp Netherlands. He mixes his powdered pigments with oil, finds the right proportion and keeps the recipe secret within a small group.

It was perhaps the mirror that caused the invention of oil paint. They certainly seem to arrive together. Maybe they are connected in this way.

The convex mirror gives them intuitive perspective, and floors coming down in a slope, not like Piero's floor, and the reverse of that mirror gives them the lens to draw objects to fit into their compositions. The compositions are still planned like the manuscript pictures, but each object is seen very clearly. The drawings would get paint and dirt on them – the one surviving van Eyck drawing has red paint on the edges. All this is not far fetched. The equipment is in the painting. What do you think? We think it fits into place.

Love
David H. and David G.

DH to John Walsh
Los Angeles
14 March 2000

Dear John

Please come and see us tomorrow. I am a bit overwhelmed at the simplicity of it all. It's as though one has found an equation that is beautiful and clicks into place.

It was in the process of doing the book that these discoveries emerged – from a visit by an optical scientist who thought what was common knowledge turned out not to be at all. It suddenly clicked on Sunday, we did it yesterday – confirmed it marvellously this morning, and I went for a drive in the mountains to think. Its simplicity made me laugh and then realize I needed a pause, to reflect myself, as it were.

All the arguments about equipment falls away, and in a way I'm not sure what to do.

Love
David H.

JW to DH
Santa Monica
14 March 2000

Dear David

Thank you for keeping me informed. I'm very keen to see what you have worked out and will be there before noon.

As always
John

PS Get some sleep.

MK to DH
Oxford
15 March 2000

Dear David(s)

Great stuff! For once I had gone to bed before midnight. I'm in a terrible period of exhaustion and disillusionment with overwork, underpay and being treated like a teaboy in this place. It is important to find space to do justice to your spectacular ideas. Can you wait until the weekend? I know your justified excitement and wish to respond *adequately*.

It's arguable that all the great innovations in the history of concepts are *simplifications* – 'a cleansing of the stables', as it were. The Copernican revolution was precisely this – a cleansing of the geometry of the heavens of all the excrescences that had become necessary to save the Ptolemaic system – a literal and metaphorical seeing of things from a new perspective. I've got a piece on this, which I will send (awaiting publication). In fact, the Copernican system did not immediately work better with the observational data (that had to wait for Kepler's elliptical orbits), but it was the conceptual radicalism that did the vital job.

Keep up the cleansing!

Love
Martin

DH to CF
Los Angeles
15 March 2000

Dear Charles

Thank you for all the things you keep sending. Your visit was very stimulating for us.

On Monday, we realized how van Eyck could have done the chandelier. So simple. We, as it were, cut a hole in the door, put a piece of paper next to it, used the shaving mirror and got a pretty good image, which van Eyck could have marked like I did with the camera lucida, and then looked at the model.

The image is not reversed – it's just upside down, so all those portraits with the window – there are a lot of them, starting around 1450 – could have been done this way.

I am amazed at the simplicity of it, and I'm wondering why anyone didn't know this. No one wrote to the *New Yorker* or me mentioning it. What you thought was common knowledge turned out to be not so common after all.

We are all still excited.

David

DH to JW
Los Angeles
16 March 2000

Dear John

I have been talking to my friends and then writing letters – the talk cleared my ideas and then I write them down as simply as I can – and now it's one to you.

I know you have some interest in this and your scepticism was correct, nevertheless I am convinced of the optical base going back a long way. 'The lens', I kept saying, groping around, but I *had seen* something I knew was there.

On Tuesday, when you were here, you witnessed something we didn't know either until that moment I turned the piece of paper around to draw. The image was upside down but not reversed. It surprised us. The article you read that Allegri translated mentioned the Bacchus drinking with the left hand. He holds the glass up. Nobody notices this very much – it doesn't seem to worry us.

I think what we discovered last Tuesday is something no one knew. It's hard to believe a mirror can project an image. A flat mirror can't, and that's the one everybody thinks about. Van Eyck must have known what we demonstrated. He was a highly intelligent human being. He saw that image we saw, and then used it. Not many people saw that projected image – like the formula for the paint, he kept it secret – yet the images he made immediately influenced other imagemakers. 'It looks like the world out there', they thought, 'amazing', and they would attempt to copy his flat surface.

The difference between the image we saw, and the pinhole image is profound. The pinhole image is upside down and reversed left to right. That's nature, but the optical qualities of the concave mirror/lens are those of a 'mirror-lens', not a mirror *and* a lens, which requires more *space*.

Caravaggio's *Bacchus* [*see page 118*] does indeed look more comfortable reversed. He had the glass in the usual right hand. Ask anybody to raise their glass. 98% will do it with the right hand. Ask people in your office – give them a glass of champagne and watch.

This is where our friend the lute comes again into the picture. It's where you would notice the reversal. Many people made music on the lute. It's held a certain way, even designed a certain way, for the right hand to play. You'd know it was wrong. 'There's something wrong with this lute-player', one would think, and there are a lot of pictures of lute-players, including Masaccio's lovely angels – have they been done better?

The drinker is the giveaway. In the piece you were reading at the table, della Porta mentions the problem of reversal. It is the pinhole, or lens alone, that does this – the concave 'mirror-lens' does not. Giotto paints the drinker with his right hand on the glass, yet suddenly later there are a lot of left-handed drinkers. That is the lens alone, or a pinhole (nature), all are upside down so:

The secret of the concave mirror was lost. So something happens between 1434 and della Porta writing in 1550.

Think now of van Eyck's floor. The convex mirror makes the room like this:

They know the lines of the floorboards are straight so they correct them and draw it the way it is in Mr and Mrs Arnolfini's room:

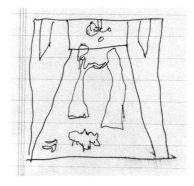

Meanwhile in Italy, perhaps not yet seeing the convex mirror, the mathematicians make the floor different. Piero's floor is like this:

It is devised from mathematics. Van Eyck's and the early Netherlandish painters seem to have an intuitive perspective. It moves about in a way it doesn't in Piero.

I think they made their pictures like the manuscript pictures of rooms, but had found the mirror-lens (a broken bit of the concave lens flashing the image on a wall perhaps) to make marvellous details that we marvel at today.

The point I'm trying to make is that the pinhole is written about, and known since antiquity, indeed it is a natural phenomenon. The lens is written about (also reversal) and then later the mirror + lens, which is the camera obscura, but the 'mirror-lens' is perhaps hinted at, but no one today quite knew what they were talking about. The camera obscura has obscured the picture.

Once an image is on a flat surface it can be copied. We can't 'copy' nature – there's too much there. I think some people can draw like lens pictures – but not as small as Ingres.

The main problem it seems today is that the lens + mirror triumphed, not Cézanne and his human vision, doubting the position of everything.

Perhaps we want the security of it, and worrying about it seems ridiculous to most people, but that triumphed image removes us from the world. I have gotten bored with the TV image and the movie image – what was that phrase we read yesterday, a 'blocked bit of reality'?

I prefer to look at the garden, yet I love pictures, have been fascinated with them all my life, love looking at them and making them. But something has happened at the end of the 20th century. What a difference in 100 years. In 1900 most images were still made individually by artists. At the end of the century, very few are, but millions of people look at them daily, unlike 100 years ago. Are they anywhere near reality?

On our wall Cézanne stood out, like his apples. A subject not of 'history', like the old hierarchies, but something right in front of us. The most interesting space of all is not 'out there' in 'outer space'. It's around our individual 'edges'. We are not a mathematical point, they have no space.

It's been an exciting five weeks doing the book. The 'lost knowledge' was what we saw yesterday, perhaps only van Eyck and the early Netherlandish artists knew of it – I don't know. Perhaps it has to be small.

I am now going to reflect myself.

Love life
David H.

MK to DH
Oxford
18 March 2000

Dear David

A few moments to reflect (difficult to avoid puns – or are they more than puns?) on Jan van Eyck et al.

Jan is astonishing, especially the Arnolfini portrait. Like Velázquez, Vermeer, Chardin, he takes the mimetic potential of paint beyond any logic of what pigments and binders on flat surfaces should be able to do – what all these magicians can do is to work instinctively with our perceptual systems to make us think that we see more than could actually ever be laid down in paint. No one has, I think, ever really come to terms with space in his work. It is, in terms of visual effect and consistency of behaviour, as convincing as Italian linear perspective, but it's not consistent in *rule*. It obeys some general principles (not dissimilar to those that Cennino derives from the Giotto tradition):

(1) Horizontal lines above 'head level' slope downwards with the space.

(2) Horizontal lines below 'head level' slope upwards into the space.

(3) Things at 'head level' are along the same level across the space.

(4) All orientations of horizontals are bilaterally symmetrical around a central, vertical axis.

(5) Objects equally spaced apart become smaller and closer together as they become more remote from the front of the picture (or the spectator).

(6) Light crosses the space in the same direction across the space (unless there is a secondary, miraculous source of illumination).

(7) Highlights rely upon the position of the light and the spectator (i.e., lustre or shine).

This shows a highly logical, thought-out approach which strikes a particularly intense relationship between seeing and representing without the geometrical formula of Italian perspective. The demands he makes (as you say) are what drives his technical innovation in oil paint. (He did *not* invent oil painting, which had been used in the Middle Ages, but transformed its practice). Where might the mirror/lens stand in this?

If his art is, as it declares, predicated on the belief that the meaning, significance, value of the created world (God's) is in every aspect of its appearance to the eye (that, as the late botanical illustrator and author Robert Thornton said, every detail of nature is a 'sermon for the learned'), the use of an optical device to act as a perfect mirror (*speculum*) of optical reality would be compelling. The potential interest is undoubtedly there. The question for the historian is what evidence is there to suggest that the potential was realized.

Jan, about whom is known a good deal (including his reputation for high intellect), is remarkably silent about his means. We are, therefore, thrown back (the wrong term!) to the works themselves, linked to clues about the available technology. The Arnolfini portrait does have the miraculous super-reality of a 'camera' image, as does the so-called *Cardinal Albergati* (not him, because not a cardinal!). Broadly speaking, I am happy to accept a historical model of Jan using an optical device of the kind you have brilliantly contrived both to serve as a guide for the portrayal of space and forms *and* to set the ultimate target for his standards of visual imitation. Such a model obviously depends on the existence of real presences in front of the device (people or things), which is entirely credible for the portraits and domestic interiors.

A different model is required for other paintings by Jan that depict imaginary spaces and do not retain any naturalistic scaling of people and settings. I am thinking of works like the *Dresden Altarpiece* which is a miracle of space, light and colour (I'll see if I can fax an image). The church (like that in the van der Paele altarpiece) is not a real one – for a host of reasons – but is one of Jan's invented Romanesque structures. He follows all the 7 principles I previously listed. If the 'camera' image is used it is as a *model* of naturalism and as a 'tutor' in the principles, rather than as the direct constructional means. What this indicates is a complex dialogue between looking, pictorial means, optical devices and adduced principles which does not rely upon the same way of proceeding in every instance. Where Jan differs from the Italians is that the direct reflection of nature – mirror-like – is what teaches the principles of perfect imitation, whereas for Piero & co the optical rules of geometrical light are used to remake nature

on the basis of the underlying armature of natural law. The overt presence of the armature, the proportional geometries, needs to be explicit for Piero, whereas for Jan it's the modelling of the image in the eye that really counts. Jan's view of how humans can gain access to a true understanding of nature, via the glories of its effects as ravishingly seen in the eye, is a supreme expression of the attitude which I suggested gave birth to the spread of mirrors as surrogate realities. It is this conceptual shift that allows lens-based, mirror-based, device-based naturalism to become viable.

One thing that need brook no argument is that Jan was *obsessed* with the behaviour of light on surfaces, passing through transparent and translucent substances, and traversing space. The metallic sheen of armour, the reflected scintillation and refracted glimmer of light passing through glass vessels, the beguiling commas of brightness and darkness in the bottle-glass windows, the lustre on the 'fake' gold of his brocades, the saturated luminances of stained glass windows, the precise charting of direct and rebounding light as it feels out to define the plastic forms....

This is someone who was irredeemably in love with light, the eye and its mirroring in paint. Yes, he *would* have seized on a 'camera' image like a famished man grasping a morsel of bread.

Still, there's the inbred caution of the historian nagging inside my conscience. If the concave mirror set-up was used (and I accept it *could* deliver what you claim), I am still worried that it is not recorded anywhere, either as an aid for artists or as a magic device. Secrecy, as we know even in the age of the Official Secrets Act, is a perennially leaky ship. Or do you think the 'shaving mirror' method is special to Jan?

As it happens, I'm sitting in my lounge (on the first floor of my house in Woodstock) with sharp rays of spring sun slanting through the leaves of a laurel tree in a pot (*Laurus nobilis* – nice name!). A series of little suns are sprinkled across this page – small round pools of light, paradoxically round, though the interstices in the leaves and branches are wholly irregular. This 'camera' effect was debated and explained in the Middle Ages – a manifestation of the way that for clever people in the business of looking the evidence of the camera is there to be seen. It's a question of knowing when and how to look. Bubbles of light.

Love
Martin

DH to MK
Los Angeles
19 March 2000

Dear Martin

We are really making discoveries now. This hole in the wall and the 'mirror-lens' is making us see how the Netherlandish artists constructed their pictures. An understanding of space and geometry is at work. They are composed of many 'windows' – not just one, as the 'mirror-lens' has trouble with size. This brings the whole floor up into the picture plane and you are really 'close' to everything. Very ingenious and sophisticated picture-making.

Your original point about geometry is now seen. In Italy, mathematical perspective is conceived with one vanishing point. We can now clearly see the difference between Bouts's *Last Supper* and an Italian geometric one. The Bouts is many windows; the Italian is one: non-Euclidean space and Euclidean space.

The joining of the two concepts occurs in Antonello da Messina, in the *St Jerome* in the NG. It is a picture with one overall concept of space, the mathematical, but with bits montaged in with the 'mirror-lens'. It all becomes visible to us now.

I am even seeing the transition to the glass lens – lens alone at first, and then lens-mirror, it is becoming clearer daily and once seen, it can't not be seen. It's very exciting, what we can now see at work is mathematical perspective, mirror-lens, and both put together, lens alone (therefore reversed), and then lens and mirror.

The transition to lens confirmed the mathematical perspective idea whilst seeing more, or so they thought then, but one now sees the pictorial problem today with the camera. I think this will change the way we see photographs.

Love
David H.

DH to JW
Los Angeles
20 March 2000

Dear John

Examine these two photographs by Caravaggio. The earlier one on the left is closer to us, it's all nearer or on the canvas surface (note table and still life.) I think he moved his 'mirror-lens' three or four times – hence things are pulled up on the picture plane.

In the 2nd one he resides in a clearer space, but further back. Possibly now he is using a glass lens with a reverse properties, hence the glass in his left hand.

David

DH to JW
Los Angeles
20 March 2000

Dear John

The point about the early Caravaggio is it's all nearer to you, brought up to the surface (like *Pearblossom Hwy* is).

Here are some Spanish still lifes. As you can see, they are clearly made up of three different set-ups (each one seen head on – they could have been done with our hole-in-the-wall, each upside down but right way round – then turned right side up and painted from life).

Now one can see Caravaggio's basket of fruit the same way, seen really head on – but how do you make a bigger picture?

We have done the *Portinari Altarpiece* this way. Every bit makes a perfect picture – looking head on at everything (drawing through our hole-in-the-wall, perhaps).

These do seem interesting links. What do you think? See you tomorrow at 9.30.

Love life
David H.

DH to MK
Los Angeles
20 March 2000

Dear Martin

In the NG London Messina's *St Jerome*, parts of it are all seen head on but put into Alberti's space.

Notice hole-in-wall portraits: many windows = non-Euclidean space (more like real space).

One window = Euclidean space.

Dieric Bouts's *Last Supper* – many windows, all looking straight on. Like our hole in the wall.

Love
David

MK to DH
Oxford
20 March 2000

David

Seeing the Bouts *Last Supper* as a 'joiner' is fascinating. The tendency to portray each discrete object as seen head on, and with reduced foreshortening, is very much a perceptual property – what is called by psychologists 'constancy scaling'. How this natural tendency, which is forcefully overcome by precise linear perspective, interacts with optical devices needs a lot of teasing out. I suspect the Bouts, as I suggested for Jan's *Dresden Altarpiece*, uses the mirror/camera as *a model* rather than as direct means.

I don't think, by the way, it's helpful to talk about 'real space'. Space is simply an extension along three coordinates, straight or (in modern space-time) curved. The way we *see* space is hugely complex, and we have clearly been equipped with some spectacularly effective ordering mechanisms for extracting what makes best sense for *our* purposes. How we *represent* space on a 2-D surface is a matter of playing towards these ordering mechanisms. Linear perspective of the kind of Castagno's *Last Supper* is just one, incredibly powerful way of playing towards one of these mechanisms. The more meandering passage of the eye in the Bouts (recalling Giovanni Bellini's statement that he liked to 'wander at will' in his paintings) plays towards other aspects of our systems of seeing. One is not more *real* than the other. They are both hugely artificial but compelling ways of working with our ways of seeing – the structures that govern the amazing perceptual equipment we have been endowed with. We are simultaneously Euclideans and non-Euclideans in our acts of seeing.

If, as I said in the fax sent to your other number, the spread of mirrors can be dated to the 'high' middle ages (i.e., 13th century), there would be a time delay in their coming to serve as a model for painting (i.e., my earlier idea of the rise of mirrors and naturalistic painting as simultaneous would need to be modified). What is needed for the *speculum* to be a model not just for *knowledge* (e.g., the *speculum vitae*) is a shift in the *function of pictures*, so that these become concerned with the visual knowledge of appearance according to an optical model. This shift appears to be linked with changes in the kinds of visualization required by devotion. The Franciscan crib becomes a model for acts of seeing great events of the Christian past as 'real' in the eyes of the contemporary observer.

This time delay also explains why optical devices of this kind, well known to Bacon and Pecham, were delayed in becoming relevant to acts of picturing. The 'glories' of the science of light (to paraphrase Pecham) as a model for knowledge would therefore coincide with the rise of mirrors. But painting would have to wait. What I left out of my earlier facile equation was the *function* of paintings. Of all people, I should not have forgotten that!

The Bacon quote on mirrors is fascinating, if somewhat unclear. It would be worth looking at the original Latin text. I'll try to find time to do so.

Love
Martin

MK to DH
Oxford
22 March 2000

Dear David

Thanks for the Antonello da Messina 'joiner'. Strictly speaking, I don't think the issue is whether the separate items are seen 'head on'. Virtually no one foreshortened round, cylindrical or irregular roundish objects towards the lateral margins of a perspectival space. Some theorists realized this was an anomaly, like the problem of the colonnade running parallel to the picture plane (in which the more distant, lateral columns should seem closer together and 'fatter'), but the anomaly was accepted because of the odd shapes that resulted if the logic of perspective was followed to its limits. Thus, no one would have foreshortened the copper bowl in the Antonello, as if seen at a diagonal angle.

There are two factors at work here.

(1) Centres of attention – i.e., areas of the picture that are set up around their own visual centres, inviting the eye to dwell on them in the act of scanning the plane of the picture. Antonello (like the Bellini quote) invites us to do this.

(2) Shifts of viewpoint as we look across the picture – i.e., different perspective centres. This occurs implicitly with the kinds of non-foreshortened objects I've discussed above, but is very rare as a deliberate strategy in most Renaissance and post-Renaissance western art. Even Uccello's *Hunt in the Forest* (about which I've written) which has lots of secondary 'tunnels' of space and 2° centres of attention, actually has a unified scheme. The centres of attention in the Antonello, such as the arcade and window on the right, come into this category, i.e., elements in a centralized, integrated scheme which serve as 2° centres. With Bouts, the centralized integrated system is not dogmatic, and the 2° centres are given more autonomy.

One small, but very significant detail on the Antonello *St Jerome*: look at the way that the perspectival pavement is taken over (subsumed) by *glare*. No artist completely within the central Italian perspectival system would have done that! The geometry would have retained its integrity. Antonello lets the light take over – a quite different sense of how geometry and the replication of seeing relate. This is a very tell-tale sign and speaks of the kind of 'mirroring' of nature through light effects which has been occupying your attention.

I hope this makes sense and is helpful. If I have time, I might try to count

the optical v. non-optical works in the *Oxford History of Western Art*, which I have just brought out.

Away in Sussex 'til Friday evening.

Love
Martin

DH to MK
Los Angeles
22 March 2000

Dear Martin

Thank you for your observations on Messina – indeed the light is the key. Lighting is essential with optics.

An example would be a comparison of Piero's *Flagellation* with Caravaggio's *Calling of St Matthew*. Here the construction of the pictures is very different. I suggest that Caravaggio was like Zeffirelli 'directing' his characters, and usually about catching the light – 'Raise your hand here.' 'Put a white feather in his hat.' 'Change the colour of his cloak.' etc., etc. – whereas Piero decides where the arms and hands go by his geometry. Both paintings show these methods clearly. One is geometric. One is optical.

How do these two things come together? Did they ever come together?

Messina does seem to be a key. He certainly seems to have known about the 'mirror-lens' – those portraits with the hole-in-the-wall suggest this. We have made a page of them.

What about this idea. It seems the 'mirror-lens' has the limitation of size. In our experiment we made the edges by cutting a hole-in-the-wall, if you try to get the whole door open, the image gets fuzzy at the edges, so the edges of the hole-in-the-wall eradicate this problem.

Now, if Messina used a 'mirror-lens' to help him with *St Jerome*, and he is trying to connect it to Alberti's method, his room has to be enormous, expanded like Bouts – but in a formal way – hence the composition with the small St Jerome in a large room.

What is confusing for us is that the lens, as we know it today, always provides a 'perfect' perspective. It dominates our way of seeing.

One other thing I have noticed only in the last few days is the difference between Caravaggio's two *Bacchus* paintings, painted almost one after the other.

In the first one we are closer to the figure. He is more pulled up to the surface of the canvas, whereas the second one (in the Uffizi) is further back – into the space.

My suggestion here is that the first one uses a 'mirror-lens', and that Caravaggio moved it at least three times – the face itself, the shoulders and arms, and then the still life. He invented the tabletop – the still life looks straight on, one is looking down on the tabletop.

The second one uses a glass lens. All is seen together, hence the reversal of the hand with the glass. The mirror-lens does not reverse, the glass lens does.

Could Cardinal del Monte have given the most talented painter a new lens? 'Look what this will do', and they thought they had seen a bigger picture.

I'm sure you could photograph a Bacchus like the second one, but you'd have to do a 'joiner' for the first – cut the bits out and it seems to work.

I must admit we've got to a stage in our layout where it would be good

if you could see it. This area of the geometry of the hand, and the geometry of optics – Caravaggio does seem to be a key player.

Sometimes my mind races too much, and I need a rest in hot mineral water and the desert. Come to think of it, didn't St Jerome go to the desert, or I am too confused at the moment.

Tired but still excited.

Love
David H.

DH to MK
Los Angeles
22 March 2000

Dear Martin

Here is something quite interesting sent me by a girl in Princeton who was doing research into how an aesthetic was set up in France after the dageurreotype appeared.

It is from a review of the Salon of 1851 – ten years after its appearance [*see page 216*]. It seems to indicate that the eye of the critic and other artists recognized something similar in past artists.

What I have now got in my mind is how small that concave mirror can be (really no more than two inches across and almost flat – the deeper the concave, the shorter the distance would be for projection).

As I have said, this was all new to us, only ten days ago did we see it. It is not mentioned much by anyone but to me it is the bit that makes the rest fall into place.

John Walsh, who was here when we demonstrated it (he runs the Getty), immediately gulped and asked why no one wrote about it. But why would they? I'll give you an example from today.

In the 'Sensation' show at the RA was a figure on the floor called *Dead Dad*, by Ron Mueck. I don't know whether you saw it, but it had amazing verisimilitude. It was half human size, so we seemed twice as big.

People marvelled at it because they thought it was modelled by hand. I doubt that it was; indeed there is now a system where the computer can scan an object, and using the old point system, make a mould, and therefore a 3D replica. It's like 3D photography. There is skill needed in the work of course – like with optical devices, yet I don't think the artist would tell everyone of his techniques. Yet other people do know of these, principally people in the model-making business, theatre and so forth.

On the other hand, it's not a small disc that can go in the pocket, and anyway since I'm sure van Eyck and others used it to measure like I did the camera lucida.

If you are tired, don't bother replying yet; but it's all very fascinating.

For myself, now I need a little time to understand this, but I'm certain of its use, what other explanation is there for the sudden portrayal of individuality?

Hope Oxford is getting springlike.

Love life
David H.

DH to Susan Foister
Los Angeles
22 March 2000

Dear Dr Foister

I sent you my hypothesis on how van Eyck painted that chandelier (a question most practitioners of painting and drawing are fascinated by).

I am in the process of laying out a book on this subject, but in that process we discovered the 'mirror-lens'. It was quite thrilling for us to discover this as it is not written about by art historians, or by della Porta, and is amazingly simple in practice – the image is not reversed, only upside down. This could also explain that globe in the Holbein (and the skull) with the word AFFRICA perfectly rendered on a curved surface.

I am still corresponding with Martin Kemp, but wondered if you had any thoughts on the subject.

It seems to me to be of great interest, because the lens dominates our way of seeing the world today. It produces a 'perfect' perspective picture. How the geometric and the optical began – and come together is difficult to find – but we think it started with the Netherlandish painters c.1430 (mirror-lens) and Italy c.1430 with geometric perspective. They seem to overlap in the National Gallery picture of St Jerome by Messina.

Martin Kemp pointed out to me the unusual aspect of this picture is the use of the light – the glare from the window – the shadows, etc. Light is essential for optics. Think of the difference between Piero's *Flagellation* and Caravaggio's *Calling of St Matthew*.

Any thoughts or criticisms you have would be appreciated.

Yours sincerely
David Hockney

PS Enclosed a letter to John Walsh on the subject.

CF to DH
Minneapolis
23 March 2000

Dear David

Recognizing that artists and art historians don't respond to equations the same way physicists do, I have been giving some thought to presenting scientific information on your work to a wide audience of non-scientists. If you think there would be a place for it, and if you think it would add to the impact of your overall story, I would be pleased to author an appendix, sidebar, essay, or whatever for your book (using the very minimum of equations and scientific jargon). Also, and completely independent of that idea, I think it would be great fun to co-author with you a manuscript for an appropriate scientific journal. What I imagine for this is basically a short description of the topic, a few reproductions of portions of Lotto's painting, and an appropriate version of that 10-page calculation I sent you. If nothing else, handing reprints of a refereed scientific publication to scowling art historians after your lectures could elicit some wonderful stunned expressions.

I'll be back in Tucson Friday afternoon.

Sincerely
Charles

DH to MK
Los Angeles
27 March 2000

Dear Martin

Here is a painting by Hans Memling [*see pages 64–5*] on the reverse of a portrait. What we have noticed is the pattern of the tablecloth (50 years before we see the problem in Lorenzo Lotto) has a change of direction in the perspective. Could this be geometry?

Our explanation here is that he used the mirror-lens, and had to change focus where the bottom of the pot rests on the table, just as Lorenzo Lotto had to do in his *Husband and Wife* painting. The pot is also very good with the pattern following the curves. What do you think?

David H. and David G.

CF to DH
Tucson
27 March 2000

Dear David

I'm finished with my AFOSR review for the year, so I now have some time to get back to Renaissance optics and art.

There are some statements in the excerpt on 'Mr and Mrs Arnolfini' that you faxed to me Saturday night that you might want to strengthen in light of the information in this letter that I extracted from several sources. For example, your present wording implies that convex mirrors were very rare in 1438, and hence only if for some inexplicable reason someone decided to silver the backside might a concave mirror have been created. In fact, both convex and concave mirrors had been studied for 1,700 years by the time of that painting, so a concave mirror wouldn't have been very unusual.

There is also a question of plausibility you might want to address. Readers of your book might be skeptical that someone in 1438 would even think to use a concave mirror as a lens. However, if they were made aware of the history, they'd realize that for 1,700 years prior to van Eyck people had been using these mirrors. Even better, the principal reason they had been using these mirrors was to focus the sun onto a surface. As you've seen for yourself, any time you use a concave mirror to collect light from the sun, you also create an image of the scene in front of you. All that is required to see that image is lighting conditions that don't wash it out. It doesn't take a completely dark room, either, just a place that isn't in direct sunlight.

The way it looks to me is, after 1,700 years of collecting sunlight onto surfaces with concave mirror-lenses, it's not just merely plausible that someone in 1438 would realize how to use the image automatically created with them, *it would be fairly implausible had they not*. Not only is optics on your side with this, the history of science is as well.

Charles

DH to CF
Los Angeles
27 March 2000

Dear Charles

Thank you for your note. Since you left it has been the 'mirror-lens', the tiny concave mirror, that has made us see how the Netherlandish artists constructed their pictures. Very exciting.

I like the idea of the scientific journal.

What is fascinating for us is that the 'mirror-lens' is so small. We are going to have some made. We just used a shaving mirror, but I'm sure with slightly better ones it would be interesting.

We are here until Wednesday morning, then we are taking 3 days at a desert hot spring, to rest.

We have mocked up of the book so far all in colour and text. We think it works very well.

Sincerely
David H.

DH to CF
Los Angeles
28 March 2000

Dear Charles

We are pretty certain how van Eyck now painted that chandelier in Mr and Mrs Arnolfini. I could draw it out myself. Is it possible to prove that the chandelier is monocular (i.e., seen from one point)? It certainly looks it to me, there are no corrections made at all. To me, it's always been a great mystery how he drew it, but not now. What do you think of the Memling of 1485, with the change of perspective?

David H. and David G.

CF to DH
Tucson
28 March 2000

Dear Davids

Especially in the light of what we now know about Lotto's use of a lens, that 1485 Memling painting is quite remarkable. Taken together with the analysis of Lotto's painting, I believe few reasonable people could doubt that Memling used a lens as well. This pushes the time scale back to the 15th century, which is very exciting indeed. Van Eyck is now within striking distance.

My first thought was that Memling's painting only provides additional circumstantial evidence since, lacking an 'internal scale' of known size – people, in the case of Lotto's – upon which to base my calculations, the same level of scientific proof wouldn't be possible. However, I then realized there *is* a scale. Although the vase and table could be of any size, I'm sure a gardener could identify those flowers and tell us the typical size of a blossom (do you know any gardeners who could help with this?). That information, plus the size of the painting and the same kinds of reasonable assumptions as before about the dimensions of the studio, would allow me to calculate the focal length and f-number of the lens that would give a depth of field requiring

refocusing where the perspective changes in the painting. This still won't be as strong as the evidence in the case of Lotto, since someone could always argue this calculation doesn't prove that Memling, rather than using a camera obscura, didn't inexplicably decide to change the perspective part way through the painting. Still, if I calculated a lens of reasonable parameters (which, actually, even before doing the calculation, my experience tells me the lens parameters will turn out reasonable), and taken together with Lotto's definitive results, anyone arguing at that point that Memling didn't use a lens would be a person too thick to worry about.

I'll see what I can do over the next day or two with van Eyck's chandelier. Meanwhile, you might try to find someone who knows what those flowers are, and especially their size.

Charles

DH to CF
Los Angeles
28 March 2000

Dear Charles

Thank you for your quick response. We are now convinced it is the 'mirror-lens', which we call the concave mirror.

The flowers in the painting are lilies, irises and columbines. The painting is 29.2 × 22.5cm.

What we have got round to thinking is the 'mirror-lens' was used by van Eyck and the other Netherlandish artists. We have found the altarpieces to be composed of many windows (against Alberti's one). We have deconstructed them and they are all made up of these windows, with everything seen straight on. When we put them together on the page I was reminded of my Polaroid pictures.

I believe them to be highly sophisticated pictures, not 'primitive' as they used to be called. Alberti's is Euclidean space; van Eyck's and others', non-Euclidean. It's that small disc, the mirror-lens, that has given us these insights.

Here are some thoughts on the Memling:

The relationship of the pot to the flowers could surely give us a size. The pot is hand thrown, but could be just a bit bigger than a pair of hands round it. (Think how they are made). Irises, therefore, could be calculated in relation to it, but we will send you some measurements for the flowers.

Would not this be a 'mirror-lens'? What difference does the curvature of the mirror make?

The book is progressing now very well. Since discovery of the 'mirror-lens', we have been able to look at the 15th-c. Netherlands with very sharp eyes and all my instincts (which I trust) tell me this is right.

The change happened, we think, in 1430. Robert Campin's *Man in a Red Turban* (National Gallery, London) is the first 'modern face', i.e., seen with optics.

Yours
David H.

CF to DH
Tucson
29 March 2000

Dear David

You probably already know this, but in searching for a copy of Campin's painting that you referred to in yesterday's fax, I learned there is a companion (*Portrait of a Woman*) that has the same 'photographic' quality. Interestingly, the dates I found given for this pair are even earlier than the 1430 you mentioned, i.e., *c.*1400–10.

In searching for Campin's painting I found another interesting portrait, by van Eyck, of *A Man in a Turban* in the National Gallery, that is listed as 'possibly a self-portrait'. It seems to me to have that same incredible photographic realism you've identified in others. This observation has a significant consequence since, given the perspective used in this portrait (including the piercing eyes staring straight at the viewer), I can't at the moment imagine any reasonable arrangement of mirrors and lenses that van Eyck could have used to project his image onto a canvas in order to paint himself so realistically. Simply observing his reflection in a mirror while he painted obviously can't explain the realism, since that would be no different than painting a live subject. Which means that, if you agree that the realism of this portrait is the result of a lens, the implication is that this *cannot be* a self-portrait of van Eyck. You should let the National Gallery know of their error. I'm sure this won't be the last example of unexpected consequences of your theory.

Charles

DH to CF
Two Bunch Palms
29 March 2000

Dear Charles

Thanks for your fax. I do not think it's a self-portrait either. There is a look (you are beginning to recognize as well) that measurement with optics gives that I recognized six months ago. Once you see it, you can't help but notice it, and you always see it afterwards.

We have located the beginning in the Netherlands with Campin and van Eyck. I think it's a 'mirror-lens'. We set it up here and the projection is very clear with just sunlight. A few notations are made for the face (because movement in the person causes great movement on the paper) but the folds, jewelry, patterns in fabric, etc. can be drawn very accurately because they don't move.

We now have a mock-up of the book. If you would like another day here, we got a whole set-up to show the technique. It's amazingly simple (hence the likelihood of its use).

We have gone to the desert for two days' rest, but any faxes will be sent on to us.

Art historians tend to regard the Flemish as 'primitive' because their perspective looked 'wrong'. But really they are highly sophisticated pictures with many windows.

Yours
David H. and David G.

DH to MK
Two Bunch Palms
29 March 2000

Dear Martin

We have come for a rest in Desert Hot Springs (the Baden Baden of California). A very relaxing hot mineral pool is just outside our door. (I'm here with David and Ann).

We have now reorganized the book and I think it works very well. Some new thoughts.

I think I sent you the review of 1851 of the Salon, and artists' reaction to the photograph. Perhaps the ubiquitousness of the photograph today is revealing (certainly to me, but I know to others as well) previous work with optics, even small use of them. There is a look it produces that we have come to recognize.

I am now poring over the Netherlandish artists – Memling at the moment. What I recognize is something like the Polaroid composite pictures I made 18 years ago. The mirror-lens enabled him to draw very accurate pieces of architecture, he can make them into any building he wants, only bits are real, and marvellous details that I recognize as seen through a lens, yet the construction of the pictures is wonderfully complex and sophisticated. They do not have 'wrong perspective', they have many changing viewpoints, many windows.

Perhaps the art historian has taken in the heroic nature of Cézanne and van Gogh – alone, working hard – and somehow seen other artists in this way, yet a more accurate analogy with van Eyck's studio would be CNN or Hollywood today. They were making big pictures. Their studio would attract the naturally talented, like Hollywood today. Talent would emerge quickly and be seen by the Master. There would be an immense amount of tracing and copying. People at work all the time on this. I believe they constructed them through drawings, with jump starts from the mirror-lens, hence the individuality in faces and beautiful architectural details with superb lighting. They are not static. Once one looks at them through time, they seem to come alive more.

What I mean is we are so used to the ultimate perspective picture (the photograph) that we look at these, and at first think the perspective is off. It isn't – they are not in the least bit 'primitive'.

As I was rereading your letters (David G. is reading them all here) you mention mirrors in your first letter, burning mirrors, concave mirrors, etc., but add they cannot be used for practical arts of picture-making in the same way as a lens. What we discovered is they can, and very well indeed. The projections we get are the best we have got with anything.

This seems to me to be the lost knowledge. Nobody knew it. We only tried it because an optical scientist just happened to mention a concave mirror has the same optics as a lens. He thought everyone knew this (like AD 1066).

This has given the Netherlandish artists a new look for me. They click into place for me now, and as you say Velázquez had quite a collection of mirrors. Our concave mirror is almost flat. You can only tell it's not because it magnifies at close distance, and gives an inverted but clear image at some distance away. It has made me deeply convinced of the general thesis. It wasn't the size of the two cans of beans, more like an old half-crown, and always in the pocket if need be.

It is, to me, a marvellous new way to look at the past. It brings us much closer to it. The break of modernism has not been carried through yet, but

I'm sure it's coming in some way with the computer. Just a hunch, but my first ones weren't wildly wrong.

Still excited
David H.

PS Reading about Memling. I'm struck by historians of the past changing accreditation a lot between van Eyck, Roger van de Weyden, Hugo van der Goes, Petrus Christus, Memling, and even Holbein. One wouldn't have this trouble with the Impressionists. Are they not saying, by this, that a common chord runs through the work. Portraits of a similar size, always through a frame, or hole-in-the-wall. They all have individuality. Knowing now about the mirror-lens, it seems absurd to think these artists did not know of it, and use them. The paintings themselves tell me. It seems to me if you have established the use of optics here there is no reason they were not used if needed by other artists later.

SF to DH
London
3 April 2000

Dear David Hockney

I apologize for not being able to reply to your very interesting letters earlier, and for not being able to talk on the phone (as being here only in the mornings does not fit well with California time).

I have read your letters regarding Arnolfini portrait and the longer letter to John Walsh, as well as the one addressed directly to me, with great interest, and also discussed some specific points with some colleagues here. One of these related to the technology of mirror-making (which is not something I know anything about at all myself), but the point raised was that concave mirrors would probably have been much more difficult to make than convex ones, as the 'silvering' was introduced during the blowing, in the same way as introducing any substance into a flask, but that it would be difficult to see how one would do the same to make a concave mirror. I am sure someone at the Science Museum would have the answer to this.

On van Eyck, it is a small point, but our scientists here have established that oil mixed with pigments had been used for painting pictures as well as objects that might be classed as furniture for probably hundreds of years before van Eyck: van Eyck's use of the technique was supremely refined and accomplished, but it was not an innovation.

On the Arnolfini portrait and the chandelier, although this is not to say at all that van Eyck might not have made use of lenses, you might be interested to know that we have undertaken quite a lot of research recently into what goes on under the painted surface of the picture and the way it appears to have been created by means of recording the underdrawing via infrared reflectography. One of the most interesting things to emerge was that whereas some parts of the painting are very extensively underdrawn, notably the areas of light and shade, the figures, the mirror itself (the shape of which has been altered) others such as the dog and the chandelier are not underdrawn. In the case of the latter there may be some barely perceptible traces of drawing there, but certainly not a detailed drawing. As we know that some Early Netherlandish painters appear to have used separate drawings or cartoons which they transferred to their panels in great detail before painting, does that suggest that van Eyck did not have such a reference for his chandelier? Dr Lorne Campbell, Research Curator at this

gallery, has written a 35-page catalogue entry on this painting, published a couple of years ago. I have shown your observations to him, and he would be happy to discuss in further details: he is very interested in the way that artists worked (his own father was a painter).

With regard to Holbein, when we were conducting research for the exhibition on the *Ambassadors* three or four years ago now, we were particularly interested in the extent to which Holbein might have used various kinds of physical apparatus to distort the skull in particular. I am enclosing some pages from the exhibition catalogue which might be of interest. It was a particularly exciting moment when we conducted the experiment with a pinhole described on p. 53 and saw how Holbein might have produced the distorted skull. With the portrait drawings (which I think it can be shown were traced onto the panels for painting over) I have always been slightly skeptical as to whether Holbein used any apparatus, because the one that has been suggested would have produced much smaller portrait drawings than the ones that survive. So I was interested to read that you had produced an image the size of the Albergati drawing by mechanical means, but I think this is smaller still than the Holbein drawings are.

I hope this is of some use in response to your queries. Please let me know if I can help with further information.

Yours sincerely
Dr Susan Foister
Curator of Early Netherlandish, German and British Pictures
National Gallery, London

MK to DH
Chicago
5 April 2000

Dear David

Many thanks for the mighty faxes. The whole picture is shaping up with remarkable coherence.… It's a splendid, overarching vision, which poses a mighty challenge to anyone who is concerned with the grand sweep of optical naturalism from the Renaissance to the motion picture. I can see how it is all of a piece with your lifelong probing of seeing and representing. I'm hoping to read your introduction in the near future, having looked at it quickly.

The case of Meissonier is very interesting – a remorselessly naturalistic painter who was overtaken by photography. I looked at one point at his relationship with instantaneous photography in the famous episode of Muybridge and horse's legs when galloping. Meissonier, as an artist who specialized in equestrian pictures, was determined to work out the exact positions of a horse's legs in various gaits – walking, trotting, galloping, etc. Knowing how difficult it is to see the intermediate positions, he arranged for a kind of sofa to be mounted on train wheels and to be pulled along a railway track beside walking horses. By dint of repeated and hard staring and recording he sorted out the walk pretty well, but the faster gaits escaped even his eagle eye. He therefore persisted with the 'flying gallop' – all legs stretched out and off the ground.

You can imagine his surprise and chagrin to discover Muybridge's photographs taken for Governor Leyland Stanford (of the University) with their entirely improbable leg positions. At least one of his later works partly takes on board the new knowledge, but not as thoroughly as, say, Degas.

Now, it's always assumed that the 'flying gallop' is wrong, and the

Muybridge positions are right. But it depends, right for what and wrong for what? The 'flying gallop' is obviously wrong if we claim that it records the position in which the horse's legs are found in a single moment, but it does not of course do that. If it is a case of giving an impression of:

(a) what we seem to be seeing (i.e., we pick up the legs best at the point at which they are momentarily stationary). Even after Muybridge we still can't see the intermediate positions.

(b) speed, through the aerial stretching of the horse *above* the ground.

All this is relevant to our present quest, because it shows how complex is the relationship between accepted conventions of representation, our acts of seeing, and what we *know*. In a way, we may say that linear perspective of the Piero sort gets at seeing through what we know, whereas Jan van Eyck gets at it through what we seem to be seeing. If you are right, Jan certifies what we seem to be seeing by reference to a device that produces the image as we seem to see it. Does that make sense?

Need to go to bed shortly.

Love
Martin

PS My schedule looking too tight for LA. Ugh!

DH to SF
Los Angeles
5 April 2000

Dear Dr Foister

Thank you so much for your interesting letter. We have also found the pictures of the underdrawing in Flemish pictures. I now think they used the mirror-lens to plot features in portraiture, and, of course, inanimate objects are easier to do (they do not move).

I might point out that the mirror-lens is not very big – the size of an old half-crown would do. The projection we get is very clear, using only daylight. A curved shield of polished metal would also work.

It is interesting that the chandelier has no underdrawing. He would not need it if he used this method. He could work straight onto the wood panel. It would be upside down of course but this is no hindrance to a painter, it even helps in a way. We have also noticed that in the Portinari Altarpiece the portrait was stuck on afterwards, but it all seems to be made up of many windows – hence the nearness to the picture plane.

We have made up a collage of all the windows, which I assume would have been drawn, and then scaled proportionately to what they wanted. Everything is always seen straight on.

The point about the mirror-lens is that it needs a frame. Think of all the portraits made after 1430 that appear to be looking through a window, or have a ledge in front of them. There are an amazing number, first in the Netherlands, and then beginning with Messina taken to Italy. They are all approximately the same size. Bellini's *Doge* is like this. The clothes could have been on an armature, as could the hat.

If you don't use a frame the edges, of course, blur, but with the frame a very clear picture can be obtained.

You could try this at the National Gallery. We just used an ordinary shaving mirror; and in bright light, because the mirror is five inches across, we cut out black discs (to stop down, like a photographer would say).

The reason all this interests me is that photography simply comes out of it – it was merely the chemical invention to fix an image that had been seen for at least four hundred years.

But taking away the hand takes away our bodies. It's why Cézanne is so important and the van Gogh *Sunflowers* lights up the room.

I don't really understand why people would think optics diminishes the achievements of these artists. They were not like Cézanne or van Gogh, alone and heroic, they had large workshops making the only images then known, so more like a Hollywood studio, with people tracing, scaling up or down, making paint, etc.

Once a talented artist saw the vivid reality they had depicted they would want to know how it was done, and the talented would find out.

It all happened so suddenly. What other explanation could there be?

I know the art historian is looking for documents, but as Roberto Longhi said, paintings are primary documents.

That's all I have been looking at (enclosed my joke on this theme) but I do think this has immense interest for us today, when lens vision has triumphed all around us, and somehow made the world seem dull. Doesn't television make everywhere look the same.

Better to have the human hand at work, at least it's connected to an eye and therefore a body. We are a part of nature, in it, not a mathematical point.

Sometimes I think religions might be right about images, but I love them myself and have a deep desire to make them, of a world I love.

Thank you
David H.

PS I've always thought the best use of photography was for photographing drawings or paintings.

Peter Friess to DH
Bonn
26 April 2000

Dear Mr Hockney

I enjoyed reading about your ideas in the *New Yorker* very much.

I believe you! I have worked in this field with great enthusiasm.
I published the results of my studies in the German language. I enclose
a copy of the article in the hope that you can read it.

It would be a great honour to discuss this topic with you in more detail.

Yours sincerely

Dr Peter Friess
Director, Deutsches Museum Bonn

CF to DH
Tucson
24 May 2000

Dear David

This morning I sent a package that should be on your doorstep tomorrow,
before you leave for London. Aside from all the scientific mumbo jumbo we
bombarded you with on Monday, it was exciting to be able to extract
interesting information from the Chardin portrait [*see page 173*]. As
I mention in the letter you'll get tomorrow, the fact that every time we get
together we manage to uncover another significant piece of new
information points to how fertile this field is, and how much more is
waiting to be discovered. Very exciting stuff.

I hope Ren convinces his editor [at the *New Yorker*] to publish a follow-
on article on your discovery, since it has taken some significant new twists
and turns in the four months since he wrote his original piece. If there is an
unidentified object in a museum storeroom somewhere that could be, for
example, a sliding apparatus for positioning a mirror-lens for full-length
portraits, the more people who become aware of your work, the more likely
those objects will be brought forward for analysis.

Still, lack of knowledge about optics (or science in general) amongst art
historians may turn out to be the single most significant impediment to
gaining widespread acceptance of your work. It appears to me that art
historians have been brought up in a culture where essentially everything
ever discussed in their field is completely relative and subjective. Since no
one *really* knows if the vellum background in a particular painting was put
there to symbolize life, death, reincarnation, virility or chastity, or was used
only because the painter had sent his other backdrop to the dry cleaners
that day, the 'final' interpretation on any matter probably goes to the art
historian with the glibbest tongue. That, and the fact that they are
mathematics-averse, may require a different approach than usual to help
some of them realize your discovery isn't simply your interpretation v.
theirs, but actually rests on absolute scientific principles. I suspect that the
idea that significant aspects about the artistic qualities of various paintings
actually can be *proven* is going to take some effort to convey.

Charles

CF to DH
Tucson
26 May 2000

Dear David

You've probably already left for the airport, but, if not, take a quick look at our
Rosetta Stone – Lotto's *Husband and Wife* – again. The wife's right arm, resting
on her husband's shoulder, is amazingly long. If I scale that arm to the width
across her shoulders, and even if I assume her arm were extended straight out
(which it isn't in the painting), it would be 30" from shoulder to fingertips.
My arm, extended straight, is only 25". Given her pose, the distance to her
fingertips should be less than ~22" (i.e., her hand should end roughly where
her wrist emerges from her sleeve).

Even after having stared at, studied and measured this particular painting
for almost three months, I only noticed this distortion this morning. Which
means there are certainly more such 'discoveries' to be made in paintings
you've already identified, not to mention all the other paintings that don't
happen to be in books you've had access to.

Charles

CF to DH
Tucson
27 May 2000

Dear David

I just got back from running some errands, taking the opportunity to stop at
Borders to look at art books. They had the catalog for the Chardin exhibition
that will be closing in London in a day or two, in which is the painting you
brought with you on Monday. I quickly skimmed through the book and
discovered another (whose title is something like 'Washerwoman') with
a similar – perhaps the same – door in the background, in which the door
frame kinks like in the other one (i.e., at the point where we think he had to
reposition his lens). However, in this painting I could see no other obvious
distortions (although, I only looked at it for a minute or so).

Also, in a new book published by the National Gallery in London I found
another Lotto with a very similar composition to his *Husband and Wife*. I don't
remember the name of this painting (uncharacteristically, I didn't have
a pencil and paper with me), but the tablecloth has a non-repeating
geometrical pattern, and in any case is partially obscured by a bowl and
a child. Still, in spite of this, closer study of that painting might reveal traces
of the lens that we now know he used.

Charles

DH to CF
London
28 May 2000

Dear Charles

This is a Chardin still life [*A Soup Tureen with a Cat stalking a Partridge and
Hare*]. The apple and pear seem gigantic compared to the cat. Assuming
handles on silver tureens have to be a certain size (for the hand) can we do
any calculations here? Is the cat very small or the pear gigantic?

David

CF to DH
Tucson
28 May 2000

Dear David

In answer to your question about Chardin's *A Soup Tureen with a Cat stalking a Partridge and Hare*, yes, it certainly would be possible to do some relevant calculations. To do so would get us into interesting – interesting for me, at least – statistical analysis, since there is nothing in the painting of completely determinate size.

To give us an oversimplified idea of what would be involved, and what could be learned, we could scale everything to the size of, say, the tureen. In doing so we might find the cat to be quite small. Still, checking veterinary tables on cats, we might discover that 2% of tortoiseshell cats are as small as the figure we just calculated. We might next find that only 5% of hares are as large as the dead one on the table. Although a proper statistical treatment is more complicated, for the purposes of this fax we would then calculate that the odds of finding such an unusually small cat together with such an unusually large hare is only $\approx 2\% \times 5\% = 0.1\%$. According to the caption you enclosed, we also have a grey partridge, two pears and an orange to use in our calculations to refine it further.

A proper statistical treatment isn't quite as simple as multiplying probabilities like I did in the previous paragraph, but it still would be rather straightforward to do if we knew the size distributions of the various items in the painting. In the end we would come up with a number that's the odds of all those out-of-proportion items appearing together, say, only 0.0035%. If that's the number we ended up calculating, and even though this uncertainty would be too large to convict OJ, it still would indicate that it was highly unlikely that Chardin could have produced that painting from real objects sitting on his table at any one time. However, while one person could then argue that the distortion in sizes was probably due to his use of a lens, someone else could argue it only indicated he was sometimes sloppy with his technique; and in this case must have moved his easel further away from the table at the time he painted the cat.

On the other hand, if we had previously conclusively proven from other optical evidence that Chardin had definitely used a lens in at least one other painting, knowing how unlikely such an agglomeration of objects was for this painting could provide a valuable insight into his way of operating. Analysis of the painting Richard will forward to me, along with *Washerwoman* that I mentioned in the fax I sent yesterday (copy attached), very likely will prove that Chardin used a lens.

Charles

DH to MK
London
31 May 2000

Dear Martin

I'm still thinking about what we have discovered. I'm now totally convinced that Campin, van Eyck and followers discovered an optical projection of the world and used it. They made optical measurements just like I did with the camera lucida. It's what I recognized slowly as I went backwards from Ingres. John Walsh now says I'm probably right about Ingres. Well, once you accept that, you've got to move backwards – he can't be the first one to use them. It's too visible now.

So what really happened in the 19th century? The old hierarchies of picture-making put the painting of history on top. The Church and State wanted this. One can understand why. Yet modern art history says this collapsed about 1870, and Ism-ism took its place. Isms followed isms. But artists didn't really invent the isms – they were called that by commentators not usually involved in the practice.

It's true Cézanne stood out. Different, non-optical, as I have said, human vision. Yet what history painting was about only changed mediums, it entered the cinema. Even better to educate the masses. The 'news' reel became the equivalent, doing really the same job. This is what I was trying to say with my diagram, especially that loop in the 20th century.

The authoritarian governments didn't care for modern art, they had the cinema, but still had a lingering fear of the painted image and its power. Yet by the thirties it was powerless compared to the cinema. When I was young we used to call them the pictures. 'Take us to the pictures Dad!' The Regal 'Picture Palace' was nearby. They are not referred to in that way anymore, not with 24-hour TV, home video, etc.

The idea that art is all very separate from this seems to me ludicrous. It's why 'Art' is now almost anything you want it to be. That *NY Times* piece on the new Tate suggested that the definition of 'Art' keeps changing. It seems to, he's right. 'How does Cézanne relate to the video artists', he asks? I'll point out the video artist probably doesn't know how old the projected image is. Certainly in modern terms it's 600 years old. I can't believe van Eyck didn't know it. The paintings are the evidence. John Walsh has a right to his scepticism, but so have I from the other side. I'm sceptical of the belief that optical measurement wasn't used. The evidence is overwhelming if you know about drawing and mark-making.

I have just spent an hour looking at some forthcoming 'Art' sales at Sotheby's and Christie's. They have 'experts' in contemporary art. There's no such thing, if you think about it seriously how can there be, only followers of an 'Art' line. Meanwhile, CNN thinks it's telling us what's going on – history painting now changed by the internet. No wonder 'Art' looks lost or irrelevant. Cézanne is still the giant, more 'modern' than video, with its mechanical-optical view of the world.

I'm just reading Robert Conquest's *Reflections on a Ravaged Century*. He relishes pointing out the Academics being taken in by the enormous social experiments of the century, all using 'history painting' transformed. He doesn't say this, or not this way, but I think when we can see the bigger sweep of things it's quite clear.

It's true none of us knew of the mirror-lens, but it seems to me it makes a big difference. We stumbled on it accidentally, even Charles Falco didn't tell us outright, it was a sub-clause of a sub-clause of a sub-clause when I picked it up.

Perhaps we really do have to look at 'Art' – when did the concept arise? The Egyptians didn't see it separately from their world view – what they did as 'Art' was a necessity. Perhaps it arrives with optics, or anyway the Greeks, then was forgotten until the revival – the Renaissance.

I'm sure there's some story here, and the chemical or mechanical fixing of the image had a pronounced effect that we still seem to ignore.

TV programmes are reality. 'Art' is over there, the commentator now says. Can this really be true?

I'm going to bed now.

David

CF to DH
Tucson
1 June 2000

Dear David

That Lotto painting I mentioned in a fax a few days ago was in one of the books I bought today. As you can see, he liked the composition sufficiently to use it at least one more time. Also, he was more clever with this 'new' painting, covering the tablecloth with bowl and a child to avoid that pesky depth-of-field problem.

Although the bottom painting is on a canvas that is 19% wider (and 9% taller), the subjects, as judged from the spacings of their eyes, are consistent with their being essentially the same size in both paintings. Even the angle at which we're looking down on the top of the table is the same.

One thing I hadn't noticed before, but that now seems apparent when I see these two paintings together, is the orientation of the tablecloth in *Husband and Wife* doesn't look quite right. The other elements in this picture (as well as in *Giovanni della Volta*) are consistent with it being a photograph taken with the lens positioned at a point straight back from the center of the painting. However, the lines on the tablecloth in *H & W* angle too steeply toward the left (in fact, the tiny bit of border peeking out from under the husband's arm should be angling to the right). If this were a photograph made with a double exposure, as we believe it is, the table would actually have had to have been even further to the right of the lens when he projected that part of the image. In contrast, in *GdV* the vanishing point for the pattern on the tablecloth is symmetric about the center of the painting (that is, lines to the left of centre angle to the right, while lines to the right of center angle to the left), as it 'should' be.

In case you don't remember the particular result, basically we calculated from those head-and-shoulders portraits that a simple lens only would be able to provide a 'reasonable quality' image for an area that turns out to be the size of the visible portion of the top of the tablecloth. In other words, Lotto would have had to build up this painting in several separate 'exposures' of roughly that size, so there's no reason he couldn't have repositioned something like the table between 'exposures'.

I hope my explanation of these effects is clear enough for you to follow what I think I'm seeing, so you can decide whether your eye sees the same thing. It now looks like I might spend one day in London in late August on my way back from Ireland. If this scheduling works out, I'll definitely spend some of that time at the National Gallery, since I suspect other things might become apparent when seeing this painting in person.

Charles

CF to DH
Tucson
1 June 2000

Dear David

As you can see, I've been busy with my art books today. On the Chardin *Washerwoman* there are clearly 4 breaks in the slope of the door frame, and thus 5 separate 'photo' segments. Those breaks in slope are exactly what would be expected for a camera lens that was moved vertically between each 'photograph.'

I'm assuming, of course, that the woman and the door frame were sketched at the same time, or, if they were sketched at different times, that Chardin's 'camera' had markings that allowed him to make the same vertical lens movements for each (which is something a scientist would have done, but something I strongly suspect an artist would not have bothered with). Still, it doesn't seem to me critical that the same lens movements had been precisely made (and note that the height of the segments I've marked aren't identical, with them increasing in spacing from the top to the bottom of the painting). It seems reasonable to assume that Chardin would have used the same moving-lens technique for both the background and for the foreground, whether or not he sketched the elements at the same time, and whether or not the actual lens movements were identical for each.

The door frame provides circumstantial scientific evidence that Chardin not only used a lens, but that he used it in a way that required him to piece vertical segments together. The woman's elbow provides direct visual evidence that he sometimes failed to piece the vertical segments together with scientific precision.

Charles

CF to DH
Tucson
3 June 2000

Dear David

The Fedex package from your office arrived on Thursday, with those wonderful 'joiners' of me. Thank you very much!

It's amazing how much evidence of that 'joiner' technique can be extracted from paintings like the Chardin, or the van Dyck (boy standing next to the too-tall seated woman) that in March I had thought of in terms of a wide-angle lens. Although the 'identical' scene can be photographed using either a wide-angle lens, or by several overlapping shots with a telephoto lens, the results are not identical. It's easier to see the tell-tale differences in actual photographs (at least, in pre-Photoshop photographs) than in paintings, since the precision of an optical-mechanical-chemical system accurately imprints vanishing points, converging lines, and subtle differences in brightness and contrast in ways that aren't masked, as they can be by an artist's eye and brush. Still, knowing of the existence of lenses, their optical properties, and the fact that they clearly were used by at least some painters, now means paintings must be examined quite differently than before. At least, if art historians want to understand the techniques the artists used, and why they might have chosen to use them.

This may turn out to be a very difficult problem for the discipline of art history. Only those willing – and able – to understand optics will be able to go beyond subjective commentary like 'the almost symbiotic relationship between the figure and the laurel is initially reminiscent of mythological themes …', or interesting factoids such as 'This painting shows Chancellor Nicholas Rolin (1376?–1462), born at Autun into bourgeois circumstances …'. To preserve the *status quo*, one approach may be to try to dismiss the discovery of the use of lenses as an irrelevant technical detail (after first, or course, trying to dismiss the whole idea of the use of lenses as a fanciful story). But that clearly is untenable, given how much time art historians already spend explaining technical things, like aspects of the artist's choice of composition and coloration.

I should have started expanding my art library earlier, since there's no substitute for having the paintings readily available for study. Being able to study at length some of the works I remember from your studio wall already has revealed to me at least one new way to analyse some of the images. Maybe it's just me, but some of these things simply take time and repeated study before they become apparent.

Charles

CF to DH
Tucson
4 June 2000

Dear David

I believe I've discovered evidence of the use of lenses in two more paintings. I don't remember whether or not either of them was on your wall, but they well might be since you have so many hanging there. Anyway, one is Jan Gossaert's *The Adoration of the Kings*, c.1510–15 (page 49 of the book *Dürer to Veronese: Sixteenth-Century Painting in the National Gallery*, Yale, 1999). A detail of this painting on p. 238 shows a clear change in the perspective line of the blocks making up the floor at a distance one block past the amazingly detailed red hat. It appears to me that at the same depth into the painting the perspective line that runs through the guy's foot to the left of Madonna also has a kink. Unfortunately, because of the scale of the reproduction of the entire painting on p. 49 I can't be completely certain of this. However, since it's at the National Gallery in London, you might be able to convince them to provide you with detailed enlargements covering the entire width of the bottom third of the painting.

The other is Anthonis Mor's *Mary Tudor*, 1554, on p. 393 of *Paintings of the Prado* (Bulfinch, 1994). The comment below, in the *Dürer to Veronese* book, led me to search for Mor's work; this being the only example I have in my modest, but growing, book collection. As you can see from the enclosed enlargement, Mor had to refocus just as Lotto did. It looks like there is enough information contained within this painting (i.e., size of woman and size and orientation of chair) to calculate the focal length and f-number of the lens he used, but I haven't taken the time to do that. However, from a quick check of the numbers it appears he would have had to refocus at least twice to get everything needed: first on the front edge of the armrest, then refocusing somewhere out of sight, roughly where the armrest meets the back of the chair, and refocusing again at the point that we can clearly see on the attached drawing.

Charles

CF to DH
Tucson
14 June 2000

Dear David

I just got the following e-mail from the editor of the journal where we submitted our manuscript yesterday. If her reaction is any gauge, it sounds like the world of science is going to be as excited by your discovery as the world of art history. People certainly seem to love the idea of art, art history, and science coming together.

Charles

I am halfway through the article and I love it. We would like to run it in the July issue, so we are stopping the presses to include it. I will give the article to Megan Riley as soon as I'm finished (by 5:00, I'm hoping) and we'll try to turn it around quickly. It will come to you formatted, with pictures, and author queries to answer.

Lisa Rosenthal
Managing Editor, *Optics & Photonics News*

I leave Saturday morning to serve on an external review panel at the University of Illinois, and will be there through Wednesday afternoon (it's an exhaustive review of a number of their programs, which is why it requires so long). I'm sure the journal will need the corrected galley proofs back immediately in order to meet their production schedule, so I'll make arrangements to have them sent to me in Illinois if necessary. But, as soon as I get the opportunity, I'll fax a copy of the galleys to you so you will see what the published versions will look like.

Charles

CF to DH
Tucson
1 July 2000

Dear David

I haven't had time this past week to do much with art, but attached are a few new things I did today. I think you'll be pleased with what I found. I started out to look for scientific evidence of 'joiners' in paintings with multiple elements, but got diverted by Rogier van der Weyden's *The Magdalen Reading* (c.1440–50) from the National Gallery.

The enlargement of Mary's book shows that although it is quite small (4.3cm × 6.0cm), it is amazingly detailed. Although the curvature of the page at the top of the book is different than at the bottom, in both cases (top and bottom), the fit of the letters to the curvature is perfect. There are 35 lines of text covering only 4.36cm of the painting (i.e., a spacing of $1^3/_4$mm per line, which is a bit smaller than an essentially unreadable 4 point font), and yet not only are all the lines beautifully aligned with each other, they follow the varying curvature of the page with remarkable precision.

The next bit is the smoking gun. I scanned the table leg (and, on the inset at the upper left, the portion of the table at the back of the painting), then stretched the horizontal dimension by ~15×. I only highlighted a few of the straight line segments so you could see for yourself on the others that they truly are straight. We can see that our friend Rogier changed his vanishing points ever so slightly (by only about 1°) when painting that table, at a place roughly at the horizontal bisector of the painting, i.e., it consists of two 'frames,' each of height $^1/_2 \times 61.5$cm ≈ 30cm. This number is getting really familiar by now, since it's the *same* dimension as we calculated in our paper for the 'sweet spot' of a mirror-lens.

The book notes that 'Weyden' is the Flemish word for 'pasture', so he is probably the 'Rogelet de la Pasture' who had been apprenticed to Robert Campin in 1427–32. I'm beginning to feel like we're FBI agents who are slowly unraveling evidence that reveals the names of all the mobsters involved in an organized crime family. It's the Flemish Mafia.

Charles

Dear David

Last week Ren sent me a copy of Campin's *Joseph in the Carpentry Shop*. The latticework in the seat back turns out to be the real giveaway. If you sight from side-to-side along the surface of the page it is particularly clear how the vanishing point changes somewhere behind Joseph's head (this change is especially clear in the board at the bottom of the latticework, which doesn't even come close to matching on either side of his head). Although it's not as obvious as in the latticework, changes in vanishing point at roughly the same depth into the scene can be seen in the tabletop, as well as in the rafters. Thus, all the optical information is consistent.

The first definitive evidence of optics has now been pushed back to a painting dated *c*.1425–28. I feel we're now very close to discovering the origins of the use of optics as an aid to painting – if there were books entitled 'The Complete Master of Flémalle' and 'The Complete Early Works of Van Eyck,' I wouldn't be surprised if we had the answer within an hour.

Charles

Dear David

OK, this is essentially impossible to fully describe in words, or reproduce with a fax, so please bear with me. It's worth the effort, since it provides fascinating insights into van Eyck's techniques as well as his tools.

I found van Eyck's drawing and painting of Cardinal Albergati next to each other in the National Gallery's *Giotto to Dürer*, so decided to see if Photoshop could tell us anything about his technique. The implications of what I found are quite interesting.

The sketch is at approximately 48% of life size. Assuming the sketch was done before the painting (i.e., from life, while the Cardinal was on a short trip to Flanders), this size is perfectly reasonable for having been an image projected by a mirror-lens. Since I scaled the enclosed fax to be essentially the original size of van Eyck's sketch, you can make the same observation of its scale as you did for the Ingres sketches that got you started on this adventure in the first place. That is, do you feel the scale of this fax is too small, too big, or just right for an artist to have 'naturally' chosen to draw had he *not* used a lens?

Next are the many features that line up *exactly* when I overlay a rescaled transparency of the drawing and one of the painting. The painting itself is 41% larger than the drawing, so either van Eyck was an extremely good draftsman (and human pantograph), or he had help transferring all those features so perfectly from the drawing to the painting. To avoid obscuring too much, I've only traced over some of the features that align perfectly to the left of the dotted line (which I'll comment on in a moment), but also lining up perfectly are the shape of the nose and the nostrils, the mouth and lines of the lips, the 'smile lines', the eyes (with smaller pupils in the drawing, as you noted long ago) and eyebrows. It simply defies credibility to believe anyone could have so accurately reproduced so many complex

features at a different scale – remember, the painting is 41% larger than the drawing – without having projected them with a lens. Or, having traced them with a pantograph, which, according to our friend Professor Kemp's book, was a secret known to at least one painter in 1603, which prompted someone to reinvent it in improved form at that time. Still, even though 1603 is quite a while after 1438, I suppose we can't rule out this as having been another secret (but let's ignore this remote possibility).

Something happens to the right of the dotted line, though, when I line up the transparencies of the drawing and of the final painting. Again, various features line up perfectly, but only if the drawing and the painting are shifted slightly. If we first shift the sketch by only 2mm to the right and down we perfectly match the neck and collar (except the frontmost portions of the collar, which van Eyck extended forward somewhat), some of the aging Cardinal's significant neck wrinkles, and the bottom quarter of his ear structure. If we then shift the sketch to the right and slightly up by only 4mm from the original position, approximately the top three-quarters of the ear structure is perfect, as is the line of his shoulder almost to the end.

Putting all this together, along with Norbert Schneider's book that says the Cardinal spent only 8–11 December 1431 in Bruges, gives us the following possible story. Assuming Albergati had reasons for coming to Bruges other than just sitting for a painting, van Eyck would have had a very limited time to capture his likeness. Looking at the sketch, it appears to me the Cardinal's head from the hairline down is remarkably lifelike, but his robe (and possibly his hair, although it's difficult to tell from the quality of the reproduction in the book) was done freehand. That head is ~10 × 10cm, which is well within the sweet spot of a mirror-lens, which we know is at least 30 × 30cm.

Why did van Eyck make the drawing so small? It could be that he drew it freehand at this scale (something you can comment on, à la Ingres). Or, it could be the mirror-lens van Eyck had at that time was of poor quality, so it only projected a small usable image. Or, remembering that the Cardinal's visit was in December, and that Bruges is pretty far north, it could have been because it was so gloomy. The brightness of an image scales as the square of its size, so by projecting one of only 10 × 10cm rather than, say, 30 × 30cm van Eyck got an image that was 9 times brighter than he would have otherwise. Given the dim light that time of year, one can imagine our friend van Eyck frantically rearranging the impatient Cardinal until he finally managed to get an image on his pad that was bright enough to use. However, the Cardinal didn't want a tiny painting. No problem. By 12 December he was on his way somewhere else and, besides, oil paint doesn't dry very well in winter anyway, so van Eyck had all the time in the world to make the actual painting. At his convenience he was able to use his mirror-lens as a 19th-century epidiascope to magnify the drawing by 41% and simply project it onto the canvas. Of course, it takes time to produce a painting, allowing plenty of opportunities to bump the drawing or canvas out of alignment by a few mm. Jan might have caught and corrected most of those misalignments before touching his brush to the canvas but, when he didn't notice in time, it probably would have been easier to simply continue and smoothly join the portions together. After all, who would ever know he had made the Cardinal's ear 6mm too tall, and his face 7mm too wide?

Charles

CF to DH
Tucson
19 July 2000

Dear David

One more update on the Cardinal. Given that I discovered a better reproduction in Schneider's book this morning, I just couldn't keep from re-examining Cardinal Albergati at the highest magnification that I could make use of. Blowing up just his head (the only portion of the drawing that I think van Eyck actually produced using a lens) to fill most of an $8^1/_2$" x 11" page, and comparing scaled versions of the drawing with the painting, I find the 'perfect' agreement of features between the two finally breaks down only at a scale of ≤1mm. That is, even though the painting is 41% larger than the drawing, in each of those three regions that I noted on my previous fax I find that van Eyck was able to transfer the many features of the Cardinal's rugged face from his drawing to his painting so accurately that deviations from an absolutely 'perfect', albeit 41% magnified, copy are visible only at a scale of ~1mm. Even if a person had an easel and a high-quality lens bolted to a granite floor today, I don't see how they could do much better than this since the tip of the brush has to be roughly 1mm in size.

Although we have yet to prove whether it was a mirror-lens or a refractive lens (or, perhaps, both) that was in use back then, the circumstantial evidence for the mirror-lens is rapidly mounting. We already know a mirror-lens would make life easier for the artist, since it doesn't flop right for left, but that doesn't prove it was the type of lens used. However, this drawing/painting pair provides us with an important new piece to the puzzle. No reasonable person could doubt that what this new evidence shows is that van Eyck used an epidiascope to transfer the image on the drawing to his canvas. Had he used a simple camera obscura, the image

would have been reversed. Yes, he could have used a mirror in combination with a refractive lens to flop the symmetry of the image back, but the more complex the optical system we assume, the less probable it is for him to have used it.

The more I think about it, the more I realize this van Eyck drawing/painting pair is gaining a significance to art history (and the history of science) comparable to that of our Lotto. Not only does it show a lens was used by van Eyck in c.1438, it shows he used it in a remarkably sophisticated way. This pair gives us amazing insight into specifically how an artist worked 600 years ago. That is, we can see he used a lens – almost certainly a mirror-lens, for the reasons already mentioned – in a camera obscura to produce a sketch at one time, then used a lens in an epidiascope to transfer, and magnify, that image onto a canvas at a different time. I'll bet that not many people today, 600 years later, could reproduce his technical feat without detailed instructions. No, the use of a lens doesn't detract in any way from van Eyck – in my eyes, the guy was even more of a genius for what he figured out.

My only question is, why did no one discover this before now? It doesn't take NASA software to place scaled versions of the drawing and painting beside each other and simply see that they are identical. For no one to have been bothered by this can only mean that art historians must think you artists are godlike in your abilities. Maybe we should keep this a secret so they won't realize you're mortal after all.

Charles

MK to DH
Oxford
19 October 2000

Dear David

A long silence, two causes. The Hayward Gallery show consumed 3 weeks – couriers from around the world arriving with diverse treasures and even more diverse temperaments and demands. The 'internal' curator employed by the Gallery wants to oversee (control) every tiny detail, in a way that slows the installation of 300+ objects to a crawl, until the objections of Marina and myself resulted in a reasonably sensible system of delegation and division of labour. Anyway, it's up and open – to massive and generally favourable publicity.

Then, during the most intense period, my mother (90+) fell and fractured her hip. She survived the operation, but a series of cumulative problems had sapped her will. She was ready to die, but the ministrations of modern medicine patched up the bits and kept her going longer than *she* wanted. I visited (in the hospital in Norwich) for the last time on the Sunday before last. It was apparent that she was intending to die, staring into the distance intently, to discern what lay beyond the scope of her normal vision. Next day, a 'phone call tells me she has died, *'suddenly'* according to the doctors (since they could not tell what was the immediate cause of death), although I knew she was about to die because that is what her mind and body had conjointly *decided*. Her death was not the hard part, but the ugly decline that preceded it. Her funeral was on Monday in the local Methodist church. She really believed in the afterlife, in its Christian form. I hope, for her sake, that her hopes have been realised. (I personally have *no* expectations.)

Many thanks for the recent faxes (texts and images), all very *a propos*. Constable certainly used some kind of perspective frame. It would be odd if

he didn't try other devices. This summer there was a 'Turner in Oxford' show at the Ashmolean Museum. Some of the complex architectural perspectives smelt of optical devices, especially their treatment of detail. Some looked as if he had worked out the perspectival geometry *from* a camera image. Why not?

I went to a dialogue/interview between Bill Viola and Peter Sellars (opera producer etc.) at the National Gallery. After discussing the Bosch that Viola used for his work in 'Encounters', the works selected for discussion homed in remorselessly on the kind of images you have been discussing – Zurbarán, Chardin etc. All that was missing was your explanation of the visual implications of that kind of naturalism. Have you ever talked to Bill Viola about your ideas? I'm sure he would be fascinated. I would like to work with him. We have a work in 'our' show, but our contact was less close than I would have wished.

I'll keep (send?) a catalogue of our 'Spectacular Bodies' show. At least it shows how good body art can be, in comparison with some of the sloppy, sub-anatomical stuff put out by the Brit-pack (though Marc Quinn, who is in the show, is very good).

It's great to hear that you are wielding a brush again on a big scale.

Love
Martin

DH to MK
Los Angeles
19 October 2000

Dear Martin

'The alternately constricting and then widening principle of the picture opening is found in all forms throughout Memling's entire oeuvre as if he were using a frame with sliding side members.'

I'm very sad to hear of your mother's death. It has a strange effect even when you expect it. My mother was also a keen Bible reader, waiting 'to be called', and, I admit, she seemed to know. But to live into the nineties must be just enough. My mother would say to me it's no fun being old. She had such bad arthritic hands she couldn't switch off a light. You'll miss her presence I'm sure.

I look forward to your catalogue. Meanwhile, the book is finished apart from my essays at the beginning and end of the visual section. The longer I can leave those, the clearer they will be.

Although I'm now painting – my house and garden – the *real* world, I'm still keeping my ever-sharper eye on the move.

These quotes are from a book on Memling by Dirk de Vos (T & H 1994). The one about a sliding frame is, I'm certain, true. It's exactly what I sensed, and with the experiment we did with the mirror, it seems to confirm it. Also, here is Caravaggio's other version of the *Supper at Emmaus* (Milan, Brera). The two figures standing at the back seem much bigger than Jesus, yet within themselves are well proportioned. Doesn't it suggest an optical collage technique?

I read Phil Steadman's book. I wrote to him – I thought it excellent. He talks about a 'collage' technique – unlike a photograph, not everything need be there at the same time, an experience any user of Photoshop now knows. I suspect as we go on we will find more and more of these things. It would be most interesting to compare Vermeer's *Soldier with Girl* (where

she is very small at the back) with Caravaggio's *Supper*. How were they both constructed? Phil's book is part of this growing awareness. The fact Vermeer did not discuss his techniques is not unusual. Almost no artist does, and today they are just as secretive about methods.

I think the whole subject is intensely fascinating. Far more than historians have acknowledged is the fact that an optical projection (seen around 1420) connects painting with the TV screen of today. This is new.

Much love
David H.

DH to MK
Los Angeles
Undated

Dear Martin

I hope you are well and the Hayward show is on. I've got some things from them but not the catalogue. Meanwhile we have finished the visual pages of the book, and I'm back painting the bigger spaces, nevertheless I keep finding things.

Here are two drawings made in 1816, the top one by Constable and the bottom one by Turner. Both architectural. Turner's is obviously eyeballed, and groped for – notice the castellation and the East window. Compare with Constable's tower – lines are not groped for. It is a bright day – notice Constable puts in the tones – deep shadow in the ruin, Turner does not. Constable finds the shadows to make the trees, Turner uses outline. I think this suggests Constable at times used a camera, and he did for this drawing. The round form is perfectly caught with no groping. Indeed the right-hand edge of the tower is one thin line. Compare again to Turner's edges. We have also made a terrific video of a cabbage on a string like Cotán's, filming the projection with the cabbage turning, so even with 'still' life we get a movie showing how clear, how colourful, and how simple it was (and is) to make projections.

It's exciting painting again after a year of sharp points and small scale.

Much love
David H.

DH to MK
Los Angeles
7 December 2000

Dear Martin

I hope you are in good health. I have been a bit 'off' lately, but now the doctor told me not to drink alcohol (I never drank much so it surprised me) I'm feeling better. It seemed to upset all my digestive system.

I have just received a copy of the *RA* magazine, with an article on the new Caravaggisti. It points out he is the only painter to have a 'school' named after him. It mentions Roberto Longhi's big exhibition in Milan in 1951, and that both he and Roger Fry earlier had compared Caravaggio's style not only with Realism, but with the most 'modern' of visual arts, photography and cinema.

Well, well, well!

I think I told you about my observations of the Milan *Supper at Emmaus*

– the figures at the back being too big in scale for Christ sitting at the table. I'll enclose a repro with this letter.

I'm now getting a clearer picture of the sweep of history. If there is a crisis in what is 'Art', then surely there is a crisis in 'History of Art'. For a few hundred years, the history of 'Art' was close to the history of images. It is only with the invention of chemical photography and its children, film and TV, that there is a parting of the ways. As I have said before, the great schism – called 'Modern Art' – was the abandonment of optics by painters. This was the big 'shock', and in a way the only one. 'The world does not look like that', was the criticism, because the optical view was seen as close to 'reality', but had only been used in European art. It's true, 'naturalistic' sculpture appears in a lot of cultures, but 'life casts' are possible, when any kind of casting is available.

I am now going to write the last essay for the book, a kind of summing up, and what it means for us today.

It certainly seems obvious that power resides with images, especially if they are separated from 'Art'. I got a note from Charles Falco from someone (in England) who'd read the piece in *Optical News* and wrote back about Brunelleschi's experiment in Florence. The source of perspective is optical he thought, and so do I. The mirror-lens gives a perspective picture, and the rational, mathematically inclined Italians worked out their system of coherent space to widen the window or image, which the Netherlandish artists did not. They were perfectly satisfied with their collage of spaces, which turns out (for me anyway) to be better able to deal with narrative and storytelling.

I have no doubt now that our major discovery was the mirror-lens. It simply had been forgotten about (the laws of optics do not change) which is why the later 16th century and early 17th century is now such a fascinating period – the move from the mirror-lens to the lens – the very one we are still stuck with.

I read *Galileo's Daughter* recently (I recommend it, a very good read), which of course covers the period. The telescope is putting together two lenses. I believe artists had done this in some way, perhaps about this time. It's also the time of the spread of the Caravaggisti. One could ask, how his influence was felt all over the place, even by people who probably hadn't seen the paintings, but had obviously learnt something of his techniques.

The secrecy (although it turns out not so secret) is perfectly understandable. Even Descartes in Holland didn't publish his book, wary of what had happened to Galileo, so the power of the Church (even in Protestant Holland) was obviously very very real. Hard to imagine today. I have also observed that when the Church stopped commissioning pictures (late 18th century?), its power began to decline, and shifted to the purveyors of images, as is very true today.

Where do we go with this knowledge? Recently I have been watching TV, because of the American election. I have noticed a few things that it has great difficulty with. Unlike the newspapers, it can't go backwards and forwards, only forwards. I realized I was better informed than my TV friends by reading the newspapers. At times I wasn't sure whether it was *Saturday Night Live*, or the *Real Thing*. A friend pointed out that people were getting bored with it, because it was not pictorial – there are only lawyers talking. David G. told me he was watching the Florida courtroom stuff and when one witness spoke on the telephone the only thing they could show on the screen was a picture of a telephone. Quite funny, but one sees the problems of the medium that's supposed to be close to reality.

So what is Art? The Greeks wrote about it, but mainly poetry and drama,

but more modern descriptions from Italy, in the 15th century, seem to coincide with the arrival of smaller pictures. Art is commodity – commerce (now Armani is at the Guggenheim). Not so long ago, art classes at school, for instance, thought it was skill in drawing and painting, as most people still think it is. For myself, I now realize I swing from idolatry to iconoclasm. I do indeed have a deep love of images, especially ones made by the hand and eye, which even with optics, is everything before 1839. I used to think the problems were with perspective – reverse it and it's more interesting psychologically – then I thought it was the photograph. Not very good at showing exciting space. Incidentally, I love the descriptions of the New Court at the British Museum, but notice the photograph can't give you any feel for it. My own photographic work was to try and expand the space, to make us feel better. Howard Jacobson in the *Independent*, describing the court, said 'space is life and the grander the space, the grander our instincts for life'. Very good indeed. I agree. Hence my obsession with the pokiness of what the lens can do, why Cézanne and Cubism were exciting, yet we are dominated today more than ever with that tiny tiny window.

Can we escape? I'd love to think so, but the lens can't show us. Drawing and painting, perhaps, with the computer can now destroy that tyranny.

Love as always
David H.

Los Angeles
7 December 2000

I have been aware of the constrictions of perspective for a long time. I carried this into its great perpetrator today, the photograph. Their spaces seem too small. Once the novelty wears off I seem to notice these things. I belong to the last generation brought up without television. I was eighteen years old when we first got one in Bradford, so the cinema was the thrill. We went to see anything. We never read movie critics; one just went to the cinema twice or three times a week. The moving picture was an event. Cinemas had curtains. Some would even start the film with the curtain still there – the British Board of Film Censors certificate came on, and I would hope they would get the curtain up in time so I wouldn't miss one second of the movie – or pictures as we called them ('Let's go to the pictures Dad'). They were thrilling – mostly Hollywood films (I always said I was brought up in Bradford and Hollywood) – because you could be sure you could see them (really good lights) and hear them (really good sound).

In those days the edge of the screen never bothered me, it was the centre that was everything. I must have seen Monument Valley first in the early forties and how grand it looked in John Ford's movies. Today I notice the edge. Can the movies show grandeur anymore? The centre does not dominate, not for me anyway, and TV has made it worse.

I went to see *Titanic* on the largest screen in Hollywood with the best sound (I'm too deaf to go see films regularly) to check what the computer had done on the screen – but within 10 minutes I thought I was looking through a letter box, deeply aware of the edge of the screen – the limits of the wide-angle lens.

My complaint with photography was it could not show space very well. Good for faces but not landscape. Perspective was attacked at the beginning of the 20th century. Cubism was a new technique for depicting reality. The innovators of it never thought it led to abstraction, they always dealt with the visible world (Picasso, Braque, Gris).

Today it seems forgotten. We seem more and more separated from History – perhaps in California especially, there are no ruins, only 'ghost towns'. Yet modern life in Europe seems less aware of the ruins, that civilizations have come and gone, and quite possibly so will ours. Where can we get grandeur? Architecture, it is true, can still be thrilling. When I was asked to do something for the Dome, I suggested leaving it empty. The space alone would be thrilling. By all accounts they filled it with clutter.

Surely if we think human beings can move to a higher awareness it would be spatial. A deeper awareness of space and time to comprehend infinity. Are not our tiny pictures doing us damage? My conflict between idolatry and iconoclasm reflects this. We all seem to love images but what have they done to our collective psyche?

MK to DH
Oxford
12 December 2000

Dear David

Sorry about gap in correspondence – I've been struggling against recurrent semi-flu, induced by stress and the endless seeping greyness of months of rain – unrelenting, every day, just a few fragile glimpses of blue. No shadows. No photosynthesis. Just oppressive dampness. Oh for California (or somewhere warm and sunny).

I've now various things to send you (unless you are going to visit England in the near future). They are:

– *Spectacular Bodies* exhibition catalogue (not much in the way of lenses until the 18th century because they were not portraying a *single* specimen or dissection, but building up a compound picture – more 'knowing' than 'seeing').

– *Visualizations: The Nature Book of Art and Science*, with the article on your camera lucida drawings (OUP, to be published by California in February).

– A section of a novel on Vermeer (in typescript) sent by its author. I think you will like it.

I recently cancelled a trip to speak at the National Gallery, Washington, because I did not want the wear and tear of travelling before fully recovered.

Important Notice!!
Paolo Galluzi, director of the Science Museum in Florence, is organizing a select workshop on perspective and drawing devices in Renaissance Florence between 24 and 31 May 2001 in Florence and Vinci (Leonardo's home town). One section will be on the newly restored Masaccio *Trinity* on site. Anything organized by Paolo is always excellent, well staged and high level. I mentioned the work you are doing, and he has asked me to invite you to tell us about the use of optical devices from a practising artist's standpoint. The last session would be one I am organizing on the 28th and 29th (I think). This *could* be coupled with an exhibition of the camera lucida drawings in Florence. Paolo has all the contacts and influence. If you are interested, I'll give you more details. It should be terrific.

When you are next here, we can arrange with Ken Arnold at the Wellcome to show you behind the scenes of 'his' collection – especially on heads, expression, etc. in relation to Marina's project 'Head On', which is now to be shown in the Science Museum.

If you're not coming here soon, let me know, and I'll send the books via my secretary.

Love
Martin

DH to MK
Los Angeles
18 December 2000

Dear Martin

Thanks for sending the Getty thing. I did know about it vaguely, but I spoke to Frances Terpek today and told her about the mirror-lens. I have realized now that that is our big discovery. No one knew, nor is it obviously written about, although I suspect it is, we just haven't interpreted the texts correctly. The Getty show (and catalogue) starts in the 17th century. We go back two hundred years before that, and as you know I do not think we are wrong.

Although the book is almost ready for the press, it never ends. It's open-ended and provides a new look at history. The implications of it seem to me to be huge. Even the definition of 'Art' seems to coincide with the mirror-lens – smaller pictures, tradable. Is 'Art' a commodity? When does that attitude begin? The purveyors of images today are the people with immense power, but they exist outside the world of 'Art'. I've even thought maybe museums belong to a certain period. Their main job is to conserve the artifacts of the past – a museum of contemporary art is perhaps an oxymoron. How do they know what is the 'Art' of our time?

I think our book will raise a lot of issues, and we are getting ready to make a film, not just to plug the book, but to show on film what can't be shown in a book. I told you we have superb videos of the projections from a mirror, including me doing a portrait. Everyone who has seen them 'gets it', and tells me it's very important to make the film as well as the book. I even thought of relating Bellini's Doge to a newscaster on TV, icons here if not in Britain, and probably both from an optical source. I have been painting (big spaces) but have to go back and finish the book, so I get excited again.

There was a piece in last week's *New Yorker* about Masaccio and his friendship with Brunelleschi and Alberti. We have been rereading your account of B.'s experiment. They must have known of the mirror-lens. I've come to believe perspective came from this. The theatrical aspects of perspective would give them a bigger picture than the mirror-lens, and the coherent space of one window, as against the many windows of Flemish art.

Hope you are well.

Much love
David H.

MK to DH
Oxford
19 December 2000

Dear David

Many thanks – great news about the painting activities. I'm going to Rome from tomorrow until the 26th, an escape from the rotting dampness of Britain, I hope. In the meantime, two responses:

(1) The idea of a painting as a commodity (not so much 'Art' in our sense) came into its own in the 17th century with the 'easel painting' made for the market, but it is there in embryo in the 15th century. 'Collecting' in the modern sense begins with classical antiquities (sculpture, cameos, etc.) in Florence, Rome, Venice, Mantua, etc. People also began to collect paintings – some Italians collected Netherlandish works (the Medici had Jan van Eyck's *St Jerome*), but they were not worth much money. There was no market for second-hand paintings! They could commission a *new* one. But you do see the birth of connoisseurship, writing about art, etc. in the 15th century in Italy. Piero's patron, Federigo da Montefeltro, owned a Jan van Eyck of *Women bathing* (lost).

(2) I don't think there is any case for Brunelleschi to have used a mirror-lens. Manetti, who knew B. and was a knowledgeable person, would have said if a curved mirror was involved. For Brunelleschi it would have been the *proportional geometry* that mattered. He stands in the Giotto-to-Piero succession, i.e. committed to linear construction of space. I'll photocopy an *old* article of mine.

Did you get the van Gogh material? I think he turned his head using the frame for his 'old' effects (e.g., the bedroom at Arles). What about the Florence workshop on Brunelleschi, Masaccio and drawing instruments at the end of May? Should be really good. Let me know.

More after my return. Best for the season, to Gregory et al.

Love
Martin

DH to MK
Los Angeles
19 December 2000

Dear Martin

I'm feeling a bit better now. I've been told to rest for my body to heal, and at times I overdo it.

We have been looking at Masaccio, and I have been talking to John Spike in Florence. His book on Masaccio is very good, with superb reproductions of the frescos in the Brancacci Chapel. We have always felt he is a problem figure in our thesis. He certainly painted very individual-looking faces, the only ones we can find before the Flemish, or should I say at approximately at the same date.

That Brunelleschi knew about mirrors is recorded. We have been rereading your chapter and notice now clues that we hadn't seen before. Charles Falco sent me your chapter yesterday underlining things that he thought suggested the use of optics. I'll enclose his fax today.

The point about fresco is that tracing seems an integral part of the technique. Drawings have to be made, we assume first, and the methods of getting them on plaster involve tracings of some kind. Masaccio's friendship with Alberti and Brunelleschi would suggest shared knowledge – it's just that it's harder to see the evidence in fresco painting, or to see depictions of mirrors, like we see in the van Eycks or Campins.

As I have said, the mirror-lens is, I think, our most important discovery – could it have been simultaneous in Italy and Flanders? Ideas seem to be 'in the air', as the saying goes – there certainly seems to be a growing awareness of our hypothesis coming from different directions. The curators I spoke to at the Getty did not know of the mirror-lens, but totally understood what I was saying. We will demonstrate it to them.

Masaccio could have made the portrait drawings the way I think van Eyck did for Cardinal Albergati, yet placed them in the spaces suggested by Brunelleschi. What do you think?

My last few notes to you seem to show I move from idolatry to iconoclasm (two sides of the same coin) by the hour. It's still all very exciting.

Much love
David H.

DH to David Graves
Los Angeles
25 December 2000

Dear David

My brother John is roasting the goose. It is very quiet here but sunny. Last Thursday I went to LACMA to see an exhibition, 'Made in California', an ambitious survey of Californian 'Art'. It was quite interesting at the beginning, and utterly fell apart at the end. Of course, you can't have a museum show of movies, and it seemed to be a case of trying to do something you can't do in that medium, and then getting bogged down with the politics of 'identity', with piles of junk, that I suppose was 'Art'.

On Saturday I went down to MOCA with Charles Falco to see a film or video installation there that sounded in a review that it might be interesting. It wasn't really, or not what I thought it would be. The place was empty like a tomb. I know it's near Christmas but yesterday at the Norton Simon it was full of people.

I have been showing people the video of the rotating cabbage. I make the point that there is a straight line from this to the TV picture of today, that goes right through European painting, or 'Art', as the historians say. I am now, more than ever, realizing it is the word 'Art' that seems to cause problems. It looks as though it is all mixed up – even gone to hell in the last rooms of the County Museum show. What is going on?

I have said before how disturbed I have been by the rather cavalier references to people of the past as patrons of 'Art', as though they were similar to the rich collector of today. This, it seems to me, cannot be the case. The Church used images to tell people the story of Christ, of images of heaven and hell, of the lives of saints etc., all concerned with the soul of the viewer, which seemed much more important than the body. 'History of Art' seems comfortable in its analysis of the great images of the past, divided up into 'schools', 'styles' but very rarely 'methods', always, it seems, assumed as 'masterly' because of superb training and a different sense of religion that we do not feel today.

Here is a story from the front page of the *NY Times* today. The interesting bit to us is the mention of images, made, as we know (but known by few others), in a very similar way to our revolving cabbage. They are describing their power, in a way no contemporary 'Art' has. It is this link that we know about that is really the huge story.

I gave up watching television a few years ago. I do not let it intrude on my life. Most people do. 'Art history' separates it, and, it seems to me, in doing so it has caused problems that most people don't understand. That

straight line I drew some time ago was a hunch that I think is clearly there. How do we deal with it today?

In the catalogue for the LACMA show they referred to my photographs as fractured pictures, seemingly totally misunderstanding what I was doing – and history – no connection with Cubism or perspective or an attempt to get out of tunnel vision into a big, wider, beautiful world. Of course, they probably said this because it fitted their political agenda for the exhibition, yet it seems a good example of the fuzzy vision of trained 'Art' experts. Do you get what I am trying to say? Should we get this in the end of the book? I'm thinking perhaps I should come to London in the New Year to finish it there. It's the hugeness of the subject I want to put in it. It is not just a rewriting of 'Art history'. I'll call you later. Have a Merry Christmas.

Love
David H.

DH to MK
Los Angeles
3 January 2001

Dear Martin

Thank you so much for your two books. They are terrific. I'm reading them in bed. I got a real dose of flu (overworked and run down) but now I'm recovering. I've read Brian Howell's chapter on Vermeer, which I thought very imaginative and better than the other novels I've read recently on the same artist. I don't know whether you read them. They were OK but I think Brian Howell's was beautifully written and a very good idea. I notice he lives in Japan, and probably knows the story of how they invented the gun, decided it wasn't 'chivalrous' or suitable for their warfare, and therefore got rid of it, secretively I suppose, and it never returned until Commander Perry arrived. It's even a plausible story. The more I think about our video of the revolving cabbage it's amazing Leonardo didn't invent movies. I'm enclosing a letter I sent David G. recently – just thoughts prompted by a newspaper article.

I have been painting and drawing, but have stopped for a while to finish the book. I'm coming to London on 10 Jan to finish it. They want it all ready by the end of the month, so I'm reflecting in bed and will make sure it's as clear as we can make it.

The twelve Caravaggios on show at the RA will be fascinating to examine. John Spike will be there from Florence. He's offered to write a blurb for the book – he's doing a *catalogue raisonné* of Caravaggio and always thought I was near with my hunches.

I noticed in the RA magazine the picture of doubting Thomas, and pointed out to friends (who hadn't noticed) that Thomas was not looking at his finger but past it. It's strange people don't notice this, but once you see it you always do. I pointed it out to Helen Langdon, who hadn't noticed, but had observed that in the *Supper at Emmaus* there is a similar thing. She told me two Italians had written an essay on this phenomena in Caravaggio but gave psychological reasons, which she thought were rubbish. I explained it could be accounted for by his method of working – once done, the eyes are very difficult to alter. I've since noticed the same thing in a Utrecht school picture of *The Mocking of Christ* in the Norton Simon Museum. The eyes of the figures are quite dramatic but are not believable in what they are doing.

I will stay in London till the end of the month. I might have three days in Baden Baden for their rejuvenating waters, relaxing the body and clearing the mind.

I detect growing excitement about the book. I think historians who doubt it don't realize we're only talking about a tool that had to be used with great skill and doesn't alter past iconographical insights, yet it does alter ideas about schools or the change from Mannerism to the Baroque.

In the RA magazine, it told of Roger Fry and Roberto Longhi relating Caravaggio not only to realism but to the modern arts of photography and film. It's amazing they didn't realize the connection with optical devices, which seems so obvious now.

I will bring the videos we made here, which have impressed everyone who has seen them. No one has filmed projections like these before and they are very clear and, of course, very 'painterly' looking.

I realize that not many people could ever see very clearly through the camera lucida, so did not see what I saw and how it could be used, and the camera obscura, as I said before, has obscured our view of the past. I'll read all your essays now. I only got the books yesterday and look forward to meeting in a cold, dark, damp London in a couple of weeks. It's very sunny here today. I hope you get a glimpse of it in Oxford. Congratulations on the books – they are very well produced.

Much love
David H.

DH to HL
Los Angeles
3 January 2001

Dear Helen Langdon

Thank you for Pamela Askew's essay. I did find it very interesting. The pictures I sent you were to demonstrate the mirror-lens, really a simple concave mirror projecting images and how it could have been used.

We have assumed Caravaggio knew of the mirror-lens, which has limitations – his basket of fruit could have been done this way, but the period of the late 16th century and the beginning of the 17th century saw the introduction of glass lenses and their use with mirrors. This, after all, is the period of Galileo putting two lenses together to make a telescope, but they can also make large projections.

With the mirror-lens, it does not matter how big it is – the image gets brighter with an increase in size, but not the area it can see, hence in my hypothesis the Netherlandish artists created pictures with many windows, not Alberti's one. It's why they appear closer to the picture surface – they are a collage. With the introduction of a glass lens, the area is bigger, and with the development of them, by the 20th century they became capable of wide angles.

In my book I compare Caravaggio's two Bacchus paintings. The earlier is nearer the picture plane, even though there is a table with fruit leading into the picture. The second one in the Uffizi is set back into the picture, with a table and fruit also leading into it. Suppose Cardinal del Monte had given his most skilled protégé this new lens. The image, of course, is now reversed, unlike with the mirror-lens. Could this be the reason he holds his glass in his left hand? We reversed the picture and he looks a lot more comfortable leaning on his left arm and now holding the glass in his right hand.

I have now realized that it was perfectly possible at this date to make large clear projections onto a canvas. If you accept this and begin to think out his methods of working, a lot falls into place, and a great deal of what is said in Pamela Askew's essay is accountable by this. Supposing he set up his tableau with all the figures there just like a photographer would. They seem like that, but, of course, a painter doesn't just click a button. The 'exposure' is a long one. Models then rest or are brought back to their positions, taking time to do this. He paints one figure as quickly as his skills allow, for example, the hand of Thomas is painted very separately from his face. To get them to totally 'match up' would be very difficult, especially where the eyes are looking – the hand wasn't there when he was painting the face. Most of the comments in her essay suggest this. Roberto Longhi's comment on the conversion of St Paul, and then Berenson's, all seem to confirm a method like this. The method also fits the lighting needed, and therefore the deep shadows, and there being no sense of 'place'. In a way he was like a film director. 'Raise your hand to catch the light,' 'Give him a white hat', etc. are the kinds of things Zeffirelli would be saying.

To think like this, but without film, and with the hand capturing everything as fast as possible, begins, it seems to me, to solve the problems. Even painting like this is a collage principle and very different from Poussin's 'theatre', where narrative is read across the stage and only occasionally in depth. Once one grasps this technique, and it is indeed a masterly one, most of the comments in the essay fit into place. The only reason people haven't thought like this before is lack of knowledge of what optics could do at this date. Remember all lenses were handmade, and would be of differing quality, as were flat mirrors, but they *were* around.

It seems knowledge of the mirror-lens would then be quickly lost, as the new techniques seemed better. It also explains how there could be a school of Caravaggisti so fast and with seemingly great skills. That there are no drawings by Caravaggio also adds to the idea.

People have thought that if optics were used things looked like a Vermeer. Not true at all. My own drawings with the camera lucida were not as good as Ingres's – I haven't his skills or his 'touch'. Each individual artist has to make his own marks. Optical devices do not make paintings, only the painter's hand, but I did begin to recognize an optical base in things and to my surprise this took me back to 1430 and the van Eycks and Robert Campin. Here they drew first and could only paint direct from a projection on a certain size of panel, and there are many of these from that date on.

The National Gallery told me that there is a great deal of underdrawing for the Arnolfini figures, but really none for the chandelier – but that with careful planning it could have been done straight onto the panel drawn upside down, but with enough notations to get the highlights in the 'right' place and then work the right way up. This is an inanimate object so time could be spent on it. It all makes sense to me and accounts for a great deal in art history: the sudden appearance of individuality in portraiture in the early 15th century, the quick spreading of skills. The guilds would keep the secrets of what was really only a tool, but one that has been ignored and not discussed by historians, yet there are plenty of writings about the techniques from the 16th century onwards, and, as you know, today artists are secretive about methods.

All this doesn't disturb the insights on iconography and readings and interpretations of narrative, but once seen and understood it seems as though it has a truth, and it becomes more difficult to think they were painted any other way.

The tools needed for the Arnolfini painting are depicted in the painting. What more evidence does one need? Knowing this, all pictures seem more interesting. Of course, Brueghel wouldn't need optics but he had been influenced by their 'look', and having been trained by copying, he quickly developed skills.

Do you think all this is plausible? I do.

Yours sincerely
David Hockney

Los Angeles
5 January 2001
'When the mirror becomes a lens' by David Hockney

Heinrich Schwarz's 1959 essay 'The Mirror of the Artist and the Mirror of the Devout' discusses the use of convex mirrors by artists from 1401 onwards. He mentions their depiction in paintings from that time and, of course, deals with perhaps the most famous in van Eyck's *Mr and Mrs Arnolfini*. He points out that painters and glass- and mirror-makers were closely connected in the 15th century and, as in Bruges, even united in the Guild of St Luke, the patron saint of both professions. 'Thus', he writes, 'a close link connected the painters who sought to attain an image as precise and true as only the mirror – the symbol of Truth – could yield and the mirror-maker who could provide the artist with an aid enabling him to reflect and retain such an exact image of reality.'

After pointing out all workshops of the time had mirrors as part of their equipment, he says that at the same time 'Italian writers on art, such as Leon Battista Alberti or Filarete recommended the mirror and its unique faculties to painters, thus leading the way for Savoldo, Giorgione and Caravaggio, for Velázquez, Claude and Vermeer, to mention but a few painters from various parts of Europe who in the sixteenth and seventeenth centuries had turned in *one way or another* to the mirror as an aid, and who by using this magic device, had discovered new means to explore and expand the realm of painting.'

There is one problem in the essay. He never mentions the simple (and scientific) fact that a mirror can project images as well as reflect them. I will try and discuss the profound differences between reflection and projection.

Each of us sees something different in a reflection, slight movement changes the scene. It has to be related to the viewer's position, the scene seems as spatial as 'reality'. It is not really possible to trace the image because the viewer moves. A convex mirror shows more than a flat one, and they were easier to make, through blowing glass. The technology needed to make flat mirrors arrives later.

Why does Mr Schwarz not discuss the opposite of a convex mirror – its back, the concave mirror? It would appear that concave mirrors have less use. Their ancient history is as 'burning mirrors'. Archimedes is supposed to have used them to burn a fleet of ships. They intensify and reflect the sun's rays with great power. But they can also project an image. Even today this is not very well known, indeed it is unknown to most people, as it obviously was to Heinrich Schwarz. To do this the mirror need not be very large. In fact, the only effect size has on the projection is in its brightness. The degree of concavity effects focal length. Optically, the concave mirror has all the qualities of a lens.

When one sees projected images this way, one knows instantly that artists had seen them and used them. To see the projected image is to use it. When we set up our system in the Californian sunlight, I was amazed and thrilled at the beauty of the projections. If one was thrilled by them in 2000, what did artists think of them in 1420? 'Magical' is the first word that comes to mind. They look 'painterly'. The three-dimensional world is projected clearly onto a two-dimensional surface. We dressed someone up like a cardinal and I made measurements, turned the drawing round and then drew from observation. The projected image is upside down but right way round (unlike a lens projection), so portrait drawings are possible with this technique.

That art history says that the artists did not know this now seems improbable – after all, artists are in the business of knowing. I have discussed reasons for the secrecy of this tool (magic = heresy, etc.), but to return to Heinrich Schwarz's essay, he is discussing reflection. Of course, it had a profound effect on artists, but let me now point out the differences between reflection and projection. The reflection is affected by the viewer's movement and position, the projection is not. It is separate from our bodies, a point I think that in the late 20th century has become a big problem.

Why now? We set up a hanging cabbage, like in the Cotán painting of 1602, and the cabbage began to spin. I videoed this projection (a still life that moves) and realized immediately that there was a straight line from this moving projection in glorious colour to the television picture of today, and it takes us all the way through European painting. When painters used these projections, they had to interpret using their hands and eyes. There was a connection to the human body. Hand and eye skills produced different treatments – all the way into the 19th century and the invention of the chemicals that became photography. This is the point that 'Art History' becomes a little fuzzy. What is the photograph?

I have suggested before that the history of this period in the 19th century needs to be examined again with great care. The great 'shock' of modernism was the abandonment of the optical projection and its influences, in 'academic painting'. Cubism, derived from Cézanne, was two-eyed, a human vision again, connected to the body.

It is obvious today that Cubism as practised by its originators, mainly Picasso, Braque, Gris and Léger, has not really been developed. Conventional history has it leading to abstraction, but that runs into problems. Early cinema seemed vividly real. The novelty of it lasted a long time. Its grammar was worked out by 1928 without sound, yet sound provided an extension of the novelty (it's why *Singing in the Rain* is the great masterpiece of Hollywood 1950s), yet the ubiquity of the moving image today has dulled it. Attempts to extend it in various ways have not really produced much, because the perspective view built into the single window cuts us off from the world. To expand it now needs drawing – collage is drawing, and could be done with the optical projection, yet the more likely excitement of seeing the world afresh means drawing and painting.

Keep going to the Museum, said a film director to a friend of mine – the pictures don't talk, don't move, and last longer.

MK to DH
Oxford
6 January 2001

Dear David

Many thanks for the faxes – letters, mirror article, letter to David. Very interesting.

Leonardo had the basic ingredients for film – he knew about drawing objects in (or from) sequential positions, i.e., cinematographically, according to what he called 'continuous quantity'; he knew about what we call persistence of vision, through observing that rotating wheels do not interrupt vision through the spokes and the *circle* of fire made by a whirling fire-brand. But he was not in a position to know the experiments conducted on vision and moving images, including what we call stroboscopic effects. But he could almost have been there.

The other day I saw an exhibition at the National Portrait Gallery which I very much hope will still be on when you arrive – the show in which each year of the last century is represented by a painting, including (as you will know) your image with three chairs and the accelerated vista of trees. An image of three wartime plotters in their office by Meredith Frampton (rather good) shows exactly what you observed in Caravaggio – i.e., realistically portrayed heads in which the gazes of the figure are directed into some indefinite points in space with no sense of any interaction or shared focus. This comes (as so often happens with group portraits) from studying the portrait heads separately and collaging them into the composition. This happens whether or not the artist uses a device, but it is virtually bound to happen if a device is used for each *individual* head. Interestingly, the first great painted group portrait to use photography, David Octavius Hill's painting of ministers of the Church of Scotland signing away their livings to found the Free Church in 1843, circumvented this problem. Hill and Robert Adamson (pioneer photographer) photographed the ministers in *groups* as if they were in conversation. This does not result in a coherent picture as a whole (too many people to get in) but it does mean that the glances do have an internal coherence. Have you thought of trying to combine camera lucida drawings of 2 or more people, done together *and* separately?

All the mirror business is fascinating. I await the spinning cabbage with excitement. It gives fresh dimension to all Leonardo's efforts to grind concave mirrors. It's difficult to think that he could have missed their image-forming properties.

Must go now – but look forward to your arrival.

Love
Martin

Los Angeles
12 January 2001

'Lost knowledge' by David Hockney

The original title for this book was 'Lost Knowledge'. Our rediscovery of the mirror-lens was an exciting event. It's a simple scientific fact. The day after, I went for a drive in the mountains to think about it. It seemed big to me. How could no one have known? The way it was discovered was indirect – a casual remark by Charles Falco, that a concave mirror has all the optical qualities of a lens, was said at the end of a long day. I realized he thought it was common

knowledge, but had no idea how to put it to use. I knew it wasn't common knowledge, and within an hour had realized how to put it to use.

Why was it forgotten? How was it forgotten? Knowledge has been lost in the past and I've no doubt it will be in future. The story of concrete is an interesting one. The Egyptians and Greeks used calcinated gypsum to give brick or stone structures a smooth coating. The Romans made a form of concrete using broken brick aggregate embedded in a mixture of lime putty with brick dust or volcanic ash, with blood and fat added. They built everything including roads, aqueducts, baths and the poured-concrete coffer dome of the Pantheon among other things. Then after AD 430 concrete virtually disappears, although some forms of mortar remained and were used again after 1300, but very sparingly.

In 1744 John Smeaton rediscovered concrete, finding that combining quicklime with other materials created an extremely hard material that could be used to bind together other materials. He used this knowledge to build the first concrete structure since the ancient Romans, the Eddystone lighthouse in Cornwall. In 1824, Joseph Aspdin, a brickmason of Leeds, Yorkshire, took out a patent on a material called 'Portland Cement'.

Well, if something that provides the essential needs of shelter, water, fortress, etc. was forgotten, what chance would a device for drawing have? Especially in plague-ridden 15th- and 16th-century Europe.

We live in an arrogant age that thinks it knows more than any other. Humility is not in style. Asking questions is better than answering them. A quest is a journey. The word 'answering' derives from 'I swear it' or 'I know it'. I don't like the idea of moving into darker ages. Wider perspectives are needed now.

'The camera cannot compete with painting as long as it cannot be used in Heaven or Hell.'

Edvard Munch

Los Angeles
12 January 2001

'Summary' by David Hockney

From Ingres's occasional use of the camera lucida to make portrait drawings in Rome I began to detect the effect of optics in previous paintings. I think Ingres only used the camera lucida for these portrait drawings. They are very small (unnaturally so) and very accurate. He was, after all, making a living at that time with these drawings. Although we value them today, he more than likely didn't. As far as he was concerned, he was a history painter of the top rank, and these drawings were made of visitors to Rome on the Grand Tour. In such skilled hands, this device would produce a likeness, which the sitter would regard as absolutely essential. Why art historians of today would doubt this is beyond me. The evidence is clearly in the drawing. In fact, I regard it as naïve on their part to assume he would reject this tool for the job.

Perhaps I should comment here on the historian's or critic's attitude to the use of optics. The ones who react in horror seem to be people who have little contact with methods or mark-making and essentially have a late-19th-century view of the artist as a solitary genius. It is an old-fashioned Romantic view, not realizing how difficult optics are to use and that the skills of the eye and hand are essential. I cannot take this attitude with any seriousness. End of matter.

As I looked back in time and saw the optical base under quite a lot of work, I kept looking for the tool. Tracing the 'look' back to 1420, I thought at first it was a lens. On 14 March 2000, I discovered it wasn't a lens at all, but a concave mirror – the back of the mirrors depicted in Robert Campin's and van Eyck's paintings. The concave mirror will give a clear projection approximately 30 x 30cm, no matter how big the mirror is (or anyway it doesn't have to be bigger than 6cm diameter). A great number of portrait panels after 1420 are of this size, and are usually head and shoulders with a ledge in front, or the subject appears to be in a box. All Holbein's portrait drawings are within this ratio. The effect of the mirror-lens in Netherlandish painting was to create an art with many windows, or, as Dirk de Vos has said in his book on Memling, 'it is as though he had a sliding panel'. I think he probably did.

The 'many windows' technique (as opposed to Alberti's one-window, mathematical perspective) has the effect of creating space, yet everything is brought up to the picture plane, as is clearly seen in the Ghent Altarpiece, the work of Rogier van der Weyden, Memling, Dieric Bouts and their followers. This does not negate the iconographical interpretations of their subject matter or their individual skills of observation, which vary between the artists. Optics do not make marks, but they give a look of naturalism.

The tool was forgotten about with the introduction of glass lenses and flat mirrors. The glass lens has a larger viewing area, so at the time would seem to be an improvement, but like a lot of 'improvements' they do not always work out to be so in the long run. It took until the 19th century and the invention of chemical photography to make real improvements, and well into the 20th century for wider angles that did not appear to 'distort'. The Cinemascope film, for example, didn't arrive until the 1950s.

I have said that there is a straight line from Robert Campin's man with a red turban, through Bellini's Doge, to the television newscaster of today. They are all seen in a similar way. We think it's realism, or naturalism. They are all optical portraits, though for the first five hundred years interpreted by the hand, eye and heart. It is in the 20th century that we begin to notice problems – indeed, the late 20th century perhaps needs the ubiquity of the moving image and television's 'close up' – head and shoulders like the Netherlandish panels – to see these. But TV is not many windows – we have gone back to one window. The difference between a reflected image from a mirror and a projected image from a mirror is profound. The first has to be related to our bodies – as the body moves so does the reflection. The second, the projected image, has no relation to the body. It is a view of the

world no body saw. Nobody saw – is that now our problem? The images that dominate at the beginning of the 21st century are images made with no body connected to the seeing. What is it doing to us? Do they have a relationship to the 'real world out there'?

Perceptual analysis in the 20th century has shown that at any given moment we see only a small amount. The movement of the eye gives us a bigger picture, which we assemble with memory in our heads. We see with memory. Is there not now a big contradiction between our millions of images and the way we actually see the world? Knowledge of visual perception made in the 20th century is surely having an effect. I began to be bored with the image on TV a long time ago. It was an instinct that realized this was nobody's view of the world, an unhuman view of it. I remember seeing a Disney cartoon of the 40s about elephants in Africa. It was a drawn film about their lives, not humorous like *Dumbo*, but a beautifully observed picture of them moving – slowly because of their weight. I said to a friend who was watching it with me that it was far more interesting to look at than photographs of elephants, even moving photographs. Why? Because the drawn one was an account of seeing by a human being. Is this not really all that is possible for humans?

The movie now seems a tired and ephemeral medium. For many years it didn't. Was this because of the novelty of it, or our acceptance of its being 'real'? Something looking similar had occupied space at a certain time in a certain place. Are we moving into a post-photographic age? What does that mean – a new drawing and painting? There have been a few people already who have suggested that the new digital cinema is a sub-genre of painting. The straight line is changing direction. Exciting times are ahead.

London
17 January 2001

'Later thoughts' by David Hockney

At the beginning of the 21st century it is becoming clear that the cinema is a very ephemeral medium, television even more so. Yet they are powerful because they are mass mediums, in an age that seems a 'mass age'. But is it?

The media seem powerful – 'Media', it's only two letters different from 'Medici'. Hegel's idea of the end of 'History', and the end of 'Art' have been revived in our time. 'Art' seems in confusion. But is it?

A recent exhibition at the Los Angeles County Museum of Art called 'Made in California' seemed confused – or at least the latter section did. Perhaps it tried to do things it cannot do. It couldn't show all the movies made in California. They are an art of time not space. It couldn't play all the music composed in California – it's an art of time not space. The past has to be edited, it looks neater because of this, and the arts of time have to be ruthlessly edited – there is a cream that stays, the rest is lost. We should be thankful – we'd be up to our necks in rubbish if this did not happen.

My own observations about the exhibition were that at the beginning (100 years ago) and for 50 or 60 years it was about 'looking at' California – quite appropriate for a Museum of Visual Art. At the end no one seemed to 'look at' California. One would have no idea that it was a great big space with mountains, forest and ocean. I assumed this was perhaps because they thought they knew what it looked like. Bit do we? We are bombarded with images of the world seen by no body (nobody). To see anew and fresh seems to me to be vital. The world of images cannot be separate from the World of Art – if so the World of Art is subservient to it, it becomes minor.

Iconoclasm and idolatry are two sides of the same coin.

The lessons of Cézanne were seen by a few at the beginning of the 20th century and seem now on their way to being lost at the beginning of the 21st century. Knowledge and awareness have been lost before; dark ages have descended before; enlightenments have happened before; and new and fresh views of the world and our relationship in it have happened before. We could be on the threshold of another higher awareness, and our images have a great deal to do with it.

London
5 February 2001

'Optics, perspective, Brunelleschi and us' by David Hockney

Alberti's story of Brunelleschi and the 'discovery' or 'invention' of perspective is well known. Published in 1435, it was really contemporary with van Eyck and Robert Campin in Flanders. Brunelleschi demonstrated perspective by painting a small panel (half a *braccia* square). To paint this, he stationed himself just inside (some three *braccia* inside) the central portal of Santa Maria del Fiore, in short, in a dark room looking out to the light.

The mirror-lens produces a perspective picture. The viewing point is a mathematical point in the centre of the mirror. Perspective is a law of optics. So was it 'invented'? It happened in Florence around 1420–30. Today, it is the window through which the world is seen, with television, film and still cameras. The Chinese did not have a system like it. Indeed, it is said they rejected the idea of a vanishing point in the eleventh century, because it meant the viewer was not there, indeed, had no movement, therefore was not alive. Their own system, though, was highly sophisticated by the fifteenth century. Scrolls were made where one journeyed through a landscape. If a vanishing point occurred, it would have meant the viewer had ceased moving.

Did the mirror-lens originate in Bruges and then was sent to Italy by one of the Medici agents? Arnolfini was an agent of the Medici bank. Did Brunelleschi show the mirror-lens to Masaccio? Is that why his heads are so individualistic? There was certainly no precedent for that 'look' in Florence before Masaccio. It occurs at almost the same time as Campin and van Eyck in Bruges. Did Brunelleschi devise the rules of perspective to make the picture bigger than those the mirror-lens could produce?

All of this has interest beyond art history or the history of pictorial space, because the system of perspective led to the system of triangulation that meant you could fire cannons more accurately. Military technology had a jump from it, and it is clear that by the late eighteenth century the West's technology was superior to that in China, hence the decline of China in relation to the West.

The vanishing point leads to the missiles of today, which can take us out of this world. It could be that the West's greatest mistakes were the 'invention' of the external vanishing point and the internal combustion engine. Think of all the pollution from the television and traffic.

bibliography

ADAMS, GEORGE, *A Catalogue of Optical, Philosophical and Mathematical Instruments*, London, c. 1765

ADAMS, GEORGE, *An Essay on Vision*, London, 1789

ADAMS, GEORGE, *Geometrical and Graphic Essays*, London, 1791

ADAMS, GEORGE, *Lectures on Natural and Experimental Philosophy*, London, 1794

AIKEMA, BERNARD AND BEVERLY LOUISE BROWN (eds), *Renaissance Venice and the North: Crosscurrents in the Time of Dürer, Bellini and Titian*, New York, 2000

AINSWORTH, MARYAN W. AND KEITH CHRISTIANSEN (eds), *From Van Eyck to Bruegel: Early Netherlandish Painting in the Metropolitan Museum of Art*, New York, 1998

AINSWORTH, MARYAN W. AND MAXIMILIAAN P. J. MARTENS, *Petrus Christus: Renaissance Master of Bruges*, New York, 1994 and 2000

ALBERTI, LEON BATTISTA, *De pictura*, Florence, 1435; edited and translated by Cecil Grayson as *On Painting*, London, 1972

ALCOLEA, SANTIAGO, *Zurbarán*, translated by Richard Lewis Rees, Barcelona, 1989

ALGAROTTI, COUNT FRANCESCO, *Saggio sopra la pittura*, Livorno, 1763; English translation, *An Essay on Painting*, Glasgow, 1764

AL HAYTHAM (Ibn al-Haitham/Alhazen/Alhazan/Al Hazan), *Opticae thesaurus alhazeni*, 11th century

AL HAYTHAM, *Vitellonis thuringopoloni opticae*, 13th century; edited by Frederick Risner, Basel, 1672

ALPERS, SVETLANA, *The Art of Describing: Dutch Art in the 17th Century*, Chicago, 1984

D'ANCONA, PAOLO, *Piero della Francesca*, Milan, 1980

ANDRE, PAUL, *Rembrandt van Rijn*, translated by Josephine Bacon and Victoria Quinn, Bournemouth and St Petersburg, 1996

ANDRE, PAUL, *The Renaissance Engravers: Fifteenth- and Sixteenth-Century Engravings, Etchings and Woodcuts*, translated by Lenina Sorokina, Bournemouth and St Petersburg, 1996

ANDRES, GLENN, JOHN M. HUNISAK AND A. RICHARD TURNER, *The Art of Florence*, New York, 1989

ARANO, LUISA COGLIATI, *The Medieval Health Handbook*, New York, 1976 and 1992

ARBACE, LUCIANA, *Antonello da Messina: Catalogo completo dei depinti*, Florence, 1993

D'ARCAIS, FRANCESCA FLORES, *Giotto*, New York, London and Paris, 1995

ARNOLD, KLAUS, *Johannes Trithemius (1462–1516)*, Würzburg, 1971

ASHMOLE, ELIAS (ed.), *Theatrum chemicum britannicum*, London, 1652

ASPEREN DE BOER, J. R. J. van et al, *Jan van Eyck: Two Paintings of Saint Francis receiving the Stigmata*, Philadelphia, 1997

BACON, ROGER, *De secretis operibus artis et naturae, et de nullitate magiae*, 13th century; translated as 'Of Art and Nature' in *The Mirror of Alchimy*, London, 1597

BACON, ROGER, *Opera quaedam hacentus inedita*, 13th century; edited by J. S. Brewer, London, 1959

BACON, ROGER, *Perspectiva*, 13th century; edited by Johann Combach, Frankfurt, 1614

BAGLIONE, GIOVANNI, *Le Vite de pittori, scultori et architetti*, Rome, 1642

BAKER, CHRISTOPHER AND TOM HENRY (eds), *The National Gallery Complete Illustrated Catalogue*, London, 1995

BANN, STEPHEN, *Paul Delaroche: History Painted*, London and Princeton, 1997

BARBARO, DANIEL, *La Pratica della perspectiva*, Venice, 1568

BARSKAYA, ANNA AND YEVGENIA GEORGIEVSKAYA, *Paul Cézanne: Unknown Horizons*, Bournemouth and St Petersburg, 1995

BASSANI, RICCARDO AND FIORA BELLINI, 'La casa, le "robbe", lo studio del Caravaggio a Roma: due documenti inediti del 1603 e del 1605', *Perspettiva*, March 1994

BÄTSCHMANN, OSKAR AND PASCAL GRIENER, *Hans Holbein*, Princeton and London, 1997

BECK, JAMES H., *Raphael*, New York, 1976

BECK, JAMES H., *Italian Renaissance Painting*, Cologne, 1999

BENESCH, OTTO, *The Drawings of Rembrandt*, vol. III, enlarged and edited by Eva Benesch, London and New York, 1973

BERENSON, BERNARD, *The Italian Painters of the Renaissance*, London, 1952

BERENSON, BERNARD, *Caravaggio: His Incongruity and His Fame*, London, 1953

BION, NICHOLAS, *Traité de la construction et des principaux usages des instrumens de mathématique*, Frankfurt and Leipzig, 1712; English translation, *The Construction and Principal Uses of Mathematical Instruments*, London, 1758

BLANCH, SANTIAGO ALCOLEA, *The Prado*, translated by Richard Lewis Rees and Angela Patricia Hall, New York and Madrid, 1991

BORA, GIULIO, MARIA TERESA FIORIO, PIETRO C. MARANIA AND JANICE SHELL, *The Legacy of Leonardo: Painters in Lombardy 1490–1530*, Washington, D.C., 1998

BRANDER, GEORG FRIEDRICH, *Beschreibung einer ganz neuen Art einer camerae obscurae*, Augsburg, 1769

BRIGSTOCKE, HUGH, *Italian and Spanish Paintings in the National Gallery of Scotland*, Edinburgh, 1993

BROCKWELL, MAURICE WALTER, *The Van Eyck Problem*, London, 1954

BROWN, CHRISTOPHER, *Dutch Painting*, London, 1976 and 1993

BROWN, CHRISTOPHER, *Utrecht Painters of the Dutch Golden Age*, London, 1997

BROWN, CHRISTOPHER AND HANS VLIEGHE, *Van Dyck 1599–1641*, London and New York, 1999

BROWN, DAVID ALAN, PETER HUMFREY AND MAURO LUCCO, *Lorenzo Lotto: Rediscovered Master of the Renaissance*, New Haven and London, 1997

BROWN, JONATHAN, *Francisco de Zurbarán*, New York, 1973

BUCHNER, ERNST, *Die Alte Pinakothek München: Meister der Europäischen Malerei*, Munich, 1957

BUNIM, M. S., *Space in Medieval Painting and the Forerunners of Perspective*, New York, 1940

BURCKHARDT, JACOB, *The Civilization of the Renaissance in Italy*, translated by S. G. C. Middlemore, London, 1990

CACHIN, FRANÇOISE ET AL, *Cézanne*, Philadelphia, 1996

CACHIN, FRANÇOISE, CHARLES S. MOFFETT AND MICHEL MELOT, *Manet 1832–1883*, Paris, 1983

CACHIN, FRANÇOISE (ed.), *Arts of the 19th Century – Volume 2: 1850 to 1905*, Paris and New York, 1999

CAMPBELL, LORNE, *Renaissance Portraits*, New Haven and London, 1990

CAMPBELL, LORNE, *The Fifteenth-Century Netherlandish Schools*, London, 1998

CAMPBELL ABDO, Sara, *Masterpieces from the Norton Simon Museum*, Pasadena, 1999

CAMPO Y FRANCES, Angel de, *La Magia de las Meninas*, Madrid, 1978

CARDINI, HIERONYMI (Girolamo Cardano), *De Subtilitate*, Book XXI, Nuremberg, 1550

CHARLES, VICTORIA S., *Rembrandt*, Bournemouth, 1997

CHATELET, ALBERT, *Jan van Eyck: Élumineur*, Strasbourg, 1993

CHRISTIANSEN, KEITH, 'Caravaggio and "L'esempio davanti del naturale"', *Art Bulletin*, September 1986

CHRISTIANSEN, KEITH, LAURENCE B. KANTIER AND CARL BRANDON STREHLKE, *Painting in Renaissance Siena 1420–1500*, New York, 1988

CLARK, KENNETH, *The Drawings of Leonardo da Vinci in the Collection of Her Majesty the Queen at Windsor Castle*, London, 1969

CLAY, JEAN AND JOSETTE CONTRERAS, *The Louvre*, Paris, New York and Lausanne, 1980

CLUBB, LOUISE GEORGE, *Giambattista della Porta, Dramatist*, Princeton, 1965

COLIE, ROSALIE L., *'Some Thankfulnesse to Constantine': A Study of English Influence upon the Early Works of Constantijn Huygens*, The Hague, 1956

COLLINS, FREDERICK, *Experimental Optics*, New York and London, 1933

CONWAY, WILLIAM MARTIN, *The Literary Remains of Albrecht Dürer*, Cambridge, 1889

COSTA, GIANFRANCESCO, *Delle Delizie del Fiume Brenta*, Venice, 1750

CRARY, JONATHAN, *Techniques of the Observer: On Vision and Modernity in the Nineteenth Century*, Cambridge, Mass., 1991

CROMBIE, A. C., *The History of Science AD 400–1650: Augustine to Galileo*, London, 1952

CROMBIE, A. C., *Science, Optics and Music in Medieval and Early Modern Thought*, London, 1990

CREW, HENRY, *The 'Photismi de lumine' of Maurolycus: A Chapter in Late Medieval Optics*, New York, 1940

DEHAMEL, CHRISTOPHER, *A History of Illuminated Manuscripts*, London, 1986

DELÉCLUZE, ÉTIENNE, 'Exposition de 1850', 8th article, *Journal des Débats*, Paris, 11 April 1851

DESCARTES, RENÉ, *Discours de la méthode*, Leiden, 1637; for English translation, see John Cottingham, Robert Stoothoff and Dugald Murdoch (trans), *The Philosophical Writings of Descartes*, Cambridge, 1985

DUNKERTON, JILL, SUSAN FOISTER, DILLIAN GORDON AND NICHOLAS PENNY, *Giotto to Dürer: Early Renaissance Painting in the National Gallery*, New Haven and London, 1991

DURAND, JANNIC, *Byzantine Art*, Paris, 1999

EICHLER, ANJA-FRANZISKA, *Albrecht Dürer 1471–1528*, Cologne, 1999

EISLER, COLIN et al, *Paintings in the Hermitage*, New York, 1995

FAGE, GILLES (ed.), *Le Siècle de Titien: l'age d'or de la peinture à Venise*, Paris, 1993

FAHY, EVERETT, *The Legacy of Leonardo*, Washington, D.C., 1979

FAILLE, J.-B. DE LA, *The Works of Vincent van Gogh*, Amsterdam, 1970

FARRAR, JOHN, *An Experimental Treatise on Optics*, Cambridge, Mass., 1826

FINCH, CHRISTOPHER, *Norman Rockwell's America*, New York, 1975

FINK, DANIEL A., 'Vermeer's use of the camera obscura: a comparative study', *Art Bulletin*, December 1971

FOISTER, SUSAN, ASHOK ROY AND MARTYN WYLD, *Making and Meaning: Holbein's Ambassadors*, London, 1997

FREDERICKSEN, BURTON B. et al, *Masterpieces of the J. Paul Getty Museum: Paintings*, Los Angeles, 1997

FREEDBERG, DAVID, *The Power of Images: Studies in the History and Theory of Response*, Chicago and London, 1989

FREEDBERG, S. J., *Circa 1600: A Revolution of Style in Italian Painting*, Cambridge, Mass., 1983

FRÈRE, JEAN-CLAUDE, *Early Flemish Painting*, Paris, 1997

FRESNOY, C. A. du, *The Art of Painting*, translated by Mr Dryden, London, 1645

FRIED, MICHAEL, *Manet's Modernism, or the Face of Painting in the 1860s*, Chicago and London, 1996

FRIEDLANDER, MAX J., *Die Altneiderlandische Malerei*, Berlin and Leiden, 1924–37; translated by Heinz Norden as *Early Netherlandish Painting*, Leiden, 1975

FRIESS, PETER, *Kunst und Maschine*, Munich, 1993

FRISIUS, GEMMA, *De radio astronomico et geometrico liber*, Antwerp and Louvain, 1545

GALASSI, PETER, *Corot in Italy: Open-Air Painting and the Classical Landscape Tradition*, New Haven and London, 1991

GALILEI, GALILEO, *Le Opere de Galileo Galilei*, Florence, 1907

GASKELL, IVAN AND MICHIEL JONKER (eds), *Vermeer Studies*, New Haven and London, 1998

GERNSHEIM, HELMUT, *The History of Photography: From the Earliest Use of the Camera Obscura in the 11th Century to 1914*, Oxford, 1955

GOLDWATER, ROBERT, *Paul Gauguin*, New York, 1983

GOMBRICH, E. H., *Art and Illusion: A Study in the Psychology of Pictorial Representation*, London and New York, 1960

GOMBRICH, E. H., *The Story of Art*, 17th edition, London, 1997

GOWING, LAWRENCE, *Paintings in the Louvre*, New York, 1987

GRANT, EDWARD, *Physical Science in the Middle Ages*, New York, 1971

GRANT, EDWARD, *Studies in Medieval Science and Natural Philosophy*, London, 1981

GRANT, EDWARD, 'Science and theology in the Middle Ages', in David C. Lindberg and Ronald L. Numbers (eds), *God and Nature*, Berkeley and Los Angeles, 1986

S'GRAVESANDE, G. J., *Essai de perspective*, The Hague, 1711; English translation, *An Essay on Perspective*, London, 1724

GREGORI, MINA, *Giovan Battista Moroni*, Bergamo, 1979

GREGORI, MINA ET AL, Paintings in the Uffizi and Pitti Galleries, Boston, 1994

GUILLAND, JACQUELINE AND MAURICE GUILLAND, *Fra Angelico – The Light of the Soul: Painting Panels and Frescoes from the Convent of San Marco, Florence*, Paris and New York, 1986

GUILLAND, JACQUELINE AND MAURICE GUILLAND, *Giotto: Architect of Color and Form*, Paris and New York, 1987

GUILLAND, JACQUELINE AND MAURICE GUILLAND, *Piero della Francesca – Poet of Form: The Frescoes of San Francesco di Arezzo*, Paris and New York, 1988

HAMMOND, JOHN H., *The Camera Obscura: A Chronicle*, Bristol, 1981

HAMMOND, JOHN H. AND JILL AUSTIN, *The Camera Lucida in Art and Science*, Bristol, 1987

HARBISON, CRAIG, *Jan van Eyck: The Play of Realism*, London, 1991

HARRIS, JOHN, *Lexicon technicum*, London, 1704

HARRIS, L. E., *The Two Netherlanders: Humphrey Bradley and Cornelius Drebbel*, Cambridge, 1961

HAVEN, MARC, *La Vie d'Arnaud de Villeneuve*, Paris, c. 1880

HENDERSON, MARINA (ed.), *Gustave Doré: Selected Engravings*, London, 1971

The Hermitage: Selected Treasures from a Great Museum, Leningrad, 1990

HIBBARD, HOWARD, *Caravaggio*, New York, 1983

HILLIARD, NICHOLAS, *A Treatise Concerning the Art of Limning*, edited by Philip Norman, London, 1912

HOGARTH, WILLIAM, *The Analysis of Beauty*, with rejected passages, edited by J. Burke, Oxford, 1955

HOHENSTATT, PETER, *Leonardo da Vinci 1452–1519*, Cologne, 1998

HONDIUS, HENRIK, *Institutio artis perspectivae*, Amsterdam, 1622; translated into English by Joseph Moxon as *Practical Perspective*, London, 1670

HOOGSTRATEN, SAMUEL VAN, *Inleydint Tot de Hooge Schoole der Schilderkonst*, Rotterdam, 1678

HUIZINGA, JOHAN, *The Waning of the Middle Ages: A Study of the Forms of Life, Thought and Art in France and The Netherlands in the Fourteenth and Fifteenth Centuries*, London, 1924

HUMFREY, PETER, *Lorenzo Lotto*, New Haven and London, 1997

HUMFREY, PETER (ed.), *Giovanni Battista Moroni: Renaissance Portraitist*, Fort Worth, 2000

HUTTON, CHARLES, *Mathematical and Philosophical Dictionary*, London, 1745

INGAMELLS, JOHN, *The Wallace Collection*, London, 1997

IVINS, WILLIAM M., *Art and Geometry*, New York, 1946

JACOBSON, KEN AND ANTHONY HAMBER, *Étude d'après nature: 19th Century Photographs in Relation to Art*, Essex, 1996

JARDINE, LISA, *Worldly Goods*, London, 1996

JOBERT, BARTHÉLÉMY, *Delacroix*, Princeton, 1998

JOHNSON, DOROTHY, *Jacques-Louis David: Art in Metamorphosis*, Princeton, 1993

JORDAN, WILLIAM B., *Spanish Still Life in the Golden Age 1600–1650*, Fort Worth, 1985

JUDSON, J. RICHARD AND RUDOLPH E. O. EKKART, *Gerrit van Honthorst 1592–1656*, London, 1999

KAGANE, LUDMILA, *Diego Velázquez*, Bournemouth and St Petersburg, 1996

KAMINSKI, MARION, *Tiziano Vecellio, known as Titian 1488/1490–1576*, Cologne, 1998

KAN, A. H. (ed.), *De Jeugd van Constantijn Huygens door Hemzelf Beschreven*, Rotterdam, 1946

KEMP, MARTIN (ed.), *Leonardo on Painting: An Anthology of Writings by Leonardo da Vinci with a Selection of Documents Relating to his Career as an Artist*, New Haven and London, 1989

KEMP, MARTIN, *The Science of Art: Optical Themes in Western Art from Brunelleschi to Seurat*, New Haven and London, 1992

KEPLER, JOHANNES, *Ad vitellionem paralipomena*, Frankfurt, 1604

KEPLER, JOHANNES, *Dioptrice*, Augsburg, 1611

KIRCHER, ATHANASIUS, *Ars magna lucis et umbrae*, Rome, 1646

KITSON, MICHAEL, *The Complete Paintings of Caravaggio*, London, 1969

KÖNIG, EBERHARD, *Die Très Belles Heures von Jean de France, Duc de Berry*, Munich, 1998

KREN, THOMAS (ed.), *Renaissance Painting in Manuscripts: Treasures from the British Library*, New York and London, 1983

KUZNETSOVA, IRINA, *French Painting from the Pushkin Museum: 17th to 20th Century*, Leningrad, 1979

LANGDON, HELEN, *Caravaggio: A Life*, New York, 1998

LAPUCCI, ROBERTA, 'Caravaggio e i "quadretti nello specchio ritratti"', *Paragone*, March–July 1994

LAVEISSIÈRE, SYLVAIN AND RÉGIS MICHEL, *Géricault*, Paris, 1991

LERNER, RALPH AND MUHSIN MAHDI (eds), *Medieval Political Philosophy: A Sourcebook*, New York, 1963

LEURECHON, JEAN, *Récréations mathématiques*, Paris, 1633

LEVENSON, JAY A., *Circa 1492: Art in the Age of Exploration*, Washington, D.C., 1991

LEYMARIE, JEAN, *Corot*, New York, 1979

LINDBERG, DAVID C., 'Alhazen's theory of vision and its reception in the West', *Isis*, vol. 58, 1967

LINDBERG, DAVID C., 'The theory of pinhole images from antiquity to the thirteenth century', *Archive for History of Exact Sciences*, vol. 5, no. 2, 1968

LINDBERG, DAVID C., 'The cause of refraction in medieval optics', *British Journal for the History of Science*, vol. 4, 1968–9

LINDBERG, DAVID C., 'A reconsideration of Roger Bacon's theory of pinhole images', *Archive for History of Exact Sciences*, vol. 6, no. 3, 1970

LINDBERG, DAVID C., *John Pecham and the Science of Optics: Perspectiva Communis*, Madison and London, 1970

LINDBERG, DAVID C., 'The theory of pinhole images in the fourteenth century', *Archive for History of Exact Sciences*, vol. 6, no. 6, 1970

LINDBERG, DAVID C., 'Lines of influence in thirteenth-century optics: Bacon, Witelo and Pecham', *Speculum*, vol. 46, 1971

LINDBERG, DAVID C., *A Catalogue of Medieval and Renaissance Optical Manuscripts*, Toronto, 1975

LINDBERG, DAVID C., *Roger Bacon's Philosophy of Nature*, Oxford, 1983

LINDBERG, DAVID C., *Roger Bacon and the Origins of Perspectiva in the Middle Ages*, Oxford, 1996

LINDBERG, DAVID C. (ed.), *Studies in the History of Medieval Optics*, London, 1983

LINDBERG, DAVID C. AND RONALD L. NUMBERS (eds), *God and Nature*, Berkeley and Los Angeles, 1986

LINKS, J. G., *Canaletto*, London, 1982

LONGINO, CESARE, *Trinum magicum, sive secretorum magicorum opus*, Frankfurt, 1604

LOPEZ-REY, JOSÉ, *Velázquez: Painter of Painters*, Cologne, 1996

LOVELL, D. J., *Optical Anecdotes*, Bellingham, 1981

LUCCO, MAURO, *Giorgione*, Milan, 1995

MANETTI, ANTONIO, *The Life of Brunelleschi*, manuscript, Florence, 1480s; published in original Italian with English translation, edited by Howard Saalman and translated by Catherine Enggass, Pennsylvania and London, 1970

MARIETTE, P.-J., *Abecedario*, Paris, 1851–3

MARLE, RAIMOND VAN, *The Development of the Italian Schools of Painting*, The Hague, 1934

MARTINEAU, JANE AND CHARLES HOPE (eds), *The Genius of Venice 1500–1600*, London, 1983

MERRIFIELD, MARY P., *Original Treatises on the Arts of Painting*, London, 1849

MERSENNE, MARIN, *Universae geometriae, mixt aeque mathematicae synopsis, et bini refractionum demonstratarum tractacus*, Paris, 1644

MERSENNE, MARIN, *L'Optique et la catoptrique*, Paris, 1673

MICHEL, MARIANNE ROLAND, *Chardin*, New York, 1996

MIRECOURT, EUGÈNE DE, *Ingres*, Paris, 1855

MOIR, ALFRED, *Anthony van Dyck*, New York, 1994

MOLYNEAUX, WILLIAM, *Dioptrica nova*, London, 1692

MORMANDO, FRANCO, *Saints and Sinners: Caravaggio and the Baroque Image*, Boston, 1999

MOXON, JOSEPH, *Practical Perspective*, London, 1670

MURDOCH, JOHN, *The Courtauld Gallery at Somerset House*, London, 1998

MURRAY, PETER AND LINDA MURRAY, *The Art of the Renaissance*, London, 1963

MUSPER, H. T., *Netherlandish Painting from Van Eyck to Bosch*, New York, 1981

MYDORGE, CLAUDE, *Examen du livre des récréations mathématiques et de ses problèmes en géometrie, mécanique et catoptrique*, Paris, 1638

NAEF, HANS, *Rome vue par Ingres*, London, 1960

NEEDHAM, JOSEPH, *Science and Civilisation in China*, Cambridge, 1962

NEPI SCIRÈ, GIOVANNA, *Canaletto's Sketchbook*, Venice, 1997

NEWBOLD, WILLIAM ROMAINE, *The Cipher of Roger Bacon*, Philadelphia and London, 1928

NEWTON, ISAAC, *Opticks*, London, 1704

NICERON, JEAN-FRANÇOIS, *Perspective curieuse*, Paris, 1638

NICHOLSON, BENEDICT, *Caravaggism in Europe*, Turin, 1990

NIKULIN, NIKOLAI, *Netherlandish Paintings in Soviet Museums*, Oxford and Leningrad, 1987

NORTON, THOMAS, *The Ordinall of Alchimy*, Bristol, 1477; facsimile, London, 1928; published in Latin as *Museum hermeticum*, Frankfurt, 1678; translated into English, London, 1893

OBERHUBER, KONRAD, *Raphael: The Paintings*, Munich, London and New York, 1999

OPPENHEIMER, PAUL, *Rubens: A Portrait Beauty and the Angelic*, London, 1999

ORTIZ, ANTONIO ET AL, *Velázquez*, New York, 1989

PACHT, OTTO, *Book Illumination in the Middle Ages*, London, 1986

PANOFSKY, ERWIN, *The Life and Art of Albrecht Dürer*, Princeton, 1943

PANOFSKY, ERWIN, *Early Netherlandish Painting*, Cambridge, Mass., 1964

PATON, JAMES AND A. S. MURRAY, 'Mirror', *Encyclopedia Britannica*, Edinburgh, 1883

PECHAM, JOHN, *Perspectiva communis*, 1279; edited by George Hartmann, Nuremberg, 1542

PECHAM, JOHN, *Tractacus de perspectiva*, 13th century; edited by David C. Lindberg, New York, 1972

PEMÁN Y PEMARTÍN, CÉSAR, *Juan van Eyck y España*, Cadiz, 1969

PIRIENNE, M. H., *Optics, Painting and Photography*, Cambridge, 1970

PORCHER, JEAN, *French Miniatures from Illuminated Manuscripts*, London, 1960

PORTA, GIAMBATTISTA DELLA, *Magiae naturalis*, 4 volumes, Rome, 1558; expanded and republished in 20 volumes, 1588; translated into English as *Natural Magick*, London, 1658

PORTA, GIAMBATTISTA DELLA, *De furtivis literarum notis*, Naples, 1563

PRICKE, ROBERT, *Magnum in parvo*, London, 1672

QUERMANN, ANDREAS, *Domenico di Tommaso di Currado Bigordi Ghirlandaio 1449–1494*, Cologne, 1998

RASHED, ROSHDI (ed.), *Encyclopedia of the History of Arabic Science*, London and New York, 1996

READ, JAN, *The Moors of Spain and Portugal*, London, 1974

REFF, THEODORE, *Manet and Modern Paris: One Hundred Paintings, Drawings, Prints and Photographs by Manet and his Contemporaries*, Chicago and London, 1982

REISCH, GREGORIUS, *Margarita philosophica*, Friburg, 1503

REYNOLDS, JOSHUA, 'A Discourse Delivered to the Students of the Royal Academy, London', 1786; in *Discourses on Art*, edited by Robert R. Wark, New Haven and London, 1997

RICHTER, JEAN PAUL, *The Literary Works of Leonardo da Vinci*, London, 1883

RISNER, FREIDRICH, *Opticae*, Kassel, 1606

ROBERTS, JANE, *Drawings by Holbein from the Court of Henry VIII*, Orlando, 1987

ROBERTS, JANE, *Holbein and the Court of Henry VIII*, Edinburgh, 1993

RONCHI, VASCO, *Optics: The Science of Vision*, New York, 1957

RONCHI, VASCO, *Storia della luce*, 1939; translated by V. Barocas as *The Nature of Light*, London, 1970

ROWLANDS, JOHN, *Holbein: The Paintings of Hans Holbein the Younger*, Oxford, 1985

ROY, ASHOK ET AL, *Andy Warhol Drawings 1942–1987*, Basel, 1998

RUSKIN, JOHN, *Modern Painters*, 5 volumes, London, 1843–60

SABRA, A. I., *The Optics of Ibn Al-Haytham*, London, 1989

SALMON, WILLIAM, *Polygraphice*, London, 1672

SANTI, BRUNO, *Raphael*, translated by Paul Blanchard, Florence, 1991

SARTON, GEORGE, *Appreciation of Ancient and Medieval Science during the Renaissance (1450–1600)*, New York, 1955

SCHARF, AARON, *Art and Photography*, London, 1968

SCHEINER, CHRISTOPHER, *Oculus*, Innsbruck, 1619

SCHMIDT, PETER, *The Adoration of the Lamb*, Leuven, 1996

SCHNEIDER, NORBERT, *The Art of the Portrait: Masterpieces of European Portrait-Painting 1420–1670*, Cologne, 1994

SCHNEIDER, NORBERT, *Still Life: Still-Life Painting in the Early Modern Period*, Cologne, 1994

SCHOTT, KASPAR, *Magia universalis naturae et artis*, Frankfurt, 1657

SCHWARZ, HEINRICH, 'The mirror of the artist and the mirror of the devout: observations on some paintings, drawings and prints of the fifteenth century', in *Studies in the History of Art dedicated to William E. Suida on his Eightieth Birthday*, London, 1959

SCHWARZ, HEINRICH, *Art and Photography – Forerunners and Influences: Selected Essays*, New York, 1985

SCHWENTER, DANIEL, *Physico-Mathematicae*, Nuremberg, 1651

SCOTT, KATHLEEN L., *Later Gothic Manuscripts 1390–1490*, London, 1996

SERULLAZ, ARLETTE ET AL, *Delacroix: The Late Work*, Paris and Philadelphia, 1998/99

SEYMOUR, CHARLES, 'Dark chamber and light-filled room: Vermeer and the camera obscura', *Art Bulletin*, September 1964

SLIVE, SEYMOUR, *Frans Hals*, London, 1989

SMEYERS, MAURITS AND JAN VAN DER STOCK (eds), *Flemish Illuminated Manuscripts 1475–1550*, Ghent, 1996

SMITH, A. MARK, *Witelonis perspectivae liber quintus*, Warsaw, 1983

SMITH, ROBERT, *A Compleat System of Opticks*, Cambridge, 1738

SMYTH, FRANCES P. AND JOHN P. O'NEILL (eds), *The Age of Correggio and the Carracci*, Washington, D.C., and New York, 1986

SOBEL, DAVA, *Galileo's Daughter: A Historical Memoir of Science, Faith and Love*, New York and London, 1999

SPICER, JOANEATH A., *Masters of Light: Dutch Painters in Utrecht during the Golden Age*, Baltimore and San Francisco, 1998

SPIKE, JOHN T., *Masaccio*, New York, London and Paris, 1995

STAMPFLE, FELICE, *Netherlandish Drawings of the Fifteenth and Sixteenth Centuries and Flemish Drawings of the Seventeenth and Eighteenth Centuries in the Pierpoint Morgan Library*, New York, 1991

STEADMAN, PHILIP, *Vermeer's Camera: Uncovering the Truth behind the Masterpieces*, Oxford, 2001

STERLING, CHARLES, *La Peinture médiévale à Paris: 1300–1500*, 2 volumes, Paris, 1987–90

STREIDER, PETER, *Dürer: Paintings, Prints, Drawings*, London, 1982

STURM, JOHANN CHRISTOPH, *Collegium experimentale, sive curiosum*, Nuremberg, 1676

TATON, RENÉ, *Ancient and Medieval Science from Prehistory to AD 1450*, translated by A. J. Pomerans, London, 1963

TEMPLE, ROBERT, *The Crystal Sun: Rediscovering a Lost Technology of the Ancient World*, London, 2000

THOMIN, M., *Traité d'optique mécanique*, Paris, 1749

THORNDIKE, LYNN, *A History of Magic and Experimental Science*, New York, 1929

THUILLIER, JACQUES, *Georges de la Tour*, translated by Fabia Claris, Paris, 1993

TINTEROW, GARY AND PHILIP CONISBEE, *Portraits by Ingres: Image of an Epoch*, London, 1999

TINTEROW, GARY, MICHAEL PANTAZZI AND VINCENT POMARÈDE, *Corot*, New York, 1996

TOMAN, ROLF, *The Art of the Renaissance: Architecture, Sculpture, Painting, Drawing*, Cologne, 1995

TOMLINSON, JANIS, *Francisco de Goya y Lucientes 1746–1828*, London, 1999

TOOK, ANDREW, *A Catalogue of Mathematical and Optical Instruments*, auction sale catalogue, London, 1733

TWYMAN, F., *Prism and Lens Making: A Textbook for Optical Glassmakers*, London, 1943

TYMME, THOMAS, *A Dialogue Philosophicall*, London, 1612

VARLEY, CORNELIUS, *A Treatise on Optical Drawing Instruments*, London, 1845

VARSHAVSKAYA, MARIA AND XENIA YEGOROVA, *Peter Paul Rubens*, Bournemouth and St Petersburg, 1995

VASARI, GIORGIO, *Le Vite dei più eccellenti architetti, pittori et scultori italiani*, Florence, 1550; translated by Julia Conway Bondanella and Peter Bondanella as *The Lives of the Artists*, 1998

VERDI, RICHARD, *Nicolas Poussin 1594–1655*, London, 1995

VERNET, JUAN AND JULIO SAMSO, 'The development of Arabic science in Andalucia', in Roshdi Rashed (ed.), *Encyclopedia of the History of Arabic Science*, London and New York, 1996

VOS, DIRK DE, *Hans Memling: The Complete Works*, London, 1994

VOS, DIRK DE, *Rogier van der Weyden: The Complete Works*, Antwerp and New York, 1999

WALTER, INGO F. AND RAINER METZGER, *Vincent van Gogh: The Complete Paintings*, Cologne, 1997

WASSERMAN, JACK, *Leonardo da Vinci*, New York, 1984

WHEELOCK, ARTHUR K., 'Constantin Huygens and early attitudes toward the camera obscura', *History of Photography*, no. 2, April 1977

WHEELOCK, ARTHUR K., *Perspective, Optics and Delft Artists around 1650*, New York and London, 1977

WHEELOCK, ARTHUR K., *Jan Vermeer*, New York and London, 1981

WILDENSTEIN, DANIEL, *Monet, or the Triumph of Impressionism*, Cologne, 1996

WITELO, *Vitellionis mathematici doctissimi repi optikae*, Nuremberg, 1535

WOLLASTON, W. H., 'Description of the camera lucida', *A Journal of Natural Philosophy, Chemistry and the Arts*, London, June 1807

WORP, J. A. (ed.), 'Fragment eener autobiographie van Constantijn Huygens', in *Bijdragen en Mededeelingen van het Historisch Genootschap*, s'Gravenhage, 1897

WORP, J. A. (ed.), *De Briefwisseling van Constantijn Huygens*, s'Gravenhage, 1911

WOTTON, HENRY, *Reliquiae Wottonianae*, London, 1651; republished in Logan Pearsall Smith, *The Life and Letters of Sir Henry Wotton*, Oxford, 1907

ZAHN, JOHANN, *Oculus artificialis teledioptricus, sive telescopium*, Würzburg, 1685–6

ZANETTI, ANTONIO MARIA, *Della pittura veneziana*, Venice, 1771

ZARNECKI, GEORGE, JANET HOLT AND TRISTRAM HOLLAND, *English Romanesque Art 1066–1200*, London, 1984

ZEKI, SEMIR, *Inner Vision: An Exploration of Art and the Brain*, Oxford, 1999

ZERWICK, CHLOE, *A Short History of Glass*, New York, 1980

ZOLOTOV, YURI AND NATALIA SEREBRIANNAIA, *Nicolas Poussin: The Master of Colours*, Bournemouth and St Petersburg, 1994

ZUFFI, STEFANO AND FRANCESCA CASTRIA, *Italian Painting: Artists and their Masterpieces throughout the Ages*, Milan, 1997

list of illustrations

Dimensions of works are given in centimetres and inches, height before width

b=bottom, c=centre, l=left, r=right, t=top

acknowledgments

This book was not commissioned. It grew out of a small observation, which led to bigger ones. Many people helped in this, but my main collaborator was David Graves, who spent many hours in the British Library researching texts, and then three months in California making our bigger picture. In the studio there, I was helped in the long job of selecting paintings by Richard Schmidt and Gregory Evans.

My main correspondent was Martin Kemp, Professor of Art History at Oxford University, who encouraged my intuitions from the start. So, too, did Gary Tinterow of the Metropolitan Museum in New York, who invited me to the Ingres symposium held at the Met in October 1999. Paul Melia and Marco Livingstone listened to hours of my phone conversations and made suggestions or argued sceptically. Phone and fax correspondents included Bing McGilvray in Boston, Lindy Dufferin in Ireland, Jonathan Brown in Nice, Helen Langdon in London, Peter C. Sutton in London and Peter Goulds in Los Angeles. Timothy Potts of the Houston Museum of Fine Arts sent me the catalogue of a Moroni exhibition organized there.

Visitors to the studio, who often arrived with scepticism but nevertheless gave encouragement, included John Walsh of the Getty Museum, who always responded promptly and with enthusiasm to keep me going with his natural and charming sceptical manners. Weston Naef and Gordon Baldwin of the Getty Photographic Department visited a few times, and Allegra Pesenti, a research scholar there, translated some texts.

Norman Rosenthal and Nick Tite of the Royal Academy in London read and published the first of my 'Post-photographic' essays, and posed for early camera lucida drawings. David Plante in New York arranged a talk at Columbia University and a meeting with David Freedberg and Jonathan Crary, which I found very exciting as their books had been key works for me.

Lawrence Weschler of the *New Yorker* was an early but sceptical enthusiast who visited many times and wrote a very good piece for the magazine in January 2000. As a result of the article, I met Charles Falco, an optical scientist from the University of Arizona in Tucson, who became a correspondent and keen visitor. It was really thanks to him that I discovered the mirror-lens. With enormous enthusiasm, Charles provided a genuine scientific base for my thesis. The two of us co-authored a piece for *Optics & Photonics News*, an American scientific journal, which was published in July 2000.

John T. Spike wrote to me after the *New Yorker* piece supporting my observations on Caravaggio (he is working on a *catalogue raisonné* of Caravaggio's paintings), and we spent an exciting three days in London visiting 'The Genius of Rome' show at the Royal Academy and then discussing Masaccio.

Dr Earl Powell of the National Gallery in Washington, D.C., organized with the Center for Advanced Studies in the Visual Arts a private seminar at the Gallery. Theresa O'Malley and Henry Millon chaired that event. Brian Kennedy of the National Gallery in Canberra invited me to give my first lecture 'Beyond Ingres and Caravaggio'.

Ricky Jay, a scholar of magic and mirrors, came to see me and I visited him in turn with Ren Weschler. We also visited two optical instrument-makers, John Braithwaite and Tom Muir, in their house and workshop (the garage) just south of Glasgow. It was a marvellous trip. They told us all optical instrument-makers are still secretive today, and so assumed they had always been.

In Los Angeles, Brad Bontems made many suggestions and posed as a cardinal. Jonathan Mills read texts, and Anni Philbin organized a show of my camera lucida drawings. Elizabeth East of the LA Louver gallery read the book and offered comments. Karen Kuhlman typed up the various letters, notes and other texts, making sense of my handwriting and Martin Kemp's less clear handwriting.

copyright acknowledgments

index